AN AMERICAN BY DEGREES

An American by Degrees

The Extraordinary Lives of
French Ambassador Jules Jusserand

ROBERT J. YOUNG

McGill-Queen's University Press
Montreal & Kingston • London • Ithaca

© McGill-Queen's University Press 2009

ISBN 978-0-7735-3572-5

Legal deposit third quarter 2009
Bibliothèque nationale du Québec

Printed in Canada on acid-free paper that is 100% ancient forest
free (100% post-consumer recycled), processed chlorine-free.

This book has been published with the help of a grant from the
Canadian Federation for the Humanities and Social Sciences,
through the Aid to Scholarly Publications Programme, using funds
provided by the Social Sciences and Humanities Research Council of
Canada.

McGill-Queen's University Press acknowledges the support of the
Canada Council for the Arts for our publishing program. We also
acknowledge the financial support of the Government of Canada
through the Book Publishing Industry Development Program
(BPIDP) for our publishing activities.

Library and Archives Canada Cataloguing in Publication

Young, Robert J., 1942–
 An American by degrees : the extraordinary lives of French
ambassador Jules Jusserand / Robert J. Young.

Includes bibliographical references and index.
ISBN 978-0-7735-3572-5

1. Jusserand, J. J. (Jean Jules), 1855–1932. 2. France – Foreign
relations – United States. 3. United States – Foreign relations –
France. 4. France – Foreign relations – 1870–1940. 5. Ambassadors
– France – Biography. 6. Historians – France – Biography. I. Title.

DC373.J8Y68 2009 327.44092 C2009-901690-7

Typeset by Jay Tee Graphics Ltd. in 10.5/13 Sabon

For all who
"wolde gladly lerne and gladly teche"

Geoffrey Chaucer
The Canterbury Tales

Contents

Foreword

At the heart of the Chancery building that houses the offices of French diplomats posted to Washington, there is a portrait gallery featuring France's ambassadors to the United States. One might expect it to start with the first French plenipotentiary appointed by Louis XVI when America gained its independence from Great Britain. Yet, for reasons nobody knows, the row of portraits begins with a photograph of Jean-Jules Jusserand. He appears as indeed he was in real life: calm, his gaze turned slightly away from the camera, his hand resting on a chimney mantel – as though slightly disconcerted or even a little intimidated by this rather formal exercise.

This photograph was my first encounter with Ambassador Jusserand, triggering an endless curiosity that, happily, is satisfied by Robert Young's remarkable biography.

With twenty-two years in Washington, Jusserand was not merely France's longest-serving ambassador to the United States. It is true that, for twenty-two years, he worked tirelessly to promote the friendship between the United States of America and his country, developing a deep, keen understanding of American society: its mores, customs and changes. Yet his longevity may be deceptive, as such records – which tend to overshadow so many other worthy accomplishments – often are. Indeed, Jusserand was much more than the sum of his years in Washington, and his life and career offer unparalleled insights into French diplomacy at the dawn of the twentieth century.

Ambassador Jusserand distinguished himself first of all by his erudition: cultured and literate, he embodied the ideal of those turn-of-the-century *honnêtes hommes* who transmitted their learning

and ideas to their fellow-citizens with the elegance and clarity of
those who don't care about appearances but who want to learn,
educate, inspire. Jusserand knew everything about English litera-
ture, immersed himself in Chaucer and Shakespeare, had an ency-
clopedic knowledge of fourteenth-century English history, wrote
prolifically and well. He was an unconventional historian, as Pro-
fessor Young so justly notes, animated by an appealing personality
and ever-lively curiosity.

But he was also a diplomat whose career, beginning in the 1870s,
unfolded quietly for more than two decades, until he was posted to
Washington – the job that put him on the map, as it were. Why
America, when his area of expertise was Great Britain? Certainly,
his erudition crossed the Atlantic, but he was no New World spe-
cialist. To this question there is no truly satisfactory response. At
best, one must admire the prescience of the official whose idea it
was to propose Jusserand for Washington. Because it turned out to
be the right choice.

Between 1903 and 1925, Ambassador Jusserand would become
the quintessential diplomat, a friend to five U.S. presidents and in
particular Theodore Roosevelt; a tireless traveller who crisscrossed
America; an interpreter of the philosophies and approaches of
American diplomacy. He strove to bridge the two countries, eager
to foster understanding of the issues that inspired American leaders
at the dawn of a bellicose century.

He achieved this aim, right from the beginning of his mission,
and his devotion to the cause of French-American friendship was
always clear. His determination to educate the public about Pierre
Charles L'Enfant and his campaign to have L'Enfant's ashes trans-
ferred to Arlington Cemetery were an integral part of this effort,
and the latter no doubt remains one of his most admirable feats. But
many will prefer the image of the patient runner, jogging through
Rock Creek Park on the heels of Teddy Roosevelt, or the stoic,
courtly swimmer, diving into the icy waters of Rock Creek – again
with President Roosevelt.

The reader may well wonder: "What's *not* in a diplomat's job
description?" One might simply say that Ambassador Jusserand
understood better than anyone that international relations are nur-
tured by efforts large and small, by a thousand minute details as
well as the most momentous decisions.

Finally, this biography gives us the portrait of a wise and serene man, of eclectic tastes, who combined a love of literature with a passion for sports; a great diplomat and eloquent writer who was supported until the very end by a wife who was particularly appreciated by Washington society.

His was "a success story," as they say in America. That is certainly true, but his success also says a great deal about relations between the United States and France, underscoring the often-essential role of sentiment and emotion that lies at the heart of this friendship. Consider Lafayette, Rochambeau, and de Grasse, and their "chivalrous" commitment to the independence of the American colonies. Or the American army's D-Day landing on the beaches of Normandy in June 1944 that is still celebrated today with the same fervour as sixty-five years ago.

Beyond that, and more simply, the life of Jean-Jules Jusserand remains that of a great diplomat who knew how to do his job and who carried out his mission in the United States with dignity and common sense. To all those who have followed in his footsteps, he remains a welcome inspiration and an enduring example. As he gazes down from his framed photograph, in the heart of the French Embassy in Georgetown, one has the sense that he is watching over each of us, reminding us, as if it were necessary, that the deep friendship between America and France is nurtured by a long history that we must not forget.

Professor Young's biography serves as a timely reminder of this essential lesson: Jusserand is but one of many actors in the French-American relationship, but the "small stones" he contributed to that grand edifice merit the attention that this biography devotes to them. For that, its author deserves our sincere thanks.

Pierre Vimont
Ambassador of France to the United States of America

Introduction and Acknowledgments

"President Roosevelt ... had typewritten notes [but] as the occasion ... inspired him, he added long and different statements ... I have often noticed such differences."[1] Suddenly the pen fell to the floor. Taken in mid-thought, the old man collapsed, page in hand, memoirs unfinished. Three days later he died, his wife at his side, hand in hand. So ended the life of Jean-Jules Jusserand, quietly, in his home on the avenue Montaigne, on the 18th of July 1932.

"Jusserand?" you say. "Never heard of him." But that is the point, as sure as ignorance is a flimsy shield. Once a familiar name to literates around the world, a scholar and a diplomat, Jean-Jules Jusserand's has slipped beneath the waves as surely as the grey-clad *Lusitania* he glimpsed on his way out of Liverpool harbour in August 1914. Historically outshone by the Hohenzollern kaiser, the French premier Clemenceau, and the American presidents Roosevelt and Wilson, Jusserand numbers among the multitudes of public servants who have receded from our consciousness. Like some family antecedent whose fame is less brightly recalled with each generation, his now rests among handfuls of scholars. Some praise his work as ambassador in the early twentieth century, or marvel at the breadth of his historical scholarship; some, more grudging and accusatory, judge him too rooted in an old world and too sceptical of the new. I am but a single digit among the handfuls, and apparently rare in the resolve to locate one man, complete, within two remarkable careers. Therein lies the ambition behind *An American by Degrees*.

Jusserand's pen was quite exceptional. For one, it was prolific. By the time of his appointment as ambassador to Washington in 1902

at the age of forty-seven, Jusserand had published fifteen books, a number in multiple editions, and several, in those very early years, translated for him from the original French. Equally remarkable, this productivity continued throughout the whole of his protracted ambassadorial career in America and into his post-1924 retirement. It was, as well, a fluid pen, ultimately so conversant with English and French that either could have been a mother tongue. Indeed, his death-abbreviated memoirs, written and subsequently published only in English, were but the last of a long trail of English-language publications dating back to the 1880s. And his was a rich, evocative English, with words that had been carefully turned on the tongue: the pardoners of Chaucer's age, "always men of excessive impudence"; a seventeen-century ambassador whose reputation warranted repair through the "benefit of extenuating circumstances [being] equitably extended to some of his worse faults"; indolent readers in the 1880s who chose cheap novels while the works of great writers "stand in their fine army on the high shelves of libraries"; or an old man's recollection of the Beaujolais hills of his youth, hills which, "according to the season, the weather, the hour of the day, assume a variety of hues, dark or pale green, dark or pale blue, pink in the sun, blue in the shade [with] rivulets flow[ing] from the heights through wheat-fields, meadows and vineyards ... singing among the pebbles, outlined in their undulating course by trees and underbrush that take on in the distance the greenish-blue tints of the trees in the old tapestries."[2]

Masterful in expression, the pen was of course but an agent of an energy-rich mind. Jusserand was exceptional in that his adeptness at English was matched by an early love of British history and English literature. This at a time when French scholars of his generation, and their mentors in *lycées*, universities, and *grandes écoles*, were mainly preoccupied with continental cultures, especially that of the dynamic, and victorious, Germany, whether seen as a liberator from the confines of French intellectual tradition or as a mesmerizer of minds too lazy to think for themselves.[3] But most remarkable of all was the breadth of Jusserand's interests. Here was a scholar who quickly became an acknowledged expert on Chaucer, Langland, and Shakespeare, his knowledge acquired, it should be said, by long labours in English and French libraries and archives. Before he arrived in the Washington embassy in February 1903, he had published books and papers whose subject matter ranged from

the history of English literature, to sports in pre-modern France, to Shakespeare's reception on the French stage.

And while he had by then not quite completed his study of Edmund Spenser's views on Aristotle, or those of Ben Jonson on Shakespeare, he had already published papers on the fifteenth-century Scottish king James I, the seventeenth-century French poet and novelist Paul Scarron, and the eighteenth-century novelist Daniel Defoe. But if there was one crowning achievement, it had to be a work originally produced in 1884 – when he was twenty-nine years of age – and published in English as *English Wayfaring Life in the Middle Ages*. A good twenty years before "social'" history had begun to win its spurs in Europe, and thrice that before it became fashionable in North America, this diplomat had opened up the roads and byways of fourteenth-century England. And he wrote not so much about princes of the realm as about charlatans, minstrels, jugglers, buffoons, and cheap-jacks – ordinary but essential men and women who build and populate the stage on which occasional individuals of power, wealth, or genius pass.[4]

If untypical as historian, so was he as diplomat, even for a diplomat of France, and at a time when future agents of the foreign ministry had long been groomed by education, class, and opportunity to speak, write and savour, debate and dress, in a manner consistent with gentlemen. Others of intellectual renown had preceded Jusserand at the ministry on the Quai d'Orsay, and others were to succeed him, but few would surpass the volume and quality of his literary labours, and fewer still were equally at home among the political classes and literati in Paris, London, and Washington. Nor should one be misled into thinking that diplomacy was for him a sideline, something to be done between research and writing, or that forgiving masters had posted him to undemanding sinecures. From the beginnings of his career in the autumn of 1878 he had worked his way up through the ranks, from junior postings in London, through several positions in the central administration in Paris, to the office of de facto ambassador to Denmark.

Full ambassadorial rank followed in 1902, with his assignment to Washington. Being chosen for the post was, in truth, far less remarkable than the fact that he retained it for the following twenty-two years. Although elevation from Copenhagen to Washington would now be seen as a meteoric rise, at the turn of the twentieth century the American federation was just beginning to

impress the European great powers with its potential as an international player. Washington was still not seen to be on a par with London, Berlin, Vienna, or St Petersburg; and so a forty-seven-year-old career diplomat, who had no personal experience in three of those four embassies, but who spoke English fluently and had the personal ear of the minister, was selected for the task. No one saw fortune smile. When he arrived, tariffs were the principal irritant between France and the United States, and the irritant they shared was the mercurial General Cipriano Castro of Venezuela. But within a decade, ten more years of American growth, Jusserand was involved in games of much higher-stakes, working with the White House to terminate the Russo-Japanese War in the Pacific, to avert Franco-German hostilities over Morocco, and to serve as mute, mutual witnesses to the terrible collapse of world peace in 1914. Thereafter, the stakes were higher still: cultivating American sympathy for France, just beneath the surface of official American neutrality; maximizing the benefits of having America as an ally after April 1917, without awarding her a disproportionate voice in the war effort, peace negotiations, and post-war world; balancing between, and moderating where possible, the stance of those Americans who insisted on early and complete payment of monies borrowed by France for the war effort and post-war reconstruction, and the stance of his own government, which chose to pay glumly, belatedly, incompletely, or, at times, not at all. No sinecure this, and no diplomatic backwater where pen could easily trump protocol.

But neither written word nor diplomatic flourish constitutes the flesh of humanity, since accomplishments are but one dimension of a life. Childhood is another, a pre-fame condition when the early roots descend. In Jusserand's, youth had provided a crucial mixture of urban and rural, his schooling in Lyon, alternating with farm boy life in the fields of Le Bachelard and in the forests on the slopes of the Monts de la Madeleine. It was there, climbing and hiking well beyond the walls of the Roannais hamlet called Saint-Haon-le-Châtel, that he conditioned himself – quite unknowingly – for the forced marches so beloved by Theodore Roosevelt. More enduring still was the imprint of family, of which Jean-Jules became the head at the tender age of sixteen upon the death of an elderly father. Thereafter, Jean-Jules Jusserand – "Trois Js" by affectionate family nickname – would serve as adviser on a broad range of matters, such as the education of his brother and two sisters, the annual

distribution of casks from the family vineyard, and the allocation of vacation time in the family home in Saint-Haon-le-Châtel.[5] Today, all but Francica, the youngest sister, lie together in the family plot: father and mother, Etienne, Jeanne, and Jules.

With them is Elise, née Richards, Jules's wife of thirty-seven years and "the greatest gift Heaven granted me."[6] She did not play tennis, or swim the Potomac with Roosevelt, and she did not communicate directly with the Quai d'Orsay or the State Department. But in other respects, she was the ambassador's constant companion, whether at semi-private embassy dinners, at public concerts and lectures, or in the treasured private moments on the footpaths, amid the birds, of Washington's Rock Creek Park. From their marriage in 1895 to his death in 1932, the Jusserands were as one. Although an American by virtue of her birth in Paris to American parents, Elise Richards was raised a French *bourgeoise*. Educated (in all likelihood, only to the secondary level), an intelligent conversationalist, judging by numerous testimonials from her husband's correspondents, poised, dignified, and discreet beyond all measure, Mme Jusserand seems to have been a classic example of the once honourable, now suspect, word "help-mate." It is in her apparent acceptance of that role, indeed her insistence upon it, that lies – however regrettably – the explanation for why her footprints are so faint and so few.

Here, the contrast between husband and wife is striking and, in its own way, ironic. A recorder as well as a maker of history, Jusserand understood the value of autobiography. To that end, between retirement and death he assembled private and official correspondence in advance of his anticipated memoirs. But death intervened before the narrative could go beyond the presidency of "Teddy" Roosevelt. Today the entire collection is housed in the archives of the French foreign ministry and takes the form of 166 thick file folders. Within them, however, are very few direct traces of Elise Jusserand. Among the many, many references to her from hundreds of his correspondents, as well as from Jusserand himself, there is little sign of her hand, her counsel, her aspirations, her anxieties. Little succour here for even the most determined of biographers – which is why moving from wife to husband is like moving from famine to feast.

Except, and here is the irony, they have been almost equally ignored. Although Jusserand's voluminous, carefully ordered

papers have been mined by many scholars over the past three to four decades, no one, French or foreign, has undertaken – or at least completed – a biography; and works with titular reference to his name are far less numerous than the books and articles he himself authored. As historian, he is all but forgotten, his Pulitzer Prize for History, his presidency of the American Historical Association, notwithstanding. As diplomat, he is little better remembered: perhaps for his membership in Roosevelt's "tennis cabinet"; his uneasy, wartime relationship with Woodrow Wilson, his stiff non-compliance with "modern" notions of wartime propaganda, or his unavoidable association with what for France was the demeaning, post-war Washington Conference on naval disarmament. It is not difficult to find his name in countless indices of books on international relations, but not easy to find much of substance on the ambassador or his embassy – another reason why it seems fitting, timely, to remind today's readers of what has been forgotten.

At first glance, a biography would have seemed the most sensible, most obvious, way of doing so – were it not for the showers of darts that have been aimed at the genre and, sometimes less kindly, at its practitioners. Edmund Gosse, for one, a long-time friend of Jusserand, observed at the outset of the twentieth century that the passion for biography was getting out of hand: practised by anyone who was "too great a fool, or too complete an amateur, or too thoroughly ignorant of composition" to tackle the life of an eminent person." A decade later, John Morley's biography of William Gladstone (both author and subject being friends of Jusserand) was dismissed by H.G. Wells as little more than "embalmed remains: the fire gone ... the bowels carefully removed." Some simply thought that "life-writing" – a term that has been in use since the late 1920s – was conceptually impossible. Four years after Jusserand's death, Sigmund Freud slammed biographers as people "committed to lies, concealment, hypocrisy, flattery ... for biographical truth does not exist." Jean-Paul Sartre later called it a branch of "fiction" but the kind of fiction that denied the author the freedom to create. Or, rephrased, the genre illuminates a paradox; namely that a novelist can draw the characters of fictitious individuals far more completely than the biographer – working within the rules of evidence – is able to do with "real" people. Indeed, ever since Freud the problem of "evidence" has multiplied a hundred-fold as the search has

intensified for the "interior personae," the private, especially the sexual, life of would-be subjects.[7]

And biographers face another obstacle as well: the subjects themselves, and beneath them an underlying, discriminating concept. Must they be figures stamped by what Leon Edel has called "singular greatness," or is there room for "minor lives," people like Geoffrey Wolff's father, who "was a 'minor' subject if ever there was one" but who was also "a major father to me"?[8] And whether one accepts or is offended by the distinction between the allegedly important and the allegedly ordinary, that divide certainly can create yet another headache for the putative biographer. The fact is that, however "popular" biography may be among book readers and therefore sellers, many academics and many academic publishers are circumspect.[9] One consideration is doubtless commercial. While demand seems insatiable for "new" works on the already famous – Alexander the Great, Peter the Great, Catherine the Great – those without such titular cachet, which is to say the less "great," the "minor," the already forgotten, have a harder time of it, however compelling their biographers' claims to novelty.

Second, "professional historians," a term that usually refers to those who teach the discipline of history and whose livelihood is therefore not dependent on purely market considerations, have marshalled complaints of another order (not all professionals, by any means, but in cohorts numerous enough to be ignored only at one's peril). Compressed to the irreducible, those complaints are singular, if bi-faceted: biography can be a distortive historical medium, for it can exaggerate the role and stature of one individual by minimizing the background, the context in which he or she operated. Conversely, it can miss the now self-congratulatory expression "big picture" in a myopic pursuit of crumbs over loaf. Beneath both criticisms, there are often strong ideological currents. Typically, those who leave much by way of historical record have been affluent and powerful members of a reigning elite. Globally, they have been predominantly male, in the western world they have been predominantly white. Little wonder that biographers have shown such interest in lives so well documented, and little wonder that they are sometimes derided as valets to rich, white, men – notwithstanding the fact that occasionally male and female authors alike break loose with portraits of a Gandhi, Mao, or Mandella, or an Elizabeth i, George Sand, or Eva Peron.

Since suspicions about biography are by no means universal among professional historians, and since the sometime critics would never be unanimous in their appraisal of individual works, it may be appropriate to clarify my own position. I set out in the conviction that biography is neither superior nor inferior to genres addressed more to groups than to individuals: peasants or bourgeois, revolutionaries or conservatives, artists, churchmen, scientists, courtesans. What follows, therefore, is intended not as a defence of biography as form but as an affirmation of its potential to satisfy author and reader. Certainly that is what professor of biography Richard Holmes meant when he suggested that the form could offer to the historical community a "bridge back ... into the living community," back from the passionately impersonal approaches that have accompanied insistence on history as science.[10]

Speaking of that author-reader tandem, it would seem that no other genre is more intimate than biography, what Lytton Strachey called "the most humane of all the branches of the art of writing."[11] From childhood every writer and every reader has observed the internal complexities, inconsistencies, and vagaries of many individuals of their acquaintance. Might we suggest that particular individuals – readers and writers included – are as likely to respond emotionally, impulsively, to stress as any group or collectivity? This parallel would mean that the calculation of motive, the search for rational explanation behind word and deed, can be as complicated for parties singular as parties plural. "The more individual people are studied in detail," Theodore Zeldin wrote many years ago, "the more complex do they reveal themselves to be."[12] In short, putting one person under the lens is not nearly as simple and straightforward as one might imagine.

Moreover, the stakes can be exceptionally high, for subject and author both. We are, after all, dealing with real people whose reputations are re-evaluated every time an historian picks up pen. But if these scholar-conducted inquiries can follow one upon another, interminably in some cases, there is no higher court of appeal to render definitive judgment; and for historical subjects there can be no tribunal to award punitive damages. That is perhaps why G.K. Chesterton thought some biographers needed to be reminded that their time, and his, was only a time, "and not the Day of Judgement."[13]

As for subjects with pens, they could also be reminded, as am I, of a remark made by an old acquaintance to the effect that every individual has some secret corner which none but he or she can enter.[14] In other words, and as Freud asserted, the most secret archive always remains inaccessible – except, of course, to him; and in its absence our best efforts at understanding may be betrayed. Since perfect honesty is rare, and since even the timid defend themselves with vigour – often by magnifying or, as the occasion demands, minimizing their roles – biographers are always on marshy ground. Anxious to be fair, to be scrupulous about separating suspicion from evidence, we do not want to be lured into specious canonization, or to be weighed down by an "obligation to greatness," so intent on collecting all the "droppings" from a single life that we rob it of its vitality and produce "one of those vast mournful compendia that add ... a new terror to dying."[15] So, too, must we be equally careful about the temptation to condemn, flexing our muscles against the defenceless.[16] For surely, the growth of an intense dislike of one's subject is a risk more likely to arise over intimate appreciations of a single individual than it would over readings of collectivities. In short, biography may represent greater than usual emotional hazards: keeping in check a growing predisposition to be either too sympathetic – a love that passeth all understanding – or too scathing. Shorter still, our own reputations are on the line.

Having quickly exposed several of the key challenges of biography, as well as the need for a delicate handling of this unstable material, one hastens to make a complementary point. If some historians are sometimes accused of writing history without recognizable, flesh and blood human beings, some biographers have been accused of doing the reverse. Their offence, it is said, is that of practising "great man" history" in other words, magnifying their subjects, male or female, out of all proportion to time and context. Gulliver in Lilliput. How simple it is to join the chorus of protesters on either side, for the shortcomings of both approaches seem obvious. To strike the right balance, however, is not such an easy matter, however clear the ideal. What is wanted is a lens ground finely enough to keep the focus sharp on the subject without producing a too-blurred background. "Biography," Philippe Levillain has written, "is the perfect location for the painter of the human condition, as long as the subject is not isolated from her or his contemporaries,

and is not magnified at their expense."[17] An old idea this, of life and times, but one that has become no easier to apply for all its longevity. Essentially, we are on our own. We cannot "assume some sort of progressive movement" is underway "towards the ideal biography of the future." And so we must find solace in Somerset Maugham's prescription: "There are three rules for writing biography, but fortunately no one knows what they are."[18]

In this particular case, the trick will be to keep Jusserand and those around him firmly in the foreground, while supplying the requisite cultural elements in the background. And I mean "cultural" in the broadest sense, for he, like all, was a creature of his times. He is impossible to decipher without some attendant sense of France's educated elite: without that elite's appreciations of the "German problem" on the one hand and of France's exceptional contribution to western civilization on the other. Similarly, understanding this Frenchman depends on an understanding of an American society directed by its own wealthy and educated elite, a political, economic, literary class that had been nourished on the history of Lafayette and of France's support during the eighteenth-century American Revolution.

Still, it was neither the eighteenth century nor the twenty-first, only the prologue to and the early decades of the twentieth. The Jusserands travelled a great deal, taking long voyages by ocean liner or railroad, shorter trips in the Washington area by their preferred conveyance – horse and carriage – and later, reluctantly, by the not-to-be-denied automobile. Reluctantly, it is said, because the pace of the horses gave the ambassador more time to think and to observe.[19] The embassy had long since moved from parchment and quill pen to typewriters, carbon paper, and telegrams, but during Jusserand's tenure was only slowly experimenting with telephones, radios, and cinematography, all of which were eventually recruited to promote France's pioneering aviation industry. Promotion, indeed, became a byword in this age, an era of increasingly global trade, mass marketing, commercial advertising, and public relations. And it meant a constant succession of adjustments for those who had been schooled in Latin, and who had spent country summers in wooden sabots.

Though the details of our individual cases will vary widely, no reader would have difficulty relating to this natural law of change and transition. The most banal example – recalling a day when

Gillette offered only one blade – illustrates the point. And with it comes the humble reminder of our common denominator: the human condition. That is the essential link between biographer and subject, between two individuals, just as it is, must be, the bond between author and reader. The latter, quite unlike the stadium spectator, engages with the author, one on one, in solitary, humanistic pursuit. Which raises another clear if elusive ideal. The bond depends on uncluttered communication ... no patronizing, no perplexing neologisms. Jargon, language used in any way to separate writer from reader, has no place in any art form. Monsieur Jusserand said that formally, and at length, eighty years ago. In my judgment, he was right, and he was a remarkably successful practitioner of that ideal. Similarly, his judgment and mine, the practice of history is not dependent on the construction of elaborate, theoretical infrastructures. Partly, again, because many people who read books are distracted by theoretical discourse.

Is it too late to qualify myself? There are in fact a few parts of the theoretical anatomy which are eye-catching. One is the old idea, only now in skimpier "post-modernist" garb, to the effect that the historian is a player in the process of history-making. Mainly, it seems, this claim is intended to be much less arrogant than it sounds, and rather more of a confession of our limitations. Evidence is never fully complete; we read it through the lenses of our own generation, cultural background, and personal prejudice; and we end up with an impression, an interpretation, truth as we have discerned it, but not the truth of absolutes. Fine. Monsieur Jusserand would have agreed, as do I a century later. Closely related to this sensible, indisputable, not to say obvious, warning is the more refined concept, and more charming expression, "*ego-histoire.*"[20] At its heart is the notion that historians are just as subject to the determinist forces of their own day as the historical subjects, singular or plural, whom they study. In short, readers may need to know something about the historian in whom they are going to invest some element of trust.

Perhaps the most salient fact in this regard is my previous experience as a biographer, not only of another Frenchman but one of Jusserand's generation.[21] Whether asset or liability, only time will determine, but best to acknowledge that this is no virgin's quest. And at least one lesson has been learned in advance. Over twenty years ago, in the early stages of research, Louis Barthou struck me

as remarkable ... and unique. Remarkable he remained, but the slow recession of my naiveté and ignorance exposed a world of patterns that qualified, and correctly so, that early sense of uniqueness. The cohort of Paris-based cabinet ministers to which he had ascended after 1890 shared elevated levels of education, legal training, journalistic experience, marriage to women of fewer years and greater wealth, and a range of recreational interests from hiking, collecting, and cultural patronage to written exercises in literature and history. With such discoveries, about group and about individual, Barthou's uniqueness diminished while his representative importance increased commensurately.

That may be why, in Jusserand's case, I was quick to welcome the signs that – for all his unique combination of talents and characteristics – he was typical of his generation, or rather of a certain cull of that generation: male, bourgeois, uncommonly educated. Even within the small radius of my interests, past and present, the signs were unmistakable. Jusserand and Barthou were born in 1855 and 1862 respectively, and both used the humiliating defeat of France by Prussia in 1870 as an inspiration for careers in the nation's service; both were university-educated, the former in Lyon, the latter in Bordeaux and Paris; Jusserand married in 1895, at age forty, to an affluent woman seven years his junior; Barthou, in the same year, at age thirty-two, to an affluent woman ten years his junior. The two couples lived within sight of each other, the Jusserands near the Seine on the avenue Montaigne; the Barthous, near the Seine on what is now the avenue Franklin Roosevelt. They were walkers, readers, patrons of the arts and charities, travellers. Three of the four, including Alice Barthou, were authors of published works. Elise Jusserand was a translator of at least two of her husband's early works on English literature. Both men were elected to chairs at the Institut de France.[22] The funerals for all but the statesman were held in their parish church of Saint-Pierre de Chaillot. There were differences, of course, those of career – one man in politics, the other in the foreign service – and those more personal. The Jusserands were without child; the Barthous had lost their teen-age soldier early in the Great War. The latter now lie together in Paris, in the tomb at Père Lachaise: Max in 1914, Alice in 1930, Louis in 1934. Two years earlier Jules had been interred in the cemetery of Saint-Haon-le-Châtel, and in 1948 Elise was laid to rest beside him.

There is another difference, too, which relates in some way to the recorder of these lives. Seasoned to some extent in the form of biography, conversant with the texture of French society in the Jusserand period and, more recently, with that of American society in the same period, a goodly number of rings have been added to my trunk between *Power and Pleasure* and *An American by Degrees*.[23] As husband and father of long standing, I could at least imagine the suffering that accompanied Barthou's loss of son and wife. I was less imaginative, twenty years ago, when it came to Barthou as a seventy-year old. Today, it is easier, one might say effortless. As I enter retirement from a career I have loved, my reading of Jusserand at seventy is certainly more authentic than anything that could have been intuited by someone in their fourth decade. It is an unearned credit, but one I consider to be more asset than liability. Whatever the case, the reader has a right to know, in ways consistent with *ego-histoire*, that I am old enough to have a history. And Jusserand is now part of it.

So too are our benefactors, his and mine. This portrait has been a decade in the making, an endurance trial that would have been impossible without the financial support of the Social Sciences and Humanities Research Council of Canada, and the many services provided so generously by the University of Winnipeg. In particular, without the support of these two institutions I would have had to forfeit the invaluable summer research assistance rendered by some of our ablest undergraduate and graduate students: Kristine Alexander, Margaret Carlyle, Valerie Deacon, Meghan Fitzpatrick, Maureen Justiniano, Jenifer Lewicki, Scott Rutherford, and Marla Williams. In this same connection, I acknowledge the kind assistance of Dr Rob Hanks for the provision of several Jusserand letters from the Henry Cabot Lodge Papers, François Lalonde of Boston University, my retired colleague Dr Donald A. Bailey, Jean Mathieu, resident genealogist and local history expert in Saint-Haon-le-Châtel, Dr Richard Lebrun, professor emeritus at the University of Manitoba, and, for his exceptional kindness, Pierre Vimont, ambassador of France in Washington.

Finally – no, ultimately – the Jusserands and I are most indebted to Dr Kathryn Young, wife, mother, scholar, and "the greatest gift Heaven granted me."

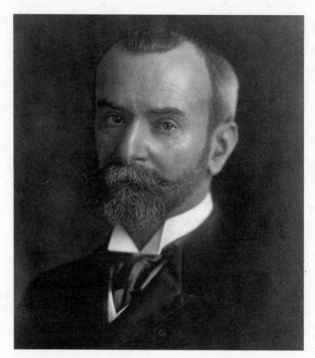

Jean-Jules Jusserand, circa 1904. (Library of Congress}

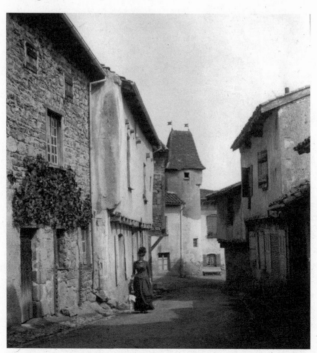

Rue de la Fleur de Lys, Saint-Haon-le-Châtel, circa 1900. (Private Collection, Jean Mathieu, Saint-Haon-le-Châtel)

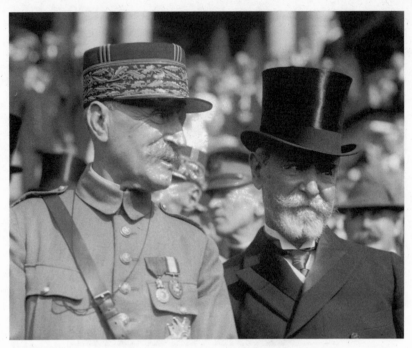

Marshal Foch and Ambassador Jusserand in Washington, 1921. (Library of Congress)

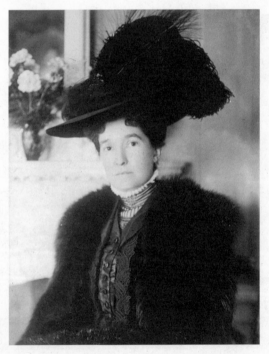

Mme J.J. Jusserand, circa 1910. (Library of Congress)

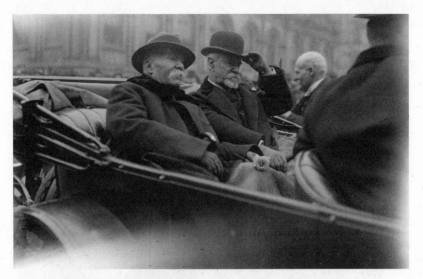

Clemenceau and Jusserand in Washington, 1922. (Library of Congress)

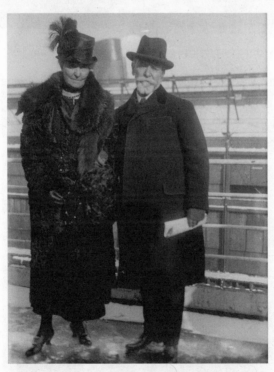

J.J. Jusserand with wife, circa 1923. (Library of
Congress)

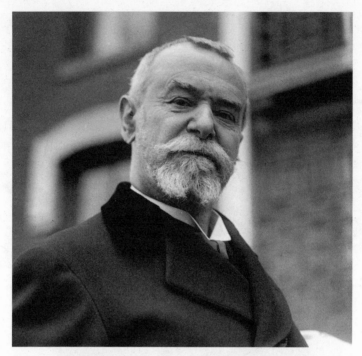

Ambassador Jusserand, circa 1924. (Library of Congress)

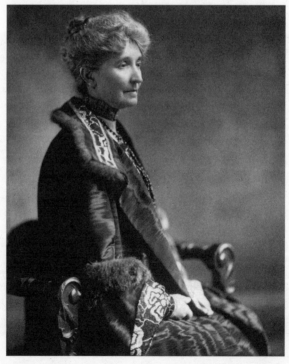

Elise Jusserand, circa 1924. (Library of Congress)

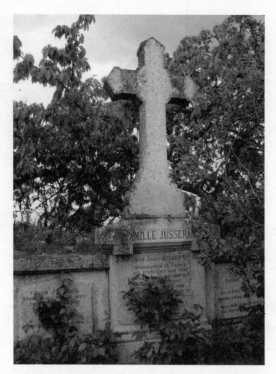

Jusserand family plot, Saint-Haon-le-Châtel.
(Author's photo)

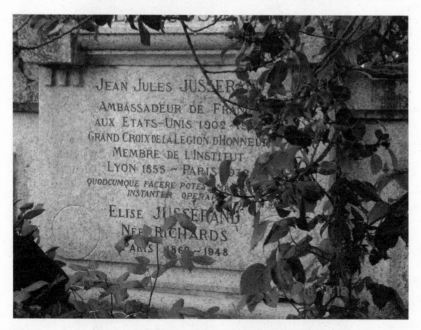

Resting place of Jules and Elise Jusserand. (Author's photo)

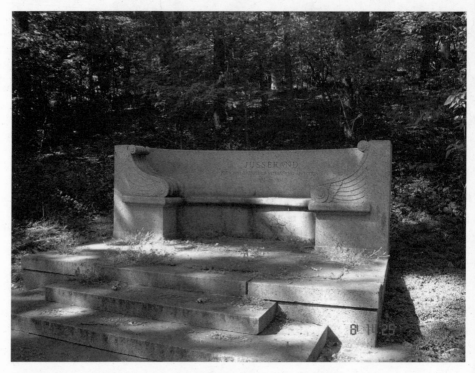

Jusserand memorial, Rock Creek Park, Washington. (Author's photo)

AN AMERICAN BY DEGREES

1 Genesis (1855–1903)

Just beyond the mid-point of the nineteenth century Jules Jusserand, *père*, married Marie Adrienne Tissot. Scion of an old Lyonnais family, a lawyer by profession, and now in his fifties, Monsieur Jusserand had suffered the loss of his only child and, more recently, that of his wife. Alone and, as one with memories of Napoleon fresh from Elba, no longer young, he chose as his new wife a woman twenty-seven years his junior, and promptly set to work on a dynasty. In rapid succession – 1855, 1856, 1857, and 1858 – Marie delivered four healthy children, two boys and two girls: Jean-Jules, Etienne, Jeanne, and Francica. Death, too, intervened at approximately the same time, in the form of *père* Jusserand's own father's demise. A substantial inheritance followed, the proceeds from a long family line of jewellery makers in Lyon; and retirement came close on its heels. Without surrendering his property interests in the city, Jules senior acquired a large home in the streets just below the medieval walls of nearby Saint-Haon-le-Châtel, and with it a farming property two miles removed from the tiny village.[1]

So it was that geography and topography allied with the formative influences of family to fashion the lives of the four Jusserand children. Some seventy years later, Jean-Jules reflected warmly and with the precision of an engraver on his town and country childhood. His grandfather's death had left his father comfortably well off – not wealthy, but with assets substantial enough to afford a modest lifestyle. As much time as possible was allocated to Saint-Haon, even after the children reached ages when state schooling

had to take over from the careful ministrations of parents and governess. Though it meant spending the school year in Lyon, it also meant long-anticipated months of liberation from classrooms when the entire family could repair to the countryside. Education and rural release went hand in hand, for Jules and Marie, through their own reading and conversation, sought to instil in their children respect for both book and outdoor learning. None learned better or for longer than their eldest son, Jean-Adrien-Antoine-Jules.

The product of a middle-class family with roots in Lyon, one of France's largest urban centres, young "trois Js" never turned his back on the countryside, the rural, and in some respects the rustic, lifestyle of his youth. Despite a slight body frame, which everyone described as *petit*, and a stature invariably classified as "short," he spent his days on rough trails from the lower valleys to the dense forests on the nearby slopes, climbing and clambering toward heights that promised spectacular views of the Beaujolais. From them, children could look down on the tiny white specks that only hours before had been sheep, and on the roof tiles and plaster walls to which the reddish local soil had left a spectrum from rose to rust. To the north, across the valley from Saint-Haon, they could see the spire of the even tinier Saint-Haon-le-Vieux; from the south could be heard the church bells of Renison, and from the forests between, the song of the cuckoo.

As their legs lengthened, the two brothers, undertook day-long marches, often accompanied by friends from the village or nearby farms. Often too, the hikes took on the guise of hunting expeditions, complete with a light firearm, homemade gunpowder, and the loyal but aging dog "Perdreau." There, somewhere in those hills of the Madeleine, a chance shot marked the boy-leader for life. A dying owl looked at him with "such an expression of sadness and reproach" that he vowed never to risk seeing "such a look again." That shot was, indeed, "the last I ever fired at any harmless creature." And within that resolve there arose a lifelong compassion for birds.[2]

Once returned from hills to hearth, the brothers resumed their indoor instruction. Mme Jusserand, a mother anxious to bequeath a love of music to her children, was even more determined to raise them within the folds of the Catholic faith. That meant on-knees prayers after every dinner, the entire family and domestic staff led by Madame herself. It meant reserving the celebration of Christmas

exclusively for religious observance, devoid of tree and delaying any gift-giving until New Year's Day. It meant, too, a code of living framed by a simple, unbending dictum of choosing right over wrong, and of respect for parents, teachers, and the acquisition of knowledge. The children were taught to be ambidextrous and, in an effort to promote imagination and creativity, were actually discouraged from playing with ready-made toys. Reading, conversely, was sure to win praise, and with praise came a pleasure equal to being in the mountains, especially when boys could slip away at night to the gardener's shed and pore over the illustrated magazine coverage of the protagonists in the American Civil War, or read adventure-filled stories by Chateaubriand, Jules Verne, James Fenimore Cooper, or Sir Walter Scott. *Ivanhoe*, in fact, in a humble, candle-lit shed, enjoyed one of his greatest triumphs, partly because he came as a gift from an adoring father, and partly because he ignited in the son a life-long passion for English language and literature.[3]

The autumn resumption of formal schooling had as prologue a final burst of outdoor living. Every year when harvest came, and almost daily, the family travelled the two miles from Saint-Haon to the farm they called Le Bachelard. It was there that husband and wife supervised the bringing in, distribution, storage, and transport of grain, wine, poultry, milk and cheese, fruit, nuts, firewood, and livestock. There, from a second-storey wooden porch overlooking the courtyard, they would select their halves of nature's returns, and assign the remaining portion to the six peasant families who lived the year round at Le Bachelard and who exchanged a full year's labour for the Jusserand investment in accommodation for families and livestock. Patriarchal it was, indeed seigneurial in nature, as owners and workers engaged in time-honoured traditions as well as time-honoured exchanges of capital and labour. The Jusserands senior celebrated baptisms and marriages with *their* field-workers, attended local funerals, and were recognized as arbiters in inter-family disputes. Finally, when the weeks-long harvesting process was nearing completion, and arrangements had been made for the occasional winter shipment of stored produce from the farm to their home in Lyon some seventy miles away, the family gathered to watch the last transports of surplus goods bound for regional markets: oxen-drawn carts heavy with wine casks, slowly, dustily, making their way to the high road leading to the Loire Canal and eventually to Paris.[4]

From the old farm house at Le Bachelard, with its wallpaper illustrating the late eighteenth-century fascination with the ruins of classical antiquity, the Jusserands moved through Saint-Haon in autumnal passage back to Lyon. The successive births of four children had necessitated a move from the family's first apartment in the rue des Marronniers to one on the Place Napoléon, and finally to a house at the intersection of the Quai d'Occident and the rue Franklin. There, from an upper window overlooking the Saône, the children were able to watch the river traffic between Lyon and Mâcon, marvelling in particular at the line of large steamers called *Gladiateurs* – but only when Mademoiselle, the governess, had completed her lessons for the day or when, in the case of the older children, school homework in history, literature, music, even dance, had been completed.[5]

At age ten the family's eldest child got his first taste of education in earnest. In the autumn of 1865 père Jusserand, determined as always to ensure that his son received a superior education, enrolled Jules, his namesake, in the school known as Les Chartreux. It was a boarding school, even for boys of Lyon residence, which offered but brief vacations at Christmas and Easter before the August–September summer recess. Run by priests whom Jusserand later decided had been "liberal-minded," the school had a reputation for associating learning with strict discipline. To that end, the boys arose at 5.30 a.m., ate their meals in silence, and were expected to devote their energies to the entire curriculum – which in this case included not only mathematics, science, and classical studies but also modern languages, drawing, gymnastics, swimming, and hiking. Still other opportunities presented themselves, at least to students who proved proficient in ancient and modern languages, from Greek and Latin, to Italian and English. One of those opportunities came in the form of Abbé Déchelette, an "extraordinary" linguistic teacher who read, in Greek, the *Odyssey* to his most gifted charges. During the school year of 1869–70 this priest led two or three fifteen-year-old students on a walking tour across the Italian Alps into Milan.[6]

It was akin to *Ivanhoe*, Jusserand's first breathtaking experience with the museums and art galleries of northern Italy, and one that he would renew in subsequent trips throughout his life. Travel, like reading, had seated itself; and there was more to come before he had graduated from Les Chartreux in the summer of 1872. One

walking tour took him and another small group of boys from Lake Leman to Zermatt, and via Saint-Moritz on to Innsbruck; one was within France, hiking through Brittany and Normandy, but affording a first glimpse of Paris. And in his graduating year, at seventeen years of age, Jusserand returned to Italy, extending his sights from Venice as far south as Capri, including a horseback ascent of Mount Vesuvius, or at least to a point where thick volcanic ash forced riders to dismount and climb to the rim of the volcano on foot. Pompeii, Sorrento, Amalfi, each in succession, reflected a vast spectrum of southern light and colour, and illuminated within the young man a "passion for art."[7]

Not all was bright or idyllic, for travel and academic success were not enough to erase the traces of recent loss. The autumn of 1870 had caught the fifteen-year old school-boy in the grasp of a stunning national defeat. The Prussian army had quickly and decisively overrun the forces assembled by the French emperor, Napoleon III. Some of those forces had been billeted briefly in the school itself, and some of the oldest boys had been recruited to help defend Belfort. But such last-ditch efforts had been for naught, and before long classes had resumed and teachers were ferreting out the reasons for the French defeat. Credit could not be given in full measure to the enemy. Instead, it was time to acknowledge one's own shortcomings: frivolousness over earnestness, indolence over application, ignorance over knowledge. And it was time to correct them.[8] Impressed by the diagnosis of his masters, and inspired by defeat to a higher level of patriotism, young Jusserand was still en route to recovery when more troubling news arrived from his father. In the summer of 1870 this proud parent had admitted tears upon hearing of his son's first place finish in Latin. Only eight months later he wrote to say he was dying, confirming his namesake's pending status as head of the family and urging him on to complete his studies "brilliantly."[9] Before the end of the year, the seventy-one-year-old father was dead, Marie Jusserand was a forty-four-year-old widow with three children under the age of nine, and Jean-Jules was its legal head.

How he felt about these new responsibilities, we do not know. What is clear is that he stayed in Lyon for the next three years, and remained very much a student long after his graduation from Les Chartreux. I "wanted to learn everything," he recalled, and I didn't know what I wanted to do afterward."[10] Between 1872 and 1875

he completed degrees in letters, and in sciences, at the University of Lyon; and added to these credits a diploma in law as well. The thirst for knowledge which such industry suggested, he attributed to the post-1870 classroom diatribes against French ignorance and sloth. By 1875, however, in the wake of remarkable but apparently ceaseless academic success, his family were expressing some concerns about where all this studying was leading. Surely, at twenty years of age, it was time to settle on a career. But such expressions fell on deaf ears, or at least unreceptive ears, for in early 1875 Jean-Jules enrolled in a series of new courses at the University of Paris, some designed to complete a Master's degree in law, others to develop his skills in palaeography, history, foreign literature, Latin, and modern languages. That autumn a decision, of sorts, was made, one that offered a new avenue without leaving one that was familiar. Still inspired by the ideal of patriotic service, he applied to write the highly competitive entrance examinations for the Foreign Ministry's consular service. And promptly, that very day, he set off for a year's preparatory study in England.[11]

There appears to have been no sense of urgency. Jusserand landed in October at London's Saint Katherine's docks – as he had been advised to do by the eminent French historian Hippolyte Taine – and began a lengthy walking tour north, in the direction of Scotland. En route he noted details best visible to a man long accustomed to hiking – from clipped hedges to woodland brooks – and to a man trained in art and architecture – from the scattered Roman ruins and the unusual square apses of Norman cathedrals, to the brick walls of Hatfield castle and its stunning art collection within. Then on to Scotland. "Going northwards, the landscape changes, meadows disappear, trees become scarcer, the sun grows dimmer. England leaves the impression of a huge park with rich verdure; Scotland the impression of a boundless moor covered as far as the eye can see with heather ... In those still solitudes, the clouds alone pursue their silent march across the sky; the wind sunders them, rolls them into flakes; they lower, halt on the hill-side, and seem to catch in the thorns."[12]

First to Edinburgh and the pilgrimage to the beloved Walter Scott's tomb at Dryburgh Abbey; and from there another 150 miles via Inverness toward the northwest coast, slowly acquiring words in Gaelic. No effortless promenade this. Language and customs were so different, the knapsack was heavy, the route solitary, and

the autumn weather harsh. By the time he reached the little inn at Achilty, he was rain-drenched, his only shoes were soaked, and his feet painful despite on-road emergency treatment with rubbing alcohol and candle tallow.[13] Further on, having made his way over ground strewn with slippery rocks and tufts of grass – when not covered by pools of water – the future ambassador spotted in the dark "the light of the distant hovel," and spent a night before a peat fire, the impromptu guest of a crofter who had never seen or heard a Frenchman. "Four walls of stone, and a roof peaked on account of the snow, such is the habitation; oatmeal cakes, fish dried under the chimney board, such is the food; the skin of a long-haired calf spread on the floor, such is comfort."[14]

Toughened by years of hiking, as well as by the spartan regime he had imposed upon himself in his university years – a regime that included riding, fencing, cold water, discarded overcoats, and a board for a mattress – Jusserand cheerfully weathered the hardships of his Scottish tour. Satisfying as they were, there is no reason to believe that he enjoyed less his southern trajectory through Glasgow, the Lake District, Wales, Bath, the Salisbury Plain. And from there into London, and the resumption of "serious work." Or so said the plan. However, on learning that the foreign ministry had postponed its next set of entrance examinations until the summer of 1876, Jusserand bowed to fate, and smiled.

No time-waster, he set for himself a set of ambitious objectives. He would work on the requisite two theses then required for a doctorate in France, one of them in Latin.[15] He would work on his English and Italian; and he would explore London and its environs. The doctorate required hours of reading and research, much of it done in the library of the British Museum, some of it in Oxford and Cambridge. Language could be perfected by attending alternate Sunday church services: one week a Protestant service in English, the next a Catholic service in Italian.[16] But there was never enough time for the rest, only fleeting moments: the South Kensington Museum, the long hike to Greenwich, Beckett's shrine at Canterbury, the popular quarters of east London where one could watch the Punch and Judy shows, listen to grimy street singers, see the crude oil lamps illuminating the push-carts of street hawkers, and endure the booming voices of red-faced merchants trying to attract passers-by to their stalls. This was no classroom education, but an education all the same, and one that would serve to insulate him against the subse-

quent lures of diplomatic pretentiousness and the seductive distractions of splendid uniforms and excess gravitas.[17]

That career was suddenly on the horizon. In July 1876 he returned to Paris, wrote the entrance exams for the consular service, finished first among the candidates, and quickly took up a post in the commercial division of the foreign ministry. With a host of academic qualifications already behind him, and more to come, the young *stagiaire* was regarded by some of his colleagues as a curiosity, a "mouton à cinq pattes."[18] Doubtless he was bright, but he was small of stature, remarkably boyish in appearance, troubled by a chronic cough, and reduced to doing what the lowliest always did: copying out letters and reports from the higher-ups. No question but that the work of *élèves-consul* was uninspiring, even when after a little experience they were entrusted with preliminary drafts of future reports; however, the two years spent in the attic heights of the ministry did offer two advantages despite the disadvantages associated with summer heat and lack of privacy. For one, the ministerial dictum against verbal inflation was a scholar's gift for life. "Never use extraordinary words ... except in extraordinary circumstances," because their effect is "blunted by being put to common use." For another, since ministerial work at this level was not very taxing, surplus time and energy could be invested elsewhere. Two years after commencing work at the Quai d'Orsay, Jean-Jules Jusserand became the recipient of a doctorate of letters from the University of Lyon. The year 1878 thus marked the end of his lengthy, formal, career as student and the beginning of a complementary career to that of diplomat, that of a professional scholar. From that point onward the two would enjoy an amiable coexistence.[19]

Revenue, it could be said with some safety, came more reliably from the personnel budget of the foreign ministry than it did from book royalties. With this in mind, young Dr Jusserand did as he was requested and took up a post as consul in training at the French Consulate-General in Finsbury Circus, London. Here again, junior status meant that while superiors concentrated on the all-important economic dossiers, *débutants* were asked to handle an endless variety of other matters, thereby acquiring a wealth of personal experience serving the consulate. Indeed, by the spring of 1880 the heavy workload that accompanied the experience, in combination with London cold and damp, had stretched Jusserand's physical capacity to the point that his doctor prescribed, initially in vain, a month's

complete rest.[20] That display of industry and commitment doubt-
less played some role in the ministry's decision to retrieve its young
charge back to Paris that autumn. This time, however, the post was
a bit of a plum. Not only was he assigned to the foreign minister's
personal secretariat, but that minister was Jules Barthélemy Saint-
Hilaire, an eminent classicist and a specialist on Aristotle. What
is more, the head of the secretariat was René Millet, yet another
classicist, who enjoyed exchanging notes with Jusserand in
Latin. Clearly a young Jusserand had caught the scholarly eye, and
approval, of a seventy-five-year-old minister who still insisted on
the superiority of quill pens over steel.[21]

Before long the minister had found a particularly important
assignment for the new addition to his staff. For several years, and
certainly since the Congress of Berlin in 1878, the European powers
had been musing over the future fate of Tunis, a relatively small ter-
ritory wedged between French Algeria and the Turkish-controlled
area known as Tripoli and loosely administered by the Bey
Mohamed el Sadock. Given the signs of continuing financial insta-
bility and political insurrection within Tunis, the question of the
day was which of the regional powers might be tempted to step in,
impose order, and stay. In January 1881 Jusserand was asked to
prepare a study envisaging the French occupation of Tunis, an area
of North Africa, so he confessed to his mother, about which he
originally knew nothing.[22] By the spring, in the face of renewed out-
breaks of violence along the Tunisian-Algerian border, French
troops had entered the bey's territory at the cost of little bloodshed,
and thus laid the ground for a treaty of May 1881 and a French
protectorate.

The young consul in Paris had initiated neither the report nor the
mission itself, but his superiors had been impressed by the breadth
and quality of his seventy-page analysis.[23] In particular, the 1881
treaty of Bardo had indeed provided for a continuation of local
organizations, and for a civilian rather than a military resident-gen-
eral. In December Jusserand was transferred from the commercial
ambit of the consular service – which some referred to, disdainfully,
as the "grocery shop" – to the more prestigious diplomatic service,
and sent on a three-month mission to Tunis.[24] That assignment led
to a comprehensive report recommending: the speedy rehabilitation
of Tunisian finances by France, a reform of the justice system, and
an extension of public education to include girls and women. For

the second time in the course of a year Jusserand had impressed his superiors and earned for himself a reputation for being a Tunisian expert.[25] It was for these reasons that the government of Charles de Freycinet, who served both as its premier and foreign minister, created a new bureau within the ministry to oversee the affairs of the Tunisian protectorate, and placed Jusserand at its head. He was there for five years, working with French officials on the ground to ensure political stability, administrative reform, and economic development. In the course of time, the bureau's mandate was extended to south-central Africa, as well as Indochina. Tunisia, however, remained his greatest glory. His official personnel file carries a commendation describing him as "the soul" of the Protectorate's constitution, and the person most responsible for the success of that enterprise.[26] Later that year he received further proof of ministerial satisfaction, in the form of a 12.5 percent increase in his salary.[27]

However demanding his responsibilities at the Quai d'Orsay, Jusserand remained intent on the pursuit of both familial and scholarly interests. On balance, the latter represented fewer challenges than the former. At home, amid general harmony, there were short-lived moments of uncertainty over matters like Francica's impending marriage, with the head of the family helping to smooth away a mother's initial doubts about "Cica's" choice, and having to negotiate his way through the legal and financial issues relating to the size of her dowry.[28] Etienne represented a more enduring challenge. It was not just his periodic requests for money, it was his post-secondary academic performance – which at 30,000 francs a year was straining family resources while proving a dubious investment. In August 1882, for example, a twenty-seven-year-old Jusserand reported to his mother that he had had to listen to his younger brother being characterized as "indolent" by the school's director. And three years later, the elder Jusserand expressed to his mother his impatience at his brother's rumblings about quitting his job with the Suez Canal Company in Egypt for lack of recognition and promotion. More distressing still, by the autumn of 1887, he felt obliged to warn his brother directly. Do not resign, he said, at least until I can try to talk to M. de Lesseps personally. But, he warned, there were risks involved in such an overture, ones that might compromise his position at the foreign ministry and

force him to take a post abroad. In short, it was time for Etienne to grow up.[29]

Although very little can now be learned about the life of Marie Jusserand, it is clear that the bond with her eldest son was close, pride-filled, and informed. He sent her books to read, on one occasion a novel by George Sand, and he confided in her.[30] In the autumn of 1885 Professor Guillaume Guizot offered Jusserand an opportunity to do a series of lectures at the prestigious Collège de France: one on the contemporaries of Chaucer, and one on the English novel before Walter Scott. It was a great honour, but with the honour came responsibility and, in his case, weeks of preparation, nervousness, and sleeplessness. Right to the eve of the first lecture on 8 December, so he told his mother, he had suffered from deep apprehension. "It's so important for me to do well."[31] For his part, mindful of Mme Jusserand's keen interest in how her son had fared in Paris, perhaps knowing that each lecture had been rehearsed in front of her in the family home at Saint-Haon, Guizot promptly wrote to assure her of her son's triumph. As did her son, reporting his success and with it the evaporation of those "horrible fears."[32]

Both sets of lectures were published in book form in 1886 and 1887 respectively, adding thereby to an already substantial corpus of publications from an author barely turned thirty.[33] In 1878 Jusserand had overseen the publication of his doctoral thesis on English theatre prior to the time of Shakespeare; and the following year he had published, also in French, a long paper addressed to the epic poem that had surfaced from medieval England, under the title "The Vision of Piers Plowman."[34] In 1884 he published an article in English on the famous figure of the Pardoner from Chaucer's *Canterbury Tales* and in the same year the first edition of *English Wayfaring Life*, under its original title, *Les Anglais au moyen âge: La Vie nomade et les routes d'Angleterre au XIVe siècle*. Finally, while still at the Quai d'Orsay monitoring affairs in Africa, Asia, and Saint-Haon-le-Châtel, Jusserand published a lengthy paper on Daniel Defoe's impact on the English novel and, at thirty years of age, had initiated an ambitious, multi-volume series, Les Grands Ecrivains Français, the first volumes of which appeared in 1887 with him serving as general editor.[35]

Toward the end of that year, with the Great Writers series well underway, Jusserand learned that he was to be sent to London at the rank of embassy counsellor. For one who was so familiar with

the city, was already a connoisseur of English history and literature, and had spent vacation weeks every year since 1880 doing research in English libraries, he surprisingly evinced no great enthusiasm for the posting. Why, remains unclear: perhaps for modest reasons, like a reluctance to abandon his comfortable two-bedroom apartment on the rue de Varenne, or concerns about the impact of London winters on his health; perhaps because of his ongoing scholarly enterprises in France, and the enriching contacts he had been developing with luminaries like Taine, Gaston Paris, Ernest Renan, Albert Sorel, and Anatole France; perhaps because he knew that careers might be made or broken by friends or rivals within the central administration in Paris; perhaps because he wondered whether his attempts to run interference for his brother had cast a shadow on his own career.[36] Perhaps a combination of them all. Whatever their proportion, he arrived in London in mid-December 1887, where he was destined to stay until June 1890.

These London years were followed by eight back in Paris and four as head of legation in Copenhagen. In total, this almost fifteen-year period from 1887 to 1902 was characterized by steady progress in his two careers as diplomat and scholar, as well as by one key development in his personal life. Because these were still early years, providing an indispensable foundation for his ambassadorship to Washington but foundation nonetheless, it seems appropriate to abandon the chronological narrative of *What Me Befell* in favour of exploring the period thematically. Although subject to the false rigidity implied by all labels, those themes are what we might call today: intellectual networking, scholarship, and private moments. I have selected these not simply as an organizational tool but as an instrument that highlights certain elements of the diplomat, scholar, and human being.

Jusserand's first foreign posting with the ministry's diplomatic service, rather than its consular branch, could not have begun more auspiciously. Initially, he may have been hesitant about leaving Paris, but the opportunity to serve as counsellor to Ambassador William H. Waddington proved a godsend. The ambassador, in his early sixties and occupant of the embassy since 1883, descended from an English family that had developed commercial interests in Normandy in the eighteenth century. French by early upbringing, and with pre-ambassadorial service as both premier and foreign minister, the Cambridge-educated Waddington was perfectly at

home in English society. In common with Jusserand's previous mentors, Saint-Hilaire and Millet, he was a learned classicist, a published author in archaeology, and a specialist in ancient Greek coins. Who better to foster the promising career of a newcomer already conversant with English literature and already connected with English literary and historical circles? Indeed, in the summer of 1890, with Jusserand on the eve of returning to a more elevated post at the Quai d'Orsay, Waddington told Paris that he had never seen a diplomat of relatively junior rank insinuate himself so quickly and completely into a foreign society.[37]

Given that rank, one had no reason to expect any dramatic diplomatic breakthrough. Indeed, there was none, although modest accomplishments there were. Anglo-French relations at the end of the 1880s were anything but cordial, particularly when it came to rival claims overseas. Competition, fuelled by suspicion, was especially pronounced over France's takeover of Tunis in the guise of the Protectorate, and Britain's determination to hold its ground in Egypt – the latter being a resolve that prompted Jusserand's undiplomatic but happily private verdict: "It is an infamy that the English have still not left Egypt. They are committing a crime against humanity."[38] But they stayed, nonetheless, and no open conflict replaced angry exchanges.

The young attaché did go on to address another point of contention, this time directly, and with greater effect than could ever come from private venting. This was the dispute over lobster fishing rights in the waters of Newfoundland, a dispute that had persisted since the Treaty of Utrecht of 1713. As Jusserand told it, in 1890 he and one Foreign Office official, Sir Thomas Sanderson, finally worked out the most modest and impermanent of compromises. That compromise, annually revisited, was simply to agree that neither country would *increase* its lobster take. As one journalist told it, however, Jusserand had taken Sanderson to the cleaners, since, so he claimed, the 1783 Treaty of Paris had made no provision at all for French lobster rights – as opposed to those of cod – in those waters. According to the journalist, this "little Frenchman" had simply walked into the Foreign Office, taken advantage of his anglophile credentials, his intimate knowledge of English history, his written English stamped with "a grace and clearness all his own," and lured his interlocutor into a "beautiful little trap."[39] Which version is more truthful, Jusserand's modest account of a

modest *modus vivendi*, or the *Evening Telegram*'s detection of a cunning plot, is left to conjecture. On balance, I would opt for the Jusserand version, if for no other reason than the fact that Sanderson and Jusserand exchanged greetings on the annual anniversary of the accord long after its signing.

The most public of Jusserand's embassy accomplishments came in May 1889, when, in the absence of the ambassador, the thirty-four year old *chargé d'affaires* was responsible for organizing and hosting a large reception to coincide with the opening of the Paris Exhibition. The event took place on the evening of 5 May and was indeed a heavy responsibility for one so young. Moreover, the ambassador had been expected to address the assembled guests, most of whom came from various quarters of London's French colony. Presenting himself in full dress uniform, and speaking without benefit of notes, Jusserand praised France the indomitable, a France that had recovered from the trial of 1870, a France with revived finances, army, navy, and place in the world. The audience, which included members of the press, was enthusiastic, and all seemed agreed that the young diplomat had been central to the evening's success. Not only was he an accomplished scholar as well as a charming host, but his fine-featured face sparkled with "intelligence and enthusiasm" and confirmed his reputation for being "boyishly amiable ... an ideal table companion."[40] No insignificant qualities these for this junior diplomat, who was still a year away from returning to higher office in Paris.

There was talk as early as March 1890 that he was going home by his declared preference, and that he would head the all-important European section known as the *sous-direction du Nord*.[41] By May it was decided, and he departed London in early June, "flattered" by the offer to become a *sous-directeur* and touched by the ambassador's affectionate farewell. More than that, he was in for a salary increase from 9,000 to 10,000 francs, and was leaving with Waddington's recommendation to minister Alexandre Ribot that he be promoted from *chevalier* (1883) to *officier* in the Order of the *Légion d'Honneur* – a process that was completed in July 1892.[42] That said, Dr Jusserand's gratitude for these recent changes of status appears to have been qualified. Perhaps he still recalled, and resented, the ministry's demand in September 1885 that it be reimbursed for certain expenses relating to his mission to Tunis three years earlier, a demand that he advertised with an exclamation

mark in a letter to Mme Jusserand. In responding to inquiries about the French diplomatic service from his old friend Sir Charles Dilke, the new *sous-directeur* complained of a capricious system whereby rank and remuneration were not necessarily allied. As for retirement provisions, only after very long service and under very strict conditions were pensions available. Indeed, he speculated, it was because such terms were "barbarous and unhumane" that the ministry refused to spell them out in its *Annuaire*.[43]

Nor was he himself entirely free from criticism, as is evidenced by the single complaint that appears in his personnel file, a complaint investigated and dismissed by the ministry. That complaint, however ill-founded, was not at base inconceivable, for one French journalist thought in 1894 that he had detected within the *sous-direction du nord* a resistance to developing any closer ties with czarist, autocratic Russia and a preference for a stronger connection with liberal England. Although Jusserand was not personally named, it seemed clear within the ministry that this acclaimed anglophile was the intended – but officially unwarranted – target; and his minister, Casimir-Périer, did ask him to delay publication of his new *A Literary History of the English People* on the grounds that it might lend credence to the allegations of a linked anglophilia-russophobia.[44] It is also true that the *sous-directeur* subsequently did express a marked ambivalence about Russia, a regime which in the 1890s and in the face of German power had become one of the friendliest toward France, despite being one of the most anti-republican, anti-democratic countries in Europe. Conversely, the northern sub-directorate was not at all ambivalent about Germany, the former and predictably future enemy. The young Kaiser Wilhelm II was, as Jusserand put it, as untrustworthy as his ambitions were limitless, characteristics that made the rapidly industrializing Germany a threat to nations large and small.[45]

Among the latter was Denmark, the country to which Jusserand was posted in December 1898, following an eight-year period of service in Paris. Just turned forty-four when he arrived in Copenhagen in February 1899, and armed with the imposing rank of *envoyé extraordinaire et ministre plénipotentiaire*, his principal task was to gently encourage the Danes to open their eyes to the German danger. "They wanted," he judged, "to persuade themselves that compliance, submission, innocence were their surest safeguards."[46] Not overly optimistic about securing a rapid change of heart, the

minister of France soon had another apprehension reinforced. Since France's representation to Denmark had only recently been raised to that of a legation, and since construction work prevented immediate occupancy, in March 1899 Jusserand travelled overland to St Petersburg on the invitation of his friend, the French ambassador, the Count de Montebello. There he met Czar Nicholas II and his Czarina, Alexandra. Conversation was congenial but "innocuous," and the diplomat noticed with a scholar's eye the ruthless order that reigned among the books in the czar's library, "a dignified array ... not often disturbed in their slumber." The man himself he liked, a man of "good-will, honesty," even gentleness, but he looked in vain for the autocrat who would make sense of the autocracy on which the Franco-Russian alliance depended. What he detected was "resigned fatalism" and a "lack of force," an impression subsequently confirmed by the Russian ambassador to Copenhagen. Russia, he confided, was ruled by hesitation and indecision, ever subject to a seesaw battle between repression and reform.[47]

Given the modest position of Denmark in European power politics, the French minister's years in Copenhagen, between 1899 and late 1902, do not appear to have been charged with diplomatic imponderables. At least such is the impression left by his memoirs. That is not to say that those years were dull or unproductive. By then, his reputation as a scholar had increased by a goodly measure, as had his place within an international community of scholarly exchange. Since such credentials were to play an important role in his selection as ambassador to the United States of America in 1902, and certainly in his warm reception by American intellectual circles, we should pay some attention to the intellectual and cultural networks in which he operated from the London years onward to those of Copenhagen.

Jusserand's English experience dated from 1875–76, the year in which he researched and wrote the better part of two doctoral theses. By 1879, and as a measure of his early impact on London literary circles, he had been elected to the Committee of the London Library in St. James's Square and was being invited to dine with a retired curator of manuscripts at the British Museum. Two years later, though by then resident in Paris, he became a vice-president of the New Shakespeare Society of London.[48] Indeed, wherever his posting, London remained a magnet for years to come, whether

researching, visiting, sketching, or painting – for among the souve-
nirs he created over the years were pencil sketches and watercol-
ours. He knew Edward Burne-Jones, the painter of "sad-smiling
women," whom he personally notified about his impending mem-
bership in the Légion d'Honneur. He dined with the American
writer Bret Harte in London's Rabelais Club, reciting for him – as
proof of French readers' interest in America – the closing lines of
"The Luck of Roaring Camp."[49] He spent considerable time with
Robert Browning, a "rather corpulent, red-faced, keen-eyed gentle-
man with a white beard and curly white hair," who had donated
book royalties to victims of the 1870 siege of Paris and whose
remains he accompanied for burial in Westminster Abbey. He spent
more time still with the American novelist Henry James, and with
John Morley, William Gladstone's aide and biographer, indeed with
Gladstone himself, a statesman of the first order but also an expert
on Homer and translator of Horace. Lord Salisbury, tall and
stooped, indifferent to clothes "provided they were not in fashion,"
asked about Jusserand's latest book, as did Lady (Margaret) Jersey,
whose Middleton Park estate he visited.[50]

The eight-year stint at the Quai d'Orsay, between 1890 and
1898, by no means reduced the intense intellectual contact that the
scholar-diplomat had cultivated in both cities. In 1892 the ministry
entrusted its young diplomat-historian with the general editorship
of its own multi-volume series of documents on ministerial instruc-
tions to its representatives abroad during the period from 1648 to
1789.[51] During the same decade Jusserand kept up an active corre-
spondence with Dilke on literary matters, made frequent trips from
Paris to the books and manuscripts at the British Museum, dined
with Morley and Gladstone in London and Paris, took Morley to
meet the great French historian Ernest Renan, was himself taken to
meet the great Lord Acton, and took Gladstone to meet the great
Hyppolite Taine and to view the famous "Victory of Samothrace"
at the Louvre.[52] Paris, after all, had few rivals; and Jusserand knew
how to separate affairs of state from those of the mind. He loved
the discussions about literature, politics and philosophy that took
place most Sunday afternoons in the home of his close friend
Gaston Paris, including the celebrated occasions when José-Maria
de Heredia stood to recite one of his sonnets, as carefully chiselled,
Jusserand reckoned, as the work of the finest goldsmith. There, and
in other homes, he met Edmond Rostand, Alexandre Dumas fils,

and Taine[53] – especially the beloved Taine to whose home he so often rushed from the foreign ministry, "as early as I could."[54] Others, we may assume, he knew from a distance, certainly many of their works: Alphonse Daudet, Guy de Maupassant, Paul Bourget, Pierre Loti, Maurice Barrès, all of whom he appears to have appreciated for their contribution to France's literary fame. All but Emile Zola, who was "detested for his filth by men of taste," and whom Jusserand considered to be a destructive propagandist for "les immoralités françaises." "Why," he would ask, "in a world of ashtrays and roses, do we pay more attention to the ashtray than the rose?"[55]

Copenhagen obviously slowed the pace of some of these contacts, but changed little else. Jusserand responded helpfully to an inquiry about sources from the British writer Maurice Baring; to a request for assistance with the publisher G.P. Putnam from a professor at Smith College in the United States; and to a reader of "your capital book" who wanted more detail on the movable scenery used in seventeenth-century theatre.[56] It is unlikely that he knew it at the time, but another of his books was being read more or less on the eve of his departure from Denmark – under rather remarkable circumstances – a hunting trip in Mississippi. The reader was President Theodore Roosevelt, and the work was the original French edition of *La vie nomade ... au XIVe siècle*.[57] The president, for his part, may not have known that his current author had the year before published a book on sports in early modern France; and it is unlikely he knew Jusserand was just putting the finishing touches to the second English-language volume of *A Literary History of the English People*.[58]

Other elements of the man of course appealed to Roosevelt, far beyond the world of books. As it happened, fate was about to deliver to him a diplomat whose talents surpassed those required of protocol or pen. Like any human being, Jules Jusserand was the product of a vastly complex sociological process that was played out through an intricate interplay of moments: some public, some quasi-public, and some very private. In London, for instance, especially as an unattached *chargé d'affaires*, he could not avoid the swirl of blue ribbon occasions: receptions at embassy or Foreign Office, concerts at Buckingham Palace, races at Ascot, banquets at the Royal Academy, weekends at country estates, and grand *soirées* to which lords and ladies came in horse-drawn coaches suspended

on heavy leather straps, with liveried, powder-wigged footmen balanced on rear platforms.[59]

Less grandiose the settings, and less numerous the participants, were the sporting occasions, some of which appealed to him, and some not. Since his youth and the incident with the owl he had disliked hunting, and recalled one occasion outside Paris when he had deliberately scared off two small deer before they had fallen prey to his party of hunters. He did go salmon fishing in England, though the occasion left no comment in its wake. Swimming was a favourite, even in a less than pristine Seine, where swimmers, he said, treated microbes with the disdain admirals showed for torpedoes. Walking, of course, was for him less a sport than a habit, but tennis was something else. Fittingly, for someone destined for the courts of the White House, Jusserand was introduced to the game by Henry White, first secretary in the American embassy in London. It became a passion, the more so as his fitness, agility, and much-commented-on enthusiasm were so well suited for the game. Thereafter, wherever he was – London, Paris, Copenhagen, Constantinople – he was keen to play. Indeed, it was on the tennis court during a brief mission to Constantinople in 1890, that Jusserand had his first encounter with Count Johann von Bernstorff, a young German diplomat and a future rival in Washington.[60]

Less public still, with little or no audience, were the longer, quieter moments spent either close to home or, more anonymously, at vacation distance. He had lived in the Latin Quarter in 1875, when he was completing a few courses at the University of Paris. From there, when not in England, he had occupied a flat at 18 rue Bonaparte, just around the corner from Taine's home on the rue du Bac. Of equal proximity to the elderly scholar was Jusserand's next residence, a fifth-floor flat at 90 bis rue de Varenne, which he occupied for more than a decade following a rental agreement of January 1884. With two bedrooms, living and dining rooms, plus kitchen, bathroom and separate water closet, this residence offered enough space for him to work on diplomatic despatches while also affording quick access to the foreign ministry in one direction and to the Seine and the Tuileries tennis courts in another.[61] It was less well suited to the needs of an animal, as the diplomat reluctantly concluded. In February 1887 he had befriended a stray dog in the Bois de Boulogne, and for two weeks took him in as a guest at home and office, and as a walking companion elsewhere. But apartment

living seemed inappropriate for the handsome "Turc," and accordingly, with Marie Jusserand's consent, he was sent to live a freer life in Saint-Haon-le-Châtel.[62]

The chargé's residence in London proved no more suitable for animal life than the flat in the rue de Varenne. Indeed, the furnished, one-bedroom flat at 5 William Street, near the embassy, was "microscopique," although it was on two floors, had a bright living-room cum study, ample book space, and a fireplace. Less happily, the bed came with bolsters, "on which the head rolls but never rests," and there was not enough hot water. Worse, what the English called coffee was little more than brown-tinted water, what they called air was thick and acrid, and the landlady was not the most understanding of types. It was she who threatened to be the principal obstacle to his second attempt to rescue an animal, in this case a stray cat he had found curled up in the hansom that was taking him – in full regalia – to an exhibition at the Royal Academy of Arts. Moved by what he regarded as the plight of "Poor Puss," young Dr Jusserand resolved to take the animal back to William Street and face the music from his landlady. Whereupon, the would-be rescuee leapt from the cab, fleas and all, and disappeared in the street.[63]

Later that year the diplomat himself took flight, this time to Egypt, a private holiday although one that presumably carried some anxiety. His brother, Etienne, was there, still working for the Suez Canal Company in Port Said, although Jusserand's memoir account says nothing of a personal encounter. Indeed, he never provides his brother's name. Instead, he seems to have been completely distracted by the art and architecture of the ancients, and exhilarated by his "unassisted" climb to the top of the Great Pyramid.[64] Less taxing, perhaps, were his "numerous" vacations to Italy, a country that had captivated him as a teenager. In 1892, for instance, he travelled across Lombardy and Venetia with Francis Charmes, an old friend, reserving special time in Florence, where he treated himself anew to Dante and completed a number of street sketches.[65] From Cairo he returned to the flat on William Street, from Florence to the flat on the rue de Varenne, until the day came when neither was suitable for a man just turned forty years of age.

Suddenly, or so it appears from the extant record, Dr Jusserand had found a mate. The background to this romance, for romance it was, is unclear, his memoirs and his voluminous papers being silent

on the subject. But on 29 July 1895 he wrote from the rue de Varenne to his old English friend Dilke, announcing his recent election. "Not by thousands of voters, but by a single one, a *she* one. I am going to be married," he wrote, to a thirty-three-year-old woman he described as "graceful, and kind, and very indulgent."[66] The lady was Elise Richards, French by birth, American by parentage, the daughter of banker George T. Richards, though officially designated as a lady of *fortune modeste*. How they met remains uncertain, but one of their early intersections was certainly publishing. Jusserand had needed a translator for his book of 1893 on Langland's "Piers Plowman." One year later the English language volume had appeared, translated by the cryptic "M.E.R.," which is to say, Elise Richards and her older sister Marian; and in 1894 the two sisters again collaborated to transform from the original French Jusserand's *A Literary History of the English People*.[67] A *parisienne* through and through, with an address on the avenue Kléber, the soon-to-be Mme Jusserand was said to speak French with an English accent and English with a French. But whatever the tongue, like the man she would marry, Elise had vivid childhood memories of the war with Prussia: in her case, the months-long siege of Paris and guns erupting in the Tuileries Gardens during the days of the Commune.[68]

On 10 August the foreign ministry provided the requested authorization for one of their senior diplomats to marry a foreigner, after what was typically a "very careful investigation" within the prefecture in which the woman resided; and on 14 October the couple became man and wife following a Protestant morning service in the American Cathedral Church of the Holy Trinity and, but blocks away, a Catholic marriage, in what would become their parish church, the Eglise Saint-Pierre de Chaillot. The groom's official witnesses were none other than Gabriel Hanotaux, the current minister of foreign affairs, and the Count de Montebello, French ambassador in St Petersburg. On the bride's side stood two prominent bankers, George Monroe of the Monroe Bank of New York and Paris, and Edward Tuck, another partner in the same bank and an "uncle" of the bride. Less official but not unseen was Alexandre Ribot, then prime minister of France, who as foreign minister had been instrumental in elevating Jusserand from his post in London to head the *sous-direction du nord* in Paris.[69] With nuptials complete, the Jusserands moved into their married quarters in the upscale

XVIe arrondissement, on one of the upper floors at 60 avenue
Marceau, between the Seine and the Arc de Triomphe. Their build-
ing, he reported, had no elevator, but "many stairs," and a large
balcony which they converted into a flower and vegetable garden.[70]

It was, it seems, the beginning of a genuine happiness on the part
of a man who wrote so much but said so little about affairs of the
heart. Whether by education, inclination, or devotion, Elise quickly
became collaborator as well as wife and friend. Her new husband,
caught up on the volume he had committed to write on the life of
Ronsard for the Great French Writers series, determined to visit key
sites along the Loire as they had been identified by the great poet
nearly four hundred years before. Together, man and wife, the cou-
ple travelled by train and foot, dividing between them Ronsard's
works and singling out the geographical reference points: Vendôme,
Anjou, Orléans, the castle of La Poissonière, where the poet was
born, the abbey of Saint-Côme-en-l'Isle near Tours, where he had
died. They also travelled often to northern Italy, where they stayed
in small hotels, identifying themselves imprecisely, so as to avoid
the kind of attentions that Jusserand's profession and rank might
have attracted. For what they wanted was the privacy to read,
sketch, and hike, especially in the area around Padua and Arqua,
the site of Petrarch's tomb.[71]

The family *maison* at Saint-Haon was a closer and more frequent
destination, especially during the summers when Paris, or subse-
quently Washington, became uncomfortable. Marie Jusserand had
died in 1896, but the remaining members of the family continued to
spend much of their time in the village setting, supervising the agri-
cultural field work. In November 1899 Léon Clédat, faculty member
at Lyon, author of a biography of Rutebeuf in the Great French Writ-
ers series, and his sister Jeanne's husband, reported to Jules on the
autumn harvest. The quality of the wine that year had been good,
despite a low yield; and each son and daughter could count on com-
pensation in both kind and cash. "Cica," too, the youngest sister,
wrote from time to time, reporting on her three children's progress in
school, on the health of villagers, the condition of the garden, and
never losing sight of the fact that Jules was the head of the family and
that his authorization on financial issues was necessary.[72]

By the winter of 1899, when unusually cold temperatures had
provided an opportunity for Cica and Albert's children to learn to
skate, the Jusserands were nicely settled in Copenhagen, where, if

anything, it was colder. Indeed, Cica could not resist a little jibe at her sister-in-law, wondering, not very innocently, if the reason for her recent silence had been a frozen inkwell – from which she retreated by expressing the hope that Jules had recovered from his illness. Cold weather, she asserted, was known to be bad for the stomach, perhaps recalling her brother's earlier complaints about London's cloudy skies and winter dampness.[73] As it turned out, these were happy years for Jules and Elise. The diplomatic work was not burdensome, which meant more time for his own writing; the Thorwaldsen and Rosemborg museums were outstanding; the castle at Elsinore had a special fascination for an acknowledged expert on Shakespeare; the swans on the citadel's moat and the storks nesting on the rooftops captured the eye of two bird-lovers; and long walks in remote woods and along the seashore left the couple with a contentment they seem to have experienced the whole of their married life. Still, there were occasional moments of pressure: for him on the tennis courts frequented by other members of the diplomatic community; for them both on that day in May 1902 when, at the request of the Danish king, they were forced to reconstruct a paper version of an unwritten speech that had been delivered in Copenhagen by the visiting French president, Emile Loubet.[74]

By this point, we have in place almost all of the fibres which, woven together by circumstance over forty years, completed the man who would represent France in America for over two decades. Almost, but not all, for an entire skein is still missing. One reason for Jusserand's warm reception in Washington, and one reason for his enduring success there, was his status as a scholar and intellectual. He was already, as the *New York Times* put it, "one of the first living authorities on the social life of England in the Middle Ages." That was the reason why the University of Chicago and Columbia University awarded him Honorary Doctorates of Letters within months of his arrival in America; and why one sympathetic wag remarked that the ambassador was becoming American "by degrees."[75] The Paris newspaper *Le Figaro* agreed with the government's choice for Washington, but put an altogether broader cast on its significance. In recent times, the writer claimed, a lie had been nurtured which contrasted the vital, dynamic, "so-called Anglo-Saxon" race with the older, "exhausted," Latin race, and notably

the once-great nation of France. Ambassador Jusserand, a specialist of English as well as French history, knew as well as anyone that the Anglo-Saxons also had their blood lines in the Celts, which is to say "our ancestors." Nothing could be more timely than for Foreign Minister Théophile Delcassé to appoint such a learned man as France's ambassador.[76] So the paper said. But for all of his book titles, what interests, abilities, and objectives were open to detection in his pre–1902 scholarship? Without having some idea of those, we would be missing an essential element of the man chosen as ambassador, and skirting any evaluation of the reputation he carried with him.

In 1889 one reviewer of *English Wayfaring Life* offered a blend of compliment and complaint. He was impressed by Jusserand's "range of learning, and ... vivacious style," and found him "excellent in details." At the same time, although it is now impossible to know how kindly or cruelly he applied the descriptive term "popular or semi-popular," the reviewer was clear and critical on two points. Dr Jusserand was prone to converting his details into inadequately supported generalizations, and to making anachronistic – in this case, too critical – judgments on the "arbitrariness and irrationality" behind much medieval thinking. In short, according to these criticisms, Jusserand had signalled his failure to accept, for what they were, the thought processes of the day.[77]

With this in mind, my own and that of any reader, it seems appropriate to preface the following with a word of caution. To some incalculable extent, my appraisal of Jusserand's work as historian has probably been conditioned by the expectations of my generation – to some extent even by those of younger colleagues. To a greater extent, however, they are my own, for I remain a still-born when it comes to theories of history, and an orphan when it comes to schools of historiography. But I do have opinions; and would like to think I have not been besotted by the subject on whom I write. That said, it would be fair to confess at the outset that I, too, have been intimidated by the ambassador's erudition and humbled by his powers of expression – the more so for its being in my native tongue. And if forty years in the profession have refined my skills at detecting bias in historical writing, perhaps they have finally licensed me to exercise it. From time to time. Of this the reader should be aware.

Speaking of reviewers and of bias, Dr Jusserand certainly belonged to our race of scholars. In 1901 he published an appraisal of a work by one John Churton Collins, a work with the subtitle *Plain Truths about Current Literature*. As Jusserand saw it, this was yet another of Collins's bitter critiques of everything that was wrong in the world of literature. So cranky was Collins that he regarded single-edition books to be proof of excellence, multiple editions to demonstrate the cheap and tawdry. Tongue in cheek, from his perch in Copenhagen, Jusserand said that he himself had occasionally enjoyed such proof of excellence, but that he had been too modest to brag about it. This sharp retort, unsurprisingly, did have a prologue, for it turns out that Mr Collins had been no happier with Jusserand's own work than with other modern productions; and had included among his "plain truths" a "violent diatribe" on *A Literary History of the English People*, an attack that had reduced Jusserand's fifteen years of work to that of an alleged two weeks, and which had been littered, the Frenchman charged, with misconstructions and errors of fact.[78] Thus two things are clear, and unremarkable, from this encounter. First, not everyone was swept away by Jusserand's scholarship. Second, authors sometimes bare their teeth along with their thin skin.

There are grounds, I believe, for some criticism of Jusserand's pre-Washington scholarship. Certainly there are many today who insist that scholarship and patriotism do not mix. When they do, it is said, the result is "the first ... act of treason on the part of a profession laying any kind of claim to objectivity."[79] From that perspective, Jusserand will be a marked man, even when we acknowledge that his emphasis upon intellectual investigation sprang from the need for national recovery after 1870. So there are within his corpus of works clear illustrations of commitment to country. His introduction to every volume in the Great French Writers series would be one example, where he pays homage to "the national genius," attributes the birth of medieval literature to "our country," and France's status as world power "less [to] the power of arms than [to] the power of thought."[80] More irritating for some readers will be his sometime carelessness about the provision of dates. For someone who was careful to document his sources, he could be cavalier about the temporal dimension. Eventually he gets around to providing a timeframe, sometimes well after the events

recalled, but not without first having allowed absence to breed uncertainty, even confusion.

Less irritating, but potentially more grave from the perspective of the academic historian, is a sometime inclination to put description and narrative well ahead of analysis. The most impressive of his works, as I read them today, are in fact problem-addressed, aimed at resolving an interpretive debate or some mystery. Others, however, seem primarily designed to tell stories, the best of them on the grounds of newly discovered documents, the least of them on those of personal pleasure. Examples from among the latter would be the story of Ethelrod, the twelfth-century abbot of Rievaulx, or the story of Regnault Girard's fifteenth-century mission to Scotland, stories that are exceptionally well told, but which make no exceptional claim to novelty of evidence or of interpretation. Similar but sharper criticism could be directed at his essay on Paul Scarron, the multi-talented French writer of the seventeenth century: similar because of the tyranny of its narrative, sharper because of its occasional carelessness of organization and of textual explanation.[81]

More generosity is warranted in the case of his historical treatments of English literature: *The English Novel in the Time of Shakespeare* and *A Literary History of the English People*, both originally published in French. If they were addressed to any specific problem, it was ignorance, that of French readers in the first instance, that of English in the second. They were written out of a sense of service and had no great interpretive objective. Others of his works were also interpretively modest but offered as compensation the novelty of documentation. Such was the case of his book on the seventeenth-century ambassador to London, the Count de Cominges, the sub-title of which included *From His Unpublished Correspondence*. Not only was this figure unknown to most readers, a condition itself which called for redress, but that condition could have been easily remedied – if one had only known where to look, namely to volumes 75–88 of the foreign ministry archival series "Correspondance d'Angleterre." Such was also the case, and such the provenance, of a document that Jusserand found in the same archive to cast light on one of Voltaire's would-be publishing ventures in England. In this instance, the document in question was a letter from the French ambassador in London to his minister in Paris, a letter that had been missed by all of Voltaire's biographers.[82]

Of far better quality, because they combined serious research with analytical objectives, were a number of Jusserand's early works. One of the very earliest centred on the controversy over the historical accuracy, or inaccuracy, of Chaucer's *Canterbury Tales*, and in particular on the exaggerated, or not, portrait of his famous Pardoner. Employing original letters, in Latin, from Pope Boniface IX and Simon Sudbury, the Archbishop of Canterbury, as well as literary sources such as Rabelais's *Vie de Gargantua*, Jusserand explored that enduring controversy. And he resolved it, to his satisfaction, with the verdict about Chaucer's "great historical value and the minute accuracy of [his] description."[83] Another early example is his *Shakespeare in France*, "a genial though serious book" that not only surveys the historical experience of the bard's plays in France to the middle of the eighteenth century but explains their limited appeal in terms of a cultural discomfort with excess in language, action, or colour. A French mind, he said, was "enamoured of straight lines." Thus, Shakespeare, if not a stranger, was certainly in a foreign land. "All the care in the world will not make fine olive trees grow in Scotland, nor fir trees in Algeria."[84]

His inquiry into the life of Daniel Defoe and his impact on eighteenth-century English literature is another example of a quest that starts with a problem and ends with an answer. So also is his painstaking and erudite inquiry into the authorship of the fifteenth-century Scottish poem "The Kingis Quair." In the late 1890s an English scholar had sent out a shockwave by questioning the long-held belief that James I of Scotland was the author of the poem. Jusserand, among others, rose to the debate and assembled a carefully argued piece that began, again, with a problem and progressed slowly toward a reassertion of the king's authorship.[85]

Through James I, Scarron, Chaucer, Cominges, and Defoe, Jusserand unquestionably betrayed a fascination and an empathy for the individual in history: the great, the tragic, the maligned, the ignored. For some, who have grown tired of men and women of rank dominating the pages of history, this could be seen as a weakness. For others, impatient of history without recognizable faces and voices, this would be a strength, especially if it is done, as Jusserand did it, without lionizing his subjects, without concealing their humanity in the folds of greatness; especially, too, if it is done, as he did it, with a kind eye to history's victims: whether James I slaughtered before the eyes of his horrified queen; Paul Scarron

released for creation only through a crippled, pain-racked body; Ethelrod's reclusive sister consigned by her love of god to forfeit that of man, but tortured by fantasies of lust and debauchery; Margaret Stuart, the Scottish princess, consigned by politics to be married to the future Louis XI of France, dead at age twenty, as estranged from him as from her own shores.

Better still if one's actors have a cast beside them, players who rotate from wings to centre-stage, from front to back. This was certainly one of Jusserand's strengths as historian, the determination and the associated ability to orchestrate large casts. Certainly, that was the key explanation for the success of his *Wayfaring Life*, that and the interpretive argument which attributed the waning of the Middle Ages to the agricultural labourer slowly breaking "the bonds which for centuries [had] attached him to the manor." It was this glacial process of liberation that permitted greater freedom of movement, as workers "detached from the soil" and joined the "race of roamers" on English roads, adding their numbers to the peddlers, entertainers, pilgrims, and friars, slowly adding their voices to the appeals for change. Not of royal blood, devoid equally of wealth and power, these were the *Every* men and women who as unconsciously but as effectively as "microbes" slowly transformed the power structures of late medieval England. Langland's characters are reborn, lacking only his names: "Tim the tinker ... Hick the hackneyman ... Hugh the needleseller ... Daw the ditcher ... Rose the dish-seller." There is grime here, dirt-under-the-nails history, and combinations of piety and lewdness as wondrous as the recipes of the herbalists and the performances of the tumblers.

To the collection of evidence attesting to Jusserand's historical dexterity should be added two more pieces, both of which I have alluded to earlier. He was an industrious researcher, and he knew how to write. As for the first, he also knew how to read, in French, English, Italian, Latin, and Greek; and his palaeographic training had left him certain of the importance of combining information from published sources with information from original documents of archival provenance – whether the national archives in London and Paris, manuscript rooms housed within the national libraries of either country, ministerial archives like those of his own foreign ministry, or archival collections belonging to the great university libraries. Refreshingly, he admitted that the work could be tedious, "petitions ... reports of lawsuits ... long rows of statutes and ordi-

nances." But, he insisted, such documents provided ground more "solid" than that offered by colourful "tale-tellers"; and it was in such dry rows, "under the apparently cold dust [that] we end by finding sparks of life."[86] Sometimes he would go further afield, for example, inquiring with his own physician about the causes behind the many distressing symptoms exhibited by Paul Scarron. Though once described as a "passionate amateur" by a reviewer who apparently believed that one had to teach history in order to write it, Dr Jusserand took his history as seriously as he took his diplomacy.[87] And in its interests he was meticulous in documenting his findings – which is to say, in the finest of academic traditions, he was helpful with his footnotes.

More helpful, by far, was an early commitment to make his work intelligible to any book-reading audience. Perhaps it arose from an awareness that most people liked novels for their very accessibility, pages they could peruse without intense concentration "in the corner of the fireplace or the train compartment." Like it or not, he said over a century ago, we want "everything made easy for us," which is why the more academic treatises "often repel us." They appear "too learned, too inaccessible." What was needed was history made alive, but by documents, not imagination. Too many editions read "like dictionaries," too many like fiction. He admired the celebrated English historian Macaulay; as one of the very best, someone who could cast a spell when one of his books was on your knees.[88]

With this in mind, the then-young scholar set out to engage a reading audience beyond the scholars who strolled within the ivied quadrangles of Oxbridge. Here is how he introduced, in English, a two-volume work on the writings of Paul Scarron: "Do you like such places and such people? Have you any fondness for roadside adventures, for talkative ostlers, for laughing maids, their laughter as an echo of the larks' song in the morning ... ?" Of the medieval recluse, fantasizing in her cave of love and passion, he writes: "Not a few discovered, when the great resolve had been taken, that the Tempter was not to be met only in public places and in merry gatherings: he found his way into the best-immured cells, and knocked at the gate of the heart. And the gate of the heart sometimes opened, and the life of austerities came to an end."[89] And from such solitude he moves to Renaissance theatre where stood the jester, clerk, monk, and knight, the angel and devil. "The play was old, the

subject threadbare ... the properties dingy, the audience dozed. Faded flowers, a dull greyness over all, a grey light, grey speeches." Then suddenly there is light, there is Shakespeare, the "invisible magician." Just as suddenly, there is a quite different darkness, until "torches flare at the window." James I is about to die, and on no stage. "Strange noises are heard in the courtyard, hasty footsteps on the stairs, the tramp of armed men, the murmur of a throng. The hour is arrived, the prophecies are come to pass, the sorceress had spoken the truth: the king was betrayed."[90]

With all this behind him, and fame secured, Ambassador and Madame Jusserand left Copenhagen in mid-November 1902 to spend two months in France before their next venture. In late January 1903 they left for New York on the passenger liner *Lorraine*, arriving there after a week's voyage, awestruck to see "for the first time rising above the waters ... a Babylonian mass of human work, the Statue of Liberty, lighting the world – a French welcome for a French visitor."[91] On the docks they were met by G.L. Richards, Elise's brother, and in turn the French Consul-General, representatives of the French Chamber of Commerce, the French Benevolent Society, and "The French Line," and a collection of journalists. About to turn forty-eight, "small, bearded, slight, and dark," the ambassador bravely faced the press, first on the docks, soon afterward at the embassy. Never, in twenty-seven years, he reported to Paris, had he faced so many questions, "from the most puerile to the most sensational," none of them especially difficult, apart from having to confess that he was not up-to-date with the latest events in the lingering European dispute with Venezuela. His wife, it seems, suffered even less embarrassment, successfully fielding a question about the respective merits of Shakespeare and the eighteenth-century French poet, Louis Racine.[92] Two days later, in Washington, the ambassador reminded the press that, although this was his first time in America, he was already familiar with Americans: "I have known many of the literary men of America personally, [and] am acquainted with many more of them through their books and through correspondence."[93] One week later he was received by President Roosevelt who, it is worth noting, seems to have discounted a remarkable – indeed mystifying – warning from Henry White, Jusserand's former tennis partner in London. For reasons unfathomable even to a startled Jusserand, White had praised

the Frenchman's erudition but warned against his extreme prejudice against America.[94] Although thus alerted, the president seems not to have detected anything untoward in his initial meeting with Jusserand who, for his part, made no mistakes. "No mission," he affirmed, "could be more acceptable to me, nor seem to me more flattering."[95] The president was suitably impressed, a verdict that he conveyed in a personal note to his son, Kermit: "... a nice little man, very dark & dapper, and ... really a fine scholar. Having the diplomats presented to me is an awful bore as a rule. But this was a different matter; I kept him talking half an hour. Among other things we discussed Lounsbury's *Shakespeare and Voltaire*, which I think is very good."[96]

2 Debutant to Doyen (1903–1913)

Three days after his letter to Kermit Roosevelt, the president began making arrangements for the new ambassador to meet Professor Thomas Raynesford Lounsbury. Jusserand, he assured Yale's prominent literary historian, thought highly of his work, not only the newly released study on Shakespeare and Voltaire, but also his three-volume work on Chaucer.[1] So it was that within weeks of his arrival in America the author-diplomat was engaging, and being engaged, in face to face encounters with members of the American historical community. The engagement was to last for over twenty years. For the moment, however, we must concentrate on the first decade of Jusserand's transplanted scholarly life, during which his intellectual credentials proved to be such a rich resource for his ambassadorship.

Unsurprisingly, the period between 1903 and 1913 was no less a time of transition than his previous decades. By its end the combination of new scholarly interests and new archival opportunities in Washington and New York were to see the development of a career not only *in* America but *of* it – which is to say that Jusserand developed a broad familiarity with the history of the United States and an expertise in the history of the French experience in North America. But it did not happen overnight. In that first decade he remained very much the Europeanist, and very much a productive one, thanks in part to his wife's involvement "in all his literary pursuits," as well as her service as his "principal secretary and ... councillor."[2] He had arrived in Washington not long after his book on French sports had appeared. Like some of his previous work, this was not so much problem-directed as it was a survey, an extended

and remarkably erudite narrative from the Middle Ages to Napoleon. Well over four hundred pages in length, the book traced the evolution of sports from activities primarily designed to develop military skills – sword and rapier, archery, shooting, equitation, and jousting – to increasingly less violent pastimes – tennis, cricket, football, swimming, and ballooning. And what came with the evolution were rules – conventions aimed at limiting bloodshed or governing the participation of women in the hunt – and philosophical cum ethical musings on the relationship between strong bodies and strong minds. It was no accident, therefore, that the ambassador chose to open an address to graduands at the University of Chicago in December 1905 on that very note, invoking while doing so Montaigne's conclusions about the connection between mind and body.[3]

It was less the philosophy, and certainly less the narrative, that interested Jusserand about Edmund Spenser's sixteenth-century reading of Aristotle. This article was one of the ambassador's first publications from America. It is simply too esoteric to delay us for long, but it is also a singular illustration of his curiosity and indefatigability, to say nothing of his linguistic skills. Briefly, he was puzzled by Spenser's attribution of specifically twelve virtues to the ancient Greek philosopher, as opposed to the nine or ten or eleven detected by some scholars; and after an extended examination of other sixteenth-century writing, the ambassador concluded that he had solved the mystery. The number twelve had come to Spenser, not from Aristotle, but from the works of two Renaissance scholars, most notably the Italian Alessandro Piccolomini. Attribution was also the theme of a much longer article in which Jusserand confronted a scholarly but controversial claim by John Matthews Manly that William Langland was not the author of the medieval epic poem "Piers Plowman." While praising the University of Chicago professor for his expertise and proven scholarship, Jusserand did his best to dismantle Manly's claim of multiple authorship. Remarking on the extraordinary smoothness that would have had to exist among five independent and successive authors, he observed that "each of these authors must have written and breathed his last, with absolute punctuality, as moths lay their eggs, gasp, and die." And as for the related claim that periodic non sequiturs in the "Plowman" text were consistent with multiple authors and improbable with a single, the Frenchman employed two examples where single authors had belatedly

discovered their own mistakes and omissions. One was Cervantes, the other Theodore Roosevelt in his *Outdoor Pastimes of an American Hunter.* No, Jusserand concluded, another of his heroes still intact, "we believe" the old manuscript's word: "William Langland made Piers Ploughman."[4]

However attentive the ambassador was to the lives and settings of ordinary people, his list of heroes showed no signs of shrinking in the years after 1903. But his "great men" were almost always those of intellectual or artistic genius. None more so than William Shakespeare, whom he defended, when necessary, and praised between complaints. He also much admired Shakespeare's gifted but acerbic contemporary Ben Jonson, whose personal affection for the bard had not made him less of a critic. "Shakspeer wanted arte," Jonson had adjudged, because he was too fanciful, too careless with his facts, too ready to accommodate the coarse and vulgar tastes of coarse and vulgar audiences.[5] Dr Jusserand knew what Jonson meant, knew Shakespeare's penchant for situating "all distant towns ... by the seaside," and for indulging in anachronisms of the sort that had placed a nightcap on Caesar's head, but he was convinced that artistic genius of such exceptional stamp had to win out over misgivings about factual precision ... over misgivings about the bard's indifference to moral instruction as well. Jonson was right. Shakespeare did indeed take his cues from an audience that wanted entertainment not education, and he did not disappoint. But writing "without moral purpose" did not mean that the dramatist was without "moral effect." Witness the case of Ophelia, he advised, and Desdemona, and Othello. Each "obliges human hearts to melt, it teaches them pity." As could, it seems, the ambassador himself, judging by the praise heaped upon his "masterly essay" by a subsequent reviewer who said that *What to Expect of Shakespeare* ought to be made mandatory reading for all literature courses in American universities.[6]

Witness also the case of the sixteenth-century poet Pierre de Ronsard, whose Vendôme countryside the Jusserands had hiked and to whose resting place they had paid private pilgrimage. Finally, in 1913, the biography appeared, many years after the then young scholar had assigned to himself the Ronsard volume for the Great French Writers series. Like the others in the series, this volume was designed to recall the life and celebrate the artistry of one of France's great men of letters; and like Jusserand's work on Shake-

speare, that on Ronsard did not claim any major interpretive break-
throughs. Scholarly in its use of published and unpublished text,
written in a style that could be savoured by non-specialists, which is
to say a book that offered "delightful reading," *Ronsard* pro-
claimed the man a genius, and the genius a man. After all, Jusserand
had always been fascinated by the human qualities of his heroes.
That is why, this time, he gave his readers not only the poet and the
poetry, but also an extended portrait of a complete life: from the
young man who loved travel, music, tennis, and Cassandre – a
woman denied him by an arranged marriage with another – to the
elderly man whose passions had become focused on gardening and
on a responsive lady in the court of Marie de Medici.[7]

As of February 1903 Dr Jusserand's other principal preoccupation
was with the court of Theodore Roosevelt. The compatibility of the
two men became obvious within a week of the diplomat's arrival.
On 7 February the ambassador was taken by presidential car to the
White House, where he presented his credentials. Roosevelt, in
frock-coat, listened politely to the customary remarks offered by all
ambassadors on such occasions, replied with more customary
remarks, and then promptly turned to the subject of the ambassa-
dor's books, on which, he said, "I am ready to pass an examina-
tion." Thus began an exceptional relationship, rooted, in the first
instance, in books. "He compared," so Jusserand reported, "way-
faring life in the Middle Ages with wayfaring life in present-day
Colorado. We discussed Chaucer, Piers Plowman, Petrarch." Secre-
tary of State John Hay, another man of remarkable erudition, said
that he had never heard a conversation of such calibre on what had
always been an occasion defined by formalities and protocol. Two
weeks later, at their first White House dinner, the Jusserands con-
firmed their intellectual credentials. Suddenly, Roosevelt with his
darting intelligence and probing curiosity, wondered aloud where
the thirteenth-century Mongol invasion of Europe had been
stopped. Out of the momentary silence, came "Trieste" from the
French ambassador, and – "by some special grace from heaven" –
some brief but well-chosen words on the Mongols from Her Excel-
lency, the ambassadress. Little wonder, therefore, that Théophile
Delcassé, their minister in Paris, was so appreciative of the intellec-
tual cachet the couple had carried with them to Washington, what
he called a "priceless guarantee" of the mission's success.[8]

Two months later there was a reprise of the table talk, this time in St Louis, and this time in Elise's absence – the first time they had been separated since their marriage eight years earlier. The occasion was the 100th anniversary of France's cession of Louisiana to the United States. The president engaged the ambassador at first sight, raising again the subject of the Mongols, as one of the "500 subjects" he wanted to discuss when they got back to Washington. And later at dinner, Roosevelt imposed his interests on the rest of the table. That night they were concentrated on French literature. He thought highly of Alphonse Daudet and Prosper Mérimée, less highly of the sometimes racy de Maupassant, and much less still of Zola, whom he considered merely a fantasist, and a crude one. To which the ambassador answered with comparable censure, not for the first time complaining that too many French contemporary novelists were only interested in sensationalism. The problem was that they totally misrepresented France, making it impossible for foreigners to understand how Parisians had held out so long against the Prussians in 1870–71, when their numbers were thought to include so many "lewd brutes" of the sort spawned by Zola's over-heated imagination. Zola, Mérimée, Daudet, all were assessed in a "noisy dining hall" in St Louis, all, for better or worse, demonstrating a French fact in America.[9]

Or rather, in parts of America, for Roosevelt was no more typical of his countrymen than was Jusserand of his. And yet, for all that, there was in them a representative quality. Certainly they had much in common. Roosevelt, like Jusserand, was neither urban nor rural, but both. Born in 1858 to a wealthy New York City family, the future president had demonstrated early interests in history and municipal politics, and a resolve to conquer ill health with self-imposed physical challenges. For reasons partly related to that resolve he had spent two years in the Dakota Badlands working cattle, hunting on foot and horseback in isolated, arduous terrain. It was a universe removed from the sedate setting of Harvard University from which he had graduated, but a better preparatory field for the cavalry unit he commanded during the war with Spain in the 1890s. Roosevelt was, indeed, a Rough Rider, an educated and cerebral man with a machismo impulse on overdrive, the kind of man who would publicly condemn as "lazy weaklings" those who were deterred by something as insignificant as inclement weather.[10]

That remark was clearly not aimed at an ambassador who had trained in the Monts de la Madeleine and on the heaths of Scotland. He, too, had a country and sports-filled background, as well as a rich experience of urban art galleries, concert halls, and libraries. University-educated, multi-lingual, an international traveller and a scholar, Jusserand was no more representative of the average Frenchman at the turn of the twentieth century than was a Harvard graduate of an average American. The majority of citizens on either side of the Atlantic did not have a secondary education, young women in particular, and did not live in urban centres equipped with electrical power and running water. The fact is that in many ways, when it came to modernization in general and industrialization in particular, the gap between "old" France and "new" America was much less pronounced than one might have thought. From the perspective of literature, art, and philosophy, it was clear who was established and who the newcomer, but not from the perspective of railroads, steel-clad ships, field howitzers, medical science, or grain harvesters. Indeed, in March 1903, after his first visit to Chicago, then a city of two million people, Jusserand told Paris of his first glimpse of the future. Touring the farm machine factory co-owned by "Mr. Deering and Mr. MacCormick [sic]," he had seen production and efficiency at their best, including legions of well-paid typists working from dictaphones. The same month, passing through New York, the assembled skyscrapers had caught his eye. He found them incomparable with anything he had seen before, individually "not things of beauty," but in their ensemble, seen at sunset, seemingly "the work of giants" bearing "an air of majesty."[11]

Seen from the perspective of an ambassador's relations with a sitting president, Jules Jusserand started at the top. And he remained there until March 1909, that is to say for the remainder of the Roosevelt years. Certainly the commonalities between the two were exceptional, extending from intellectual engagement to sorely established athletic equality, and to genuinely affectionate social relations.

The scholarly association was never allowed to lapse. In the summer of 1905 the president was still consumed by the Mongol invasions, newly stirred by a book he had borrowed from the ambassador: Léon Cahun's 1896 study of the Turks and the

Mongols. "Frenchmen," the president ventured, found Cahun dry, but he was "miles asunder from the hopeless aridity of similar writers among our people." Three years later he was reading in French translation, so he reported to Jusserand, Guglielmo Ferrero's multivolume study of the Roman Republic, Léon Poinsard's work *La Production*, and Lord Acton's new *History of Freedom and Other Essays*.[12] And another three later, he was praising Jusserand himself for a recent gift-essay on William Shakespeare. Elise, too, did her part, responding on one occasion to what she obviously thought was the president's overly ardent enthusiasm for blood-spattered Norse and Germanic heroes, by recommending to him *La Chanson de Roland*. "There," she said from across the table, "you would find as much valour and more poetry." A few months later, he confirmed his enjoyment of the medieval French poem, but was clearly squirming over "a dozen points I want to talk over with you."[13]

Even after Roosevelt's departure from the White House in 1909, the relationship continued by correspondence, the retired head of state reporting on one safari harvest – "nine lions, eight rhinos, four buffalo, five giraffe" – and closing with "warmest love to Mme Jusserand." In turn, the ambassador continued to cultivate the former president's knowledge – and perforce his admiration – of France. When you are in France, you "must" go to the Sorbonne, the Elysée Palace, Saint Cyr, the museum at Saint-Germain, the Sainte Chapelle, the Cluny museum, the Gobelins tapestry works, Versailles ... And when you go to Versailles, go on a Sunday, when it is crowded. Otherwise, "most of the fun is gone. People who have swam [sic] together the crystal waters of the Potomac are not afraid of mixing with any crowd."[14]

Certainly the two men had been linked by more than conversation. Personal commitment to physical fitness was another bond; in Jusserand's case, it went back to the searing memory of France's military defeat in 1870. Two activities were high on their list of favourites, tennis and what today might be called, extreme hiking. Early in his tenure Jusserand submitted to another test of his suitability for Roosevelt's Washington. If the first had been intellectual in nature, the second was anything but. Instructed to wear their "worst clothes," the ambassador and one or two other invitees travelled by carriage behind the White House automobile to a destination miles away from the capital. There they dismounted and did their best to keep up with a head of state intent on a gruelling,

several-hours return by foot, the president leading the way, over rock obstacles, rather than around them, through water and brush obstacles, rather than around, scorning all but the most direct, as-the-crow-flies route homeward. At a pace closer to running than walking, Jusserand, himself an inveterate hiker, was among the few who could keep up the pace, on land and in the Potomac, even to the end when, returned in darkness to the White House, wet and mud-covered, he was challenged to a game of medicine balls. It had been a test of endurance and fortitude, and passing it in the president's eye was the perfect complement to possessing a strong mind. He had found in the French ambassador, so he wrote to Kermit, a worthy and "unexpected playmate."[15]

Further proof of the slight Frenchman's agility and tenacity if proof were needed, came on the White House tennis court. The president tried to play every afternoon, usually in double matches, with partners and opponents drawn from members of his government and the diplomatic community. Unsurprisingly, for reasons of physique and temperament, Roosevelt and the French ambassador played a very different game, whether as partners or competitors. The president, "a very husky looking figure," in his old trousers and sweater, stuck close to the net, swung viciously when he could, but let his back court partner do "all the work." Jusserand was far lighter and more nimble, "covering about ten miles to the President's one," and calculating his shots like a billiard player. As one newspaper editor observed, the ambassador "always seems to be on the winning side," a conclusion not shared by the president who, on the contrary, could only recall the many times he had defeated the diplomat – to which the ambassador replied, eyes a-twinkle, that he could not always separate tennis from diplomacy when playing the president of the United States.[16]

This athletic camaraderie, floated on a genuine respect for the range of each other's abilities, also extended to their social contact, that is, to the more intimate gatherings of Roosevelts and Jusserands, as distinct from the grand public occasions at which presidents and ambassadors perform in varying uniforms to the custom-beat of state protocol. One of the first such encounters was in April 1903, when the ambassador and his wife dined "dans l'intimité" at the White House, there being present only the Roosevelts, including daughter Alice, the Jusserands, and two unidentified young men. By the autumn the diplomat had come to

be regarded as "a great chum" of the president, two small signs of
which had been an intimate if earnest conversation among the
Roosevelts and Jusserands over some details of Lewis Carroll's
Alice in Wonderland, and the table talk about the valour and art-
istry of *La Chanson de Roland*.[17] Within three years a genuine
affection had developed between the two couples, with the presi-
dent closing his letters with informal expressions of "love to
Madame Jusserand," and singling out as a highlight of one evening
a walk with her along the banks of the Potomac. She, for her part,
responding to a presidential letter of condolence on the sudden
death of her mother in 1906, concluded her grateful acknowledge-
ment: "I cannot tell you all it means to us to feel we have your
friendship." Further evidence of this special relationship, if such
were needed, came in May 1907. Unsure of the time or location of
the Jusserands' arrival at a large multi-site exposition, Roosevelt
issued a handwritten instruction that they were "to be admitted
wherever I am"; and the following month he had them spend a
week at his country residence at Sagamore Hill.[18]

Two years later his presidency was over. Emotions ran high
among his intimates, and deep within the burly, tough-hide head of
state. In a note of thanks of March 1909 to the Jusserands, "you
two dearest people ... our very dear friends," he wondered "if ever
people had a better time than you and we have had together in the
last few years." And he added that the only thing he and his wife,
Edith, missed about leaving the White House was no longer seeing
"those we loved."[19] Later that month, at an emotional farewell lun-
cheon to which he had invited thirty-one intimate friends – tennis
players, fox and wolf hunters, the occasional cabinet member, a few
lawyers, and one ambassador – Roosevelt said his goodbyes. Tough
men with wet eyes looked away. Included among his remarks was a
special tribute to Jusserand, which, for reasons of diplomacy, "did
not appear in print." Possibly, he said, "there never was such a rela-
tionship between an ambassador and a president or ruler of a coun-
try as there had been between Jusserand and himself." At which
point, the ambassador, too moved to speak with absolute control
but charged with the task of presenting the group's gift to the presi-
dent, rose to his feet, and performed a totally unanticipated service
to all those assembled. With not a dry eye in sight, he expressed on
their behalf thanks for the president's friendship and presented him
with an engraved silver bowl. Suddenly the room was alive with

laughter. However exquisite his use of English, after six years in America the ambassador's pronunciation was not yet flawless; and in that tiny gap between mastery and imperfection he had uttered the incongruous sound of silver "bowel." By chance or calculation, with a single word he had released the tension from men conditioned never to cry.[20]

None experienced the changing of the guard more deeply than France's representative in Washington. As Roosevelt had mused in front of his friends, it was unlikely that ever again would an ambassador and a head of state enjoy so close a friendship. Indeed, it proved a prophecy. William H. Taft, Roosevelt's successor in the White House, was an entirely different man from his former chief and predecessor. Taft, a graduate of Yale and trained in the law, had served as Secretary of State for War between 1904 and 1908, before first being anointed successor by Roosevelt and soon after by the electorate. Jusserand liked the new president personally, describing him to Paris as a man, not unlike himself, of modest fortune, indifferent to wealth, committed to public service, suspicious of Germany and her kaiser, but very well disposed to France if not to French. Less happily, he was no fan of tennis; indeed, for a short time the court became an enlarged pasturage for "Pauline" the White House cow.[21] France's relations with the new administration suffered no comparable decline, but they were tested time and time again by the enduring problem of protective tariffs. This will require attention as part of a subsequent examination of the political and economic issues with which the embassy had to deal under the Taft administration. Here, we need only confirm that nothing close to the Roosevelt-Jusserand connection ever developed before Taft's single, four-year term ended in electoral defeat to the Democrats and the inauguration in 1913 of the country's twenty-eighth president, Woodrow Wilson.

The intimate setting that the Jusserands frequently experienced at Roosevelt's hearth was of course but one dimension of both couples' lives. Nor should one forget, any more than could the protagonists themselves, that even those moments, however enriching and pleasant, could never be entirely private, unofficial, free from the risk of compromising the interests of their respective countries or casting a shadow on their reputations. Whatever was said, whatever the location, these were at best but semi-private moments.

Many other occasions in the life of an ambassador are carried out under public glare, and even more behind embassy doors where uninspiring, quotidian tasks are begun, finished, and recommenced according to the conventions and caprice of distant bureaucrats. In short, in permanent tandem with the semi-private moments come those intended for the public eye and those to be carried out in confidence – the visible and the invisible. Each in turn has many facets, far too many to be surveyed here, but to ignore them altogether would mean short-changing the activities of an embassy and misrepresenting the duties and life of an ambassador. Since they were designed to catch the eye of witnesses in any case, a few of the public events seem appropriate places to capture some flavour of a Washington embassy at the turn of the twentieth century.

Until the Spanish-American War of 1898, Washington had not figured prominently in the ambitions of current or aspiring diplomats. Considered a posting "distinctly of the third grade," it had yet to acquire the status of even Copenhagen or Lisbon, never mind that of London, Paris, Berlin, Vienna, or St Petersburg. Its principal disadvantages from a European point of view ranged all the way from its geographical distance from the seats of power and society gossip, through what was taken for the absence of European "atmosphere" and careless regard for proper ceremony, to the capital's sultry, stifling summer weather. But by the turn of the century, increasingly mindful of the dramatic increase in American wealth and power, more and more diplomats had come to consider such sacrifices worth it. The United States was a nation on the rise, one measure of which had been the French decision in 1893 to promote its diplomatic representation from legation to embassy.[22] Indeed, Jusserand himself had gone off to Washington with assurances from the deputy Alexandre Ribot that there was "no post more considerable," and from the Academician Georges Picot, that his mission was "one of the most important on our small planet."[23] Certainly the signs of a trend were obvious by the first decade of the twentieth century and in the wake of the victory over Spain: John Hay's efforts to improve the calibre of America's own diplomatic representatives; Roosevelt's contributions to ending a war between Russia and Japan and averting one between France and Germany; Cyrus McCormick's harvesters and Henry Ford's automobiles.

So diplomatic corps came to Washington with much greater interest and ambition than ever before, and they started purchasing

properties for their embassies, the kind of commitment not much in evidence until the end of the nineteenth century. With the embassies came the domestic staff, and the drivers and footmen decked out in liveries long familiar to the old European powers: the British in dark blue, with black cockades, and green and yellow striped waistcoats; the Germans in black livery, with brass buttons and cockades of red, white, and black; the Austrians in dark green, sporting cockades either of Hapsburg black and gold or the national red and white; the French in dark blue livery with cockades in republican colours of red, white, and blue. Equally telling, and equally impressive, were the carriages, coachmen, and footmen of the White House, the men all sporting hat cockades in their own republican colours of red, white, and blue.[24]

State occasions of all sorts brought out horses, drivers, carriages, as well as uniformed and be-gowned occupants, to be seen by the citizens of Washington, the elite of which often had their own coats of arms and their own liveried servants. Sometimes it was a two-staged event, starting with a concert of Brahms and Schubert at the White House, followed by a ball at the British embassy on Connecticut Avenue: Mrs Edith Roosevelt, elegant in a white satin gown embroidered with pearls; Lady Herbert, wife of the British ambassador, also in white satin, her gown illuminated by diamond necklace and tiara. There they chatted, danced, and dined beneath the life-sized portrait of Queen Victoria, amid the azaleas and roses, and to the soothing sounds of an orchestra hidden behind palms and more azaleas.[25] Sometimes it was a single event, like the Tafts' New Year's Reception at the White House, on which occasion the ladies of the French embassy caught the eye of a fashion-conscious reporter: Mme Jusserand in a gown of rose broadcloth embroidered in gold, complemented by a black "picture hat" with plumes; the Countess de Chambrun, wife of the military attaché, in a gown of black satin with a matching black hat; Mme Benoît d'Azy, wife of the naval attaché, splendid in gown of blue chiffon trimmed with gold and lace, with a large, matching blue hat, and a stole of marabou feathers.[26]

As grand and colourful as they always were, such events were not equally successful, at least from the perspective of the diplomatic corps. Earnest as they tried to be, the Americans still had a lot to learn about protocol, that is to say, about what "old" Europe considered appropriate. Jusserand recalled two early experiences in

Washington. One was a White House event when the contingent of uniformed ambassadors had been put on display – in what he called the "salon d'exhibition" – but were denied an opportunity to personally greet President Roosevelt, denied an invitation to dine subsequently with the American guests, and allowed to enter and depart only via the service stairway. To add to these affronts, Count Cassini, the Russian ambassador, had had his hat knocked to the floor by a servant intent on setting a banquet table, an accident aggravated by the dark mood that had already settled on the diplomatic corps and, in that horse-and-carriage day, by the fact that the servant was black. The second incident occurred at the funeral for a deceased senator, at which time not only were the foreign representatives relegated to the very tail of the official procession but the presiding chaplain managed to enrage the British, German, and Austrian ambassadors by a string of anti-monarchical remarks.[27]

Happier, for several reasons, was the society wedding of Alice Roosevelt early in 1906. The bride had become a family friend, the groom was Congressman Nicolas Longworth, whose sister had married into the de Chambrun family, and there were no blunders. The glamour one could always take for granted – the gowns, hats, gloves, boots and furs, the embroidery, the gold and silver buttons; gowns of broadcloth, satin, silk, velvet, and chiffon; gowns long and short, sleeves long and short, trains yes and no. The new British ambassadress, Lady Durand, in pearl grey chiffon; Mme Jusserand in apple green velvet, Baroness von Sternburg, the German ambassador's wife, in silver velvet. Seven years later, there came another happy occasion, again in the form of a wedding, this time that of Jessie Wilson, the new president's youngest daughter. By then, Dr Jusserand had graduated by virtue of seniority to role of the *doyen*, the head of the diplomatic corps in Washington, which meant that it was up to him to decide whether the corps would attend in uniform or in morning dress. For a month he let the capital speculate, thus adding mystery and energy to the impending occasion. Finally, two days before the event, the other embassies were informed, and with them the public. It would be dress uniform for those so entitled, and it was intended as a compliment to the head of state who, had he been a European, could have expected such an honour. And so the occasion offered Washingtonians the sight of medal-bedecked chests, jewel-hilted swords in shining scabbards, miles of gold braid. With one prominent exception. The doyen of the corps

had arrived early at the White House by limousine, wearing a fashionable civilian's pointed, patent leather shoes, peg-top trousers, a frock coat of the latest Parisian style, and a glistening top hat of silk. Beside him, in a Paquin gown so stunning that it caused a "gasp of admiration," walked Elise, now the first lady of the corps.[28]

Wedding occasions such as these in Washington required neither travel nor talk beyond congenial chatter. Many other occasions required both, with public addresses being delivered within and also beyond the perimeters of Washington, New York, and Philadelphia. Again, it would be pointless and provocative to try to record each and all of these moments for some fragile notion of posterity. What needs to be recognized is that this ambassador travelled extensively in America within the first decade of his posting to Washington, a pattern originating from his youth in Europe and retained throughout his tenure in the United States. The inspiration behind the trips, principally by rail, varied according to circumstance: invitations from a chapter of the Alliance Française in Boston, from the French Hospital in New York, from the universities of Chicago, Virginia, and Stanford. He was in Philadelphia for an event to commemorate the life of Benjamin Franklin, in New Jersey to unveil a monument to the French scientist André-Marie Ampère, in Louisiana for the anniversary of what Americans called the "Purchase," in California to commemorate San Francisco's survival from the devastating earthquake of 1906, in Annapolis, Maryland, for the unveiling of a statue to the unknown French soldiers and sailors who had seen service in America's eighteenth-century revolt against Britain.

Indeed, history became an early leitmotiv for Jusserand's remarks from coast to coast, not simply because he was an historian but because refreshing America's historical consciousness had the potential to serve the interests of twentieth-century France. In this sense, the diplomatic assets of history in this "new" world were also to open new doors for his personal scholarship. And the requirements of speaking in public forced him not only to learn more history but to express what he had learned in English. Within months of his début in the country he had discovered that speaking in French had its drawbacks. Press reports of a talk in Boston convinced him that so little had been understood, and so many banal and error-filled remarks had been attributed to him, that he concluded he would have a much better chance in English.[29] The

historical tenor of the remarks was less contentious. In his first
Independence Day address he recalled the old Franco-American
alliance; France and America were two peoples with the "same
ideal," just as had been "our ancestors" over a century before, flags
joined, colours identical. A year later, presenting to Congress a
replica bust of George Washington by the French sculptor David of
Angers – a reproduction paid for by the "Ladies of France" – he
recalled not only the eighteenth-century alliance and the original
gift of 1833, but also the 1851 fire which had destroyed that origi-
nal work.[30] At the University of Virginia he gave reminders of
Thomas Jefferson's years as minister to France, and of the Louisi-
ana Purchase of 1803, a purchase which he said had been really
more a gift from France. At Arlington, he helped unveil the statue
of Major Pierre L'Enfant, eighteenth-century soldier-architect who
had done so much to design the District Capital.[31]

Design and associated art had long been of interest to Jules
Jusserand, an interest manifested years before in Milan and Lon-
don. Little did he know then that he would be called upon by the
demands of aesthetics and comfort, if not by his government, to
make something of the embassy facilities in Washington. He had
begun early, months before arriving at his new post, by asking that
electric lights be installed throughout the first floor of the embassy,
and in the master bedroom.[32] It is this reference to creature com-
forts that opens an avenue from the glitter and hub-bub of an
ambassador's public life into the quiet corridors and private
recesses of home and office, to the offices where the real work was
done, whether on telegrams, written despatches, public addresses
or, in his case, on scholarly manuscripts. This was the nether world
of the diplomat, its margins only occasionally overlapping with
those of the embassy's reception and dining rooms where select resi-
dents of other embassies were invited to meet Americans of distinc-
tion as well as prominent visitors from abroad, each guest faithfully
identified by name and association in the society pages of the *Wash-
ington Post*.

But it took a while before the Jusserands could implement their
own style of wine-and-cuisine diplomacy. The embassy that greeted
them in February 1903 was in a parlous state, its walls so badly
cracked that drafts made some rooms "uninhabitable." More
alarming still, the ambassador was advised where, and where not,
to install his books on the second floor – in order to prevent a

collapse of the first floor ceiling. Fortunately, the Jusserand's new home was only a temporary accommodation. Plans were already afoot to build a new embassy on grounds acquired in 1901 by his predecessor, Jules Cambon. In the interim the couple would have to make do, initially in the building that he said was too "difficult to describe," then in 1904 in a more comfortable house on Rhode Island Avenue, and a year later in a property overlooking Sheridan Circle on S Street.[33]

There they stayed until the end of 1907, at which time they were able to move into a new, four-storey building at the corner of 16th Street and Kalorama Road. This leased property, it should be said, was also intended to be temporary, pending funding and architectural plans for a building on the grounds purchased in 1901. The 16th Street building had been designed by George Oakley Totten Jr. It offered two large reception rooms, a large and a small dining room, plus office facilities, all on the ground floor; a master bedroom and an assortment of smaller bedrooms and reception rooms on the second floor; and more bedrooms, including accommodations for domestic staff, on the third and fourth floors. It also featured an exterior facade of white marble and terra cotta, a grand interior white marble staircase leading from ground to first floor, and an impressive total of six bathrooms. Upon completion, it was described as unequalled in style and artistic taste, an achievement due partly to the attention paid by the ambassador himself to interior appointments and furnishings. The latter, most of which were his own, were gilded pieces of Louis xv design that fit nicely with the building's more modern touches: white enamelled woodwork, ornamental plaster cornices, and French silk hangings.[34]

The ambassador was doubtless a good deal happier with this accommodation than he had been on arrival five years earlier; and in 1908 he still had the prospect of a yet newer, French-owned embassy to come, a facility to which he would propose design changes better suited to cope with Washington's climate than anything Parisian architects had envisaged.[35] By now, Jusserand was a man in his fifties, a man of modest personal wealth and considerable intellectual reputation, and a man senior enough in years and ministerial rank to speak his mind. Writing to his masters about the design of the future embassy, he recommended stone construction over brick ... unless the government really wanted to be commonplace.[36] Usually, he couched his complaints to Paris in terms of

conditions that reflected badly on France or on her representative in America, rather than admitting to bruised personal dignity. The embassy, old or new, gave continuous grounds for expressing dissatisfaction with the penny-pinching policies of masters in the Quai d'Orsay. And it had not taken the first glimpse of the embassy in 1903 to arouse his anger. The Jusserands' first trip to New York on the *Lorraine* had been a disaster from the point of view of accommodation, and the ambassador had been quick to say so: two narrow beds, and a porthole that afforded a view of hundreds of immigrants strolling on a lower deck, some of whom seemed the victims of smallpox. Hardly, he steamed, the first-class accommodation to which an ambassador on official mission ought to be assigned![37] With a run-down embassy coming into view, the ambassador quickly settled into a habit of confronting superiors in Paris every time he thought the gap was widening between what they expected of the embassy and what they were prepared to pay for.

A year after his arrival in Washington Jusserand reported that his embassy's budget put France in last place among the European great powers. True, he said, his own salary was slightly higher than that of his German counterpart; however, the latter received his accommodation free, had a much larger budget for public occasions, had a more generous travel subsidy, was eligible for additional funds to rent summer properties, and got vacation pay at 80 percent of his salary. By contrast, the French ambassador had to pay rent in and outside Washington, received vacation pay at 50 percent of salary, was less handsomely subsidized for travel, and had much less money to sponsor public events.[38] Perhaps even more disturbing for Jusserand was the fact that his French counterparts in London, Berlin, and St Petersburg all received free housing as well as supplementary allowances not far removed from his own.

Speaking of such distant places, the ambassador was never loath to rebuke his own minister when it seemed warranted. Paris tells me next to nothing about what is happening in Russia, or Germany, or the Far East, he complained, and ignores my requests for information. The reports I get are almost devoid of substance; "and when I say that, I am exaggerating in the most optimistic sense." The end result, he said in an attempt to escape any suspicion of personal hubris, was that he could not have the influence he needed to have in the White House. The president, with whom he enjoyed "confident rapport," found too many ambassadors too ill-informed about

world affairs to make any discussion with them worthwhile. Having raised the spectre of reduced influence in the White House, the ambassador continued. Perhaps he was "out of place," he ventured, by criticizing his superiors, but he did so only out of a sense of duty to his mission.[39]

More disturbing still was a new wave of government cost-cutting that originated in 1908 in Paris and slowly swept toward the distant embassies. Jusserand's budget was cut by nearly 17 percent and the ministry asked him, admittedly with a touch of embarrassment, to reimburse it for a 250 franc over-expenditure from the previous year's subscriptions budget.[40] Not in the best frame of mind, the ambassador balked at a newly designed form for recording expenditure, with detailed line entries for everything from staff salaries to carriage and automobile expenses, to elevator maintenance. Balked, by ignoring it, a course of inaction that prompted a scolding from his minister, Stephen Pichon, and a demand for immediate compliance from either Jusserand "or your successor."[41] Worse news came in 1910: more cuts to the allowances, more services rendered ineligible for state support, no recognition from Paris of American cost-of-living increases, and no recognition of the higher heating and cooling costs that accompanied embassy life in Washington, or the high costs of travel for ambassadors to sprawling countries like the United States, or for their trans-Atlantic trips home to France.[42]

Central to the question of state funding, adequate or inadequate, was the distinction between the expenses of the embassy and the expenses of the Jusserands. In October 1910, reporting on the previous trimester, the ambassador reported a total utilities cost of $44.91, three-quarters of which was reimbursable by the ministry. The remainder was seen to be the private charge of the ambassador himself. More complex was the case of an individual who was at the same time a member of the Jusserand's domestic staff and the embassy usher. The state paid for the latter position, the Jusserands for his food, wine, uniforms, laundry, holidays, and biennial trips home to France. But the exact nature of his duties and the allotment of his time remained an ongoing bone of contention. More straightforward but no less easily resolved was the difference between minister and ambassador over summer rental property. Jusserand argued that it was unreasonable for the state to pay winter heating costs but not cover the summer costs of an embassy moved out of

Washington. The city, he insisted, is simply "uninhabitable" in the summer, a conclusion long shared by the politicians and the rest of the diplomatic corps. And adding insult to the injury of settling up every year was the time-consuming process of working out the percentages and filling in the lengthy forms. Especially in connection with heating costs and the calculation of how much had been spent on people doing official work during embassy hours and how much on partly-private bodies at rest. It seemed, the ambassador remarked, that the time invested in calculating these percentages was not commensurate with what the ministry was trying to save. "I will of course do as I am instructed, but it seems to me that we would be better to simplify the process."[43]

Right or wrong, Foreign Minister Pichon said there was a principle at stake, one that applied to everyone, and which seemed to have been accepted by everyone – except Monsieur Jusserand. The government would pay for the labour, food, and laundry of anyone doing official work at the embassy, from the concierge, to the usher, to the office boy. It would not pay for the services provided to the Jusserands by their personal staff. It was a clear and seemingly reasonable principle, but the practice was confounding, given the presence of two indistinct, indeed overlapping, sets of employees under the same roof. Confounding and persistent. In June 1911 the ambassador was asked about a missing water bill and missing receipts for expenses relating to the usher and the office boy. As well, Paris would only cover a premium rate of pay for embassy staff working at Easter functions *if* such was local custom. If it was only the ambassador's personal idea, the government would not.[44] Disinclined to be submissive to a distant bureaucracy, Jusserand insisted that such parsimony, expressed in a new rash of budgetary cuts, was quite out of line with the fact that the embassy workload had doubled in his first decade in Washington.[45] Such was the tenor of the irritants exchanged between the Quai d'Orsay and the embassy in the first decade of Jusserand's tenure.

The thorny issue of embassy personnel could become thornier still, leaving the ambassador with responsibility for smoothing out differences between aggrieved parties. The fact that none was likely to endanger world peace in no sense lessened the diplomatic efforts required. Several times in the course of 1904–05, an automobile registered in the name of the embassy's counsellor, M. des Portes de la Fosse, was stopped for speeding "greatly in excess" of the twelve

miles per hour allowed by the city of Washington. Having been notified of the first two infractions by none other than John Hay, American Secretary of State, the ambassador spoke to his counsellor who, in turn, spoke to an apparently unrepentant, or at least incredulous, embassy chauffeur. "Apparently," because another infraction, which occurred some months later – the third to be communicated by the State Department – produced an element of French resistance. While the counsellor would speak to the chauffeur once again, Jusserand assured Hay, he was doubtful that his reported speeds were correct, and found it inappropriate for the police to be bringing such delicate matters to the local press.[46] More speedily dealt with was an incident later in 1905 when neighbours near the Connecticut Avenue embassy complained of excessive noise. The miscreants in this case were servants singing with too much enthusiasm on an August evening, accompanied by three barking dogs and a screeching parrot. Police investigating the complaints heard no barking but quickly accosted the servants and the parrot. This incident, at least, was handled quietly, in the form of a personal and confidential note from the State Department to the embassy.[47]

Somewhere among the banal, the grand public occasions, and the graver questions of state were embassy functions of middling stature. These were not issues of war or peace nor weighty issues of international commerce, but rather the range of tasks that surfaced with every day: supplying the State Department with intelligence on anarchist ties between the two countries; proposing modifications to American copyright laws along lines less inimical to foreign authors; requesting financial compensation for damage done by the American Navy to French undersea cables in the course of the Spanish-American War; countering public denunciations by Catholic congregations of France's recent secular laws pertaining to Church and State; representing the interests of French citizens who had been denied entry to the United States by the Immigration Department; facilitating the visits of prominent French citizens to America and the visits of prominent Americans to France.[48]

Among the graver questions that arose during Jusserand's first decade as ambassador were those related to international commerce. Although never likely to interrupt the peaceful relations that the two republics enjoyed, issues of tariffs and trade practices – which is to say the financial fortunes of producers, investors, and

voters on both sides of the Atlantic – were never far from the public eye. However complex tariff formulae might be, just below the surface there was a foundation of simplicity: neither party wanted to see its agricultural or manufacturing interests compromised by cheaper and perhaps superior competition from abroad. The *Dingley Act* of 1897 was the governing regime when Jusserand landed in America, and would be the focal point of his efforts to lower duties on would-be French imports to the United States: products like wines, champagnes and liqueurs, chinaware, gloves, hosiery, soaps, and perfumes. In a letter of March 1904 Jusserand complained to Hay about a variety of carefully placed obstacles, including new American packaging regulations, requirements for detailed identification of a product's contents, and a recent increase on the duty payable for imported French ribbon. Such measures, he suggested, were hardly appropriate for a country whose exports to France were twice the value of French imports to the United States.[49] But tariff policy is rarely one-sided. Throwing up their own obstacles to American imports, sometimes by special duties on cottonseed oil ("an exclusively American product"), sometimes by "microscopic" (another word for time-consuming) inspection of American pork products, the French government waged a quiet but relentless resistance against the restraints of the *Dingley Act*.

The Roosevelt government at last relented and made provision for France to enjoy minimum tariff conditions within the guidelines of section 3 of that act. Briefly put, that meant the duties on French champagnes would be lowered, as would those on American cottonseed oil. Ominously, however, this "arrangement," explicitly distinguished from a treaty, included an opt-out clause for either side: on three months' notice, the president could cancel the "arrangement," should he detect any new signs of French protectionism.[50] Concluded on a suspicion in January 1908, the new Franco-American arrangement was short-lived, as were its co-existing predecessors of 1898 and 1902. In 1909 the Taft administration formally replaced the *Dingley Act* with the *Payne-Aldrich Tariff Act*, a move which was better for France than the *Dingley Act* had been but was less accommodating than the recently negotiated "arrangement" of 1908.[51] In Paris there was a reaction of "deep astonishment" over the arbitrary termination of the 1908 accord, and open talk of a possible tariff war. In Washington Ambassador Jusserand sounded "decidedly warlike" beneath his professed opti-

mism that a new accommodation would be found. But Henry White, now American ambassador in Paris, still found his counterpart "full of resentment and ... talking angrily of reprisals."[52]

As it happened, there proved to be some substance within the optimism. After months of written and face-to-face negotiations with Philander C. Knox, Taft's new secretary of state, and with the president himself, Jusserand could see new undertakings emerging, particularly after he had promised yet one more detailed summary of the French position on the condition that Knox undertook to read it personally. In mid-March 1910 the American public learned that the *Payne-Aldrich Act* would be modified along the lines of the 1908 alteration of the then-defunct *Dingley Act*. France would be allowed into an inner circle of foreign countries that would enjoy minimum tariffs on certain select products.[53] Only for a while, as it turned out. Less than three years later Jusserand was back at the White House, which was now occupied by Woodrow Wilson, and the State Department, now presided over by William Jennings Bryan, to discuss the seemingly endless issue of tariff policy and to raise again the spectre of French retaliation.[54]

The long and drawn-out process that governed the creation and periodic renewal of a Franco-American arbitration treaty was symptomatic of relations between the two countries in general. Ongoing abrasions over trade practices and import duties there may have been, but the desirability of having an arbitration agreement to help avert conflict over political differences seemed obvious to both sides. In principle, and with caveats. Jusserand had not been in the country a year before he was recommending such a measure to his minister, Théophile Delcassé. While relations with the United States in 1904 were generally amicable, their external policy betrayed a strong aggressiveness, which sometime in the future could complicate relations with the Third Republic. A month later Jusserand proposed such a treaty to the State Department, one modelled after an Anglo-French agreement of the previous year.[55] In November he and Hay signed an arbitration treaty, subject to the approval of the American Senate. Such approval was not forthcoming, and delay followed delay, until a new, if "weaker," version of the treaty was concluded in 1908 with Secretary of State Elihu Root and approved by the Senate for a five-year term.[56] In that interim, new but futile efforts were made to replace the treaty with an improved version. Instead, it was renewed for five years on the eve

of its expiry in 1913.[57] In all, a decade's worth of negotiations had demonstrated not only the sustained good intentions of both nations but also the concurrent difficulties of securing agreement on ways to avert trouble over disagreements.

Curiously, in Jusserand's first decade in Washington, agreement was more easily reached on three international trouble-spots, the Caribbean, the Far East, and North Africa. The first revolved around Venezuela's General Cypriano Castro, an eccentric nationalist in the eyes of some, and "an unspeakably villainous little monkey" to others.[58] But if it took brilliance to offend at one and the same time Belgium, Colombia, France, Germany, Britain, Italy, Mexico, the Netherlands, Spain, Sweden, and the United States, Castro was brilliant. Between 1902 and 1908 he antagonized the governments of all these countries – and their moneyed supporters – by restricting their economic and financial activities in Venezuela, and by seizing some of their assets. Central to France's grievances was the cancellation of the French Cable Company's concession in Venezuela, and central to those of Washington were seizures of American assets from asphalt production and shipping. By December 1905 Jusserand – who spoke sarcastically of the "peerless, matchless and ever victorious Castro" – was discussing the possibility of a direct French military intervention and getting a green light from Roosevelt on the understanding that any French occupation of Venezuela would be brief and impermanent.[59] In fact, logistical considerations, combined with greater concerns over North Africa, militated against aggressive action in 1906. But the Americans were losing patience with the obstructive general, though not quite as quickly as the Dutch, who in the summer of 1908 sent several naval vessels to strengthen their position in the Caribbean and, by this show of force, to oblige Castro to address their own claims against his government.

By this point it had become clear, as one newspaper framed it, that either the general had to be made to recognize international law or he had to "be ignored as a pest whose power for harm [was] not great."[60] As it turned out, neither occurred. A medical condition requiring treatment in Europe, together with a surfeit of self-confidence, led Castro to leave Venezuela voluntarily in November 1908. To no one's surprise but his own, he was never allowed to return to Venezuela and to power.[61] Looking back, he

and the crisis he had provoked were tiny tempests in a teapot. For France and America, however – for Jusserand and Roosevelt – they offered opportunities to extend their accord from history and literature to contemporary politics.[62]

The Far East and the Russo-Japanese War proved even more beneficial from a Franco-American perspective, although the president and the ambassador were not of one mind at the outset. Neither had been sufficiently distracted by the early antics of General Castro to have missed the storm clouds gathering over rival Russian and Japanese claims to Korea and Manchuria. By October 1903, with war on the horizon, the president was dead-set against the Russian cause, while the ambassador understood full well that Russia remained France's most important ally in Europe. Struck by Roosevelt's animus toward the autocratic Russian state and its czar – whom the president called a "preposterous little creature" – Jusserand still thought he detected some presidential misgivings about Japan's growing power in the Far East.[63] Few were in evidence in February 1904, however, when Japan declared war and immediately went on the offensive. The combination of presidential admiration of Japan's military and naval efficiency, his hostility toward the eastern European empire from which so many recent American immigrants had fled, and the anti-Russian sentiments expressed by the bulk of the American press, represented a challenge to an ambassador on mission. Acting on his own initiative, Jusserand tried to put the best possible face on Nicholas II, a man whom he knew and whom he reckoned to be "passionate about truth," and "contemptuous of any lie." As for the Japanese, one could hardly deny the brilliance of their attacks, although who could tell, he wondered aloud, face-to-face with the president, what implications there might be, for example in the Philippines, if Japan in the future acquired "absolute preponderance" in the Far East.[64]

Jusserand, it should be said, did not underestimate the challenge in the person of Roosevelt. One year after their first meeting, he understood that the president was a remarkable combination of the cerebral and the impulsive, a learned man who claimed not to read the newspapers, a man whose behaviour was difficult to anticipate, who drew his conclusions quickly and to whom second thoughts did not come easily.[65] In the president's opinion, Kaiser Wilhelm II, while erratic, "immeasurably vain," and inclined to ingratiate himself through flattery, was a man of energy and action, a happy

contrast to his dithering but repressive cousin the czar of Russia. As for France, Roosevelt had a genuine vein of sympathy for its people and history, but still needed to be educated and disabused of the commonly held ideas that French literature was ill-disguised smut and that French vitality had dissolved into decadence. Thus, from the ambassador's perspective, in 1904 he was working with a head of state who quite liked the Germans and the Japanese, quite disliked the Russians, and was on edge about the French.[66]

By the autumn, however, with Japanese victories having mounted through the summer, the president was showing some signs of rethinking: "une sensible modification."[67] Impressed as he was by Japanese *élan*, dismissive as he was of what he considered Russian incompetence and lies, he had to acknowledge that a new power was potentially arising in the Pacific, bringing a new justification for the enlarged navy Roosevelt was determined to build. Indeed, Ambassador Jusserand reinforced the president's apprehension, observing that a Japanese victory would have a great impact on the psychology of all Asians. "Up to now," he had pointed out to Roosevelt, the strength of the white race had been the ability to play upon Asian lack of confidence.[68] With whatever encouragement, by late 1904 the president was discreetly urging the Japanese to end the war with peace terms the Russians could accept; and by the spring of 1905 he was working with Jusserand, and through him with the French foreign ministry, to urge reasonableness and compromise on their Russian allies. Indeed, just at the time when the State Department was in early transition from John Hay to Elihu Root, the French ambassador was called upon to help draft more Russian-sensitive American despatches destined for St Petersburg.[69]

Indeed, with Roosevelt's encouragement, the French ambassador was active on several fronts, as well as from two continents. Prior to leaving for his annual vacation in France at the end of June 1905, he was in frequent contact with the president, partly about developing concerns over Morocco, and certainly also about a strategy for getting Russians and Japanese to agree on peace terms; and it was no secret that his government was doing what it could to bring the Russians to the table.[70] At the same time, Jusserand had several talks with Ambassador Takahira in Washington, almost certainly along the lines of a confidential letter that he had prepared in France and sent to the Japanese government in August. Currently, he said, Japan was respected for her ambitions and for her military

and naval prowess, but her demand for a massive financial indemnity from the Russian government would sour public sympathy for the emperor's regime. More than that, since the czarist government would not, and could not, pay anything like the $600,000,000 then at issue, fighting would resume, the war would be extended, and the cost to Japan alone would be comparable to the proposed indemnity. A day later, Jusserand took to the Quai d'Orsay a telegram from Roosevelt in which the president urged more French pressure on the Russians and undertook to do what he could to reduce Japanese demands for financial indemnification.[71]

Ultimately, the pressures and persuasion applied by French and Americans to both sides played a role in getting the Russians and Japanese to the negotiating table and in producing what became known as the Treaty of Portsmouth. It was not, of course, the work of two men, or the product of anything like a singular or static motive. But whatever the limitations of this abbreviated account of war and peace, it should be clear that the president and his friend the ambassador had reason for satisfaction when the treaty was signed in early September 1905. The president was to receive the Nobel Peace Prize for his role in the affair. Jules Jusserand quite rightly received much less public acclaim than the American head of state, but his service did not go uncompensated. His willingness to cooperate with the president, to urge his own minister to bring the Russians to reason, and to initiate his own talks with Japanese diplomats all confirmed Roosevelt's estimation of him as a man who could be relied upon, who could be trusted. Since the same four months of intense diplomatic activity over the Far East, May to August 1905, coincided with the escalation of what came to be called the Moroccan Crisis, having the American president's gratitude was no small recompense. Nor was it a small investment in an affair potentially more dangerous to French security than the Caribbean or the Sea of Japan.

This was an affair in which Morocco was but a symptom of a potentially dangerous malady. By 1905 the Sultanate of Morocco had slowly been falling under the sway of French interests based in neighbouring Algeria as well as in the *Métropole*; and by then, too, the Third Republic had negotiated tacit recognition of those interests by reciprocal recognition of English interests in Egypt, Italian interests in Tripoli, and Spanish interests at the northern tip of Morocco. At the end of March 1905 Kaiser Wilhelm made a

surprise visit to Tangier, where he asserted the presence of German economic interests in the region, the single remaining territory in northern Africa that had even a nominal claim to autonomy from European powers. In short, it was a rival bid that raised the spectre of a new clash between the land and naval forces of France and Germany, perhaps initially on the southern slopes of the Mediterranean, perhaps subsequently closer to the Rhine. For that reason bilateral talks became imperative, talks that would legitimize either the French or the German claims to Moroccan resources, or would find some compromise between them. It was also clear that resolution of the first option, that is to say vindication of one side over the other, would involve a public loss of face to the disappointed party.

While the Tangier incident itself was as much of a surprise to Jusserand as to anyone else, there was nothing new in the Germans' behaviour. From Washington, as from London, he perceived the kaiser as a man of excess, flamboyance, envy, and dangerous ambition. From Washington, Roosevelt detected something else. Beneath the bluster was fear, fear that England would try a pre-emptive strike against the embryonic German navy, perhaps in some kind of combination with the French.[72] From Paris, whatever the kaiser's motives, the question was how to scotch his ambition in Morocco without provoking a recourse to arms. In that aim, Roosevelt concurred. In response to the German government's insistence upon resolving these rival claims by international conference, the president determined on the role of publicly impartial broker, but with a secret "intermediary," as he put it. He made it clear to Berlin that he would not support its bid for a conference unless the French were prepared to accede to that demand. He made it clear to Paris, via Jusserand, that a conference might be the most prudent course of action for the Third Republic. By mid-July 1905 both governments had agreed to the principle.[73]

Then came the spadework. The kaiser, whom Roosevelt in private exchange had taken to calling "our friend" and Jusserand "our fiery friend," objected to the French appointment of M. Revoil as their chief negotiator, on the grounds of his former office as governor-general of Algeria. The French did not like the German insistence on Tangier as the proposed setting for the conference. Roosevelt remained patient, no mean feat, given the fact that he was entering the most delicate and trying stage of meetings with the Japanese and Russians, resisting with difficulty the urge to utter

"whoops of rage and jump up and knock their heads together."[74] By the end of September the Portsmouth treaty had been concluded, and M. Revoil reported a successful end to the Franco-German talks intended as prologue to the conference. By early April 1906, following three months of negotiations, the conference at Algeciras – not Tangier – had concluded very much on French terms, and in the interests of European peace.

From Washington, the president looked on with some pride and satisfaction at the defusing of a troublesome international situation, the more so as he knew his own role in its resolution would have been impossible without the assistance of two close friends: Baron Speck von Sternburg, the German ambassador, with whom he was "on close terms," and Jusserand, "one of the best men I have ever met ... and with whom I was on even closer terms." Both had been instrumental in discouraging their respective governments from taking too rigid a line on Morocco and thus, even from a distance, had served well their countries and the world. The president's friendship with both diplomats had been central to the success of their efforts. In the month of June 1905 alone the president had seen Jusserand on something like nine occasions, and there were times when he had privately handed the French ambassador German notes on the Moroccan issue – for the purpose of soliciting his advice – and, in the ambassador's physical presence, had dictated a letter addressed to the German emperor.[75] When all was over, Roosevelt wasted no time in writing a note of thanks to Jusserand, recalling the previous twelve months, which had brought them together in "peculiar intimacy" to address "more than one great problem." But you, he said, "more than any other man" were central to the escape from a Franco-German war; and that was so because the ambassador had managed to convince his government that accepting the German demand for a conference was consistent with France's interests and dignity. His own role, the president maintained, was conditional on "the entire confidence ... in your unfailing soundness of judgment and in your high integrity of personal conduct ... the two dominant notes in your personality." Rephrased, it seems clear Jusserand had endeavoured, successfully, "to leave the impression that to defend the French interest was to defend principle."[76]

Of the three great problems with which these two figures were involved in 1905–06, this last was potentially the most serious for

France. It also proved the least resolvable, for Algeciras did not produce much of a compromise, and thus did nothing to assuage German resentment. Encouraged by the show of international support that had emerged at the conference, including the backing of the American delegate, France continued to extend its interests and its grip on Moroccan territory.[77] Not surprisingly the German government grew more and more disenchanted until, again not surprisingly, it resorted to another dramatic gesture in July 1911. A gunboat appeared in the port of Agadir, a not so subtle way of demanding territorial compensation for France's slow conversion of Morocco into a *de facto* protectorate. For the second time in a few years the German penchant for theatre was confused with farce. Although new negotiations did yield some territorial opportunity in central Africa for the kaiser's regime, they did so only at the cost of its recognizing French authority in Morocco and witnessing a strengthening of French ties with Britain and Russia. Unknown to any in 1911, the stage was being reset, this time, not for Africa but for Europe, and not for farce but for tragedy.

In an account of these final approaches to World War One, the individual is at risk of being subsumed both by events and by office. There is reason, therefore, to return at this point to the man who was the ambassador, and to review the salient features of his character. He was no longer young, having turned fifty-nine years of age early in 1914, but visual evidence suggests that he had weathered well. Still slight of build and fit from walking and tennis – though with a peculiar leftward tilt to his head and neck – his "Edwardian" beard cut as precisely as his suits, if visibly greyer than it had been on his arrival a decade earlier, Dr Jusserand impressed people with an agility of both mind and body, a disciplined, controlled agility of one who swung a racket with the precision of a billiard player, and who did not indulge in fidgeting. There was one early report from St Louis to the effect that he gestured a good deal with his hands when he spoke, but that was countered by a complaint that he had kept his hands stuffed in his pockets throughout his entire speech. More certain were his vast knowledge of English literature and his mastery of the language, although years later British Ambassador James Bryce still found his accent "somewhat difficult to understand ... at a distance."[78] Equally certain was his emphasis on punctuality, and the impression he conveyed of personal dignity and appropriate decorum.

He was, indeed, an interesting mix of one who loved the city crowds of London and the palace crowds of Versailles, but thought it inappropriate that first-class accommodation should be demeaned by a view of immigrants in steerage, or that the diplomatic corps should ever have to use a service entrance. There was an "edge" to the man, especially when discourtesy or stupidity were at play, as they were it seems, all too often. Referring to a French visitor who had failed to contact the embassy before requesting a meeting with Roosevelt, the ambassador remarked parenthetically that such a *faux pas* "proves him more untutored than I would have thought." Worse, in his mind, was the harmless but humiliatingly unforgettable public crash of a French-built aircraft at Belmont Park, a casualty of an empty gas tank and manifest human error. Jusserand was also known within diplomatic circles to make sarcastic if private asides about American customs.[79] Publicly, however, charm was his hallmark. One journalist recalled the ambassador's declining a request for an interview, but doing so with as much poise "as if he had been giving out the most valuable piece of information in diplomatic history."[80]

Wit was most certainly part of that charm, not a wit "that hurts" but one of gentle repartee – the sort that might playfully link the occasional loss of tennis matches to certain heads of state with the occasional imperatives of diplomatic tact. Recalling a single afternoon with Roosevelt, first on the court, then on a run, and then in the gym, when asked what he wanted to do next, the French ambassador said he would prefer "to lie down and expire." It made more sense than his reply to another presidential question, this one posed on the banks of the Potomac. Why, Roosevelt had asked, when he, Jusserand, and General Woods, were all stripped naked for a swim, was the ambassador still wearing his black kid gloves? Famous, and teased, for his sense of propriety, the diplomat had replied: "Oh, I feared we might meet some ladies."[81]

Charm, gentleness, and good humour were all entwined within this man, to whom animals were also drawn – the abandoned "Turc" in Paris, the London street cat, and the stray dog he rescued one night outside Washington's fashionable Riding Club. Dressed in evening clothes and top hat, a liveried servant holding open the door to his carriage, the ambassador had stooped to retrieve the apparently homeless "small yellow dog," entered the carriage, and proceeded home to the embassy.[82] Animal reactions to him were no more uniform, however, than those of humans. "Pete," an irascible

bulldog of White House residence, had been another matter, an animal that had treed the ambassador on the presidential grounds. Dressed for tennis, "in a stunning flannel outfit," the diplomat had to be rescued "by several sturdy policemen." Long joshed about the encounter with the repeat offender, and long known for using exaggeration as a device for humour, it took the diplomat three years before making a diplomatic effort to exonerate the canine miscreant. The dog, he told a New York audience, with fingers crossed, had been a perfect gentleman and utterly without defect. Indeed, "he does not drink, smoke, or possess any vice or bad manners."[83]

Although Jusserand was often in the public eye, one has a sense that he became accustomed to it rather than at ease with it. For he remained a very private man and seemed determined to protect a private life. His posthumously published memoirs, for instance, are sometimes as revealing for what was left unsaid as what was said. His siblings are unnamed and their adult lives ignored, quite in contrast to the private and sustained interest he took in them. Ever the obedient if sometimes impatient public servant, he kept his responses to French domestic politics muted in print. One could not guess from *What Me Befell* whether, as appears to have been the case, he was a practising Catholic, although he was not obviously at odds with the government's insistence on the separation of Church and State.[84] One unidentified Washington photographer found him photogenic, but remarked that "he dislikes being photographed. There are fewer pictures made of him than of any other diplomat."[85] The earlier-mentioned reluctance to give press interviews may have been related. Certainly, it seems to have endured, especially in regard to interviews seemingly calculated to detect differences between his own views and those of his government. For there remains far more in the American press about his books than there are insightful pieces in that press on the man who wrote them.

The same is doubly true of Mme Jusserand: her post-1895 presence in her husband's memoirs is certain but her personality is left almost without remark. Informed and intelligent by conversation, stately and reserved by deportment, devout in her converted Catholic faith, she seems to have been a "lady" by temperament and upbringing.[86] Not a woman of dramatic gesture, of school-girl giggle or matronly belly-laughs, of language loud or coarse, of dress immodest or flamboyant, she, like so many others of her class and circumstance, was expected to facilitate her husband's mission by

playing a role that prized tact, mastery of protocol, and disciplined elegance, and forsook what was boisterous or could feed suspicions of "loose" or indiscreet behaviour. In annual reports, the British embassy found her to be "singularly charming and amiable," rather like the Russian ambassador's wife, who was "kindly and agreeable," skilled practitioners both of "tea cup diplomacy."[87] All this was well-intentioned praise for its day, but teeters on the vacuous for our own. Fragments of such diplomatic text, including her husband's memoirs and his voluminous correspondence, together with the occasional photograph, offer momentary flashes of Elise Jusserand. But flashes only, nothing intimate of him to her, or from her to him, as if, correctly enough, we had no right of entry.

Nor, it seems, did the press. She might inspire a headline like "Mme Jusserand Attracts Attention," but it was for her "carefully cut coat suit," her lace blouse, and feather boa, always trim as if she had just left the ministrations of her maid. On rare occasions the ambassador's constant travelling companion might say something in public – about the landscape of the Far West, the smoothness of the roadbeds, the clarity of the air – but of the woman inside, very little was seen or perceived.[88] If anything, Washington journalists may have collaborated with the embassy in keeping her life as private as possible. It took seven years in America before they revealed that she was popular, and had a wide "circle of admiring friends." In the eighth year there appeared a short report on the exquisite Christmas gift she had purchased from Paris for a child connected to the embassy. By the ninth it was being said that she had "great personal influence in Washington society;" and by the twelfth, that she was "easily the most successful hostess" of any Washington salon. But for her, and for the American public, there was nothing even approaching the feature articles and photographs that appeared in the *Washington Post* between 1903 and 1907 on her diplomatic counterparts: England's Lady Durand and Lady Bryce, Austria's Baroness Hengelmuller, or Germany's Baroness von Sternburg. Nothing of substance for the French Republic's untitled Madame Jusserand.[89] Was it a matter of an aloofness inspired by shyness? Was it a matter of personal choice, of ministerial preference, or some combination of all? Of that, we shall never know.

Fortunately, we are better able to trace the contours of Jusserand's diplomatic strategy in the course of his first American decade and, therefore, on the eve of the next great European war.

The mission was permanently charged with maintaining good and better relations with the United States of America. To do that meant keeping abrasions, economic or political, to a minimum, and meant ongoing efforts to extend the grounds for cooperation and the reasons for mutual admiration. To accomplish that, Jusserand was always polishing the image of France, not a self-indulgent France of racy novels, alcoholic excess, and military defeat, but a disciplined and cultured France which, like him, had been hardened in the crucible of the 1870 defeat. Indeed, he was wary of awarding too much emphasis to France's cultural finesse as a "dangerous compliment" capable of minimizing other facets of her genius, including her talent for war. Jusserand, so Roosevelt recalled to Sir George Trevelyan in late 1911, tells me that the French "pride themselves upon being a military nation, and admit to no military inferiority to any people, no matter [their] proficiency in all that tells for grace and refinement of life."[90]

The latter proficiency, to be sure, was as central to the life of Jules Jusserand as it had become an institutional mantra for men of his generation within the Quai d'Orsay. Reminding the world of France's contributions to western civilization, and teaching those who had yet to learn, were fast becoming favoured devices in the French government's global competition with German *Kultur*. Admiration and respect for French genius of all forms were calculated to seed the ground from which political and economic amity might grow. That belief, certainly, was behind virtually all of Jusserand's public addresses, which recalled with genuine if constrained pride the many forms in which French ideas, art, literature, philosophy, and science had developed in America. And not uncommonly in reverse. "When you go to Paris you will find a boulevard named after Franklin, a street named after Washington, and a street named after Lincoln."[91]

The manner in which this was to be done was perfectly clear to Jusserand. The ultimate answer was: subtly, gently, and indirectly. The initial answer was: sometimes alerting, and sometimes silencing, the most inattentive and clumsiest of one's own countrymen. The ceremony at Annapolis celebrating the service of French soldiers and sailors to the War of Independence was largely ignored in France, he complained. Even the semi-official newspaper *Le Temps* treated it as a "curiosity piece ... in small print." This was partly the work, or lack thereof, of the Agence Havas, France's official news agency,

which typically doled out American news in "negligible quanti-
ties."[92] Silence, however, sometimes had its advantages. It really
was not very helpful to the embassy in Washington to have a Pari-
sian press revelling in the alleged contrast between French idealism
and American materialism, or to have Roosevelt's safari repre-
sented as a massacre in Africa, or American women as selfish des-
pots.[93] Nothing was better calculated to attract the eye of an
American press anxious to see how their country was viewed
abroad.

Still, eliminating the negative had to be matched by accenting the
positive. Discreetly. By 1911 Jusserand had become cautious about
the practice of distributing French honours to American citizens of
distinction, partly because he considered such decorations by for-
eign governments to be contrary to American law, and partly
because they fed suspicions of influence peddling, or rather the per-
ception thereof.[94] Similarly, while he believed implicitly in the desir-
ability of having Americans speak for France, thus limiting the
chances of the embassy being fingered as France's official propa-
ganda agency, he had reservations about the momentary prolifera-
tion of francophile organizations in the United States. It was
important, he said, that the new French Institute in New York
would develop its programs in ways that were compatible, and not
competitive, with those of the Alliance Française and the Comité
France-Amérique.[95] But ultimately, he stressed from the beginning
of his days in Washington until his death, the image of France, the
reputation of France, rested with Americans who had been touched
in some way by French genius.[96] It could not be done by France's
official representatives, who were only facilitators at best. It could
not be done by purchase. It could not be done overnight, the prod-
uct of sudden media blitzes and infusions of gold. Such was the
belief system with which France's ambassador to the United States
approached the advent of World War One. Whether it could be sus-
tained in wartime against the more overt and richly financed efforts
of Kaiser Wilhelm's regime remained an open question, as it did for
years to come.

3 Cautious Seduction (1914–1917)

War among the European powers seemed improbable in the spring and early summer of 1914. Tensions, rivalries, resentments, fears were there in numbers, as they had been for several decades; but none but the most prescient anticipated the crisis around the corner. Washington, like Paris and Berlin, was tranquil, its streets animated by people out for a carriage or street car ride, for a stroll, or for amusement. Compared to New York, it was still a "small town," hovering around half a million people, a capital with only two grand hotels, the Willard and the Shoreham, and no nightclub. For the younger set, including members of the diplomatic corps and the corps of *débutantes*, there was St Mark's, Rauscher's, and the exclusive Chanticler Club for lunches, teas, dinners, and dancing. For the even younger, there was Huyler's restaurant, famed for its chocolate ice cream sodas, at 11th and F streets. On Saturday afternoons, in Peacock Alley at the Willard, truly chic and aspiring-chic schoolgirls came together over damask covered tables to savour the range of teas and French pastries. Outside, en route home they might well spot sleekly tailored foreigners of distinction, themselves out for a stroll: Constantin Brun of the Danish embassy, always in glistening top hat, walking stick in hand, twinkle in eye; or Ambassador Jusserand, more pensive, on one of his twilight walks from the embassy at 2460 16th Street down into Rock Creek Park.[1]

Pensive, but not agitated; on the contrary, a man at ease. So it was that in late June, on the very eve of the crisis to come in the Balkans, the Jusserands did what they had been doing ever since their first summer in America. They set sail for their annual two-to-three months' vacation in France, this time on the liner *La Savoie*; and as

usual, in their absence the embassy closed its Washington gates and, like the Austrian diplomats, its staff fled the heat of the city for the fresh breezes of Manchester on Massachusetts Bay. The German ambassador, Count von Bernstorff, for his part, was also looking for refuge, and not only from the heat. That June, on his way to speak at the University of Illinois, his speeding vehicle had actually been shot at by an over-zealous traffic officer in Champagne, an incident that prompted an editorial about "Fools with Deadly Weapons." Presumably safer, and certainly cooler, the ambassador – recently described as "an enthusiastic motorist" and owner of multiple cars – took up summer residence in Newport on Rhode Island Sound, not far from the Russians' summer embassy.[2]

This recollection of a summer still innocent of war, and of a diplomatic community still at ease, offers a brief reprise to Jules Jusserand's first decade in the United States. It was a decade, very simply put, that was characterized by a developing Anglo-French *entente*, and a static Franco-German *mésentente*. Predictably, therefore, the French ambassador was more positive in his appraisal of his British homologues than he was of the Germans. He seems to have personally liked Sir Mortimer Durand – Britain's first representative with ambassadorial status in America – and in December 1903 remarked on how well the new arrival and President Roosevelt had got along at their first meeting. Their congeniality, Jusserand thought, was due to Durand's closing remark, "with God's help," a plea that had pleased the president, who responded with his own invocation of their mutual "reverential trust in the Almighty."[3]

But the pleasure was brief. Despite some excellent diplomatic and intellectual credentials, for he, too, was a published author, Durand soon fell out of Roosevelt's favour. Despite a "superb physique" and a "love of outdoor exercise," he faltered on the president's wilderness endurance runs, deprecated the "unkempt" condition of America, and complained of the "impossible" attitudes of American servants. Almost from the start, therefore, he was compared unfavourably both to his predecessor, Sir Michael Herbert – whom Roosevelt had tagged with the affectionate nickname "Mungo" – and to "Springy," Sir Cecil Spring-Rice, Roosevelt's close friend and preferred choice as British ambassador. Largely because of this presidential antipathy – which inspired his private branding of Durand as "a creature of mutton-suet

consistency" – the ambassador was pulled into retirement in the autumn of 1906 and replaced, not yet by Spring-Rice but by James Bryce, a scholar, mountain-climber, and former cabinet minister.[4]

The Germans, too, had known Roosevelt's displeasure, though soon after, his satisfaction. In January 1903, in an effort to please a president on edge about European incursions in the Caribbean, particularly with respect to Venezuela, Kaiser Wilhelm had chosen Baron Speck von Sternburg to serve as an "extraordinary" ambassador within the Washington embassy of Ambassador Theodor von Holleben.[5] Had the kaiser's manoeuvre not been so professionally insensitive – von Holleben had to endure several humiliating months before being recalled in April – and had not the strategy been so obvious, the choice might have seemed brilliant, given Roosevelt's respect and affection for "Speck." That was why the German diplomat had been asked to return so precipitately to Washington, and why he had been accorded the "extraordinary" title until being raised to the official rank of ambassador in August 1903.[6] It was then that he presented his full credentials, not at the White House, but at Sagamore Hill, the president's country home in Oyster Bay, at the first such ceremony held outside Washington. After the presentation, the two "old friends conversed animatedly. The president was openly delighted."[7] Another of his new friends was not. The French ambassador regarded this fellow new arrival with a mix of disdain and resentment.

The German, a wealthy, gregarious man married to an American, had impressed the president with his intellect, his charm, and a horsemanship refined in the kaiser's Hussars. Jusserand respected and disliked him in equal measure. Von Sternburg, so Jusserand reported, exploited every public occasion to spotlight himself and Germany, almost daring fellow diplomats to compete in such "ridiculous" expressions of "rivalry."[8] Fluent in English, "with hardly an accent," von Sternburg found it easy to please an audience with catchy phrases like "No great nation can escape the penalty of greatness." What differences there might be between Germany and America, he claimed, were merely the products of "misunderstandings"; not so, Germany's differences with other powers. In a veiled reference to the French empire he suggested that Germany did indeed have an "African problem, but it is not in Africa." More brightly, he assured the world that the kaiser was a

"genius," very much like Roosevelt, a "writer of plays," a creative but benign painter of pictures.[9]

In the face of such public massaging, Dr Jusserand determined to say as little as possible, not only on grounds of temperament but on those of calculation. Von Sternburg had a close relationship with Roosevelt, he had somewhere between two and three million German-American voices behind him from an American electorate of some twenty million, and he obviously had an entertainment budget generous enough to support the many social events that were taking place in his newly refurbished embassy.[10] Indeed, compared to the degraded facilities of the French embassy, the German embassy looked like "a fairy palace." Nonetheless, the ambassador assured his minister, there were risks that went with too much spending and too much talk. Diplomacy was a profession that depended on restraint and discretion more than public posturing. That was why he, personally, did not go overboard with public addresses, why he declined many invitations to speak, and why he avoided any occasion that seemed designed to stage a jousting match between ambassadors. At the same time, he made it clear to Paris that its relative parsimony, compared to Berlin's generous allocations, made restraint the handmaiden of necessity.[11]

Although that imbalance was destined to continue for years, one of the critical factors in diplomacy of any kind was about to change. In August 1908 Baron Speck von Sternburg died after a year's struggle with cancer and was succeeded as ambassador by Count Johann Heinrich von Bernstorff, the once-young diplomat with whom in 1890 Jusserand had played tennis in Constantinople. Two decades later the competition had grown more serious. The kaiser seemed more intent than ever on winning the admiration and affection of the United States; and his new agent in Washington was expected to continue the public courting for which his predecessor had become celebrated among Washington's elite. Indeed, when he arrived in the District of Columbia with his American-born wife in December 1908, he announced that they would be staying in the Shoreham Hotel for some months, while the embassy was again "refurbished and completely overhauled."[12] And the ambassador had other resources to work with; his wife was from the wealthy Luckemeyer family of New York. He was tall and handsome, athletic in build and movement, a cultured man with a fondness for

classical music, a diplomat who was quickly known for his easy charm, unflappability, and total accessibility to members of the press.[13] All these he recruited for his mission to America, and immediately set to work.

Within a few weeks of his arrival in Washington he was in New York reading to a business audience the kaiser's assurances that for two hundred years Germany had observed an "unbroken fidelity" to her friendship with the United States. Then it was to Chicago, and an address to a national peace congress, in which he announced the resumption of negotiations for an arbitration treaty with the United States, and made a point of correcting, downward, the published number of new Dreadnoughts that the German navy hoped to have operational by 1912. Then to Baltimore in May, where he greeted officers and crew of the cruiser *Bremen*, to whom he confessed his joy on seeing it flying the German and American flags, as well as being saluted by its guns in Baltimore harbour. Then to Philadelphia in November, where he told the American Academy of Political Science that Germany had no further territorial ambitions but wished to concentrate exclusively on commercial competition, an assurance that had made him unpopular in nationalist circles at home. Then back to New York, where he promised a student audience at the College of the City of New York that they would be cordially received by their "German cousins," and attributed the "free institutions" with which they were so familiar to the "customs that prevailed in the German forests." A year later, again in Chicago and again on the subject of armaments, he went so far as to assert: "Small armies mean warfare; large armies mean peace."[14] Always the same: German-American amity, cultural affinity, peaceful intentions.

These were hardly the kind of messages to which the French embassy could object, especially when it was pursuing a similar strategy. Indeed, by no coincidence, the French government had been running a foot race with its German rival for well over a decade, and employing similar tactics to those being refined by von Sternburg and von Bernstorff as they courted America. This in itself is another reminder of the fact that these agents, Jusserand included, were nothing but official spokesmen for their respective national governments and, more particularly, for their ministries of foreign affairs. Since this was very much a symbiotic relationship, with master dependent on servant's skill and obedience, and servant

correspondingly dependent on clear instructions and the provision of adequate physical resources, there is reason to explore more closely the ministerial system within which Jusserand operated, as well as the expanding bureaucratic structures that so often aroused his ire.

When Jules Jusserand entered the service of the foreign ministry in 1876 there were fewer than a hundred ministerial employees at the Quai d'Orsay. Apart from a small handful of people who worked in the minister's personal *cabinet*, the majority worked in one of four operational *directions*. However indispensable their services, certainly the least prestigious were the administrative directorate (Chancery and Archives) and the financial directorate (Funds and Accounting). The most prestigious was the directorate of political affairs, to which only candidates with considerable money and elevated connections needed to apply for diplomatic service. No higher than second place came the directorate for commercial affairs, to which the consular service belonged. It was the latter's entrance examinations that Jusserand had passed so brilliantly, and whose service he had first entered. The 1880s he spent in London with the consular service; in Paris, with the minister's personal secretariat; in London at the embassy, following his transfer from consular to diplomatic service. By 1890 he was back in Paris, this time with responsibilities for Northern Europe, and with the rank of assistant director within the directorate of political affairs. By then, in the course of the previous decade, several structural reforms had been implemented, notably the introduction of a new *sous-direction* for North America – the first-in-line recipient of any despatches from Washington – and the creation of a new *service* within the minister's own offices for attending to relations with the foreign and domestic press.[15]

In 1907, four years into Jusserand's mission to Washington, there was another major overhaul of the French foreign ministry, all designed to help the government better cope with twentieth-century international relations. As a testament to a heightened awareness of trade as an instrument of international power, the government turned two of its four long-standing directorates into one, a single *Direction des affaires politiques et commerciales*. Henceforth, embassy and consular reports from the same geographical provenance would be sent to the appropriate regional *sous-direction*. Moreover, each of these sub-directorates was to be allocated its

own commercial, financial, and legal specialists, an important
development which at one and the same time acknowledged the
necessity of having in-house expertise, and quietly increased the
number of ministerial bureaucrats. So, too, did the advent of two
new departments, one for translation, another for geography, two
genres of expertise required by any country with global interests
and pretensions. Two other innovations completed the Quai
d'Orsay's administrative renovations. In 1907 the press service was
transformed from an agency of the minister himself into a truly
ministerial Communications Bureau that was responsible for all
liaison with French and foreign media. And 1909 saw the appear-
ance of a *Service des écoles et des œuvres françaises à l'étranger*, an
office made responsible for all educational and cultural liaison with
the world outside France – or, as some considered it, for French
propaganda abroad.

All these changes reflected a trend toward specialization – from
linguistic and geographic to legal and financial – and they constituted
a firmer institutionalization of the conduct of foreign affairs. At the
same time they brought a more complex in-house competition for
funding, and in-house resentments between traditionalists and inno-
vators. Though a traditionalist in many ways, even Jusserand com-
plained of embassy personnel who had not learned to type. "It's like
sending me someone who does not know how to write." Slowly,
therefore, but inexorably, the days of the pen, whether quill or steel,
were giving way to the machine and the telegram, the carriage to the
automobile, the ancient classical tongues to modern language, the
educated amateur to the trained professional.[16]

Neither education nor training, however, proved an adequate
defence against the forces that were gathering in the summer of
1914. A single agent on a large and distant continent, Jules
Jusserand had more to contend with than the expanding bureau-
cracy and changing personnel in Paris. Far above the world of the
capital, a world much larger was showing its cracks. Less than a
year earlier, in October 1913, Jusserand had had a remarkable pre-
sentiment of what might be in store. If there was to be a war in
Europe, "inevitably" it would be a "long" one. Americans would
stay aloof from it, unless they could detect within it a great moral
cause, for beneath their pragmatism and their materialism ran a
deep vein of religiosity, humanitarianism, and mysticism. And
Wilson was sure to play a major role in any peace conference, as

Roosevelt had done to conclude the Russo-Japanese war in 1905.[17] By the summer of 1914, however, great power rivalries in the Balkans, especially between Austria-Hungary and Russia, had become central to the issues of war and peace. At the end of June, as the Jusserands were en route back to France and their vacation, the heir to the Austrian throne was assassinated in Sarajevo. Vienna needed less than a minute to conclude that the act had been instigated by Serbia, an autonomous Slavic kingdom, an enduring thorn in Austria's side, and a de facto ally of Russia. Resolved to humiliate the Serbs, and eventually to crush them, the government in Vienna declared war, but took no direct action. The Russian government, intent on sparing the Serbs, on sparing itself public humiliation, and on deterring Austria from war, announced the mobilization of its large but ponderous army – not to commence war, but to avert it, an intention badly understood in Berlin where the nightmare of a two-front war was taking shape.

Committed to defending Austria against its most probable foe, Russia, and committed to a military strategy designed to avoid a two-front war by knocking France, Russia's ally, out of the war by a powerful offensive in the west, the kaiser's government became a prisoner of its own logic. On 1 August 1914 it declared war on Russia, and two days later started its attack on France via the poorly defended neutral territories of Belgium and Luxembourg. By 4 August, all the European great powers, with the exception of Italy, were at war: Germany and Austria-Hungary, in what was called the Dual Alliance; France, Russia, and Great Britain, in what was called the Triple Entente.

While men were about to start dying in Belgium and northern France, Ambassador and Madame Jusserand were trying to get back to Washington. On 28 July they had booked passage from Le Havre, only to find out a few days later that the ship was being requisitioned for military purposes. Given the absence of berths out of France, they set their sights on London in the hope of securing passage from England. More delays had followed, some occasioned simply by the shortage of vehicles to get them out of Paris. In the end, on 3 August, Jusserand, his wife, and two servants made it to the coast courtesy of an automobile lent by a sympathetic American, and soon reached London. There, with most of their baggage discarded in the interests of the exodus from France, and very short of money, they were welcomed by old English acquaintances and

bailed out financially by another generous American friend. There, too, with the assistance of Walter Page, the American ambassador to England, they were able to book passage out of Liverpool on the American ship the *St Louis*.

After the better part of two weeks in England, the Jusserands were underway for Washington, their ship slipping out of port past a star-crossed vessel named the *Lusitania*. They were accompanied by the British ambassador, Sir Cecil Spring-Rice, James Bryce's successor as of 1912, who was similarly anxious to return to his embassy. Their names, however, did not appear on the ship's passenger manifest. Cautioned by the ship's company against identifying themselves in wartime, lest they and the vessel become an enemy target, the three travelled under pseudonyms: Spring-Rice simply as I. Rice, the Jusserands as Mr and Mrs John Jacob Jewett (again the *trois Js*). But that was the least of their difficulties. The diplomats were each put in second-class, interior staterooms with three other men, Elise with three other women. The air was poor, the lighting comparable, and the funnel-heated room close to 100 degrees Fahrenheit. Too uncomfortable to sleep on this "voyage un peu rude," Jusserand spent several nights on deck, fully clothed, politely declining Spring-Rice's proposal that they alternate between his own, somewhat more comfortable quarters, and the oven-like room assigned to the French ambassador. Still, the discomfort was brief, and far removed from the conditions in Belgium and in Alsace and Lorraine, where battle casualties were already mounting. On 22 August, two days before von Bernstorff's return from Germany, they landed in New York, their spirits revived, partly by the end of the voyage itself, partly because a customs agent had approached Jusserand saying: "We're supposed to be neutral, but you know full well what we think." And so he thought he did. Writing a few months later to Dr John Finley, president of the University of the State of New York, Jusserand acknowledged the "neutral *cuirasse* which every American has been asked by the President to don during the present war."[18]

One week later, with the German army now across the Somme and driving for Paris, an incident in front of the White House testified to other thoughts. As Jusserand's carriage footman was waiting for him under the portico, a cyclist from the German embassy arrived. "Unpleasant remarks" were exchanged, and the two, "swelled up like pouter pigeons," glared menacingly at each other.

They could hardly have felt their patriotism more strongly than the
ambassador himself. Disdain for von Bernstorff's bent for publicity
had turned to white hot anger, tempered only by a satisfaction that
the German's "obvious lies" and "playful banter" were not work-
ing. Not after Louvain, the undefended Belgian city, had been
shelled and torched by the German army. Not after Berlin's repre-
sentative had publicly proclaimed his country's cause "just," por-
trayed Germany as the victim of a "frivolous and unwarranted
attack," and tried weakly to defend German "barbarie" by remind-
ing Americans that war could not be conducted like "five o'clock
tea." Most of the American press, Jusserand reported, had now
turned against Germany and was deaf to its agents' attempts to jus-
tify its actions.[19]

Such was the tenor of Jusserand's reports to the end of 1914, as
France fought for her life on the Marne, and slowly settled into a
new kind of war against the invaders, a war of trenches, along the
Aisne, the Argonne, the Moselle, and in the Vosges. Gone was any
sign of scholarly detachment, any inclination to examine impar-
tially the causes of this war. For Jusserand, and certainly for most
Frenchmen, the answer needed no question. In mid-September, in a
confidential despatch to fellow believers in Paris, the ambassador
raged against a people who called their own attack one of defence,
but a Belgian defence an act of stupidity. Since 1870 there had been
too many signs of their savagery not to realize that the Germans
had reverted to the barbarism of fifteen centuries earlier. Days later,
he was at the State Department conveying his government's protest
to all neutral countries against the recent shelling of the ancient
French cathedral at Rheims, a deliberate act "for the mere pleasure
of destruction."[20]

As 1914 slowly expired, what disappeared with it was the belief,
indeed the widespread assumption, that the war would be short-
lived. With French and German commands confident of their
respective offensive plans and capabilities, and with millions of
armed men prepared or preparing, it had seemed likely that modern
firepower and the mobility afforded by the railroads in particular
would combine for one party's quick victory. Instead, the guns and
locomotives had worked not to a breakthrough but to a stalemate.
Only then, toward the end of the year, was the scale of the requisite
resources becoming obvious. Soldiers by the millions, on the west-
ern front alone, needed a volume and diversity of supplies that had

been unimagined only months before – not simply guns and shells, but food and drink, clothing and footwear, communications and optical gear, sanitation and medical services, shoring materials, sandbags, shovels, and spiritual care.

Satisfying that first line of necessity required the activation of others. Well before the dawn of 1915 skilled workers were being demobilized from the armies and returned to their mines and factories, the output of which had fallen dramatically with their departure to the front. A war grown longer quickly registered the importance of industrial – which is to say civilian – production. The combination of accelerating military requirements and the attendant need for accelerating production released yet another consequence. The longer it lasted, the more financially demanding the war would be, and not only because of the costs associated with soldiers and factory workers. The demand for imported raw materials skyrocketed, especially in France, which had lost to the German invasion its richest natural resource area in the northeast. In the simplest terms, this meant a skyrocketing of the need for capital, French and foreign, through devices like war bonds and loans. Finally, that need was even further inflated by the costs of public relations. If the war was to be long, the morale of one's own soldiers and civilians would need as much shoring up as the trenches, just as that of the enemy would need undermining; and countries resolved to be neutral would require a different kind of cultivation, so that their economic and financial resources might be enlisted even while their governments avoided battlefield casualties.

One can see at a glance the potential significance of the United States of America. By 1914 few observers would have disagreed with what Jules Jusserand had been told a decade earlier. America, with its one hundred million people and its vast natural, industrial, and capital resources, had within its power the capacity to shape the outcome of the war in Europe. Therein, of course, lay both promise and peril: the promise to aid or to deny aid to any or all belligerents and the peril of interfering in their respective causes. Such was the central dilemma of the at-war embassies in Washington, including that of Italy, which joined the Entente coalition in April 1915. The French government and its principal spokesman in Washington were fully aware of that dilemma, which is why they made no effort to recruit the United States as a wartime ally. President Wilson had immediately resolved on a policy of neutrality and

had behind him the support of public opinion. Whatever the cross-currents of sympathies within the republic for one belligerent or another, very few felt that Americans should be mobilized and should die for European causes. Indeed, from the start, voices were raised against any possibility that the United States government would be lured into this imbroglio by covert propagandists or wily diplomats.

Ironically, one of the first issues to be addressed by the French and British embassies in Washington brought them into potential conflict with the Wilson administration. Barely a month into the war, with the prospect of a quick victory in the west diminishing, Count von Bernstorff raised the idea of recruiting Wilson to mediate between the warring sides. On 6 September, Secretary of State William Jennings Bryan told Jusserand that he had heard rumours to that effect, and two days later received the German ambassador at the State Department. By then, the French embassy had picked up intimations of the idea from another source, namely the most recent press columns written for German-language newspapers in New York. The author, a naturalized German by the name of Hermann Ridder, had suddenly abandoned his anti-French diatribes in favour of peace talk and praise of French, Belgian, and English heroism, a sure sign, so Jusserand thought, of Count von Bernstorff's orchestration. Although Bryan was sufficiently interested in the idea of ending the fighting and returning to the *status quo ante*, he found little comfort in the response of Spring-Rice or Jules Jusserand. The former dismissed the idea unless and until Germany was prepared to make categorical assurances about the future security of Belgium. Jusserand was more blunt. On his own initiative, he told Bryan – whom he already regarded as "impracticable and in the clouds" – that the idea was inconceivable without the disappearance of German militarism, and without the resurrection of France's dead. In short, mediation was not on.[21]

Neither was it entirely dead, but was kept alive, it seems, by the German embassy and a senior member of the Wilson administration. Although the embassy's official line had reverted to a denial of interest in an early peace – given its claim that the war had been thrust on the kaiser's regime – von Bernstorff took the idea to Colonel Edward House, Wilson's most trusted advisor. Quite possibly because of Jusserand's rock-hard stance against immediate peace, House floated the idea only with Spring-Rice, even going so far as

to suggest the possibility of direct, bilateral talks between Germany and England. The ambassador politely declined the invitation, and assured Jusserand to that effect. The news enraged the Frenchman. It was, he thought, a deliberate attempt to split the tripartite alliance, and was therefore "perfidious" as well as dangerous. "I can see," he telegraphed the Quai d'Orsay, "no advantage in such an American intervention."[22] Still, it had to be said again. With battlefield casualties mounting at Ypres and in the muddy trenches of Flanders, and with Germany trapped in the two-front war it had tried so desperately to avoid, von Bernstorff continued to fan whatever sparks of interest he could find in an early cessation of hostilities. In January 1915 Jusserand warned Paris of another overture to come. Wilson, he reported, continued to "flatter himself with the idea that he could play a key role in the negotiations." So he was sending House once again, to feel out the reactions of the belligerents: "But I've already told the Colonel that he would not find us disposed to talk or even listen. It has pleased the Germans to provoke and declare this war, and to conduct it with unprecedented barbarism. We should not be expected to take any more initiative for peace than we did for war."[23]

While it is true that Wilson, Bryan, and House seem to have been fairly prudent in their expressions of interest in this series of feelers from von Bernstorff, the fact is that they were interested, and the French and British were not. Certainly Jusserand could hardly have been more adamant, a stance that must have complicated the challenges ahead of him. For he was never entirely at ease with the Wilson administration, nor it with him. Although as doyen of the diplomatic corps he had been front and centre at the president's inauguration in March 1913, the ambassador confided to an American friend that he had not seen Wilson prior to that event and had not exchanged a word with him during it. "It seems," he wrote to his friend James Garfield, "we are in a different country."[24] Nor had the landscape changed by November of that year, even after the ambassador had pulled out all the stops to honour the president on the occasion of Miss Wilson's wedding. Thereafter, it was clear that the relationship between the two men was never to be close. Cordial, polite to be sure, but infrequent and never intimate: "Unlike his predecessors, he sees few people."

In Jusserand's eyes, especially on reflection, the president was so intent on being his own man that he had cut himself off from close

contact with anyone, House being the notable exception. Wilson, punctual to a fault, started and ended his interviews on schedule, with such precision that the ambassador joked he could set his watch by start and finish – a joke the more amusing since he himself was developing a reputation for "invariable tardiness," though perhaps not where the White House was concerned.[25] More disconcerting was Wilson's determination to be a peace-maker, an objective he thought was realizable only if he remained strictly – and from Jusserand's perspective, alarmingly – neutral. Indeed, in January 1915, when the von Bernstorff ideas were still being circulated, Wilson publicly claimed indifference both to the causes of the war and to the objectives of the belligerents. This, Jusserand found unfathomable. How was it possible, he wondered, that this president and his secretary of state, moralists both, could not distinguish aggressor from victim, wrong from right? More than wondered; he interrogated. In June 1915 he wrote directly to the president, confronting head-on the posturing of the German ambassador: "Did France on whom Germany declared war on the 3rd of August attack? Did Belgium whose fate left England no choice? ... [Despite the German Kaiser's claims] it is not enough, even for a Monarch, to say that 2 and 2 make five for its ceasing to make four."[26]

Bryan, in particular, made no secret of his moral values, having no use for swearing, alcohol, or gambling. Doctors, he said, could "take the taste for liquor out of a man, but only God" could cure the "curse of gambling." More disturbing to Jusserand was Bryan's inability to distinguish "invader from invaded ... shooter from shot" and his attendant vow to follow the teachings of the "Prince of Peace" by doing anything to keep the United States out of the war. Indeed, in a phrase made famous two decades later, the ambassador warned Paris that Bryan was "a partisan of peace at any price." He was as "intransigent on matters of pacifist dogma as the Christian martyrs of the first century."[27]

Tensions increased in the spring of 1915. On 7 May the ship the Jusserands had passed in Liverpool harbour was sunk by a German submarine. The *Lusitania* went down with the loss of over a thousand civilians, over a hundred of whom were Americans. A few days later the president spoke in Philadelphia, mourning the loss and condemning the action, but repeating his determination to stay out of the war. If anything, Jusserand reported, the tragedy had strengthened the president's conviction. He had a hundred million

citizens, the ambassador noted, ten to twelve million of whom were German-Americans. He had in Mexico a neighbour on the verge of anarchy, and a munitions-light, tiny army of thirty thousand. No wonder he wanted to avoid war in Europe.[28] Even so, there was a falling out between Wilson and Bryan, the latter's nerves shot by the *Lusitania* tragedy and by the risk it had represented to a country at peace. On 10 June the ambassador astonished Paris with news of the secretary's resignation from the cabinet, and four days later offered his masters the following, unsympathetic synopsis of the event. Never before in American history, he wrote, had a secretary of state resigned on the basis of "such an extraordinary mix of beliefs and of ignorance, of mysticism and pragmatism, of humani-tarianism and naiveté, of personal convictions and a matching capacity to throw them away for some chimera." But in the end, just as well, for his successor was Robert Lansing, a lawyer, a writer "of exquisite verse," a landscape painter and draftsman, a man whom Jusserand had known for long and with whom he related. He was, Paris was assured, "experienced, tactful, an authority on international law, a reflective man of good judgment."[29]

At no time did Jusserand see Bryan in such a light, the more so as the now-resigned minister's legacy continued in quite a different way. That way offers us a route back to the French embassy in Washing-ton, and to the myriad responsibilities that it was expected to assume in wartime: notably, fund-raising, shipping, purchasing, and public relations. The first of these, and this the connection with William Jennings Bryan, was fundraising. At the very outset of the war Bryan had received presidential backing for a proscription against Ameri-can loans or credits being made available to any belligerent. In French terms, the victim of aggression, as well as the aggressor, was to be denied access to the money markets of America, a restriction of acute concern for a nation fighting for its life, with some of its richest resources securely in the hands of the enemy.

Until the middle of 1915 Ambassador Jusserand was in charge of this critical effort, the groundwork being done by Maurice Léon, a New York lawyer with strong connections to the banking world. In October 1914 Léon and the embassy managed to arrange the sale of $10 millions worth of French treasury bonds in the United States, principally with funds raised by the National City Bank.[30] It was a financial coup for Léon, for Alexandre Ribot, the finance minister in Paris, and for Jusserand, who seems to have succeeded in quietly

lobbying the State Department's Robert Lansing, with some suc-
cess, for a relaxation of the Bryan restraints on aiding bellige-
rents.[31] Several months later, in March 1915, Jusserand and Léon
secured another sale of French government bonds, this one for $50
million, the proceeds of which were deposited in accounts at the
National City and the Morgan Bank, where they could be used for
French purchases of war materials. Not all was rosy, to be sure, for
halfway through the year the ambassador and Léon paid the price
of run-ins with the House of Morgan. By the autumn of 1915 they
had been "shunted to the sidelines" as French government fundrais-
ing was placed in the hands of Octave Homberg, a former diplomat
and banker, now in service to the French ministry of finance.[32]

Although the French government was ultimately able to raise des-
perately needed capital in the United States, it did so at the risk of
displeasing a Wilson administration intent on neutrality and, for
more obscure reasons, at the risk of irritating the powerful Morgan
Bank, which was already more disposed to raising funds for Eng-
land than for France. More potential for conflict arose over the
equally sensitive issue of shipping, for much of the money raised in
America was to be used for the purchase of materials for export to
France. Between August 1914 and the spring of 1915 one point of
abrasion was the American government's plan to purchase for its
own commercial fleet some of the German-owned ships that had
been caught in American harbours at the outbreak of the war. The
"agitated" French ambassador protested this plan on the grounds
that such sales would only contribute to Germany's financial
resources and that such a benefit would therefore severely compro-
mise the effectiveness of an allied strategy based on naval blockade.
Which is to say that such purchases would constitute a violation of
the American government's commitment to neutrality by advantag-
ing one side over another – "providing aid to a belligerent" – an
argument which, in February 1915, Bryan had simply declined to
discuss further.[33]

A larger problem was the blockade itself and its head-on collision
with the principle of freedom of the seas. Given the clear superiority
of Anglo-French surface vessels over those of Germany, it became
increasingly evident as the war progressed that this advantage was
potentially a war-winning tool: assure their own war economies
of secure access to goods and raw materials from America and
from their respective empires; deny the same access to Germany's

economy and war machine. That meant stopping ships of any flag
on the high seas, inspecting their cargos, and confiscating war-valu-
able materials that might directly or indirectly find their way into
Germany. While unassailably logical from an allied point of view,
the blockade strategy quickly became a point of contention with
American ships, suppliers, and government. In December 1914 the
State Department protested against French interference with
Europe- bound cargos of American cotton, a material that the Brit-
ish had yet to place on their blacklist. In January 1915 there was a
protest over the detention by a French cruiser of the *Metapan,* an
American-registered ship, in international waters, an action that
had involved examining the ship's passenger list, identifying three
men of German nationality, and requiring them to sign an oath that
they would not take up arms in the war.[34]

Incidents of this sort would continue to occur over the next two
years, and American protests would follow. But the intensity of the
blockade issue abated in the course of 1915 as the allies stuck to
their strategy and as Washington recognized the relationship
between its accelerating exports to the markets of those allies and
the security of those exports as assured by allied ships of war.[35] In
July Colonel House even wrote to Sir Edward Grey, the British for-
eign secretary, suggesting that more of the high seas stoppages
should be done by France, partly to reduce expressions of anglo-
phobia in America, and partly out of a recognition that France
remained so well respected among Americans. Jusserand, he said,
was seen in the State Department as "the most forceful representa-
tive that the Allies have here," an appraisal at least partly informed
by the colonel's recent blow-up with Spring-Rice.[36] For his part, the
ambassador urged his government to follow the British example
and adopt publicly and unabashedly the word "blockade," a word
until then absent from French official correspondence. That was all
it was, he advised, a device neither tyrannical nor permanent; and
while the Americans protested, they were conceding with less resis-
tance than anticipated. Moreover, the strategy was working. By
May 1915, he reported, the value of German exports to America
was down by three-quarters compared to May 1914, a decline com-
parable to that of imports to Austria-Hungary. Indeed, by the end
of 1915 it looked as if the Austro-Germans had lost four-fifths of
their export markets, and thus severely damaged their international
credit standing.[37]

Unlike fundraising and shipping, the issue of wartime purchasing created more problems for the ambassador – with his own government – than it did with the State Department. After all, by the spring of 1915, millions of American dollars had been secured on interest-bearing bonds, dollars that were likely to be spent in large part on the purchase and shipping to France of American products and materials. From an American perspective, it made good business sense. But it made less sense to the French, given the new obligations to America that rose with the sale of every bond issue and therefore increased national indebtedness while exerting downward pressure on the franc. But this was a war of survival in which expenditures were fast losing touch with peacetime prudence and reason. The challenge was to meet fantastic costs with a sober purchasing strategy.

Therein lay the rub for the French embassy, certainly in the first year or so of the war. What was needed was a centralization and coordination in Paris of government purchases abroad. That meant the need of someone in charge, teams of technical experts in communication with each other and with the commercial and financial attachés at the embassy and the consulate general, experts capable of purchasing materials needed by all ministries, civil and military, and, in the case of America, experts who could communicate in English. What happened in the early years, perhaps not surprisingly, was something akin to the blunders on the Somme: too little control and coordination, too many purchasing missions arriving in succession from a multiplicity of ministries, too many *missionnaires* unfamiliar with the United States and its official language. In February 1916 Jusserand wrote to the War Ministry in Paris, recalling his complaints over the better part of the past two years, which seemed to have fallen on deaf ears. Indeed, his most recent initiative to his own ministry had gone without response. Hence, his desperate plea to Albert Thomas, Under-Secretary of State for War. Too often, the ambassador said, these missions ended up competing with each other, often inadvertently, partly because they did not make contact with Maurice Heilmann, France's commercial attaché, or with Homberg, the government's key financial advisor in New York.[38]

Money, blockades, purchasing were three areas in which Jusserand's embassy was called upon to play a role. A fourth was the vast and important area of public relations, or more candidly,

propaganda. Because this was an activity with which a diplomat would have more experience and expertise than he would on capital markets, high seas seizures, or copper purchases, and because this was wartime and within a neutral country, Jusserand as propagandist became an early and sustained subject of interest in the United States and in France. But as central as this role became to his reputation as a diplomat, there is reason to defer the subject for the moment and to address what has already become a sub-text of Jusserand's career in Washington, before and during the war. The truth is that he was a bit of a scourge when it came to ministerial performance, a man who was to turn sixty-two in February 1917, and therefore felt at ease in chiding officials at the Quai d'Orsay and deeply resented being kept in the dark.[39] Since some of those complaints were inspired by what he saw as errors in the conduct of French propaganda, it seems advisable to provide a broader base from which to appreciate his frustration, his sometime sense of alienation, and his outspokenness. Thereafter, we may better turn directly to the subject of propaganda.

Fundamentally, the problem, as he saw it, was one of communications between himself and his ministry. Throughout the period of American neutrality, which is to say until April 1917, although the details of his complaints varied, the substance remained the same. Tell me what I need to know; listen to what I tell you. Within that simple parameter, however, there developed a series of irritants between masters and servant. Occasionally, for example, Jusserand's instructions were vague, prompting him to wonder how superiors in Paris would fare if they had to execute in practice what they had expressed poorly in writing. Or, in a similar vein, he suggested that perhaps they could make clear what information was to be released to the public and what had to be kept confidential.[40] Speaking of releasing information, there were a number of problems that needed to be addressed. If the ministry wanted some publication to be distributed in America, it made sense to send more than a single copy, which earned the assumption that the embassy's bare-bones staff would do the necessary duplication. Unless, of course, Paris wished to revisit the embassy's embarrassment of December 1914 when the translated text of the ministry's *Livre jaune* – on the immediate origins of the current war – was in the hands of the London *Times* and the reading public, a month before a copy had reached the embassy in Washington.[41]

That public, the ambassador kept reminding Paris, was over-whelmingly dependent on English texts. Which is why, having received in January 1915 not one but 2,000 French-language copies of Joseph Bédier's report on German atrocities, he deemed the sup-ply "more than sufficient," while observing that a copy of the Eng-lish version still had not reached him – although the essence of that text had already appeared in the *New York Times*. As a guideline for future ministerial distribution of such materials, he suggested in February a ratio of six or seven English language copies to one in French, and in April a ratio of over fifteen to one.[42] Spoken English was equally important, a condition often left unsatisfied by other "shipments" from Paris; namely sundry delegations of *mission-naires* bearing some accreditation from the French government. Too often, he said, they came with the best intentions, but they could neither speak to nor understand Americans, they knew next to nothing about the country, and he knew next to nothing about them: whether they had the expertise they claimed to have, or were, as some appeared, rather "shady dealers."[43]

In fact, the state of ignorance demonstrated by too many official and volunteer agents was just one symptom of the most trou-bling condition of all. Too often, they came uninformed and misin-formed, and therefore reflected badly both on the government that sponsored them and on the embassy, which could only be embar-rassed by the lack of information about its own government's inten-tions and the objectives of successive missions. Early in November 1914, for example, Jusserand was angered by his inability to pro-vide the Russian ambassador with a list of French experts who had been sent to America as part of a recent purchasing mission. There could be some major disadvantages, so he complained to his minis-ter, if he was to be kept in such a state of "total ignorance."[44]

Ironically, and to his great distress, he was not alone, for too often his government chose ignorance over knowledge, seemingly paying no attention to his reports and his counsel. In the spring of 1915, for instance, he added to his complaints about the latest *missionnaires*. Despite what he had been telling Paris, namely that France was very well regarded by the American press and public, these agents had arrived with a sense of apprehended crisis, a sense that Germany was winning the propaganda battle, and that extreme measures were necessary to reverse the situation. They got this impression, the ambassador raged, not in America but in

France where this state of mind seemed to prevail, thus demonstrating the "complete uselessness of the reports I send to the ministry." Instead, despite his pleas, the fashion in France seemed to be to "complain about America, rather than to thank her, to grimace in her direction, rather than smile." Later that year he multiplied his censure by confronting the "incomprehensible phenomenon" by which the press in France chose to ignore all the evidence of francophilia in the American press, thereby behaving exactly as the Germans would wish.[45]

Knowledge, pragmatism, and courtesy were closely linked in the mind of Jules Jusserand, as they had been since the school days in Lyon. Again and again he was appalled by the ubiquitousness of their opposites within the French bureaucracy. Partly because too many officials confused American neutrality with latent hostility toward France – despite the ambassador's repeated efforts to correct that impression – they missed one opportunity after another. In February 1915, he suggested that a word of thanks be sent to the American author of a book entitled *What We Owe to France*, twenty-five copies of which that author had placed in the service of the French government. Indeed, the author had sent a bound copy of the work to the president of the French Republic. Yet three months later Reverend Landon Humphreys had never received "a word of thanks, or a word of appreciation." That autumn Jusserand returned to the charge, repeating his astonishment at governmental clumsiness, especially its apparent inability to find a balance between its complaints about American behaviour and attitudes and its too infrequent expressions of gratitude. "We seem to find more satisfaction in complaining than thanking." If attitudes and practice changed, they did so at a glacial pace. Four months later, in a private letter of January 1916, the ambassador wrote that it usually took several telegrams to elicit from the ministry a single note of thanks to some American benefactor, a note which by then naturally appeared very belated and was typically "flat" and insincere.[46]

Throughout these early years of the war, and within the flow of correspondence from Washington to Paris, two major and, in his mind, related complaints surfaced from Jusserand's embassy, both of which will already have been inferred. He hated being ignored, especially in wartime when the consequences of his government's deafness were potentially lethal; and he detested incompetence.

As for the first, he kept a running record of all the things he had
not been told, even after repeated requests for information. In early
June 1915, following House's visit to Paris, the ambassador point-
edly suggested that it might be useful if the embassy in Washington
were to be told what had been said by and to the colonel: "I confess
that I'm at a loss to explain why my request has received no
response." Nor had it three weeks later. In November 1916, citing
several new examples of ministerial hearing impairment, he said with
unmistakable sarcasm that he was "envious" of his colleague the
British ambassador, whose advice was customarily followed by the
government in London; and in the following month he made clear
his discomfort to superiors in Paris when the Japanese ambassador
came to discuss a French-drafted note on eventual peace conditions.
He had been forced to admit that he knew nothing of the note, and
been reduced to learning its contents from an on-the-spot, oral trans-
lation from Japanese to French of a telegram sent from Tokyo. "The
Department," he wrote with ink and acid, "will decide for itself how
appropriate it is for the Japanese ambassador to know more about a
note prepared by my government than I do."[47]

Still, more than two years into this war of survival, little change
was in sight. In February 1917, with American intervention becom-
ing more likely, Jusserand was asked by various Americans what
their country could best do toward the war effort. He offered a
strictly personal reply, to the effect that France was probably more
in need of American materiel than a large fighting force. Was this
the right thing to have said? he asked Paris on 5 February. Was this
the right thing to have said? he inquired again on 4 March – to
which the ministry finally managed a response that ignored the
issue of an American fighting force. The ambassador replied with a
pro forma but hollow hope that the ministry and embassy could get
on the same page.[48]

There were times, however, when the problems between the Quai
d'Orsay and the embassy seemed to surpass shoddy communi-
cation. Occasionally, deafness and inattentiveness signalled sheer
incompetence. In mid-January 1915 Jusserand turned livid when he
discovered that one of his own reports on the reception of an Amer-
ican medical team in the Basses-Pyrénées had been completely mis-
construed by some official in Paris. The latter had recorded the
team's complaints about their reception in France whereas, in fact,
Jusserand had reported they had only "complained" about being

too generously received. Upon reading the ministry's version, he wrote to Delcassé, "I could not hide my stupefaction," could not "believe my eyes," never before having seen such an example of an embassy report being so turned on its head. Weeks later he discovered a new affront, occasioned by a simple if generous cash gift from the American banker and Paris resident, James Stillman, to assist French civilians living under German occupation. From beginning to end the gesture had been smothered in administrative errors, delays, and mix-ups. Stillman's name had been misspelled "Steelmann," his cheque took three and half weeks to clear, and next to nothing was done to publicize the gift.[49]

Then there was the embarrassing incident of a French Finance Ministry report on Chile's fiscal prospects. Intended for the subdirectorate "Amérique" at the Quai d'Orsay, the envelope bearing the document had been incompletely addressed, ending prematurely at "Affaires Politiques et Commerciales – Amérique." In the absence of a line indicating "Paris" ("Why," Jusserand added, "pay attention to such slight details?"), mistake number one at Finance was compounded by mistake number two at the foreign ministry. Someone short on experience and tall on imagination sent it off to "America" where, through steps unknown, it ended up in the New York Customs Office. From there it had been sent to the State Department which, alerted by the foreign language, had the document translated. Only then were ownership, contents, and intended recipient belatedly discovered, once more to the grave embarrassment of France's principal representative in America.[50]

This terrible combination of human error, inexperience, inattentiveness, and genuine ignorance was as much a part of wartime diplomacy as it was of every other aspect of the war – including, emphatically, that of propaganda. And here, too, the French experience included problematic relations and communications between the ministry in Paris and the embassy in Washington. In short, Jusserand's complaints simply became more pointed when it came to the propaganda war, as did the complaints that, increasingly, were directed at him. But fundamentally, from his perspective, it was a matter of whether he could gain, and keep, the government's ear. Looking back from April 1917, a joyous moment when at last the United States could be called an ally, the ambassador reflected bitterly on the previous two and half years. "The fact is," he wrote to his friend, Alexandre Ribot, the new premier and foreign minis-

ter, "that contact between embassy and ministry is perfunctory and uncertain; the cordial exchange of views, impressions, information and analyses that exists in the diplomacy of other countries, and which used to apply to our own, is now very rare. At least in my post." Troubling, too, he confided to his new boss, were the complaints he had been obliged to endure from various quarters about his approach to propaganda in America.[51]

The shift from peacetime to wartime propaganda represented just one more way to square off with the Germans and, given the wartime resource potential of the United States, a critical way indeed. Unsurprisingly, as Jusserand saw it, the manner and means employed by these combatants in America were significantly different, as each merely accelerated its pre-war tactics. It is true, of course, that both countries emphasized their cultural affinities with Americans, the related prospects of educational exchanges among their teachers and students, their commitment to peace before August 1914, and their status as hapless victim of aggression thereafter. In these fundamental ways, their propaganda strategies for courting the sympathies of the American public were identical. Tactically, however, they were so antithetical that a man like Jusserand, a scholar alert to bias and an historian mindful of the destructive consequences of national antagonisms, could detect no complexity, no ambivalence, no doubt, about the cause of this war. The kaiser's armies had attacked France by way of neutral Belgium, had rewarded their act of aggression by occupying resource- rich, northeastern France, and had employed long-range artillery to commit carnage against civilian areas that had been fortunate enough to escape their control. Any attempt to deny these charges, any attempt to justify them, was an insult to truth. Rephrased, they were confirmation of Germany's reliance on a campaign of lies.

Those lies were floated on a sea of money and propelled by public relations officers from a variety of germanophile agencies: the embassy, the German Press Office, the German University League, the Special Imperial Mission. Within a month of the war's outbreak, Jusserand learned that Count von Bernstorff had a budget the equivalent of ten million francs for propaganda; and for months to come the French embassy reminded Paris of the "inexhaustible" funds that had been allocated for distribution by the German ambassador.[52] Von Bernstorff himself adopted a low-key profile for the most part, relying on other agents to cultivate American public

opinion across the continent and nurture the higher-yield fields of German-Americans in the Midwest. One such adjutant was Maximilian von Hoegen, a graduate of Yale Law School, who warned that every German-American would "take up arms for the Fatherland" if the United States ever entered the war on the allied side.[53] More publicly prominent was Dr Bernhard Dernburg, the "horrible Dr Dernburg" as Jusserand called him, whose analysis of the current situation appeared in the North American Review late in 1914. Predictably, Germany was not the aggressor but the victim of aggression, a nation that had always been "striving for peace," a nation that had "never expanded except peacefully, never acquired territory except by treaty." Conversely, the English, the Russians, the French, all wanted to subdue her, deny her legitimate ambitions, especially the French, whose awareness of their own decadence and decline had left them envious of Germany and determined to destroy the new rival. So said Dr Dernburg, Germany's "public prosecutor" in Jusserand's jaundiced eye, master of "inane accusations and untruths," but fluent in English, a skilful manipulator of words, and usually subtle enough to avoid appearing ridiculous.[54]

Convinced that Germany had no choice but to combat truth with lie, Jusserand had in one sense boxed himself into a corner. Despite having much greater resources at its disposal, both human and fiscal, the German embassy simply had no right to win; in a battle that pitted wrong against right, ethically, it could not win the battle for public opinion. Though others, his critics, slowly came to have their doubts, the French ambassador never wavered in his faith that too much money, too many lies, too many public addresses, too many articles and letters in newspapers and magazines, would prove counter-productive to the German cause. Within a month of the war's outbreak, with the German government having stolen a march on France by the early publication of diplomatic documents on the origins of the war, Jusserand reported that "all the names and all the newspapers that count" had been offended by the German embassy claims, and that France was holding its own against the Teutonic barrage of words. Early in the New Year he concluded that the performances of Germany's own *missionnaires* were starting to irritate the American public, as were the more strident claims from within the German-American community. That trend, he and the consul-general in New York both discerned, continued into the spring of 1915, with the German cause weakening "the more they

spoke, pleaded, gesticulated, printed, and celebrated," and the French cause strengthening in the face of Germany's "incessant distribution of brochures."[55] Almost a year later, the ambassador's reading of American opinion remained unchanged and optimistic. By an "immense majority," the American public is sympathetic to us, he wrote: "Our situation here is good and our task easy."[56]

By August 1915, this perception of the public mood had drawn new energy from an exposé of German propaganda techniques in America by the *New York World* and its affiliates: attempts to buy up American newspapers, creation of various news agencies, financial subventions for sympathetic publications and speakers, and anti-ally agitation among American workers.[57] The very scale of German efforts was strengthening the public impression that France did not engage in propaganda – precisely what Jusserand wanted. Americans resented any kind of foreign intervention in their domestic politics, and especially feared becoming entangled in a distant war. Hence, in contrast to the high profile German campaign to cultivate sympathy for their cause, the ambassador continued a very low profile for France. Our image in the United States has benefited, he assured Paris, from our "dignified, proud and stoical deportment."[58] In short, France was not panicked by the military situation in Europe, was not desperate, was not in doubt about her eventual victory over the aggressor. From that determination flowed all the other elements of Jusserand's approach to propaganda.

To begin with his "do not" list, he wanted fewer amateur *missionnaires* from France, people who were culturally and linguistically ill-prepared to do much good among Americans. Some of them made audiences uneasy with talk of crushing Germany and imposing on her a humiliating peace, employing language that to American ears was excessive, indeed alarming.[59] Some, carried away by their own enthusiasm, were inclined to overstate their case with exaggeration too patent for American audiences, whose passion had yet to be engaged in this war: a France, guardian of western civilization since the Greeks, versus a Germany, backward, brutal, and materialist.[60] But even these novices, whatever their clumsiness abroad, were far less destructive than the French press at home. For every time some slight to America occurred in France, whether by action or inaction, elements of the American press were quick to inform their readers, especially those who were most

determined to keep the United States out of the war. Indeed, if ever Jusserand saw an enemy as formidable as the Germans, it was the badly harnessed and unruly troika of French writers, journalists, and politicians.[61]

In September 1915, after months of pleading with his superiors in Paris, the ambassador said it gave him "no pleasure" to raise the issue once again. But no matter how many times the ministry said it understood his counsel, the evidence contradicted it. Somehow, the most recent example being Colonel House, Americans had the impression that the French government and its people did not appreciate what the United States was doing in terms of money and materiel; indeed, that the French were critical of the Wilson government and unsympathetic to American people and culture.[62] They had come to that conclusion for two reasons, he adjudged. First, expressions of sympathy for France in the American press, particularly on the part of prominent Americans, were typically ignored or downplayed in France; such expressions, even those carried in a press like the New York Times, too often went without appropriate thanks or even acknowledgment. Such was the case of sympathetic remarks offered by Harvard president, Dr Charles Eliot in November 1914, the Stillman gift in 1915, the New York Tribune's special tribute to France in August of that year, and a Life magazine article of the same month.[63] Second, silent ingratitude was often sharpened by verbal barbs. Because the Lusitania affair had not changed the administration's position on neutrality, elements of the French press had turned to mockery, a resort that Jusserand abhorred, "because mockery never made a friend." Neither did irony, or sarcasm of the sort found in an article of July 1915 in the Paris paper Echo de Paris. "Keep irony and sarcasm for better days," he pleaded with his government, for "our sarcasm just makes enemies. Too many in France seem to take pleasure in displeasing."[64] Equally clear but more acerbic, indeed sarcastic in its own right, was the recipe he laid out for Foreign Minister Aristide Briand in January 1916: "If we think that this country's good will is an encumbrance for us, if we find tedious its praises, if we feel swamped by too much sympathy from too many neutral countries, we just have to stay the course in order to free ourselves."[65]

Consistent with the ambassador's tactical desire to replace criticism with praise, ingratitude with more frequent expressions of thanks,

were four other tenets of his grand strategy. One concerned money. The Germans' excessive and ostentatious spending on public relations made Americans suspicious, uneasy. He counselled the reverse and believed he had achieved the opposite results. Early in the war he reminded his minister that he neither had nor needed money, "pas un seul dollar," for massaging the American press: "We don't need millions ... to refute German claims of innocence, not after Louvain, Termonde, Reims." Early in 1916 he confirmed the utility of such financial restraint. In contrast to the German millions, "I have asked the government for nothing at all." We don't need millions of francs, he said, or postcards bearing the portraits of French cabinet ministers who have lost their portfolios by the time the cards arrive in Washington, or "similar trinkets." "All I need is a government willing to reciprocate French good will for that of Americans."[66] By then, of course, the ambassador would have steeled himself against hearing that his government was going to act in precisely the opposite direction. In June 1916 the French Chamber of Deputies approved the expenditure of twenty-five million francs for the conduct of propaganda in neutral countries. The ambassador reacted in horror, as did a visiting *missionnaire*, the Marquis Melchior de Polignac, who warned Paris that this news had created "a deplorable impression" in the United States, shattering the belief that out of respect for Americans France had eschewed propaganda.[67]

In the interests of truth, that belief needed to be shattered. Neither the French government nor its ambassador had ever renounced the need for propaganda, which is to say – as they would have said it – the need for sustained efforts to strengthen relationships between the two countries. It was a question not of "whether," but "how." Fortuitously, for an ambassador who did not want money for propaganda lest discovery of its use do more harm than good, it seemed more efficient, as well as safer, to have prominent American volunteers do the job however and wherever they chose to do it. This was his second tactical tenet. Francophiles eager to help should be allowed to use their skills of "word and pen" to rally support for France and the allied cause, while French nationals should keep as silent as possible, merely providing information at the request of these dedicated crusaders. Again and again Jusserand hammered home that message, partly in the face of accusations that his embassy was doing nothing and that it, and he, did not under-

stand the field of public relations. On the contrary, he retorted, if we do it ourselves, we stoop to the level of the Germans and will suffer the consequences. But to accept offers from Americans of "eloquence, enthusiasm, persistence, and talent," he insisted, was the formula for success. And even better, volunteers would speak out for love of France and French culture, without expectation of financial reward. Indeed, his position on the practice of recognizing foreign volunteers through state decorations and public ceremony, was that it should cease until the end of the war.[68]

Unshaken in his belief that "the only truly effective propaganda for us is what is done by Americans themselves,"[69] the ambassador was certain that whispers carried further than shouts, and that moderation – his third tenet – was always more compelling than profligacy. No need for massive, free-copy distribution of pro-France brochures, a practice that would strike Americans as excessive: "I've always recommended moderation over excess, quality over quantity." Which is why in August 1915 he simply refused to distribute to American contacts the second edition of Bédier's book on German atrocities, precisely because those contacts had already received more than one copy from more than one office of the French government.[70] Guided by this faith in the power of restraint, the ambassador lost no opportunity to caution his ministry against over-statement and careless tone. Just as he had warned against any suggestion of French vengeance against a surrendered Germany, so he cautioned against boasting that Germany was already exhausted. If true, he said, all that does is diminish our military success; but if it proves untrue, it will just increase our embarrassment.

By the same token, one had to strike the right balance when addressing France's own wartime needs. If those needs were made to sound too acute, the situation too desperate, and France was made out to be on the brink of collapse, it would lose respect in America and be assigned the status of supplicant. The ambassador also thought that France risked getting too much aid from the United States by borrowing any more than was absolutely required. Over-borrowing and wasteful expenditure would mean, he predicted, a post-war debt the size of the French government's annual revenue.[71]

Minimal funding for officially conducted propaganda, maximum use of American volunteers, and maximum reliance on moderation, these were three of the four planks in Jusserand's tactical platform,

all of which fit nicely with the fourth: the cultivation of francophilia in America through the myriad instruments of education and culture. Lectures, concerts, and exhibitions could be designed to remind audiences and spectators of France's past-and-present genius in art and architecture, philosophy and science, music and fashion. French Institutes, continent-wide chapters of the Alliance Française, associations of French language teachers, campus-based *maisons françaises*, all could be animated and largely funded by Americans. These were organizations that could keep the image and reputation of France bright and unsullied in America without overt engagement in domestic politics, or in the street-fighting commonly associated with wartime propagandists. So central was this emphasis to French propaganda that a very few examples can be used to illustrate the point without trying a reader's patience.

In December 1915, for instance, Jusserand took part in a New York unveiling of a statue to Joan of Arc, an occasion that ended in a plea for the safe delivery at war's end of Alsace to France. In September he returned to the city to celebrate Lafayette Day with the France-America Society, and learned later that month of an upcoming tour of America by Jacques Copeau and his *Théâtre du Vieux Colombier*, with a playbill replete with the work of French dramatists. In December it was New York again, this time alongside President Wilson, to view the unveiling of the new illumination system for the Statue of Liberty, itself an earlier gift from France to the United States. A month later, early in 1917, the embassy and consulates in America were asked to promote an exhibition in New York's Museum of French Art of battlefield watercolours by Charles Duvent, as well as to promote an extended lecture tour by the renowned philosopher Henri Bergson.[72] Less public, but the more telling for it, was the ambassador's quiet but energetic promotion of Dr Finley's latest book, *The French in the Heart of America*. Seeing in the work a testament to France's historical contribution to American society, Jusserand successfully urged authorities in Paris to get the book translated and published in French so that French readers, as well as American, could appreciate that historical sisterhood. "I consider it of the highest importance that that feeling [of America for France] be known and understood" by the French people.[73]

But was the emphasis on cultural affinities working? Were the prudence and the parsimony paying off? Jusserand's report of 27 April 1917 to Alexandre Ribot quietly celebrated the success of this

propaganda strategy, but it also lashed out at critics who had com-
plained of his methods and disparaged his results. At this happiest
moment, he said, when the United States had entered the war, he
was feeling miserable about accusations of inaction from people
"who confuse propaganda with publicity."[74] One of those critics
was Maurice Casenave, the New York–based financial attaché,
who had concluded by December 1916 that too much was being
expected of francophile Americans.[75] Another was the Marquis de
Polignac, who advised the Quai d'Orsay that what it needed in
Washington was "a Bernstorff ... with a French style."[76] By mid-
March 1917, six weeks before the ambassador's letter to Ribot,
Polignac's impressions remained implicitly critical of the ambassa-
dor – but not entirely so. This *envoyé* – as Jusserand called such
men on mission – did endorse the use of Americans to lead the pro-
paganda effort, the ambassador's strictures about avoiding exag-
geration and strident tone, and his complaints about the harmful
association in American minds of French culture and dirty books.

But the marquis by then had associated himself with Consul-
General Liebert's complaints from New York about the embassy,
and with the idea that France needed to adopt a higher propaganda
profile – not as high or as clumsy as that of the Germans, but one
that was more energetic and robust. For the fact was, this agent
reported, that France was losing ground in terms of public sympa-
thy. On the one hand, the Germans were doing everything they
could to promote and nurture American pacifism – and thus their
determination to stay out of the war – and on the other, France's
counter-efforts were mired in "absolute passivity."[77] As the war
entered its radically transformed stage, with von Bernstorff sent
packing back to Germany, with German-American diplomatic rela-
tions severed, and with America now an associate member of the
western alliance, it was only a matter of time before major adjust-
ments would have to be effected between the embassy in Washing-
ton and its critics at home and abroad.

4 Hesitant Embrace (1917–1918)

In fact, the first significant adjustment had occurred in the autumn of 1916, when Premier and Foreign Minister Aristide Briand had announced the imminent arrival in America of yet another *envoyé*, this one with a more enduring mandate. He had asked the journalist-editor Stéphane Lauzanne to set up an office in New York for the purpose of liaising between the French government and the American press. But in deference to the ambassador's sensitivities, Briand had made it clear that the office would come under the direction of the embassy in Washington via the New York medium of France's consulate-general. The tricky part of the mission, Briand predicted, would be for Lauzanne to deny any official status lest Americans interpret his presence as one of covert propagandist.[1] True to prophecy, the new agent spent much of his time in the early months combating such suspicions, as he and Jusserand tried to maintain the fiction of a private initiative carried out under the cumbersome organizational title of "The Effort of France, of Her Allies, and of Her Friends." Not until the summer of 1917, well after the United States had entered the war, was the office's stationery changed to include a final, and finally candid, line: The Official Bureau of French Information.

Inasmuch as the Lauzanne office was technically part of the embassy for its first six months, its early history became part of Jusserand's personal story. Certainly their joint experience in America provides further illustrations of his sense of what needed to be done at this critical stage of the war – as well as what needed to be avoided. The situation prior to Lauzanne's arrival was as follows. Given the ambassador's growing concern about his own ministry's

wilful ignorance of American affairs, in February 1916 he had arranged with Maurice Heilmann, his commercial attaché in New York, to prepare a daily digest of the American press for tele- graphed despatch to Paris as well as to the embassy. Given his con- cern about the judgment of Consul-General Liebert, Jusserand had instructed Heilmann to keep the matter confidential, an embassy matter exclusively.[2]

Although the idea for a new and separate office under Lauzanne had not been his, although he was given no opportunity to dissent, and although Gaston Liebert was already associated with Jusse- rand's critics, the ambassador does seem to have been receptive to an agency capable of relieving his hard-pressed staff of some of its public communication responsibilities. Not long after Lauzanne's arrival the ambassador apologized to a friend for having fallen behind in his personal correspondence: "Even without losing a min- ute of my time, I cannot keep up with all I have to do day by day."[3] Unlike the embassy, with its myriad duties and minimal person- nel, the New York office focused on what was called press liaison – which is to say supplying the American press with articles, letters, accounts of interviews, and statistics of all sorts pertaining to France's military and civilian war effort. Little wonder that the output of public information on France soon quickly surpassed the volume that had been handled by an embassy of modest finan- cial resources.[4]

Not only did Lauzanne's office offer some relief to Jusserand's resource-strapped embassy – a condition which, we might surmise, owed something to the ambassador's own spartan sense of econ- omy – but the two shared many of the same perspectives. In particu- lar, they pressed upon hearing-impaired Paris officials that the key to success in America was the timely provision of detailed and accu- rate information for the enlightenment of the American public. Certainly Lauzanne was quick to join the Jusserand chorus, com- plaining in December 1916 that, in the space of three months, he had received only one communication from the foreign ministry's new propaganda command post, the Maison de la Presse. "If I am to light the American lantern," he complained, "you must ensure that my own flame is not guttered."[5] And like the ambassador, he drew the line on paid journalism. In March 1917 he told Jusserand that he had dismissed the offer of a five-page article on France in the *Evening Post* in exchange for a $500 subsidy per page. France,

he had assured the offending journalist, had no need to pay for publicity, to which Jusserand added his crashing approval, associating "such a project" with "countries which have something to hide and people to fool."[6]

A month later, Jusserand's direct involvement in France's wartime propaganda diminished even further, although the principles of restraint and moderation that he had established remained intact. On 2 April America formally abandoned her neutrality in favour of a declaration of war against Europe's Central Powers; and with that shift came the immediate creation of a French High Commission to the United States. On 15 April Premier and Foreign Minister Ribot informed the ambassador that the journalist-statesman André Tardieu would head the High Commission, thereby relieving the embassy of all "technical" responsibilities for the Franco-American war effort. Careful to assure the ambassador that this was in no way an implicit criticism of the embassy's previous work, Ribot made a point of saying that Tardieu had been a public defender of the ambassador's wartime work in Washington.[7] Henceforth, Jusserand would be free to concentrate entirely on *affaires politiques*. Indeed, Tardieu wasted no time in asking Jusserand not to raise any shipping issues with the State Department, since such questions were part of a much larger problem that was now clearly under the mandate of the commission, which, with its personnel of over a thousand employees, simply dwarfed the human and financial resources of the embassy.[8]

Propaganda, too, came under the commission's aegis, although it took some time before the government's intention was fully clear on this highly sensitive and important matter. In mid-April, Jusserand knew that the Washington-based High Commission had been designed to handle military exchanges, financial cooperation, purchasing, and shipping; and one month later Tardieu confirmed these responsibilities to Premier Ribot. Neither invoked the language of publicity, public relations, press liaison, or propaganda.[9] Yet within the next few months it became apparent that Tardieu's Washington Commission did indeed have a budget for propaganda, that his associate Louis Aubert had established a *Service d'études et d'information*, and that Lauzanne was sending his monthly reports from New York to the High Commissioner and copying them only to the ambassador.[10] Something fairly subtle had occurred in the summer–early autumn of 1917 within the power dynamics that

obtained at the ministry in Paris – particularly with respect to a major shake-up by the Ribot government of the Maison de la Presse – and between the ministry, the embassy, the consulate-general, and the High Commission in the United States.[11]

The fact that the Washington embassy's status had been sorely challenged by the establishment of the powerful High Commission seems clear. In short order, Jusserand found that many of the responsibilities he and other embassy personnel had assumed on a rather *ad hoc* basis in the early years of the war had been taken on by new agencies and agents. Propaganda, to a considerable extent, was among them. Precisely why this occurred is a matter of conjecture, for the changes of 1917 hardly had the performance of the Washington embassy at their core. The American declaration of war represented a sea change in itself, for now the hitherto low-key expressions of sympathy and affection between the two governments and their citizens could be expressed openly, indeed loudly. French concern about prudence and subtlety diminished overnight as the fear of being accused of domestic political manipulation evaporated. Now, almost any effort to promote francophilia in America could be seen as consistent with their joint wartime cause.

There was, of course, another inspiration behind the coming to office of the Ribot government, its reorganization of the foreign ministry's information services, and its sudden installation of Tardieu's High Commission. By the spring of 1917 the war was in its fourth year and no end was in sight. Instead, the disastrous offensive on the Chemin des Dames had taken some 200,000 French lives, the army was coping with a series of mutinies, and the overthrow of Nicholas II, czar of Russia, confirmed doubts about the resolve and the material ability of the Russian forces to even stabilize the eastern front. In a word, there was a sense of crisis; and the argument for doing more, doing it quickly, and doing it with public flourish became invincible. Since propaganda in the United States had become a doubly patriotic duty once the United States had entered the war – doubly by serving America's new cause as well as that of France – more words at a higher pitch seemed, to some, more timely and appropriate.

Obviously, however, there was still more to it than the coincidence of a president's decision in Washington to enter the war and a bleak military situation on the Aisne and in Champagne. The crescendo of criticism that had been directed at Ambassador Jusserand

was certainly part of the context in which the premier decided on the High Commission and awarded it more and more responsibility for French propaganda in America. Some of those criticisms were apparently friendly in intention. In January 1917 a journalist for the *New York Tribune* warned the ambassador that the Germans were making headway in American opinion, partly at least because the von Bernstorff embassy was so much more accessible to the press than the French embassy. That same month Jusserand received another note, begging for an escalation of French propaganda, particularly in the Midwest, where the results were deemed inadequate. Rather pointedly, the author observed: "Refraining from feeding the press is not an answer."[12]

Also in January, at once more scathing and yet less obviously directed at his own boss, the ambassador, came Consul-General Liebert's characterization of French cinema propaganda as bad enough to be called "a true scandal." And in March, the *envoyé* Melchior de Polignac echoed the consul-general's view, beginning by describing Liebert as "one of the best collaborators" he had found in the course of his own extended propaganda mission to the United States. On balance, he judged, France had not competed well against the Germans – "we are in a full-blown crisis" – which is why he, like Liebert, recommended the creation of a permanent information office in the United States, one headed by a single individual who could "speak in the name of France" and supply the embassy and consulates with good and timely data.[13]

There is no doubt that the misgivings expressed by some of these critics reached the ear of senior officers at the Quai d'Orsay, including that of the minister himself. Indeed, Jusserand had ensured by his own efforts that these very criticisms were well aired in Paris, as prologue to denying and demolishing them. In late April he thanked Ribot for informing him of the complaints about his alleged inaction in propaganda, although he was unrepentant about the strategy he had pursued and dismissive of critics who could not grasp the value of subtlety in propaganda. With tone unimproved, he went on to angrily deny suggestions that he had poor relations with President Wilson – when there was "not a single ambassador" who saw him more often than the ambassador of France – although he did admit that there was no personal friendship between them. Neither would he tolerate suggestions that he had somehow served poorly the interests of the French Chamber of Commerce in New

York – "when I, myself, could reproach them for their own inaction and lack of influence."[14] He suffered no second thoughts a month later, when he again addressed Ribot, once more in the wake of reported complaints. His anger had not cooled.

Reporting on the successful, highly publicized visit to the United States of General Ferdinand Foch and former prime minister René Viviani, the ambassador took careful aim at those who continued to denigrate his efforts. He had heard of the "intrigues" against him, he wrote, some of which had taken him by surprise. Professor Bergson, for example, whom "I received with open arms" and whose lecture tour I facilitated in all sorts of ways, is said now to "want my head, or at least my job." From the telegrams Bergson had sent back to Paris, it was now clear how "remarkably naive he was for such a serious philosopher," thinking somehow that he could personally speed up the whole diplomatic process.[15]

No surprise, however, about the fault-finding office of Louis Aubert, chief information officer at the High Commission and the author of a previous report on the shortcomings of France's propaganda efforts to date.[16] Aubert, the ambassador suggested, had two faults of his own: one, his ignorance, having been in the United States for fewer months than he himself had years; two, a definite shortage of modesty. I wonder, Jusserand speculated, how any of my critics would have done had they been in my place when Foch and Viviani appeared before Congress. Having spied the ambassador on his feet, about to leave the Chamber, the Speaker of the House publicly invited him to address those assembled. Caught completely unaware, the more so as it was the first time a foreign ambassador had been so honoured, Jusserand gave "the least prepared speech of my entire life" – and to frequent applause, he assured his premier, as he savoured both the moment and the conviction that his critics would not have fared so well.[17]

Riding this wave of self-assurance, the ambassador only succeeded in widening the circle of those who would find fault with his service. Some officials in Paris had not cared for his complaints about their own performance and had signalled as much to Ribot. But was his own criticism not justified? How can I remember fondly my wartime service, he asked, with a ministry that: "leaves me in the dark, strips me of personnel, sends me instructions which, in some cases, are so badly thought out that had I followed them would have led to a rupture of relations with the United States – as

might have been the case when I was ordered, without a second thought, to notify the Americans that our ships would fire on sight at any submarine spotted in the western Atlantic."[18]

In yet another note of self-vindication, the ambassador leapt at a chance to report on an article of 13 July in the *New York Tribune*. America's entry into the war, it reported, represented a "fine feather in the diplomatic hat of Ambassador Jusserand," which was fitting, the author continued, given the criticism he had received from influential circles of French officialdom. And in case those officials were still not listening, or had forgotten, the embattled diplomat set out an extended testament of faith.

When he had arrived back in Washington in August 1914, he wrote to Ribot, he had quickly decided on the strategy he would follow, and he had "never deviated." Given the widespread sympathy for France across America, he had concluded that France needed no propaganda, that is to say the "pleading sort of propaganda." What was needed were accurate facts delivered in "the least sensational manner" by talented Americans who appreciated France's stoical response to the suffering brought on by the German invasion and occupation and could combat the flood of money allocated to propaganda by the German government. He, himself, had resolved to say nothing in open public and to write nothing, convinced as he was that "despite all predictions to the contrary – even a few that had been well-intentioned – events had proven him right." Those views, he reminded officials at the Quai d'Orsay, had been well rehearsed with the department, with neither applause nor blame by way of response; nor, more recently, with as much as a word of defence against allegations that he had been "mute, immobile and useless." In fact, he ventured to say, and not for the first time, everything seemed to have changed in the relationship between ministry and embassy. "Nothing is left of the old cordial exchange of opinions among compatriots working in the best interests of the State."[19]

There was, of course, much more to these expressions of frustration than disagreement over the conduct of propaganda; and in fairness to the usually nameless officers in Paris, from those in the American sub-directorate to the ministers themselves, readers need to be reminded that such agents were as complained against as they were complainers. Long familiar with unsolicited lectures from the ambassador in Washington, they may well have guessed that the

key changes of April–May 1917 were unlikely to inspire reports
from him on how much the situation had improved with the advent
of the High Commission. Sometimes, it must be said, he com-
plained that the government in Paris did too little to curb press free-
doms, tolerating not only snide jibes at the Americans but also – in
ways that associated France and Germany in American eyes – all
the reports about French executions of German spies.[20] He resented
the "peremptory" tone of many of the communications he received
from Paris.[21] Sometimes he faulted the content of those despatches,
particularly when the statistics were wrong, or when he was asked
to convey information to the State Department which, in one case,
reflected badly on their British ally, or when maps essential to any
comprehension of written text were missing from the despatch.[22]
And, as trite as it might appear at first glance, he continued to be
astonished, and embarrassed, by gaffes in the postal service: both
the inter-ministerial service in Paris, which, by improper addressing,
too frequently managed to get mail intended for the Quai d'Orsay
delivered into the hands of the State Department in Washington;
and the ministry's own service which, by sloppy packing, too often
delivered damaged contents to the embassy, or through some other
misdemeanour could take months to complete a delivery.[23]

Other irritants were more serious, and more common. He was
even more opposed than he had been earlier in the war to the
stream of "countless" *missionnaires* who arrived in America ill-pre-
pared, ill-coordinated, and insensitive to a country now "satu-
rated" with foreign missions; and he deplored the lavish spending,
even waste, that was associated with the profusion of such missions
and the expenses they incurred, whether those of single individuals
or of delegations.[24] On the initiative of the American Council for
National Defence, which was concerned about mounting shortages
of wool, he even urged Paris fashion designers to be more economi-
cal in their styling for the 1918 fashions. He did so by convincing
his government to dissuade French dress designers from pursuing
an early trend away from shorter skirt lengths toward longer styl-
ing, purely for reasons of fashion. The reprieved shorter styles, it is
said, were for a time known as "dresses à la Jusserand."[25]

Related to his efforts to cut down on waste were his warnings
about excessive borrowing from the public and private purses of
Americans. He was troubled on several fronts. First, the more the
French government borrowed, the greater its risk of looking like a

beggar, or worse – images that were detrimental to the dignity of France.[26] Second, unrestrained borrowing, quite apart from the images it might convey, risked putting France into the clutches of the United States, transforming a "tie into a chain." The more we borrow, he cautioned Paris in September 1917, the greater the power we give to Wilson, who will then be able to "determine the hour and the conditions of the peace settlement."[27] Third, France's growing indebtedness threatened the country in yet another way. As early as June 1917 he linked wartime spending with the *déluge* to follow: heavy national debt, stringent peacetime economies to pay for the borrowing, a long-suffering population now disgruntled by the peace, and the attendant threat of "anarchist revolutions." Imagine, he said, the soldier who expects to return to his former life only to find that the nation's financial situation has put everyone under the eye of some "auditor."[28]

Whether he was right or wrong in such forecasts, justified or not in his cornucopia of complaints, one can imagine the irritation Dr Jusserand had been causing fellow public servants in the ministry, in parliament, even in the consular service. The consul in Chicago, he complained to Paris, read people and facts quite differently from himself; and the consul-general in New York had no business getting involved in appraising American public opinion.[29] It comes as no surprise, therefore, that complaints of his own service continued to accompany those he directed to Paris. Toward the end of May 1917 he was aware of an unsuccessful effort that had been made in the foreign affairs committee of the Chamber of Deputies, to recall him from Washington on the grounds that he was doing "nothing useful." And in late October he learned of yet another unsuccessful attempt that had been made to unseat him, this one conducted by "two or three defamers," led, he was convinced, by Louis Aubert in the High Commission. What troubled him as much as the subterranean campaigns themselves was that they had been received in silence, even, he suspected, in complacency, by the ministry itself.[30] Not so, said Minister Ribot. Public servants are always open to criticism, even to "malign insinuations," ambassadors included; but it is not always best to defend them publicly. "You should take the silence of your superiors to mean nothing but their full confidence in the excellence of your services."[31]

The detached nature of these words of apparent reassurance may not have been what Jusserand was looking for. But they, in combi-

nation with the fact that the rather sustained efforts to unseat him
had failed, were some measure of the support and appreciation he
continued to draw from others closer to his way of thinking. Since
there is a danger of translating his critical outspokenness into the
curmudgeonly and unprovoked behaviour of a man in late career
or, worse, into the arrogance of one too long in office, there is also
an argument for turning to those who praised his efforts on the part
of France. For contrary to his critics' view, there was effort aplenty.

For starters, he and Mme Jusserand engaged "in no social diver-
sion," took no vacation for the duration of the war, neither in
France nor in northern coastal resorts, and suffered instead with
American officials and those of other embassies the sometimes suf-
focating summer heat of the nation's capital. These were trying
days for them both, being tied to the city "as are our soldiers to
their trenches," burdened by the weight of the war and with the
casualties ever-present in their minds. One Washington resident
recalled seeing them strolling in the evenings on 16th Street, Elise
doing her best to distract her husband from the cares of the war by
pointing out the neighbourhood gardens and flowerbeds.[32] Only a
few months into the war, one journalist portrayed them as a "sad
and heavy-eyed couple," without benefit of children or grandchil-
dren, silent, wrapped in furs, during their late afternoon carriage
outings in autumnal Rock Creek Park. Almost every day their victo-
ria, drawn by two handsome bays, would leave the embassy gates,
their slow entrance into the traffic-congested roadway being super-
vised by a uniformed policeman. Moments away, the coachman
would stop briefly at a nearby drugstore where the footman in high
hat and long black coat would collect a newspaper for his boss
before proceeding down the slopes into the park. There, the couple
would read as they rode under the forest canopy; or, if news from
the front was particularly troubling, the ambassador would step
down and go for a long, solitary walk. Often, too, they simply dis-
missed the carriage in the park and sent it back to the embassy
while they continued homeward on foot. His hair was greying, and
one photographer so captured Mme Jusserand's stress and fatigue
that the ambassador requested that the photos not be made public.
They made her look "ugly and disagreeable," he wrote, and as such
misrepresented her "physically [and] morally."[33]

True to form, however, whether of her own making or that of her
husband, Elise Jusserand remained in the shadows, somehow insu-

lated from a press that had discovered the weaving talents of Countess von Bernstorff, the lace-making skills of Madame Riano, wife of the Spanish ambassador, the painting gifts of Austrian Baroness Dumba, even the acting and playwright accomplishments of Countess d'Azy, wife of the French naval attaché. And when offered an opportunity to put herself forward, in the form of an invitation from the Otis F. Wood Agency to write an article on the role of French women in the war, she declined. Not long after the war, as prologue to the one press interview she submitted to, she confessed to having "literally sat on her doorstep week on end before she would surrender to even an informal talk."[34] A public figure by marriage draft, she seemed resolutely content to be seen and not heard.

Her husband made up for it. In a letter of December 1916 to the distinguished educator Dr John Finley, the ambassador confessed that he had been unable to find a promised photograph in "the indescribable pile of accumulated documents" he had to attend to as soon as he could get a minute. In letters to two friends in October 1917 he referred, in passing, to the workload, which allowed no time for even a half-day of rest, never mind Sundays or holidays. To another friend he described the "billows of paper" accumulating on his desk, despite a 6.30 a.m. start to every day.[35] In a subsequent report of embassy activities between January 1917 and September 1918, he calculated that he had sent nearly 3,500 telegrams and 1,100 letters to the Quai d'Orsay alone, without counting all the other communications traffic with the consulates and other government ministries, as well as 800 additional letters to the State Department. All that, in addition to a diversity of other official and private correspondence. Then there were the many public occasions for which embassy representation was required, so many in fact that he, personally, could only satisfy little more than ten per cent of the invitations.[36]

This reminder of the personal opens the door to a reprise of one aspect of the ambassador's multi-textured life, and offers a momentary break – for the reader, as for Jusserand himself – from the demands of political and diplomatic discourse. At least an apparent break, for the fact is that Jusserand's scholarship and his diplomacy had become closely intertwined. He himself identified one such connection in the early summer of 1917, as he fought back against the whispers of his critics. If you need more ammunition to defend

me, he wrote to Ribot – adding that this was "the first time in my life I have had to spend so much time on myself" – you should know that my latest book has just been awarded a $2,000 prize by Columbia University. It was, in fact, the first Pulitzer Prize for the best book of the year in American History.[37]

Equally factual was the wartime context and, more precisely, the period when the United States was turning its back on Germany and gravitating toward France. Under the circumstances, it could not have been a huge liability for the winning author to be an already established scholar as well as the long-serving French ambassador in Washington. Nor would his chances have been compromised by the fact that Ralph Pulitzer, son of the prize's donor, was the publisher of the francophilic *New York World*. That said, *With Americans of Past and Present Days* cannot be dismissed as some tossed-out, light confection designed to appeal to the tastes of Americans. Designed it certainly was, but the propitious circumstances of 1917 should not detract from the substance of the work itself. One reviewer for the *Chicago Tribune*, while acknowledging the volume as "an open plea for our friendship," and "a discreet piece of literary diplomacy," also acknowledged the work's research, original documentation, and "artistic manner." Another, writing for New York's *Times*, praised the author's skill as an historian as well as his "literary grace," and recommended the work to those American readers who "may have forgotten or who may never have known the full extent of our indebtedness to the French people." Hopefully, the reviewer wrote, the book might "refresh and invigorate ... the sense of close and sympathetic brotherhood between the two nations."[38]

The book itself comprised seven essays, including the prominent opening four on the Count de Rochambeau, Major L'Enfant, George Washington, and Abraham Lincoln. Among the ambassador's many sources were the Rochambeau, Washington, Hamilton, and Jefferson papers, all held at the Library of Congress; diplomatic despatches and "recriminatory pamphlets" from the British archives; documents from various French state archives; the L'Enfant papers then in private hands; records of the Columbia Historical Society, and artifacts in the Museum of the New York Historical Society. The research certainly found its complement in language, the language of a wordsmith expressed with the eye of an artist. Indeed, one reader for the *American Historical Review*

praised "the sparkle and gracefulness of style" and went so far as to ask, "Why cannot Americans write as Mr. Jusserand has written?"[39] In the closing essay, for example, optimistically entitled, "From War to Peace," Jusserand first described the Social Darwinists of his own day, people who seemed fascinated with war and struggle and satisfied with the descent of "reasoning man" to "unreasoning vermin," then counter-attacked with Hugo Grotius, Blaise Pascal, the Encyclopaedists, Emmanuel Kant, Jeremy Bentham, Alexis de Tocqueville, and his own pen.

There was a time when war was a seasonal occupation of monarchs, and when it was heralded for its very "mercilessness." To none of the master artists who represented the day of judgement on the walls of Rome, Orvieto, or Padua, or on the portals of our northern cathedrals, did the thought occur to place among his fierce angels driving the guilty to their doom, one with a tear on his face: a tear that would have made the artist more famous than all his art; a tear, not because the tortures could be supposed to be unjust or the men sinless, but because they were tortures and because the men had been sinful.[40]

Overall, the work itself reflected themes familiar in the previous works of Jules Jusserand, as well as those with a more recent, wartime stamp. His appreciation of "great" actors, whether Langland or Washington, remained undiminished, as was his resolve to make the great, human. Rochambeau, for example, a distant relative of Ronsard, thus doubly a favourite of the ambassador, is cloaked in admiration, from birth to burial place in a little village of the Vendôme where he lies overlooking the Loire beneath a loving inscription composed by his wife. Citizen Genet, one of France's first representatives to the fledgling American Republic, was great only in human frailty; "self-complacent, self-advertising," he conspired against George Washington and, accordingly, against the interests of the revolutionary government that had sent him – and was to recall him. The same critical spirit could train on historians as well as on their subjects, as Jusserand had proven years before in various published exchanges with leading scholars. In this case, he took issue with an editor of some of Washington's own writings, referring to "one of the embellishments" that this allegedly

imaginative editor had "thought he was free to introduce in the great man's letters."[41]

Nor was there anything new in the ambassador's adulation of France, except that the war had sharpened and magnified that appreciation. Had distorted it, too, some might think, upon reading the ambassador's dubious assurances to Americans that the Republic of his day had preserved "no privileges of any kind" and that "the right to vote [was] refused to none"[42] – with the notable exception, he might truthfully have added, of women. More credible, surely, were his references to the Republic's progress toward public education and, for readers more inclined to associate France with pastries and fashion, his here-abbreviated inventory of France's scientific contribution to humanity: Pasteur, Ampère, Daguerre, Lumière, Curie.

Altruism, by his telling, was characteristic of France. Shorn of any motive but her love of liberty, France had supported America's revolt against eighteenth-century England. Contrary to some suggestions, she had acted neither out of hatred for the English – whose culture, at that very time, was being embraced and celebrated in Paris – nor in the expectation of compensation of any sort. Washington himself had wondered what she might have wanted in return for her manpower and her money, and was surprised to learn she asked for nothing. Less surprised, so the ambassador suggested, was the Prussian king, Frederick the Great, who had come to appreciate the resilience and determination of France, a country with "such a temper that there [is] no bad minister nor bad generals ... able to kill it."[43]

But Germans of a later day might try. This was a theme much newer to the corpus of Jusserand works, and by no accident one of wartime. Though ostensibly a work of history, *With Americans ...* is salted with reminders of contemporary German perfidy. Contrasting eighteenth-century French "anglomania" with the self-adoration of the kaiser's Reich, the ambassador's essay on Rochambeau provides a reminder of Germany's twentieth-century "destruction of Louvain, the cathedral at Reims, the town hall at Arras." Similarly, while surveying General Washington's growing affinity for France, the ambassador did not shrink from evoking "the submarine-haunted ocean" of 1916.[44]

But while he newly condemned, he also newly praised. Prior to 1914, certainly prior to 1903, the subject of Franco-American

friendship had rarely caught the eye of Jules Jusserand. The war changed both the frequency and the intensity of that reference. Indeed, that was the central theme and purpose of his new book. Washington's death in 1799 had prompted ten days of public mourning in France. Benjamin Franklin had died "venerated and loved" in France, "the one who gave [her] her first notion of what true Americans really were."[45] Thirty-one French cities had sent notes of condolence to the American government on the death of Abraham Lincoln, and a commemorative gold medal had been coined for his widow, the costs covered by public subscription. Repeatedly throughout the volume Jusserand maintained the thread of healthy, respectful, even affectionate relations between the sister republics of France and America: from the first stitch – the opening dedication of the book to the original thirteen colonies – to the last – his closing reference to his own part in negotiating the first Franco-American arbitration treaty.[46]

For all of this, the book, the letters, the speeches, the prudence, the tact, Ambassador Jusserand accumulated his own backers, French and American, who admired his energy and who endorsed his strategy for keeping France and the United States in sympathetic tandem. In response to anti-Jusserand currents circulating in parliament in the spring of 1917, Senator Stephen Pichon published an admiring piece on France's ambassador in Washington; and Paul Deschanel, president of the Chamber of Deputies, sent the ambassador a personal letter of reassurance. In November, Ribot himself, notwithstanding his earlier assurance that public servants could expect public criticism but not public defence, did in fact rise in parliament to counter the latest criticism of Ambassador Jusserand, and defend a friend whose wedding he had once attended.[47]

A month later, James W. Gerard, former American ambassador to Germany, publicly praised his French colleague in terms that must have raised Jusserand's spirits. "He has acted during the painful years of our neutrality with a tact as exquisitely balanced as the scales which weigh to the thousandth of a milligram." Another month later, in a private letter to the ambassador, Henry N. Hall, Washington-based correspondent of the *London Times*, congratulated him for the splendid work he had done for France. "No one knows better than I do, how ... very large a part you have played in bringing this country into war ... Now that the dawn has broken, all men can see that your work was good."[48] Also private was the

British ambassador's assessment of Jusserand, whose prudence he praised to London's Foreign Office before concluding: "I do not think it would be possible to replace him." It was a judgment shared by one regular correspondent for the *New York Times* who, in similar fashion but at greater length praised both Ambassador Jusserand and Spring-Rice for the restraint they had shown in the face of German propaganda and, significantly, in the face of domestic critics who had confused prudence and subtlety with inertia and inactivity. For indeed, Spring-Rice, too, also stood accused of being "too tame" and "old-fashioned" to be an effective propagandist.[49] The article, misleadingly entitled "France and England Wisely Avoided Propaganda in U.S.," featured the fine profile of Jules Jusserand under the separate caption, "France's Tactful Envoy."[50]

The reasoning behind these praise-filled assessments of the ambassador's service derived entirely from his approach to the subject of propaganda in America. Although he never denied the need for it, he had worked from his earliest days in Washington to ensure that the word *propagande*, so commonly employed within the French foreign ministry, had no venom in America. Because, so the *Times* article suggested, he realized that "the people of the United States would be disposed to resent anything in the nature of propaganda" So he wooed them differently from the high-profile and prolific manoeuvres of von Sternburg and von Bernstorff, and from the strident wartime claims of Dr Dernburg. Like them, it is true, he cultivated those circles in America who were disposed – in his case – to France, by culture and education. But never with extravagance of coin or claim, usually with the discretion and modesty that were the hallmarks of his life with Elise, always with reference to France's long association with aesthetics and ideas. He was, as the reader will now know, an intellectual and scholar of exceptional accomplishment, a talented amateur in art and design, and a gifted public speaker. These credentials he employed in full measure, at insignificant public cost, among those American francophiles who, when war came, saw themselves as volunteers and not recruits.

Language rarely failed him, English having become second nature to him after so many years in Washington. In December 1916, standing by a president still locked on neutrality, he spoke briefly to an audience assembled to witness the illumination of New York's Statue of Liberty. At first, he said nothing of the current war, although he did supply an early reference to the sculptor Frédéric

Bartholdi, an Alsatian who had been deprived of his homeland in 1870 by Prussia. He spoke rather of values shared between France and America: "Not to a man, not to a nation, was the statue raised; not to a man famous and useful as he may have been, not to a nation as great as she may be. It was raised to an ideal – greater than any man or any nation, greater than France or the United States – the ideal of liberty." Thereupon he turned to the present struggle in Europe. In response to a recent question as to why France persisted in the war, he invoked a French work of art in Washington's National Museum. It was an image of Marianne, symbol of the French Republic, "tall and erect, her cap of freedom wreathed with laurel," engaged in battle; and in the background, "the dim distance, across the waters, is discovered a pale outline of ... the Statue of Liberty." The inscription below "is," he said, "and my answer is, 'That Liberty may continue to light the world.'"[51]

Once the United States had committed itself to the struggle in the spring of 1917, the ambassador, like many others, felt freer to sharpen his lance against the common enemy. Eloquence was no casualty. Speaking in New York on the 160th anniversary of Lafayette's birthday, he recalled the hateful Austro-German coalition: "who had thought Belgium would submit – and Belgium had answered at Liège; that England would keep aloof – and she has barred the sea and sent to France that admirable army; that France would be crushed – and she answered at the Marne and at Verdun; that Japan would be an onlooker – and Japan answered at Kiaochow; that Italy would join them – but Italy, one of the foster mothers of civilization, joined civilization against barbarism."[52] On a related note, speaking to yet another New York audience, the ambassador shrewdly and implicitly countered an idea that he knew was brewing in the mind of President Wilson: namely that there was a distinction between the militarist regime of the kaiser and an innocent German populace, an idea that would one day open the door for a generous, forgiving peace settlement. It was true, the ambassador conceded, that France and America were at war with German militarism. But militarism meant far more than having many soldiers. It "consists of the whole nation, young and old, soldier and civilian, layman and priest, blindly accepting to be ruled over in military fashion ... all believing the word received from the people above them." That phenomenon, that dull passivity into which the German people had fallen, Dr Jusserand

explained, was how "the whole forces of the nation [were] placed in the hands of a single man."[53]

His use of language, by subject and expression, was but a part of a long-standing French campaign to wed through common culture the sentiments of America and France. Promoting the study of the French language was one such device, especially in the form of university-level, oratorical prizes, of the sort Jusserand delivered to the president of Harvard in July 1918.[54] Celebrating the history of the sister republics was another. Lafayette Day provided one such occasion for paying explicit, annual tribute to a glorious age of Franco-American cooperation, and implicit tribute to the selfless service of France. In July 1918 he enlisted history again, in a jam-packed Madison Square Gardens. Reading in wartime from a general's diary, he recalled the reference to "our generous allies" who had supplied money, ships, and soldiers. Thereupon, the ambassador held up the original diary of General Washington, from which he had read the entry for 1 May 1781.[55]

And history was supplemented by Art and Music. Supplemented, sometimes, through public reference to French aesthetic genius of the sort he invoked before the Statue of Liberty, sometimes by means of behind-the-scenes embassy support for a four-month exhibition of French art in San Francisco, or for guest appearances of French musicians in Chicago.[56] And art, in turn, was supplemented by Literature, sometimes through the embassy's work with American affiliates of the *Comité du Livre*, a Paris-based, government-sponsored agency for intellectual propaganda; sometimes by public paeans to the genius of a Molière or a Balzac; sometimes through confidential efforts to distance the government from such pacifist and – he thought – sensationalist and unpatriotic texts as *Le Feu*, Henri Barbusse's stomach-turning account of life, and death, in the French trenches.[57]

But, ultimately, did any of this work? In the absence of anything like public opinion polls for this period, one cannot speak with any degree of certainty about American "public" opinion; and the in-fighting within French officialdom, which crescendoed in 1917, may have left some residue in the appraisals offered, alternately, by friends and critics of the ambassador. Whatever the camp, French officials generally agreed on a number of crucial points about America and Americans, starting with the conviction that the majority knew very little about Europe, historical or contemporary.

Because of their geographical remoteness, and the limited formal education of the many (Tardieu believed that when it came to reading comprehension, 10–12-year-old French children were on a par with 15–16-year-old Americans), they were anchored in ignorance and indifference.[58] The more so as these "many" either did not read newspapers or magazines on a regular basis or, if they did, chose publications that concentrated on subjects of local interest or depended on visual and textual sensationalism.[59] That, together with their intellectual and often geographical distance from art galleries and theatres, concert and lecture halls, made it particularly difficult to tune their sentiments in a key favourable to France and French culture.

Added to these liabilities was the fact that many recent immigrants, while better informed, were often more reluctant to get involved in the disputes they had fled. Or, they were German-Americans, linguistically and culturally allied to the Central Powers. Or they were Catholics who had not forgiven the anti-clerical laws of the French government, or what they regarded as the occupational forces of Great Britain in Ireland. Referring to such diversity, Jusserand wrote regretfully to Paris: "No longer does the bell peel forth a pure sound, so much has its metal been alloyed."[60] What remained most promising for the propagandist, therefore, especially one determined to retain a low profile, were the better educated, more urban, and more demographically concentrated Americans of the eastern United States. And thus French readings of "American" opinion were considerably dependent on trends they thought they detected in those newspapers and magazines of national and, in a case like the *New York Times*, international circulation.[61]

Even then, it was difficult to be sure of trends, apart from signals in the editorial pages. In January 1915, Jusserand felt it necessary to remind Minister Delcassé that an American newspaper was less a family of like minds than a city inhabited by residents of diverse views.[62] And, he might have added, their diversity was only multiplied by the unmonitored reactions of the readers themselves. In any event, with such limitations in mind, he regarded both the *New York Times* and the *New York Tribune* as generally sympathetic to the case of France, a reading supported by the consulate in New York, which in June 1915 characterized American press opinion as broadly sympathetic to the allied cause. The ambassador was more

guarded, reading the *Washington Post* as hostile to England, more favourable to France, but relatively pro-German, and the *Chicago Tribune* as more consistently neutral, but inclined to waver toward the German side.[63]

As for the early wartime disposition of William Randolph Hearst's press empire and his International News Service (INS), both Jusserand and the commercial attaché in New York suspended judgment. Hearst and his newspapers had acquired the reputation of being francophobic in temperament, but in May 1915 the two diplomats agreed that both the *New York American* and the *Evening Journal* provided a mixture of opinion. Sometimes, Jusserand wrote, Hearst "publishes articles which are favourable to us, and sometimes those which are not."[64] Before the autumn, the pattern had become clearer, and darker. An embassy press analyst in New York had surveyed the editorial columns of the *New York American* and concluded that they represented "the most powerful influence now at the command of the German government." The paper, as read by one Monsieur Ortiz, had tried to block allied fundraising and purchasing in the United States, and to fan the flames of resentment among Irish-Americans against England. Jusserand, too, had soured on Hearst, seeing in his repeated editorial references to God attempts to ingratiate himself with Wilhelm II: "to prove he is the Kaiser's boy." Mainly, these French analysts agreed, Hearst's scorn was directed at England, with only diversionary attacks targeted at France and Russia.[65]

Occasionally, the press baron would publish something broadly sympathetic to France, but the overall pattern of 1916 remained unchanged. In October the ambassador condemned the germanophilic, selective practices of Hearst's INS; and in November he warned Paris that its latest intent was to encourage the German population and discourage the allied effort by predicting that France, already "bled white," would be suing for a separate peace in the spring of 1917.[66] Indeed, not until that very spring – after Germany's reversion to unrestricted submarine warfare, after the severance of Germany's diplomatic relations with Washington, and with the United States poised to enter the war – did the Hearst chain turn its guns on Germany. Within months of those developments, it was assuring Jusserand that it had always been pro-French if admittedly anti-English in nature, and was concluding a deal with *Agence Radio* in Paris for the exchange of news, the latter much to the

disgust of a sceptical Lauzanne. And a sceptical Jusserand, who recalled the English proverb: "the leopard has not lost his spots." Not one of them, said his old friend "Teddy" Roosevelt: "Hearst is the ablest and most dangerous foe of the Allies, and friend of the Germans, in this country."[67]

Prominent events such as the German-American falling-out of 1917 had always been capable of altering the mood of press and public. While the sustained allied blockade against neutral America had been a substantial irritant to Americans, it never conveyed the horrifying human drama of the *Lusitania* disaster in May 1915, or, that autumn, of the German execution of the British nurse Edith Cavell, both of which contributed to a shift in American opinion against Count von Bernstorff's cause.[68] But public mood was less static than trench warfare. The German embassy and its acolytes replied with new energy, and the French ambassador watched in frustration as American media elements least sympathetic to the allies pounced on every report of French complaints against the United States. In January 1916, Jusserand had warned the Quai d'Orsay that American opinion, which had been broadly so supportive of France, was showing signs of a shift in the opposite direction, some of it in direct response to public expressions of French ingratitude. Two months later, it seemed to show another correction, with the pendulum coming back a bit in the wake of France's heroic defence of Verdun.[69]

A year later, and coinciding with the mounting disgruntlement against the ambassador, the picture looked less promising. In March 1917, de Polignac concluded that only the German return to submarine warfare against neutral shipping had salvaged France's star in the United States. Jusserand thought that the flood of foreign missions, ill-coordinated and expensive, had become offensive to Americans. Tardieu thought that, despite the best efforts of High Commission, Lauzanne, Bureau, and embassy, public opinion in America was "deplorable" when it came to the allied cause. In particular, like the ambassador, he was alarmed by the public's sense that France was down and almost out.[70] That summer, Pierre de Lanux, completing a seven-month sojourn in the United States, reckoned that the American public had simply resigned itself to the war. Some, especially along the Eastern seaboard, were enthusiastic about defending France against German aggression. Some were hostile, German sympathizers to be sure, but also those who found

in England and France provocation sufficient to fuel their pacifist, anti-imperialist, anti-capitalist, or anti-militarist ideals. Many, especially recent immigrants of immature nationalism and limited education, those unfamiliar with the issues behind the cause to which they had been called, lacking knowledge, commitment, or enthusiasm, would simply resign themselves to obey.[71] Not, on balance, the brightest of pictures for French officers assigned to nourish this populace with good information and to monitor the results of their efforts.

Another year later, the picture had turned much brighter. The combined propaganda efforts of the British, French, and Italian governments were part of the explanation but, one assumes, a small part in comparison with the efforts of the dynamic, well-financed Committee on Public Information in Washington. Suddenly, there was an American-born, American-targeted, propaganda machine at work, one that gained even more momentum with the choking of the German offensive in the summer of 1918 and the opening salvoes in the allied counter-offensive.[72] By August, the French High Commission was satisfied that Americans were fully behind the war, that they accepted both the legitimacy and the necessity of Alsace-Lorraine's return to France on the conclusion of the war, and that, in general, they were manifesting a pro-France "enthusiasm." The trick, Maurice Casenave warned, would be to retain that mood in the face of the durable rumour that France was a spent force, drained of capital, energy, and will. What was doubly upsetting, he observed, was that this false and malicious rumour was being kept alive through the not-so-kind efforts of France's British ally. In short, manoeuvring for position in the post-war world had already begun.[73]

This expression of unease about the ambitions of one's closest ally found echo in the misgivings that Jusserand and others had long nurtured about President Wilson and the American administration. If, given the government's elaborate information campaigns of 1917–18, the American public's perception of the war had been transformed in the allies' favour, was it not obvious that this might have been done near the very outset of the war, had the president, in particular, not been determined to remain resolutely neutral. This is why Woodrow Wilson was so central a figure in the fortunes of all foreign embassies in Washington, and a figure critical to any evaluation of the career of Jusserand. It is time to bring the president into the foreground.

Europe's several declarations of war in the summer of 1914 had inspired Wilson's prompt declaration of American neutrality. Formally, no judgment was to be made in Washington about the guilt or innocence of the warring parties, and no American was to die in their interests. This position was never meant to imply indifference, for a man of Wilson's intellectual and theological background could not countenance the idea of resolving differences with guns[74] – the more so when the direct interests of the United States seemed better served by neutrality than armed intervention. Which came first in his mind, principle or pragmatism, is a matter of conjecture, but as long as the two coincided it was easy enough to remember the ancient affirmation: "Blessed is the peace-maker."

That recollection had been behind the president's interest in mediating an early end to the fighting in 1914 and 1915, just as it was in the spring of 1916 when Jusserand had picked up new rumours of another presidential initiative in the name of peace. His response had been to rush to the State Department in hopes of heading off any new offer at mediation, and to counsel Colonel House in the same direction. Indeed, he was instructed to do so by Foreign Minister Aristide Briand, who saw potential hazards for France beneath the surface of Wilsonian benevolence.[75] Although the president had a natural preference for the liberal-democratic regimes of the western allies, his commitment to neutrality still prevented him from taking sides on the key issue of who or what had caused the war in the first place. Particularly when he was up for re-election in the autumn of 1916. This resolute ambiguity on the causes of the war therefore brought him closer to the German position, which thus, in the eyes of Briand and Jusserand, compromised his contribution as future peace-maker.[76]

The turnaround occurred only after Wilson's successful, but narrow, re-election. Jusserand closely observed that campaign right up to election day, uncertain almost to the end as to whether the Democrats would return to the White House. Wilson, he observed, still cherished the idea of America being "humanity's knight," but much of his backing came from public support for neutrality. Within two weeks of his re-election Wilson delivered a speech in New York which the ambassador heard with mixed feelings. He thought he detected in the text some gesture of sympathy for the western allies, but was sure that the president was marking out for himself a leading role in the conclusion of the war and the outline of the peace.[77]

Two weeks later, in mid-December, there was new evidence to that effect. The State Department published a note from the German government raising anew the possibility of a negotiated peace. Significantly, the Wilson administration declined to mediate this new overture, prompting Jusserand to surmise that the president wanted to ensure that any breakthrough peace initiative came from him alone.[78] Within forty-eight hours the ambassador took as confirmation the issuing of an American note inviting the belligerents to publicly identify their war aims, an invitation that annoyed the ambassador with its implication that those war aims had common elements.[79] He expressed that annoyance in a conversation with Colonel House, who ended up comparing the French ambassador unfavourably with the German. While he judged Jusserand's assurance that France would "fight to the last man" as simply "high-flown" and "foolish," House reckoned that von Bernstorff was the only ambassador of the warring countries who had "any sense of proportion."[80] But Jusserand was equally outspoken to State Secretary Robert Lansing, marvelling at the president's ignorance of, or perhaps his indifference to, the actual causes of the war, likening him to a "doctor who says, 'I don't know what is causing your illness ... but let me cure you,'" and working in a barbed reminder of "the unavenged dead of the *Lusitania*." Drawing from an even older history, the ambassador asked Lansing, rhetorically, what the North would have thought of a foreign proposal for peace with the South in 1864. Without waiting for an answer, the ambassador ventured: "You would have said, 'Thanks very much, but we would prefer to wait.'" In short, this was no time for a peace initiative that would only play into Germany's hands.[81]

The new year started badly, with a re-confirmed president offering Congress a sanguine vision of European reconciliation. He spoke of an eventual "peace without victory," a prospect that appalled Frenchmen. In Paris Georges Clemenceau remarked: "No assembly had ever heard such a beautiful sermon on what humans were capable of realizing, if they were not humans." The ambassador was equally troubled by presidential rhetoric: no guilt, no punishment, only some hazy glimpse of a post-war era kept peaceful through the conflict-resolving services of an international league of nations.[82] "What is this 'peace without victory'?" he asked rhetorically, "this peace of equals ... this peace that puts aggressors and victims back to back; this peace that is unlike any peace that has

ever been signed by the United States, whether with England, Mexico, or Spain."[83] But there was one bright spot on the horizon.

In December 1916 Jusserand had been assured privately that Wilson's sympathies definitely rested with the allies, a confidence repeated days later by Lansing.[84] In early February, the tide began to flow more quickly in France's favour, and against Germany's hapless and unheeded ambassador in Washington. In response to his government's decision to resume its campaign of unrestricted submarine warfare, the United States terminated von Bernstorff's diplomatic mission to America. The State Department returned his passport to a tearful and "bitter" Count von Bernstorff, and sent him and some two hundred embassy and consulate officials back to Germany, thereby severing its diplomatic relations with the kaiser's regime.[85] A sad day for the Germans, a jubilant one for the French. Eyewitnesses watched the ambassador's car "bowling rapidly ... in and out through the streets" of Washington, American and French flags flying from either side of the radiator. Yet even Jusserand could not observe the departure of his German rival on 14 February without a touch of sympathy for the statesman who had toned down his rhetoric in the course of 1916, and who had argued vehemently against any break with the United States. Not without a tinge of bitterness either, as he compared the three working staff of his embassy with the thirty departing the German embassy.[86]

Ten days later the Wilson administration learned via British intelligence of a German offer to join Mexico in a war with the United States, news of which incensed American opinion. No surprise, therefore, that the president proved a good deal more forthcoming when he saw Jusserand on 6 March. He wanted to explain, in March, that by "peace without victory" he had meant, in January, only a peace that was not built on a colossal error like the annexation of Alsace-Lorraine in 1871, thus privately implying that any future settlement would have to see their return.[87] Roughly two weeks later, three still-neutral American merchant ships were sunk by German submarines; two more followed before the first of April. Jusserand kept count of the dead, 226, before neutrality became a thing of the past on 2 April 1917.[88]

The United States' entry into the war represented a sea change in global politics, although Wilson had made the decision reluctantly and with many of his earlier convictions still intact. None was more aware of this fact than Ambassador Jusserand, who quickly picked

up on one line of a Wilson speech of late May 1917. Even though America was now at war in response to prolonged and murderous provocation, the president had maintained that the United States still had no quarrel of its own with the Central Powers. It was an unfortunate, dumbfounding slip, the ambassador told Paris, which may have occurred because the president reportedly relied on others to prepare his speeches.[89]

Despite renewed assurances from the White House, both private and public, that the government was truly committed to waging war to the fullest, Jusserand remained guarded about Wilson. In August he warned House that German talk of peace was fraudulent, and was generated only to save "the criminals" from being punished; this while Belgium and France remained "ravaged [and] blood-soaked." He did not venture his personal suspicion that vanity had something to do with Wilson's lingering interest in a negotiated peace – vanity in the form of a resolve not to forfeit leadership of a movement for peace, not even to Pope Benedict xv.[90] Wilson himself almost seemed to take pleasure in the fact that a misspelled "Jouserand" had gone "up in the air" at the thought of Germany escaping unpunished. Indeed, the president told House that, in the face of the ambassador's too-open resistance to the idea of a negotiated peace, and his "excitable impertinence," he was wondering if the time had come for him to be recalled to Paris.[91] Although some of that tension seemed to dissipate early in 1918 with the president's public commitment to the restoration of Alsace-Lorraine to France and the escalation of his forceful language to and about the German government, Jusserand still felt the need to warn any interlocutor against being gulled by Germany's "gentle words" or by wishful thinking that France would accept a "bastardized peace." For his part, the president confessed to House that he could never be sure if his interviews with the French ambassador were going to become "stormy," especially when there was any talk of negotiating an end to the war.[92] "I hope that there will be no peace at all," Jusserand wrote to Myron Herrick, former and future American ambassador to Paris, "if it is not to be a glorious and definitive one."[93]

Central to his uneasiness was the president's apparently unshakable resolve to separate the German people from the German regime, the former largely innocent, the latter principally guilty. In January 1918 the ambassador warned Paris, following a conversation with House, that Wilson and the British prime minister, David

Lloyd George, seemed to agree on the need to target Prussian militarism rather than the German people at large.[94] In August the president's determination remained intact; if anything stronger than ever in the face of Republican critics like Senator Henry Cabot Lodge of Massachusetts, who said post-war Germany would have the government it wished, just as it currently had the government it wanted and whose ambitions and barbarism it supported. Indeed, well into October, as the allied military offensive in the west gained momentum, it was clear that the distinction between people and regime still prevailed in the president's mind.[95] And nothing was likely to change it. Although Lansing was equally set against a peace settlement inspired by a desire for vengeance, he and others in the State Department knew that, in any case, Wilson was not a man for turning.[96]

Lansing and Jusserand had had many conversations about where to draw the line separating the wish for "justice" from the desire for revenge.[97] Perhaps it was one of those moments that had reminded the ambassador of Blaise Pascal's observation that "Justice without force is powerless; force without justice is tyrannical." Whatever the inspiration, it was to Pascal and this theme that he turned when addressing the United States Senate in late September 1918, as the military tide was turning against Germany. Force, he said, was the only argument Germany understood. In a philippic worthy not of a scholar but of a patriot aroused from a nightmare, he recited the charges:

We have to deal with a strange enemy; I shall not say a monstrous enemy, though, in fact, such he is ... That unique enemy can devise liquid fire, poisonous gases, poisonous propaganda, noxious germs ... and accurate shelling of Rheims and burning of Louvain, the sinking of the Lusitania and hospital ships, perfectly appointed wagons to carry off loot, the efficient slavery of civilians ... He can devise, he cannot understand; he has no eyes to see, no heart to feel ... [Germans] now pretend their eyes begin to open and they babble of peace [though] not the peace of right. They still admire their Treitschke who said, "small states have no right to exist."

Lansing's colleague Thomas R. Marshall responded with a jeremiad of his own. In a speech full of adoring references to Charles Martel,

Joan of Arc, and Joseph Joffre, he turned on Germany as he might
some anti-Christ: "I hope the good God, ere my race is run, will
let me grasp reverently the hand of Ferdinand Foch. He will con-
quer and survive, for, never fear, Berlin must not triumph over
Bethlehem."[98]

But Marshall was only the vice-president. Though disinclined to
take a back seat to anyone when it came to Providence, the presi-
dent had to exercise more caution in his public statements. While it
was morally essential to be able to distinguish good from evil, polit-
ically there were risks and liabilities in drawing too sharp distinc-
tions. Had there been any doubt as to why he had defined the
United States as an "associate" rather than an "ally" of the coali-
tion led by Britain and France, that doubt was completely dispelled
in October – only a month prior to the war's end – when he and
Jusserand had a tense conversation in the White House. It was tense
from the French perspective, partly because the president was deter-
mined to enshrine an unrestricted "freedom of the seas" clause in
the peace settlement to come, thus potentially threatening the
future application of the naval blockade that had been so central to
Anglo-French survival in the current war. Partly, too, because Wil-
son had remarked that in the absence of that war, America's most
likely enemy would have been Britain.[99] However hypothetical the
view, it did not augur well for an "allied" coalition that needed to
be as united at the peace table as it had been in battle.

It was in that same month of October that Germany and Austria-
Hungary, as their military fortunes were collapsing, again proposed
discussions for ending the war, discussions based on the principles
of Wilson's visionary Fourteen Point speech of January 1918.
Because Wilson had foreseen a future free of naval blockade and
regulated by an international body that would guarantee the "terri-
torial integrity [of] great and small states alike;" because he had
leaned heavily on words like "open-minded" and "impartial" and
had envisaged "open covenants of peace" being "openly arrived
at," the Central Powers detected opportunity within their despera-
tion.[100] There ensued a series of telegraphic exchanges between the
German government and that of Woodrow Wilson, the contents of
which were quickly published in the leading newspapers. Not with-
out controversy. According to Stéphane Lauzanne's office in New
York, prominent Republicans like Theodore Roosevelt, William
Taft, and Henry Cabot Lodge, as well as papers like the *New York*

Tribune, condemned the idea of negotiating in any way with the enemy. Most Democrats, and papers like the *New York Times* and the *New York World*, supported the president, as did, by Lauzanne's reckoning, a majority across the country. That meant, Lauzanne continued, that France had to accept the inevitable, namely that the war could be brought to an end through discussions between her recent "associate" and her time-honoured enemy. What France must do, he wrote to Jusserand, who needed no convincing, was to continue to resist any arguments based on the innocence of the German people and to remain sceptical about the sincerity of their regime's acceptance of Wilson's Fourteen Points. As for the Americans, best to address them kindly, but firmly. Sometimes, he continued, people in Paris took flattery to excess, a technique badly contrived to impress Americans. Jusserand, for his part, now confident that Wilson accepted the need for an absolute victory as prelude to any kind of armistice, worried about overdoing anything, particularly in the area of propaganda. "We already have the Head of State and the two federal chambers behind us."[101]

By the end of October 1918 and Lauzanne's report to the embassy, the war was entering its final stages and there were new reasons for Jusserand to feel more optimistic. On 2 November he was the first to tell Wilson about the abdication of Kaiser Wilhelm II – news just broadcast by the German legation in Denmark – and for the first time heard from the president's mouth that priority would have to be given to the post-war restoration of northern France and Belgium.[102] But he did not like Wilson's worrying over whether or not Germany would accept the terms of an armistice, and, with remarkable prescience, articulated his own fear of the future. Unless the ensuing treaty formally and openly confirmed Germany's military defeat, its army would invent a claim that it had been betrayed by civilian negotiators.[103]

Nine days later the president read the terms of the Armistice to Congress, in the presence of a French ambassador "too choked with emotion ... to express himself," particularly when he realized that the loudest applause came when Wilson referred to the now-determined return of Alsace and Lorraine to France. Later that evening, the president broke his own custom of avoiding foreign embassies by appearing with Mrs Wilson at the celebratory party being hosted by Ambassador Jusserand. Even more remarkably, he volunteered a few words for those assembled, invoking a boyhood

memory of the German theft of Alsace-Lorraine, and adding mystically that he had known from that day on that he himself would be instrumental in the return of the provinces to France.[104]

Nevertheless, only days later, the same president was making sounds more promising to the Germans. He was speaking less and less of Germany's acts of barbarism, Jusserand reported to Paris, and more and more of her own suffering and her vulnerability to the Communist threat now realized in the form of Bolshevik Russia. In a telling response to a question of Paris origin as to whether France should be contemplating a statue to honour the president, Jusserand advised against the suggestion. Partly, he said, because it would look too much like flattery at best, genuflection at worst; partly, he did not say – but meant – it would be a mistake to lionize the president before he proved at the peace conference that he was indeed a lion.[105] The fact was that the president had just suffered a major political blow in the form of congressional elections, which had punished the Democrats and rewarded the Republicans with majorities in both the Senate and the House of Representatives.

5 Old Arguments, New Quarrels (1919–1921)

It took a wise man not to prophesy Woodrow Wilson's future conduct toward France. Jusserand's critics were right to say he had never succeeded in establishing an intimate relationship with the American president. He was right, in turn, to retort that Wilson's inner circle was miniscule: his wife, his secretary, his doctor, and Edward House. That view was shared by the British ambassador, Sir Cecil Spring-Rice, who complained that ambassadorial access to the president had become all but impossible – except, he added, for the ambassador of France.[1] By late 1918 that ambassador and the president had a history of turbulent relations. Their personal interaction could be warm, at times even jovial, when their views coincided on policy or performance, but when they did not, as was just as often the case, both men privately expressed variants of anger, resentment, and frustration. Sometimes the issues were relatively minor, such as Wilson's failure to attend the House of Representatives in early May 1917 when that body officially welcomed officers of the newly formed and newly allied French High Commission. Confident of his ground, which is to say of what *he* thought was appropriate and what not, the ambassador asked the White House for an explanation. "Astonished" at being thus challenged, especially by a foreign diplomat, Wilson instructed that – "if an answer had to be sent" – the embassy could be told, somewhat dismissively, that he understood no French.[2]

More serious were the Franco-American policy differences, which by the final year of the war, had become sharply defined and which explained increasing moments of testiness between diplomat and head of state. To be sure, not all was difference. By the autumn

of 1918 they were in unison about the need to prosecute the war to
a decisive victory and not to jump at any German-offered armistice
lest such an opening undermine the American public's commitment
to the war effort. They were agreed on the need to make the western
front the number one strategic priority, and to work within the
realms of the possible when it came to reconstituting some kind of
eastern front.[3] Indeed, the latter objective was so fraught with com-
plexities that neither the French nor the American government was
secure enough in its stance for any acute difference to arise. Both
regretted the advent of the Bolshevik regime in Russia – though not
in equal measure the disappearance of czarist government; both
anticipated that at the last moment Germany would cynically offer
to return to her pre-war boundaries in the west in exchange for a
free hand in the east;[4] yet both were apprehensive about the spread
of communism in a German society weakened by war and disaf-
fected by the approaching defeat. They also shared apprehensions
about Japanese and British plans to establish an allied foothold
around the Russian port of Vladivostock – ostensibly with a view to
rescuing elements of the peripatetic anti-bolshevik Czech Legion,
striking a blow at a communist regime which in March had unilat-
erally concluded a peace treaty with Germany, and distracting the
German army with a hint of yet another hostile military front. In
their shared suspicions of the less ostensible and certainly unstated
Japanese and British imperial agendas in the Far East, Washington
and Paris found yet further common ground.[5]

But shared suspicions of others was an unreliable glue for filling
the cracks in their own relationship. Indeed, the war had produced
or sharpened its share of mutual suspicions, all of which Ambassa-
dor Jusserand had fought hard to diminish. For reasons under-
standable, given their geographical distance from the war zone and
the sizeable numbers of Americans whose cultural roots were Ger-
manic, American observers were far more tolerant than French
observers of Germany's aspirations to be a world power, of the kai-
ser's blustery regime, and of its claim that Germany had actually
been drawn into the war by the machinations of its rivals. They dif-
fered, too, on the degree of responsibility that the German people –
as distinct from their government – should assume for the war and
for associated outrages against civilians on land and sea; and for
that reason, they approached the peace conference with different
notions about justice, retribution, and the kind of settlement that

would make future war less likely. Within days of the armistice in the west, Jusserand had detected a softening of the president's language: less inclined to remind his nation of German barbarism, more inclined to worry whether a harsh peace would nurture German communism.[6]

Next to such fundamental differences, some of the earliest postwar disagreements were transitory if not trivial. Wilson preferred Switzerland as a venue for the impending peace conference: France, France. The palatial facilities at Versailles won out, partly on the grounds, as Jusserand put it, that the eighteenth-century treaties confirming American independence had been signed there. For a time, the president had considered sending someone else to head the American delegation, partly out of concern that a presidential absence from Washington of three or four months could raise some constitutional issues. Jusserand urged him to reconsider, playing the card of the president's importance to the war effort and to the settlement about to ensue. That argument prevailed, although almost certainly what the ambassador had said was little more than confirmation of the president's own views.[7]

Whether Mr Wilson was as fully in accord with his wife's views is unclear. Nevertheless, it seems to have been Mrs Wilson who, over a mid-November lunch, proposed that the Jusserands should accompany her and the president to Paris. Three days later the ambassador received the official invitation, promptly notifying Paris to that effect and suggesting that the ministry ensure that a golf course adjacent to Versailles was made ready for a presidential visit. Five days later, the bloom on the rose faded just a little. Public disclosure of the president's travel arrangements had prompted a flood of requests from would-be travellers to France, including those from the Belgian and Italian embassies.[8] The chances for an intimate Atlantic crossing, in fact never good, were thus dispelled; and it would seem that the two men avoided any onboard discussion of serious issues, a prudence that Wilson's attending physician attributed to Jusserand's "wily" sense that the president was not for pushing.

What did not happen on the early December voyage proved less obstructive than what did. While still on board, Jusserand received a ministerial telegram, courtesy of the State Department, urging him to finalize the arrangements for an early presidential visit to the devastated regions of France. From a French point of view it made

sense for Wilson to see first-hand the destruction caused by the war in general and by Germany in particular; to see, as Henry White, an American peace commissioner, would express it: "more than two hundred miles [where] not a city or village ... is not more or less badly damaged." But the president took it as an act of manipulation at best, arm-twisting at worst, and balked. He saw it as a crude propaganda ploy, especially the unseemly haste with which the French government insisted he go on tour, a suggestion promptly repeated by Clemenceau in Paris – so that "you may see ... for yourself ... the German strategy for ... pillage and destruction." In short, he was "seriously annoyed" by the pressure; and thus began this "obstinate" man's sojourn in France, irritated and resentful. It was to get worse.[9]

Well before his ship had landed at Brest on 13 December, Wilson had received through Jusserand the French government's broadly brushed proposal for the peace conference agenda. Once the procedural arrangements had been worked out in the second half of December – arrangements such as those relating to secretarial, administrative, and archival services – the plenipotentiaries would turn their attention, first, to issues pertaining to the "settlement of the war," and second, to the organization of Wilson's pet project, a League of Nations. As for the first priority, it was made clear that the conditions of the peace would be "imposed ... on the enemy without any discussion with him." Also understood from the very beginning was an allied commitment to territorial restoration – Alsace-Lorraine, Belgium, Luxembourg – and territorial reallocation, notably the cession of German colonies, and the anticipated recognition of newly independent or enlarged states which had emerged from the collapsed Russian, Austro-Hungarian, and Ottoman empires. And lest the point be lost, it was once again asserted that whoever the former enemy – German, Austro-Hungarian, Bulgarian, or Turkish – they "would have no right to discuss the terms that will be imposed upon [them]."[10] Impossible here to miss the French government's resolve that this was to be a victors' peace. Impossible also to anticipate the unease it produced in an American president who believed that now was the moment to erase international antagonisms, rather than confirm them.

While a great deal is known about the president's triumphant arrival in Europe in December 1918 and about his final, troubled

departure six months later, the opposite is true about the ambassa-
dor's role over the same period.[11] Unlike Woodrow Wilson, the
Jusserands looked forward to their departure from Washington and
the return to "dear France" after an absence of four years; and
unlike him, they were determined to visit the northern battlefields –
not to confirm the devastation that had been wreaked on French
countryside, towns and villages but to rejoice in their liberation.[12]
This they did in April 1919, while the president was engaged in
high level discussions at the Paris Peace Conference, and once more
– unlike Wilson in Paris – finding their experience "thrilling." We
saw, he wrote to John Finley, "what the Hunnish fury had done and
what the valor of the soldiers of Right had performed. To see the
tri-color at the top of the steeple of the cathedral in Strasbourg was
a thing to gladden one's heart for the rest of one's life." No less
moving for France's long-serving ambassador to the United States
was the visit to St Mihiel, where the Americans had fought only
eight months earlier, and which their valour and sacrifice had
"made French again." It was, he told Senator Lodge, "the most
memorable journey in our lives."[13]

Less inspiring, certainly, was the turbulent course of international
politics. The end of disciplined trench fighting and the recent sur-
render of an enemy had soon uncovered manifold fissures in an
"allied" camp no longer sworn to unity. Ambassador Jusserand was
remote from decision-making levels. His principal task was to act
as a liaison officer between the foreign ministry and the American
delegation headed by Wilson; more specifically, that meant trying
to calm the troubled straits between the negotiating objectives of
his own government and those of the American president. Some of
his duties were aimed mainly at providing to Secretary of State Lan-
sing, or soliciting from him, information on relatively secondary
matters such as the Danish interest in Sleswig, the allied military
occupation of Austria, the possible recognition of a combined Ser-
bia and Montenegro. Given the facts that Jusserand was but an
ambassador, that Lansing was accustomed to being left on the mar-
gins by his president, and that Jusserand considered the Lansings –
with whom they were to tour the battlefields in April – to be
"among our best friends," this was a happy illustration of unruffled
Franco-American exchange.[14] But it was not unique, for in May
1919, some weeks before the terms of the peace treaty with Ger-
many were made public, Wilson was received and feted by one of

France's intellectual bastions, the Académie des Sciences Morales et Politiques. Accompanied by American ambassador Hugh C. Wallace, the president enjoyed one of his final moments of acclaim in France. Also escorting him that day was Ambassador Jusserand, who had more than one reason to be reminded of the president's current stature. Until the end of 1918, the Jusserands' Paris address had been 28 avenue du Trocadéro. By 1 January 1919 the street had been renamed the avenue du Président Wilson; remarkably, it still bears his name.[15]

Remarkably, because Franco-American relations were beginning a new chapter of unprecedented strain, one that would outlast the peace conference and cast a long shadow over the whole of Jusserand's post-war career in Washington. To understand the depths of this stress, however, we must leave the ambassador to his own devices, even if momentarily, while we focus our attention on the high-level negotiations that took place in Paris: especially those between Wilson, Prime Minister David Lloyd George, and Premier Georges Clemenceau.

Between the third week of February and the middle of March, Wilson was absent from the conference, either on the Atlantic between America and France, or at home, trying to staunch Democratic bleeding on the political front. He returned to France on 14 March, no happier than he had been on his first arrival in December. Even before his first meeting with Colonel House, on that very day, Wilson knew that American opinion already was turning against a purportedly vengeance-crazed France, a shift facilitated by his government's decision to abruptly discontinue the work of the short-lived but effective Committee on Public Information. He also knew that influential voices within the Republican majority were determined to resist his efforts to build into each of the peace treaties an international agency to ensure future peace – namely the vaunted League of Nations.[16] House brought no cheer to Brest. No progress on the League had been made during the president's absence; and talks had stalled on what the Europeans considered to be the single, most critical issue. There would be no lasting peace, the French had said, until Germany had been declawed. More explicitly, France would never be secure against an industrially and demographically more powerful – as well as inveterate – enemy until there existed between them a semi-autonomous buffer state in the Rhineland, and until permanent control of the principal Rhine

bridgeheads was awarded to France and her erstwhile allies. Even given the anticipated treaty restrictions on the future size of Germany's armed forces, the buffer and the bridgeheads were the minimal insurance against another invasion of France and another war fought on her soil. So had said Clemenceau, prompted by the former allied commander, Marshal Ferdinand Foch, and buttressed by the Republic's president, Raymond Poincaré.[17] Conversely, Lloyd George had said there would be no lasting peace if Germans were plucked from Germany to create an artificial state for France's convenience. Nothing, the prime minister had contended, would be better calculated to ensure German animus, for precisely the same reason that, after 1870, the French had never given up on the return of Alsace and Lorraine. Point and counter-point, each reasonable in its own terms, neither mutually acceptable. What was clear, apart from the guns being silenced, was that two months of intermittent discussion had left the principal parties far apart, engaged in another kind of war. And now Wilson was back, angry that his homologues had ignored the threat of communism in Germany, had failed to gauge the long-term consequences of a German nation humiliated by a victors' peace, and angry that the League – as he envisioned it – had been shunted aside.[18]

But House knew that better news awaited the president upon their arrival in Paris. Within what was left of the day, Lloyd George had apprised Wilson of a dramatic new idea and had secured the American's support for presenting it to Premier Clemenceau later that same day. If Britain and the United States of America formally guaranteed the future security of France against an act of unprovoked aggression, would the French government abandon its demand for an autonomous Rhenish state and permanent control of the Rhine bridgeheads? The answer was not immediately forthcoming. Indeed it took a full month for the French premier to accept the offer, resisted to the end by the offices of Marshal Foch and President Poincaré, "who drew themselves up the full height of their particular genius, and brought down on me the flood of condemnation."[19] But in the end, Clemenceau reluctantly agreed.

That decision, conveyed on 14 April to the Anglo-Americans, proved to be of crucial importance for the immediate present and an elongated future. It meant for France the abandonment of what many soldiers and statesmen considered to be the very best insurance against some future German attack, in exchange for a

possibility of better Franco-German relations – since the Rhineland would remain German – and for the possibility of Anglo-American protection in the event that Germany should once more resort to invasion. It meant for the conference, first, that progress could now be made on critical issues relating to western Europe, and second, that whatever terms came to be written into the treaty with Germany, none would be as harsh as those of the original French plan. The French concession, because it essentially restarted the negotiating process in the second half of March, also enabled Wilson to secure one of the things he had come for: formal provision for his League of Nations concept within the treaties of each defeated enemy. The rewards for France, however, were nothing like as immediate, and therefore nothing like as certain. That uncertainty slowly turned into a sense of betrayal. Not until late June, only a day before the Versailles treaty with Germany was signed, was Clemenceau told, verbally, that the status of Lloyd George's pledge to French security was, in fact, dependent on Wilson's ability to secure Congressional ratification of his own, complementary guarantee. Suddenly, what had been proposed in mid-March, and accepted as a bilateral assurance, had become no more than a possibility hanging from an American thread.

It was not until July, after the delegates had left Paris, that the now qualified British pledge was passed by parliament in Whitehall. And it was not until August that Wilson submitted his own guarantee treaty for Senate ratification, three weeks after his submission of the Treaty of Versailles and therefore in contravention of the textual provision for simultaneous submission of both treaties.[20] Well before then, before July, indeed before April, everyone knew, including the president, that the passage of either was not at all certain. Having tied the German treaty to the controversial provision for a post-war League of Nations, and having insisted that the guarantee treaty to France also carry within it a reference to the "jurisdictional authority" of this barely born international organization, Wilson seemed bent on provoking his Republican opponents in the Senate. Indeed, Washington insiders knew that while most Republicans were entirely open to a straightforward guarantee of French security, they were chary about subordinating America's freedom of manoeuvre to an international organization.[21]

What had happened in Paris had made one thing clear. The League had become Wilson's passion ... and his obsession. From

mid-March onward, he had betrayed the zeal of a "militant." House had seen it, as had Jusserand, whose delicate attempt to raise the possibility of making some changes to the League concept had drawn an immediate rebuke from the president: "Hold on, Mr. Ambassador." He had already compromised on the wording of the League charter, or Covenant, and was not in the least disposed to make further concessions.[22] Relations with House had deteriorated that spring, the latter somewhat belatedly discovering that his boss was "the most prejudiced man I ever knew," and grumbling over Wilson's unwillingness to draw effectively upon the expertise and secretarial support readily available within the American delegation. Disappointed, disenchanted, resentful, Wilson had become more and more querulous, his mood symptomatic of an idealist outraged by pragmatists and by political realities in Europe and at home. More than that, perhaps, by the necessity of having had to bow to both. Contrary to his instincts, in mid-June 1919 he had collaborated with his erstwhile "allies" to draw up "the complete arraignment of Germany," which would ensure that German arguments against a punitive settlement were "thoroughly demolished." He had succeeded, it is true, in ensuring that the indictment had been confined to the kaiser and his regime – rather than incorporating the German nation – and, to be sure, he had managed to enshrine the nascent League of Nations in the Treaty of Versailles, the German treaty. With that, the president had wanted desperately to go home.[23]

Unhappy, apparently unwell, and in no mood to celebrate, Wilson had been ready to allow any teapot to brew a tempest. All that was needed was an excuse. Curiously, it had come from Elise Jusserand, a presidential dinner guest who innocently had expressed the hope that Wilson would pay his respects to Monsieur Poincaré, president of the French Republic, before leaving for the United States. It was, she had remarked to Dr Grayson, a matter of etiquette – to which the physician had quickly countered with a complaint about a recent breach of etiquette by the French foreign minister, Monsieur Pichon. From there, matters had deteriorated. As an indirect but none too subtle way of securing his goal, Poincaré had tried to extend a dinner invitation to his fellow president through Jusserand. House, in whose eyes Wilson had lost much lustre, noted that Wilson "absolutely refuse[d] to accept." Indeed, knowing in advance the purpose of Jusserand's attempted

visit, the president had avoided the invitation simply by refusing to see the ambassador. Later that day, in a meeting with House, Wilson had remained adamantly opposed to spending another minute in the company of the French president, whom he considered a close-minded militarist. "He said he had no notion of eating with Poincaré, that he would choke if he sat at the table with him." "Why," Wilson had exclaimed, "does he not come to me?" Recognizing, however, according to House's account, that neither the colonel nor Henry White agreed with such petulance, Wilson had reluctantly opened the door to a reversal. Perhaps he would see Jusserand, and perhaps he would agree to dine with Poincaré, as long as neither House nor White said anything to suggest they had ever thought him to have been in the wrong.[24]

But in truth, his temper had not improved. The next day, 24 June, he had gone to Versailles to discuss the official signing ceremony for the treaty with Germany. Clemenceau had been in a good mood, but less obviously Wilson, who had railed against a rumour that the Germans intended to delay the ceremony – and hence his departure. On edge about his former allies, he was not about "to take foolishness" from a former enemy. The mood continued. Later in the day he had declined, again, to see Jusserand, and asked Grayson to explain to the discomfited ambassador that he "could not go" to any dinner. He was too busy. More to the point, he wanted to leave France as soon as the treaty was signed. Even more to the point, as Grayson knew full well, he "did not want to go." The president, he knew, was still nursing a resentment over "a number of nasty things" that Poincaré had allegedly said about him; and therefore was determined not to accept "any hospitality at his hands."

But he finally relented, mainly because Poincaré had been prepared to compromise by moving up the dinner by one day in order to accommodate the president's travel plans; partly, perhaps, because the twice-rejected ambassador had left behind a conciliatory, hand-written note sympathizing with Wilson's workload and attendant fatigue.[25] This time Wilson had given in, not graciously, and certainly not through any change of heart. He simply disliked Poincaré, a reaction reinforced by Mrs Wilson, who was said to have aided him "in his obstinacy." But they had gone, attended the Versailles ceremony the following day, and departed France in haste, confiding to one of their entourage how "terrible it was to have to ... love France!" The feeling could be mutual. Even the

time-tested Jusserand went on private record as seeing in Wilson a tyrant of old, "because he does not seem to have the slightest conception that he can ever be wrong."[26] The treaty the American president had helped broker, Jusserand considered to be a minimal achievement, inspired not by a spirit of vengeance but by a concern for "reparation and safety; nothing more, rather something less." In the interests of a broader accommodation, France had sacrificed her interests in the Rhineland and in the Sarre Valley, and had done so when there was still no sign of contrition from the Germans and when their school teachers were already picking up on the theme of Germany victimized, Germany in need of revenge.[27] Still, because it was their duty, and because it was in their respective national interests, the two men had met again only weeks later, this time at an embassy reception in Washington to mark the French national holiday on 14 July. The appearance of the Wilsons, the second time in less than a year, was unexpected, as was the late hour at which they departed.[28]

Jusserand was grateful for the gesture but appalled by the president's obstinate refusal to give ground on the matter of the League's incorporation into the treaties with the defeated powers, and into the presidentially promised guarantee to France. Long had it been known that many senators and representatives were opposed to such incorporations, just as many were determined that Congress, and not the White House, should be the final arbiter of any peace treaty. By the end of July, only weeks after the glittering reception at the embassy and the public expressions of Franco-American amity, the ambassador warned his minister, Stephen Pichon, that trouble was brewing, the more so as the country was approaching a presidential election in the new year. There was growing uneasiness with the League itself, with its formal linkage to the German treaty, and with its linkage to the guarantee to France. A few months ago, Jusserand said, the treaty with Germany, minus reference to the League, would have been approved. But Wilson had refused to separate treaty and guarantee from his League and, inexplicably, had delayed submitting either for Senate ratification – mainly, Lansing thought, because he always dug in his heels when urged to do anything. Now he was reduced to lobbying individual senators. On 30 July, the day Wilson finally submitted the German treaty for Senate consideration, Jusserand believed that its chances for success were poor, recalling the president's words: "I shall consent to nothing.

The Senate must take its medicine."[29] By late August, with France's popularity in the United States even further diminished, he reckoned that there was still a thin possibility that the treaty could pass, but only if the president relented and finally accepted various Senate amendments.[30]

This was a war in which the French ambassador could do little ... a civil war: partly between Democrats and Republicans; partly between Congress and the White House; partly and more personally between an ailing president who associated compromise with weakness and a congressional resistance grown impatient with such vanity and self-destructive stubbornness. In mid-August, Jusserand reported on Republican Senator Henry Cabot Lodge's penetrating critique of the League concept, in the course of which the senator had identified a series of potential constraints on the future independence of American foreign policy. He had asked Jusserand, the ambassador informed Paris, whether he thought provision for the League was "indispensable" to the treaty – a curious question given the fact that the ambassador had already expressed his views to Lodge in April. From Paris, he had written privately that he had "never ceased to advocate that the *principle* of the League be inserted" into the treaty "and that the League itself be the object of a separate convention." Now in August, in the face of Lodge's question, and in the certain knowledge of how apprehensive Americans had become about being dragged into future European squabbles, the ambassador told his masters that he had replied: "In my personal opinion, not at all," a response that Pichon was quick to endorse.[31] But Wilson remained unmoved, convinced that the country was behind him, and harbouring for his opponents what he declined to call "hostility" but admitted was "utter contempt."[32]

By mid-September the Senate's Foreign Relations Committee seemed poised to resist, remarking that the good but naive intention of organizing international reaction against aggression as a way of preserving peace was just as likely to backfire by multiplying the chances of war and the number of its participants. "The fight that is going on now over the treaty," Jusserand reported to Paris, "has raised so much noise and dust that one is half blinded and deafened."[33] By mid-November, congressional stalemate was turning into presidential failure. The Senate refused to endorse Wilson's League, and with that refusal the treaty with Germany. And above

those two failures there loomed a heavy cloud over the all-but-lost guarantee to protect the security of France. For a while, in November and December, Jusserand worked behind the scenes, hoping that through Lansing, or Vice-President Marshall, or Senator Gilbert Hitchcock, or Joseph Tumulty, Wilson's private secretary, the president could be nudged into one key compromise: dropping any reference to the League from the proposed treaty of guarantee for France. To no avail. The ambassador was now convinced that Wilson would never yield, suspicious and fearful that Congress would approve the guarantee to France and then leave the League and the German treaty in suspension.[34] But there would be no more movement on that front than there was to be with respect to the German treaty. It, too, still had a chance of passage if only its reference to the League of Nations could be amended into some kind of vague allusion to the principle of a future international organization. The president would not yield. By now a bed-ridden stroke victim, he preferred total defeat to partial victory.[35]

Indeed, there were no victors in Washington, except perhaps the most rabid of isolationists. If Wilson had failed legislatively, Jusserand knew that many found no pleasure in such a setback, for there was a general sense that the American public admired Wilson's integrity and idealism, and considered Republican leaders like Senator Lodge to have been intransigent spoilers.[36] Certainly France had been no beneficiary of the months-long war in Congress. Even before the end of the summer the embassy knew that France's image and reputation had deteriorated in the eyes of the American public, partly as a result of the unflattering memories of France with which too many American soldiers had returned, and partly because, with war ended, American francophobes had returned to the charge.[37]

All the talk of treaty, League, and guarantee of French security had prompted various kinds of unwelcome comment. It was not pleasing to read unfavourable comparisons between an apparently unthreatening Germany – now without a large army, or air force, or the right to conscript – and a France suddenly vaulted into the status of strongest continental power. Especially, when congressional spokesmen and journalists were able to point out that while the United States was contemplating a commitment to defend France, no such commitment had been assumed by France toward the United States.[38]

Moreover, intense domestic debate had given rise to new out-breaks of francophobic sentiment. Indeed, some quarters of American press opinion had become intoxicated by their own anti-French brew, a state akin, the ambassador noted, to a kind of "alcoholism" as dangerous as that induced by liquor. They criticize us for the secret treaties we signed before and during the war, he wrote, and they claim to be worn out by "our demands, complaints, and fears." In particular, it is being said that we keep expecting more aid and bemoaning our losses instead of just getting down to work. Americans, he said: "detest and scorn the down-hearted, the dispir-ited, the weepers. They must not see us beaten-down while we stare at our ruins. The right chord to strike is: thanks to our ferocious perseverance, and to the energy of our people who work more than they bleat, we will emerge healthy from all of this, despite the fact that we have been faced with a challenge greater than that imposed on any nation."[39] Americans, he continued, are tired of our count-less photographs of countryside laid waste by German shells, and offended by the way our public responses to America seem to vacil-late daily between calumny and flattery. Could we not, he pleaded, have some photos displaying our recovery, our fields being reseeded, and could we not try to be more forthright and measured in our dealings with this country?[40]

It was, of course, an old complaint concealed within an old plea. And neither was singular. Throughout the summer and autumn of 1919, the French ambassador to Washington tried to keep an eye on the prolonged treaty debate, only without raising a voice or an eyebrow that could be construed as French intervention in Ameri-can politics. At the same time he had to compensate for what he considered to be bungling superiors at home, whom time had made no wiser. His complaints were many and varied, but they can be compressed into two large accusations: one against ministerial par-simony, the other against ineptitude.

The post-war embassy, he complained, had been stripped below a minimal peacetime complement, rendering him unable "to cope, day by day," with his obligations. The four young officers who had been assigned to the wartime embassy by the High Commissioner were about to be demobilized, leaving him with no one to code and decode telegrams, and obliging the ambassador himself to conduct daily, and necessarily superficial, analyses of eight to ten American newspapers. His sole secretary could barely cope with the increased

volume of paper work; nor could the embassy's typists, whose combined total of two compared unfavourably with the twelve employed in the British embassy. And unless he was given authorization to hire a filing clerk, he wrote, the office records would be in a shambles grave enough to impede the efficiency of the entire embassy. That said, given the ministry's accelerating bureaucratic expectations, one must wonder whether it would have been in the ambassador's interests to increase the size of his miniscule labour force, given the fact that it already required twenty-three specimens of his signature, per month, to arrange to pay a single typist.[41]

Speaking of money, Jusserand thought it important for Paris to know that the effective salaries of all diplomatic agents in America had suffered significant reduction since the beginning of the war. This was partly the result of rising costs attributable to war expenditure, but it was due principally to a sharp reversal in exchange rates. In 1914 it had cost just over five francs to buy a dollar; five years later it took over nine. In combination, price rise and franc decline, Jusserand figured that his own emoluments had been cut in half.[42]

Disheartened by what he saw in the Wilson White House and what he experienced in his own embassy, Dr Jusserand drew little solace from the ministry in Paris. Part of it was his sense of isolation, a familiar complaint on the part of someone who expected, at least wanted, replies to his despatches – or at least acknowledgments of them. "All of my telegrams," he grumbled, on the matter of his skeletal embassy staff, "remain without replies ... The Department's indifference is inexplicable." So also was the contrast between the funds showered on the short-term, extraordinary missions, and the "penury" in which the embassy tried to operate.[43] The same applied to ministerial decision making. Why, for example, would the embassy be sent 30,000 postcards in October, depicting the Paris celebration of Bastille Day in July? Why would we circulate in America copies of a pamphlet entitled *La gloire de la France* when it carried within it completely irrelevant illustrations of nude women and men? Did no one imagine, he mused, that the embassy might receive letters of complaint from the directors of two girls' schools, and their assurances that fifty copies from the first and one hundred from the second would be condemned to the garbage pail or the fire? German propagandists must be delighted, he ventured. "It's just astonishing that after so many incidents, so

many missteps, so many useless expenditures, and so many pro-
tests," that we still do not understand what works. Namely, "not to
say too much, not to publish too much, [and] not to reduce every-
thing to the lowest common denominator."[44]

He had not finished. Why do we allow our press to minimize, if
not actually belittle, America's contribution to the military victory of
a year ago, when the defeated Marshal Hindenburg is smart enough
to acknowledge and pay homage to that contribution? Conversely,
why do we put so much emphasis on the destruction we have suf-
fered, and so little on our recovery efforts?[45] Indeed, why would
France ever abandon moderation for excess, simplicity for extrava-
gance, impulsiveness for patience? "One does not make a plant grow
more quickly by tugging at its leaves, one only kills it."[46]

The frustrations expressed by the ambassador through the sum-
mer and autumn of 1919, while not entirely novel, were a clear
measure of one thing. If war, as Clausewitz had observed, was
merely an extension of politics, then post-war politics were capable
of continuing the war in another guise. The truth was that the war
of image and reputation was heating up as the gunfire was receding
into memory. Since this kind of struggle is so central to the efforts of
every foreign mission, including that of Jules Jusserand, it may be
instructive to reflect on that early transition period from formal
war to formal peace, and with a particular eye on the wooing of
America. Less happily phrased, we should be attentive to the
close-quarter clashes of the propaganda warriors.

The wartime German propaganda campaign had executed a shift
to accompany the slow reversal of its military fortunes, from the
early days of strident accusation to a final year of appeals to Ameri-
can pacifism. Neither had worked well enough, as Jusserand assured
– and congratulated – one New York audience. "Even in the worst
days of German propaganda, trumpery, tainted money, false affida-
vits, plots and threats, American good sense and uprightness were
worthy of America." By the autumn of 1919, the Senate's judicial
sub-committee had confirmed that appraisal in a report that con-
trasted the volume of German propaganda activity with its limited
effectiveness. Yet even before the November armistice had been con-
cluded, senior French officials in Paris had detected a new German
offensive, a new war of words that cast Germany as the victim, as a
lover of democracy which was about to be crucified by allies intent
on vengeance and imperial acquisition.[47]

Within three months of the armistice the campaign had spread to the allied-occupied Rhineland, where American soldiers were targeted with doubts about how fairly their former enemy was going to be treated in Paris. And while diplomats and heads of state deliberated at the peace conference, German efforts continued unabated. Some of them were facilitated by American presses of the massive Hearst empire, which liked nothing better than to repeat the fraudulent accusation that France had charged American soldiers "rent" for the use of her trenches.[48] Lest there be any doubts on that score, in February 1919 Information Commissioner Anthony Klobukowski warned the foreign ministry that German propagandists had never been more active, and that the need for a counter-campaign was therefore as great as ever. By March the need was even more urgent as the French military attaché in Washington reported Germany's efforts to infect American soldiers on board homeward-bound ships, in military hospitals, even within barracks on American soil. Too many of these young men had acquired a sense that Germany was modern and oriented to the future, that France was backward, a country with a surplus of wooden shoes and a deficit of indoor toilets. Worse, just at the time that Wilson was submitting the treaty with Germany to the Senate, Jusserand acknowledged that too many soldiers were returning home complaining that they had been cheated by French hotel proprietors and bilked by greedy French merchants. There were, it is true, attempts to attenuate such charges, including a *New York Times* article entitled "Our Bad Boys in France"; but in America it was difficult to fill the imagined chasm between American innocents and French scoundrels.[49]

So it was that in the course of 1919, the year after battlefield engagements had ended, the French government, like the German, shifted gears from war- to peacetime propaganda. The initiative, to be sure, came not from the embassies but from Paris; but an increasingly important consideration for French propagandists was America, and its state of mind. Its resources had proven critical to the successful prosecution of the war, and its post-war status as France's principal creditor had magnified that importance. Thus the drift toward new levels of francophobia called for early recognition and redressment, a call that was certain to prolong the long-standing debate over how propaganda should be conducted in post-war America.

The question, as usual, was one of means and manner. The war itself had given rise to a series of developments within the French government's propaganda services – the birth in 1915 of the foreign ministry's Maison de la Presse, the 1917 addition of the Foreign Information service, and the May 1918 creation by the premier's office of the Commissariat for Information and Propaganda. In addition, in late 1919, with peace restored, the foreign ministry recovered control of the government's information and propaganda services by introducing a new Service for French Works Abroad.[50] It was, therefore, these two Paris-based organizations – the Commissariat and the foreign ministry's new service – that were expected to counter the propaganda offensive launched in late 1918 by Germany's new, and now democratic, Weimar Republic. They, as well as the chain of embassies and consulates abroad, constituted the means.

The manner in which they would work, the devices they would employ, the messages and images they would transmit, proved far more contentious. For if the war had failed to resolve all the issues troubling European peace before 1914, it had been no more successful in settling all the debates surrounding campaigns of persuasion. Early in the post-war period it became clear that certain wartime arguments would not be allowed to fade away. Indeed, when it came to America and the best way to improve her image of France, those arguments only increased in intensity. And at the centre of the storm was an ambassador preparing for his sixty-fifth birthday in February 1920, as well as his seventeenth anniversary as ambassador to Washington.

The truth was that Jusserand's critics would not go away. They were muted, to be sure, as the United States joined the wartime alliance, as military victory was realized, as the president pledged himself to the restoration of Alsace and Lorraine, as the Wilsons arrived in France in the company of the Jusserands, and as the two couples jointly celebrated France's national holiday a month after the signing of the German treaty. But they would not depart. Among the intimations of future trouble had been a lengthy debate in the French Chamber of Deputies in October 1917, six months after a patient Jusserand had been recognized by many as having been instrumental in Wilson's slow conversion to the allied cause. Georges Leygues, a savvy politician of the centre-left, and current chair-

man of the Chamber's Foreign Affairs Committee, had complained at length of the foreign ministry's traditional recruiting and training practices. It was only interested, he said, in men of socially conservative dispositions and elevated educational distinction. Once hired, they had been trained to be ciphers and copyists, deferential to the hierarchy, and wedded to the ways and means of the system they had been privileged to enter. Neither innovation nor dissent was encouraged, and neither used as a formula for advancement. That is why, Leygues had charged, France's campaign of persuasion among neutral countries had been so lacklustre compared to that of Germany. That was why not all, but some, of her diplomatic agents abroad were old-fashioned, indeed "antiquated," short on vigour, and too much inclined to take the pulse of small segments of a foreign population rather than venture out into the real world. Indeed, some such agents had tried to cover up their inactivity beneath a vocabulary of prudence and discretion and within a "systemic mutism."[51]

Not a word was said of Washington or Jusserand, or for that matter the long-serving Paul Cambon in London or Camille Barrère in Rome. But beneath the brume of an attack on the system, it was understood that this was not random assault. Former premier and foreign minister Aristide Briand was the first to return fire, reminding the Chamber that ambassadors were but agents of their government and were thus ill-placed to defend themselves and, instead, praising the work of ambassadors who had helped stitch a massive, anti-German coalition together: England, Japan, Italy, Roumania, and the United States of America. This, in contrast to the "modern" methods of Germany, indeed – lest the sarcasm be missed – the "supermodern" methods of her diplomats who had thrown themselves into the propaganda war, with no results to show for them, except humiliation. Conversely, Barrère, Cambon, and Jusserand had rendered "noble," indeed, "glorious" service to their country and had refused to "Bernstorffize" the countries to which they had been accredited.[52]

Quite so, had said Alexandre Ribot, the then-current foreign minister. Such ambassadors were the envy of other governments, the more so as their resources were often much more limited than those supplied by the same admiring governments. The numbers of personnel in England's embassies and consulates, for example, were almost double those of France; and the salaries awarded were, to

his embarrassment, substantially greater. The fact was, the minister had confessed, that many of France's diplomatic agents could not live on their salaries, especially in countries where – he might have said America – the combination of adverse exchange rates and rising prices had effectively reduced incomes by forty to fifty percent. Yet despite the odds, it was Germany, with its aggressive, "modern" propaganda campaign that stood "rejected and denied by a large majority of the civilized world," and France that was respected and applauded.[53]

But it is doubtful that Ribot or anyone else would have made quite the same claim once the war and peace conference had been concluded. In the United States all the controversy associated with the German treaty and the budding League of Nations in the summer and autumn of 1919 raised a new cloud of ill will over the French Republic. With the wartime alliance a thing of the past, it was easier for francophobes, isolationists, anti-imperialists, anti-militarists, outraged moralists, and anxious creditors to compile a host of suspicions and grievances about France and the French. Looked at through a certain lens, the Third Republic could be discerned not only as the now strongest military power on the continent and principal beneficiary of the Versailles decision to strip Germany of her overseas colonies, but as a country of sexually and materially self-indulgent people who would not stop whining about their insecurity, their wartime damages, the money they owed, or the ingratitude of their former allies.

The problem, from the French perspective, was hydra-headed. German propaganda was certainly part of it, as the Weimar regime churned out its own charges against the former enemies. Charges not easily dismissed. One favourite was that the armistice of November 1918 had been far more severe than the German government had been led to expect from President Wilson's earlier assurances of conciliation. Another was the accusation that German civilians had died needlessly and in large numbers in the eight months it had taken the allies to lift their naval blockade following the November armistice.

But Germany had important peacetime allies. Some of its allegations, including those that were false, were passed on to unsuspecting papers by Hearst's International News Service. Such was the case when the *Washington Post* published – then retracted – a "fake" story about a German officer having been shabbily treated

by French authorities. Some such damaging stories appeared in the French press, some in America, where Hearst's own papers were especially attentive to the news contained in radio telegrams originating in Germany and paid for by the German government – thus confirming, in the opinion of Maurice Casenave, that the newspaper proprietor was France's "worst enemy ... in America."[54] Predictably, those papers had also welcomed the 1920 appearance of John Maynard Keynes's angry, bestselling book on what had been done in Paris the year before, a work in which the English economist condemned the spirit and the substance of allied decision making. He had made out the Germans to be "martyrs without precedent," Jusserand observed, and the victors as powers inspired by "greed and mindless ferocity."[55]

Still, Germans with a cause, combined with their willing and even their inadvertent accomplices, had yet another resource: the ignorance of too many American journalists who were tasked to write about European affairs. That at least was the perception, and a revealing one, of French foreign ministry officials who thought they could distinguish between the malicious and the incompetent. Among the former was a Paris-based journalist for the *Chicago Tribune*, whom the ministry considered "thoroughly shady," and another for the *Washington Star*, whom they dismissed as "a jackass." Among the latter, the well-meaning, were simply those journalists who were accustomed to dealing with the more straightforward, not to say "simplistic," nature of American domestic politics. Unfamiliar with Europe, they were over-taxed when it came to the levels of "finesse" familiar to Europeans.[56]

There was reason to think that the same was true of President Wilson, and not only about his uncertain understanding of Europe's true problems – true as perceived by self-seen realists in the French foreign ministry. Ambassador Jusserand believed that the president had lost his grip on American politics. Although it was clear by January 1920 that the country was behind ratification of the treaty with Germany, and that ratification could only be achieved if Wilson accepted several Senate amendments, the president just contented himself with repeating the very "intransigent statements" he had been making from the outset. He himself, Jusserand adjudged, was the "principal stumbling block." The *Washington Post* claimed that the White House now expected foreign ambassadors to beg for an "audience" with the president, and attributed to Wilson an

extreme touchiness about any kind of contact between such diplo-
mats and members of the Republican party. And things were getting
worse. Given the president's physical and emotional condition, Col-
onel House was convinced that it "was manifestly impossible for
him to perform his duties." Robert Lansing obviously agreed. But
by taking an initiative to deal with matters of state in the absence of
his ill and increasingly remote president, he so infuriated Wilson
that he felt obliged to resign from the State Department. Left on the
periphery during the Paris negotiations, his personnel recommenda-
tions for embassy posts ignored, even contradicted, by the head of
state, Lansing now rejoiced at being "freed from an impossible situ-
ation."[57] Jusserand, too, was in trouble. A few days after the
Wilson-Lansing blow-up, the ambassador learned from the depart-
ing secretary of state that Wilson believed the French embassy had
backed Senator Lodge's efforts to amend the troubled treaty with
Germany – a conclusion that the ambassador vehemently denied,
adding that the Democratic leadership had been kept fully informed
of any contact between himself and Lodge.[58]

Futile protest. Frustrated beyond measure, Woodrow Wilson
mistook France for a recalcitrant world. Within weeks of his break
with Lansing, he ensured the publication of a private letter in which
he had portrayed France as being under the spell of militarists and
imperialists. That, he said, was a circumstance appalling enough to
cause one to wonder whether America should simply forget the
treaty and withdraw from the concert of world powers.[59] What is
more, in the face of the ambassador's perfectly predictable protest
to the State Department – in language "so energetic" that he had
thought it best not to repeat it to his own ministry – the president
instructed Lansing's immediate successor to have "a pretty plain
talk" with Jusserand, "a very frank and firm talk." Make it clear, he
said, that when I was in Paris, I was fully aware of the "militaristic
intrigues" going on against Premier Clemenceau, intrigues led by
Marshal Foch and encouraged by President Poincaré. Moreover,
make it clear that we suspect France of trying to use any breach of
German reparations obligations as a pretext for staying perma-
nently in the Rhineland, a ruse that will only "sow the seeds for
another disastrous war." Then, in a closing passage testifying to a
relationship truly soured, the president confided to the acting secre-
tary of state, Frank Polk: "It has for some time caused me some
uneasiness that the French Ambassador rushes in even when it is

none [of] his business and insists upon things for which I must believe there is no precedent in diplomatic usage or international currency."[60]

The month of April brought no reprieve for the fast-deteriorating relations between president and embassy, particularly as it came right on the heels of a final Senate failure to ratify the German treaty. In Germany, a sudden outbreak of armed rebellion prompted Weimar authorities to move army units into the resource-rich Ruhr Valley, a decision that provoked the French government to order its own army into such Rhenish cities as Frankfurt, Darmstadt, and Hanau. What the French anticipated was a campaign of infrastructure destruction – conducted either by the insurgents or by the army itself – aimed at denying France the material reparations that were hers by the new treaty rights.[61] What Wilson discerned was more evidence of French militarism, to which he responded badly. See Jusserand, he instructed Bainbridge Colby, his new secretary of state, whom Jusserand regarded as a committed *Wilsonien* and thus a doubtful voice of restraint. Find out how long the French intend to occupy the Rhineland; and in the interests of "our delightfully cordial relations with the French Government," make it clear that we do not expect them to stay long.[62] Remarkably, for a man who took such pride in his own probity, Wilson made no mention here, or elsewhere, of his utterly broken promise to France. In March 1919 he had countered French security anxieties with an offer of an American guarantee to defend France. By April 1920 he had renewed his old suspicions of France, and conveniently forgotten the undertaking that had inspired Clemenceau's critical concession in Paris. Conveniently forgotten, as well, were reminders in papers like the *New York Times* of the connection between French security anxieties and the American failure to ratify the treaties. In fact, the treaty of guarantee to France was *never* discussed in the Senate's Foreign Relations Committee and never debated on the floor of that chamber. "It simply disappeared."[63] Simply put, France was left betrayed by this silent act; and perhaps out of a sense of richly deserved guilt, American critics, like the president, re-registered against her their accusations of intransigence and bellicosity. Little wonder that a jilted Clemenceau would watch the president from afar, musing, as he did, "What on earth is the Lord Almighty doing that he does not take him to his bosom." And little wonder that he "rejoiced" when Lloyd George fell from power in 1922.[64]

As difficult as the summer of 1920 was for the French ambassador, it did offer some respite from his deteriorating relations with Woodrow Wilson. Neither man, it is true, had much revised his view of the other. To Wilson, Jusserand was the agent of a government still mired in the eye-for-an-eye morality of the Old Testament, incapable equally of seeing the destructive potential of revenge or the healing potential of conciliation. To Jusserand, Wilson displayed all the sins of the doubt-free moralist – he was inflexible, authoritarian, intellectually vain, blind to the possibility that best intentions could ever yield malevolent results. But Wilson was becoming more and more ill, his presidency was ending in less than a year, and his Democrats faced a mounting Republican wave. Jusserand, for his part, was destined to spend an unusually long period away from the embassy and the White House, most of it in France, some in Poland, some of it work and some a long-sought vacation. It could not have bothered him much to take leave of the president in June 1920 or to turn his back on two competing, continent-wide, propaganda campaigns: one that championed France, victim of war, the other, Germany, victim of peace. Indeed, from that particular field of battle, now nominally a time of peace, some old demons had found new life.

That Jusserand had proved to be no miracle worker was clear, especially to those who had long nursed their frustrations with him. One of the early post-war reminders of these frustrations had come in mid-February, in the days immediately following the departure of Robert Lansing. Various American newspapers had carried a story that Wilson was going to request Jusserand's recall, on the grounds of his interference in American politics through the offices of Senator Lodge. Maurice Paléologue, who was poised to become the Quai d'Orsay's new secretary general, quickly countered the story, assuring Jusserand that the government was fully confident of his service and had no intention of recalling him.[65] But the rumours, most of them French-inspired, would not go away. In May, the ambassador learned indirectly that a New York–based correspondent for the paper *L'Information* claimed he had not found a single pro-French American who did not want to see the end of Ambassador Jusserand, an antiquated figure who spent all his time "making speeches for publication in bound volumes." And it was small consolation to the diplomat to be told by Frank Pavey, president of the

New York chapter of the Alliance Française, that the said journalist neither spoke nor understood English very well.[66]

Pavey was not alone in trying to assuage the ambassador's discomfort. In the face of this public campaign of complaint and innuendo, and persistent rumours of Jusserand's recall, the New York Sun ran a sympathetic article entitled "America Retains a Great Ambassador." The New York Times followed with its own counter-assault in June 1920, an editorial assuring its readers, on the one hand, that countries did not need banquet-attending ambassadors who could make "jolly speeches" and rub "shoulders with the crowd" and, on the other, that Jusserand had provided "eminent service" and was on "precisely the right course for an Ambassador to pursue." In France, that same month, the journalist Georges Dinago attacked on a different front, ridiculing the complaint that Jusserand had become too associated with Wilson and the Democrats to be suitable for service in an America where the Republicans now controlled Congress. The complaint was ridiculous, partly because the same fears had been voiced – and proven to be unfounded – when the Democrats had taken over from the Roosevelt-Taft administrations in 1913, and partly because Jusserand was currently being pilloried for his inability to get close to Wilson.[67] Less publicly, Premier and Foreign Minister Alexandre Millerand again assured his ambassador, this time by telegram on 12 June, that he considered these public criticisms to be "malevolent," "unjust," and futile. I assure you "again, that you have the government's complete confidence."[68]

The fact that such assurances had to be repeated was evidence of persistence in the opposite direction. Only the week before, the Philadelphia Ledger had run an article by the French journalist, André Géraud, which had raised new complaints against Ambassador Jusserand. Writing under the pseudonym of "Pertinax," Géraud attributed his own misgivings to former premier Georges Clemenceau. The latter, it was said, claimed to have been misled by Jusserand's overly sanguine predictions that Wilson would pull off ratification of the German treaty in the Senate. When it had become clear by March 1920 that Wilson had failed definitively, and that both the Versailles treaty and the promised American guarantee of French security had no future, Clemenceau, the man who had compromised on and then signed the treaty for France, was in an awkward position. Any way of dispersing responsibility may have

seemed to have merit. Whatever the true state of Clemenceau's thinking, Pertinax used these attributions to predict Jusserand's early departure from Washington.[69] "France now fully realizes the imperative importance of being represented in America adequately." A week later the same paper went on record with an even more precise forecast from Pertinax. In an article entitled "Jusserand Ending Career in America," the *Ledger* anticipated the ambassador's resignation in response to what it called a "political storm" in France. The country, it suggested had been "lulled into a sense of false security" by the optimism of Jusserand and former high commissioner Tardieu. In fact, the president, the treaty, and the guarantee had failed, in that order, leaving the ambassador's departure a certainty. Unless it had a death wish, no political party in France could afford to perpetuate Jusserand's stay in America.[70]

Like many predictions, this one proved baseless. At least for a time. Although Jusserand had been subjected to public rumours designed to discredit, he was not without influential supporters in France and the United States. And never was he lacking in feistiness. Indeed, one has to wonder whether some of the criticisms directed at him had at their origin his own long-standing willingness to speak his mind. Curious the criticism of his lack of energy, his reluctance to speak with a strong voice, when put beside Wilson's complaints that he spoke too much, or beside his personal tradition of intolerance toward ignorance, incompetence or, for that matter, impudence.

His relations with the consul-general in New York, Gaston Liebert, were showing no signs of improvement in the course of 1920. Having been associated with wartime criticisms of the ambassador's views on propaganda, Liebert seems to have been on the ambassador's list of suspect characters. Ironically, given his own frustrations with President Wilson, Jusserand was quick to reprimand Liebert for critical remarks the consul allegedly, and perhaps falsely, had made about the American head of state. In a rebuke that not so subtly recalled both the ministerial chain of command and the respective spheres of diplomats and consuls, Jusserand wrote: "You are lucky that you don't have to concern yourself with such matters ... In future, please observe a complete silence."[71] Those whom he considered his subordinates were not the only ones who bore the marks of his candour. Again and again he reminded the

ministry in Paris of the need to address the financial requirements of its diplomatic corps in America. At five francs to a dollar in 1914, nine by 1919, the exchange rate by February 1920 had plummeted to fifteen francs to the dollar; and this without any reference to soaring post-war price increases of anywhere from eighty to one hundred and thirty per cent.[72]

And could not more be done by the ministry to stifle the destructive urges of certain quarters of the French press? Their verbal excesses, especially when it came to America in general and Wilson in particular, kept transforming his job as ambassador into the futile efforts of a modern Sisyphus. These excesses, he warned Paris, "quickly undermine[d] the footings" of French propaganda efforts in America. As did the reports – most of French origin, though gleefully repeated by American newspapers – of French post-war indulgence in stock speculation and gambling. How could one explain this to Americans who had heard so much about France's suffering and heavy tax burden? Nor, he suggested, did it help when the ministry chose to make public the contents of his despatches from Washington. Certainly the State Department had not been amused to discover that confidential despatches from the embassy to Paris, based on accounts of conversations with senior officials in Washington, had been released to the French press by the Quai d'Orsay.[73]

Along with his identification of things that should not be done and should not be said, Jusserand offered some very positive if somewhat predictable suggestions. In an extended and confidential note to Paléologue, the ambassador advised developing a more central and powerful role for the embassy. First, given growing American doubts about appeals for more financial aid, France should reduce all of its "extraordinary" expenditures, offices, and personnel throughout the United States – which is to say, all the agencies, commissions, and missions that had been despatched in the course of the war. Second, a new financial office was needed in New York, but one that was run by the embassy through the office of the commercial attaché. The third need was a new information service, but again, one that would be run through the embassy, not through some agency more or less independent of France's sole official representative. In short, the ambassador's control over all such efforts would be "indispensable." Nothing would be submitted to the American press without the assent of the embassy.[74]

For a time, his counsel seems to have earned a sympathetic hearing from the Millerand government. Within three months of receiving the ambassador's recommendations, Millerand had instructed that responsibility for the government's New York–based French Information and Press Service be transferred from what had been left of the old French High Commission offices to the direct control of the embassy in Washington. Indeed, all government-sponsored information services in the United States were to be placed under the general aegis of the foreign ministry and the specific aegis of the embassy.[75] Such, at least, was what was supposed to have happened. Had it done so, the ambassador would have chalked up a clean victory. But evidently things soon went awry, for as late as October the embassy was complaining that irritating overlaps in information dissemination were continuing. The New York office had not surrendered control to the embassy, which meant among other things that it continued to sponsor propagandists of whom embassy and consulates knew nothing.[76] Troubling, too, was the fact that toward the end of September the supportive Millerand administration was replaced by one with Georges Leygues as premier and foreign minister. Given the new premier's record as a critic of a tradition-bound foreign ministry and his dislike of diplomatic agents lacking in ideas and energy, this was not a development in which Jules Jusserand could have taken any satisfaction.

By that time, however, the ambassador had been distracted by affairs of an entirely different order, starting with his annual vacation in the summer of 1920. At least it was intended to have been a vacation. In fact, within weeks of his return to France, the Millerand government had summoned him from his property in Saint-Haon-le-Châtel and asked him to be part of an Anglo-French mission to Warsaw. The premier's reasoning was as follows. In April, the new Polish state had undertaken a military offensive against the Ukraine-based army of Bolshevik Russia, but by July the initial Polish successes had been reversed into a full-scale retreat. With Warsaw on the point of being over-run, the Polish government requested immediate assistance from the western powers.[77] The answer, formulated as an emergency measure at the Spa Conference, was to send an Anglo-French advisory mission. The British side was led by Viscount Edgar d'Abernon and General Sir Percy Radcliffe, the French by Jusserand and General Maxime Weygand.

The hastily prepared mission arrived in Warsaw by train on 25 July, spent the better part of a month there observing a successful Polish counter-offensive, and were home by the end of August.

Although the outcome of the war was critical to the survival of the Polish state and hence to the history of eastern Europe, the contribution of the Anglo-French mission, and of Jusserand's role in it, seems to have been rather modest. Fittingly, having resorted to war in the spring, it seems to have been the Poles who came to their own rescue in August. Early reports to the contrary, General Weygand had not pushed his advice on the Polish commanders and certainly had not been the inspiration behind their successful summer counter-offensive.[78] As for Jusserand, no more ambitious claim can be made for him. He had gone as instructed, but visibly unhappy about having had his vacation interrupted and no happier at the prospect of spending time with Weygand, with whom he had had an earlier dinner table spat.[79] Besides, he was a diplomat in a military arena and in a country which – however threatened it felt – had no intention of taking instructions from foreigners.[80] The best that could have been expected was that Warsaw would be saved, that the warring sides would fight to an early draw, that the mission could leave under a patina of success, and that the leading *missionnaires* would, in this case, be rewarded for spending a "horribly difficult & rather nerve-wracking" month near a war zone. And so it was. Within weeks of their return to France, the Millerand government had conferred on Jusserand and Weygand the highest rank of the Legion of Honour.[81]

In all likelihood, there were two motives behind the award of such a distinction. One, undoubtedly, was to recognize both Jusserand's long-term and his most recent service to the Republic. The other may well have been to short-circuit any new campaign of complaints following the ambassador's return to his post in Washington.[82] If such had been part of Premier Millerand's thinking, it did not work. Indeed, even before Jusserand's return in November – after a five-month absence – the *New York American* and the *Washington Times*, both Hearst papers, were renewing the prediction of Jusserand's recall once the Republicans, as anticipated, had won the November presidential election. The thinking in Paris, these papers claimed, was that France needed a representative more in tune with the views of that party – an argument that of course contradicted the familiar complaint that he had failed to ingratiate himself with

Wilson and the Democrats, in part because in the president's mind
he was too closely linked with people like Senator Lodge.[83]

One of the two predictions was borne out, that confirming the
end of Wilson's Democratic administration and the début of War-
ren Harding's presidency. The second was not. But neither was it
laid to rest. Having so recently witnessed first hand a Russo-Polish
hot war of artillery and infantry, it seemed that the ambassador had
only moved from one field of combat to another, a war of words
and innuendo. Two thorny but interrelated issues complicated rela-
tions between the French and American governments by mid-1920;
and on each one the ambassador's conduct was certain to be scruti-
nized by a collection of by-now inveterate critics. On the surface,
both were issues of money, but within each was the clay with which
either side could fashion its image of the other.[84]

One issue related to the German reparations payments that were
called for by the Versailles treaty, a treaty left unratified in the
United States. From the day of its requisite signature on the treaty
in June 1919, the Weimar government had postponed or minimized
those payments in a series of silent protests against the provisions of
a treaty it had been obliged to sign. It had been unjust, Berlin said,
to hold Germany and its allies responsible for the war and its atten-
dant destruction. In Paris, however, that attribution of guilt was as
justifiable in 1920 as it had been the year before, as was the expec-
tation that Germany should pay for the damages. If the new Ger-
man government defaulted on this now-legal obligation, France
was entitled both by law and by morality to enforce respect for the
treaty through the application of military might. This the govern-
ment had done in April, through its armed, if brief, occupation of
several Rhenish cities, and this it was entitled to do again in retalia-
tion for any further defaults. In Washington, however, the receding
Wilson administration was still plagued by suspicions about French
post-war behaviour, sometimes detecting vengeance, sometimes
overweening ambition on the European continent and elsewhere,
always, conveniently, forgetting its own here-today-gone-tomorrow
pledge to defend France against unprovoked aggression. Now, it
seemed, she, and not Germany, was the menace. It would be
"impolitic, unnecessary and inexcusable," Jusserand was told by
the State Department, for France to contemplate further armed
intervention on German soil.[85]

The other thorny issue related not to what Germany owed France, but to what France owed the United States in the form of accumulated war debts. If Washington wanted the Third Republic to be more patient toward Germany, it wanted more action from that Republic toward itself. In part, it was a matter of money for its own sake. As Treasury officials told Jusserand in December 1920, it was increasingly difficult to explain to American taxpayers why they were currently paying the interest on the three billion (*milliards*) dollars that had been loaned to France – especially when those taxpayers were aware of their government's current deficit, the very recent post-war slump in agricultural and industrial prices, and the quantities of monies owed to the United States not just by France but by other foreign governments. Given such perceptions, and growing resentment, it certainly did not help when governments, like that of France, were seen as slackers in debt repayment, and when the populace, like that of France, was made out to be despondent, unproductive, and anxious for the next hand-out. Neither was it difficult to detect on this troubled field, so Jusserand warned Paris, the impulse behind the Republican-animated "America First" movement and the demand for higher protective tariffs. [86]

If money aggravated by attitude stood in the way of cordial Franco-American relations – and thus sorely impeded Jusserand's mission – an associated and very familiar problem continued to supply an impediment of its own. In large part, this was less a dispute between Americans and French than a feud within the French family. With attitudes so closely linked to money, and vice versa, the old pre-war and wartime question remained as germane as ever. How could one best endear Americans to France? Jusserand had discovered an answer years before, and he stuck to it. For that he had been feted as a pivotal figure in relations between the two republics. His enduring status as dean of Washington's diplomatic corps, his gravitas lightened by a quiet sense of humour, his reputation for both probity and intellectual reach, his extended familiarity with the American continent, and his mastery of the English language had all drawn public acclaim in both countries. This was especially true when Roosevelt had been in power, and when the desperate years under Wilson finally culminated in 1917 with America's entry into the war. But before that culmination, when France had been fighting for its life and the United States had been

neutral, blame had been mixed with the praise. Was he really the man for the hour, and was the prudence with which he approached the subject of propaganda not a sign of lethargy and antiquated thinking?

A month before he had even returned to Washington in November 1920, the Hearst presses had revived the forecast of his imminent recall. The New Year brought new grief. Pertinax returned to the charge in January 1921, recalling the accusation that the ambassador had been too sanguine about the treaty's passage in the Senate, and about American acceptance of the League of Nations. Either way, whether he really had misread the circumstances, or whether he had only resigned himself to reporting what he knew his superiors wanted to hear, Monsieur Jusserand, said Pertinax, had outlived his usefulness in Washington. Nor was that journalist a singular scourge. Louis Thomas, the New York correspondent for *L'Information,* was at it again, attributing to Jusserand more than just a reputation for "proverbial laziness." He was an anachronism, or so the journalist stooped to imply by claiming that the ambassador's trousers were twenty years out of date. Less personal in his complaints, but a familiar complainant nonetheless, was the francophilic architect Whitney Warren. He, too, had been associated with pleas for a more aggressive wartime propaganda than Jusserand had thought wise; and now, with war won but with France's reputation under a shadow, had added his "howls" to those of Thomas and Pertinax.[87]

It was not as if opinion in America or France suddenly had become homogeneous and agreed that France was waging a losing, post-war battle. On the matter of German reparations payments, for example, the embassy reported a substantial degree of support for France in the editorial columns of many American papers. The bill was not excessive, so they assured their readers in the period between February and May 1921; nor was it beyond Germany's capacity to pay. When the Weimar government, in the face of threats, made new undertakings to fulfil its reparations commitments, the *Washington Post* called it a "return to common sense," and the *New York Times* judged French threats of forceful action both justified and effective.[88] Still, there was no mistaking the fact that the heady days of the wartime alliance had ended with the peace. The Hearst empire continued to associate the French Republic with militarism and imperialism, and portrayed both as threats

to international peace. The Germans were always the victims, the English and French always the exploiters. The Pulitzer-run *New York World* ran pieces highly critical of France's behaviour in the demilitarized Rhineland, at least one of which accused the French Republic of "Napoleonic" ambitions. In Chicago the *Tribune* was predictably anti-English and through association often critical of France. Moreover, most of the city's papers agreed with the claim that Germany's reparations bill was too high, as most were inclined to support their readers' views that Europe should be left to sort out its own mess.[89] So it came as no surprise to Jusserand when Charles Evans Hughes, Harding's new secretary of state, made it clear that – despite his personal sympathy for France – American opinion was determined to avoid any further entanglements in Europe.[90]

By the spring of 1921 several things had become clear. Although France and its ambassador in Washington retained much of the support they had earned in the course of the war, if not well before it, a number of intractable issues had arisen in Franco-American relations which neither the French government nor its representative could resolve quickly. Those issues – consolidated in the public representation of France as militarist, materialist, culturally supremacist, and a paragon of self-indulgence – did much to explain the common perception that France had lost headway in America and that the resolution of specific issues like the payment of war debts was impeded by images of France as a whiner and shirker. Given that condition, it was natural if not inevitable, that the need would be voiced for a renewed campaign of persuasion. On that, all agreed, even Jusserand. He had made his bid for control of the effort early in 1920, winning in principle, losing in practice to the various New York–based information agencies that had toiled for the French government during the war – and still toiled: the Offices of French Services in the United States, the Official Bureau of French Information, the French Press Bureau, and the information services being developed by Gaston Liebert in the Consulate General.

One has a sense that frustration-induced pressure was building on and within Ambassador Jusserand. French-American relations were even more troubled now than they had been a year earlier, a condition both monitored and aggravated by hostile elements in the American press. The campaign against him personally had found a second wind, assigning to him part of the responsibility for soured relations with America and much of the responsibility for the

clouded image of his country. Whatever the combination of provocations, the ambassador seems to have been on edge. In late March, upon receiving a report of Liebert's public remarks on Franco-German relations, he added a frosty note in the margins: "Since when is it within the duties of a Consul to address such matters?" Two weeks later he upbraided his superiors in Paris. It was a mistake, if press reports in America were true, to have charged General Ferdinand Taufflieb with a propaganda mission to the United States. For one, Americans think they are saturated with foreign propaganda aimed at influencing their decision making. For another, most of these *missionnaires* had proven to be "infatuated with their title" and thus prone to committing "all sorts of stupidities."[91] But his anger boiled over in April, in a response that seemed out of proportion to the specific provocation. In what he took to be an accusation of negligence on his part – namely for not having forwarded a copy of an American note to the German government – he rounded on his superiors with a counter-accusation that they had a tendency to misconstrue the performance of their agents abroad. Indeed, they were far too quick to blame those agents for any mishaps, whatever the circumstance. In fact, he retorted, if I did not send it, "it was because I did not have it." And in a closing peroration this dutiful but incensed public servant addressed his critics and his superiors. "None of us in the French diplomatic service who serve abroad have any claim to infallibility. It seems, however, that in cases of this nature, the way in which our administration rushes to apply the worst and the most damaging hypothesis – when reason would have dismissed it – is as contrary to fairness as it is to our traditions."[92] Given his eighteen-year history in Washington, and particularly given the steady bureaucratization of the diplomatic service in both peace and war, it is doubtful whether the ambassador expected this dressing down to have much effect on the conduct of personnel at the Quai d'Orsay. Other than to encourage a moment of second thought before blundering into his den. What he certainly could not have expected was the force of another gathering storm, one that would further strain relations between Washington and Paris, and would therefore unleash yet another wave of criticism directed at his embassy.

6 The Impassable Road to Separation (1921–1924)

Apart from a momentary flash of optimism in May 1920, when Senator Philander Knox attempted to salvage some form of the guarantee to France, the ensuing months brought very little joy to the French embassy.[1] By January 1921 it seemed clear that the Wilson administration had chosen to forget about the moribund guarantee treaty and to shelve those treaties that the president had signed with the defeated Central Powers. Already there was talk of extricating America from this enduring embarrassment by concluding – perhaps simply by declaring – a separate peace with each of its former enemies. With that prospect on the horizon, the French and British governments were soon at work trying to secure as much as they could from a trend that they both found menacing. The incoming Harding administration was not going to retrace Wilson's steps and try to get the signed but still unratified treaties through Congress. But separate treaties, unilaterally promulgated, might well eliminate any form of American participation, however indirect, in critical post-war bodies like the international Reparations Commission. The trick, therefore, was to ensure that any such independent action by the United States, with respect to altered editions of the treaties concluded in Paris, in fact retained frequent reference to the provisions of those original treaties. And rather than leave the outcome to fate, it was agreed among the governments of London, Rome, and Paris that Ambassador Jusserand was best suited to gently restrain the Americans from drifting too far away from the "essentials" of the Paris peace settlement.[2]

Understandably, there was little point in being too compliant in such matters. Premier Briand warned that a simple abandonment of

the Versailles treaty by America would close the door to Washington's rumoured interest in a disarmament conference; and in March 1921 Jusserand was quick to reiterate to President Harding the allies' bottom line: American acceptance of the German treaty as signed – with the attendant clause of American assistance on the matter of German reparations – and formal recognition of the ever-elusive guarantee to French security. To underline the importance that the former European allies attributed to this position, the ambassador informed the president of an imminent diplomatic mission to the United States headed by former Premier René Viviani – who himself would be under orders to push for the rapid congressional ratification of the Versailles treaty.[3] But that proved much easier to say in Paris than to do in Washington. Within days of his arrival in early April, Viviani fathomed the depth of the Senate's opposition to Wilson's League and was doing what he could to salvage a Versailles liberated from that international body. Within two more days he was suggesting to his premier that continued French insistence on American ratification of Versailles might well end up doing more damage to Franco-American relations than would a separate American-German treaty. Within two more, he was pronouncing Wilson's treaty well and truly dead, and predicting – apparently to an attentive audience – that any attempt to revive it would "serve no useful purpose." By mid-April 1921 the American embassy in Paris was detecting more signs of public sympathy for America and fewer signs of official intransigence; and Briand was expressing satisfaction with the results of the Viviani mission.[4]

What the premier seems to have meant was not that his representative had changed American minds, but that he had managed not to exacerbate Franco-American relations any further. For the fact was that by mid-June the House of Representatives had led the way by approving a motion for a separate peace with Germany as well as with Austria and Hungary; by July it was clear that the Anglo-American guarantee to France had "vanished into thin air"; and by August, the United States Congress had concluded the process of establishing a formal state of peace with its former European enemies, one that provided the United States with "all the rights accorded to the signatories of the Treaty of Versailles, without any liability or obligation on the part of the American Republic."[5] One month earlier, as the treaty of 1919 and the French security guarantee of the same year were slowly and definitively sucked into the air,

the American embassy in Paris delivered to the Quai d'Orsay an invitation to an international Disarmament Conference. "It will be accepted," Edwin L. James reported from Paris, but without enthusiasm. The French, he predicted, would not want to hear proposals for any reductions to their army, since that was their best and now their only insurance against future invasion.[6]

James proved to be no false prophet, for the three-month period of the Washington Conference was among the testiest in Franco-American relations between the two world wars. Commencing in mid-November 1921 and extending into February 1922, this American-inspired international gathering became especially contentious for a French government long since persuaded that it had been betrayed by its former allies. Since a good deal of scholarly attention has been addressed to this conference, and since Ambassador Jusserand was not a central figure in the proceedings themselves, the reader might appreciate an abbreviated account of the French experience at Washington and, conversely, a more focused but fuller appraisal of the ambassador's role and his responses to the circumstances that confronted him both as a delegate and as France's permanent representative to the government of the United States.[7] In brief prologue, this was one of the most difficult periods of his career in Washington, partly because he soon came to the painful conclusion that France was being discriminated against by the other powers, and partly because he himself was soon under a new assault from French critics who awarded him a substantial share of the blame for that discrimination.

On the surface, the motivation behind the conference was guiltless. In the wake of the most expensive and destructive war in history, post-war governments and their populations worldwide recommitted themselves to the maintenance of permanent peace. At least rhetorically. Since the pre-war European arms race now stood indicted as a principal cause of the recent war, the logic behind disarmament seemed irrefutable. And so it was that the Harding administration, with Secretary of State Charles Evans Hughes as its point man, seized the initiative and proposed an international conference. More than that, it promptly offered a plan, and a formula, for ensuring that the day's great powers would do themselves no harm by engaging in a post-war arms race. With the German surface and underseas fleet destroyed at the end of the war, and France's fleet strength sacrificed to the more urgent, wartime needs

of the land forces, the sole Atlantic naval threat to the United States was Britain, while the Pacific threat took the form of Britain, again, and as yet on a lesser level, Japan.

It was no coincidence, therefore, that the American plan offered a formula for capital ship strength which allowed parity between the United States and Britain, and a three-fifths ratio to Japan. As for France and Italy, it seemed reasonable to the new Big Three that the Latin sisters should be equal one to the other but, at less than two-fifths parity, substantially inferior to the strengths Washington, London, and Tokyo had allocated themselves. Indeed, on the first day of the conference the senior British delegate, Lord Balfour, quickly approved the American formula, and just as quickly suggested that the reduction of land armaments should be next on the conference agenda. What more reasonable, he might have asked, than for the British fleet to enjoy parity with the American, as well as marked superiority over the French, Italian, and scuttled German, *and* to ensure reductions in the currently largest land and air force on the continent – namely that of France.[8]

As James had predicted, the French did not think much of the idea. Now patently stripped of the Lloyd George–Wilson guarantee to their security, and faced with an America that had made its own peace with the Germans, the French delegation was justifiably upset by the opening volleys in Washington: proposed inferiority to Japan, proposed equality with Italy, proposed reductions in land armaments, and compelling evidence of advanced collusion at least among the three self-defined maritime powers. Next to these, the struggle to ensure that the conference accorded linguistic equality to French and English, and that delegate seating arrangements were consistent with the honour and international status of France were but minor irritations. Irritations nonetheless, especially when, having decided that countries would be seated alphabetically, the United States designated itself as America, and Great Britain as British Empire, both comfortably ahead of France.[9]

Aristide Briand, again premier and again his own foreign minister, responded to the opening remarks by Harding, Hughes, and Balfour with lifetime-acquired savvy. He did not like much of what he had heard. But apart from softly mocking Balfour's denials about having had prior knowledge of the Hughes naval formula, and being soothed perhaps by some of the contents of the 2,000 "dossiers" of champagne and brandy that had been brought in by

his delegation, the head of the French government allowed for the possibility of France being willing to entertain some thoughts about reductions in land armaments.[10] A week later, however, he offered more frown than smile. While acknowledging that the proposed five-power naval strength ratios did not directly or immediately impinge on the security of France, he asserted that the issue of land armaments was entirely different. On the one hand, the German menace remained in place. In Europe, "one had only to look at all the surface signs of volcanic activity in order to detect the unextinguished fires below. If France had not been as strong as she was," he offered, "a new war would already have broken out." On the other hand, as alternative proof of her commitment to peace, France had reduced her military service from three to two years, and was about to reduce it to eighteen months. "Beyond that ... I tell you clearly and frankly that it is impossible to go further."[11]

Two days later the premier stunned the conference with the announcement that he was returning to France forthwith, ostensibly to lead the parliamentary debate over the latest proposal to reduce the period of military service. In short, he still believed in disarmament – which was likely true – and he was sorry to be leaving Washington – which most certainly was not. Indeed, he was leaving America's shores without having fully endorsed the battleship ratios, and with two forceful reminders. First, of the five principal powers at Washington, France was singularly vulnerable to invasion from an unpacified, potentially formidable enemy in the form of the German Republic. Second, candour called for a reminder of the evaporated Anglo-American guarantee of French security. Until other governments were prepared to assume some share in the costs of defending France, he warned, "they have no right to impose limits on our armaments." Simple enough, and not easily contradicted, although the supremely polished Arthur Balfour tried to do so. Not only had he the temerity to remind Briand of the discarded and defunct British guarantee to French security but, in a manner that "beggared belief," he spoke openly of British concerns about a possible air attack.[12] This in the hearing of the premier of a recently allied country that now had the largest and most proximate air force in Europe. That particular exchange could only have reinforced Briand's decision to flee the charged and increasingly hostile atmosphere in Washington. The Anglo-Americans had set up their own deal on the waters, and now were intent on saving world peace on the back of France.

Almost equally disturbing, their newspapers were coming closer and closer to identifying France as the great obstacle to everyone's dream of a world disarmed.[13]

On that apprehension Briand – pronounced [*Bree*-ahn] according to the *Washington Post* – left for Paris, leaving in charge, former premier René Viviani [*Ray-nay Vee vee-a-nee*] the current colonial minister, Albert Sarraut [*Al-bear Sar-ro*] and Ambassador *Zhule Zhuss-air-ahn*.[14] Despite public reassurances from the American and British delegates, to the effect that France's singular position was well understood, the tone of press discourse was alarming. The usually sympathetic *New York Times* warned the French mission that any thought of trying to tinker with the naval formula – such as demanding parity with the Japanese – would be unwise. Any such efforts might leave France "morally isolated," and "German militarists" smiling. The *Boston Globe* displayed similar concern, urging greater "tact" on the French mission and more "cordiality" toward the British, their former ally.[15] But whatever the well-meaning advice, the atmosphere in Washington remained as charged as ever. No sooner had Briand departed than Viviani was engaged in a "spirited and rather exhaustive" exchange with the Italians, who had welcomed the notion of parity with France on the seas but who also wanted the French to follow Italy's lead by further reductions in their land armies.

"Cordial" was hardly the word to describe relations between the French and British, particularly when it came to the matter of their respective submarine fleets. If the British were to be privileged to have a superior tonnage in capital ships to defend their shores, so the argument came from Paris, France should be able to compensate for that disproportion with a naval arm that had proven essential for the defence of her own shores. Or, as Briand was reported to have put it, somewhat indelicately: "If the British want 500,000 tons of capital ships in order to fish for sardines, France wants her full quota of submarines in order to study under-sea flora for the benefit of French botanical societies." No surprise, therefore, when rumours started appearing that the French mission would be withdrawn from the conference if the pressure on it to agree to further cuts in land armaments did not cease. And probably no surprise either when, barely a week after Briand's departure from Washington, Viviani indicated that he, too, "would like very much to leave" in two weeks' time.[16]

Christmas produced neither miracle nor good will. Progress had been made to stabilize the Far East by means of a four-power treaty among Japan, America, France, and Britain. Similarly, conference delegates were working out an international weapons agreement to limit the use of poison gas. For the time being, pressure was off the land armaments issue in the hope of reaching a final agreement on a ratio of naval tonnage for the five major powers. But therein lay plenty of room for continuing discord. The Japanese were not fully reconciled to the idea of being placed behind the British and Americans, or the French to being behind the Japanese and on a par with the Italians. Moreover, the thorny matter of submarine entitlement remained as contentious as ever. To this volatile mix were added reports of a new naval construction program in France, one which the Americans feared would undermine their formulaic approach to naval armaments, a fear that Viviani maintained was completely baseless. That said, the former premier took his leave of Washington with the naval agreement as elusive as ever. It would not be settled for a long time, he assured Briand in his closing report.[17]

A few days later, his successor, Albert Sarraut, sent his premier more disturbing news. To the "stupéfaction" of himself and Jusserand, they had just learned from Hughes that the British, Japanese, and Americans had worked out more details for the naval formula and were proposing that France accept what the three powers suggested was a generous entitlement of 175,000 tons in capital ships. Having been kept in the dark about these tripartite discussions, and knowing that the target sought by the French navy was in the order of some 300,000 tons, the two Frenchmen entered into very heated talks – best "not to repeat our language" – with Charles Evans Hughes and subsequently with other members of the Naval Committee. In brief, the proposal was wholly unacceptable, having paid no regard to the fact that wartime exigencies had caused France to fall far behind in its naval construction programs, or to the fact that its national and imperial responsibilities could not be fulfilled with its existing fleet. Indeed, said the French naval expert Admiral du Bon, "to reduce our current tonnage would mean leaving us with practically zero."[18]

But Hughes, Balfour, and Senator Schanzer of Italy were unmoved. If we cannot progress on land armaments, Hughes said, we must reach agreement on naval issues; but everyone must understand that French resistance is "capable of ruining the results so far

achieved by three powers"; understand, too, that the inflated target of 300,000 tons would amount to an actual *increase* in French naval strength, which was precisely contrary to the intent of a Disarmament Conference. Lest his French counterparts failed to grasp the political significance of his arguments, Hughes wrote immediately to Briand in Paris, denouncing outright any thought of building ten new capital ships and predicting that anything like the proposed global tonnage would create "the greatest difficulties."[19]

For the moment it had reached the stage of diplomatic "chicken." On 19 December Briand allowed for the possibility of accepting a tonnage of 175,000 but then suggested that the restriction would only include "offensive" vessels like battleships, and not "defensive" vessels like cruisers and submarines. That was the position he ordered his delegates in Washington to take. Hughes, however, would have none of it; no such distinction was acceptable. Indeed, he stepped up the pressure by asking at whom the submarines would be directed, a question parried by Sarraut with a counterquestion. Against whom would be addressed the 525,000 tons that were to be accorded to Britain and America? And as for Hughes's suggestion that the matter would have to be brought back to the Italians and Japanese, the ambassador indelicately asked why this would be necessary when France had been excluded from the original discussions.[20]

But trying to be firm in Washington was no easy task. On the 20th, Sarraut asked Briand to confirm his instructions to defend the 330,000 mark in tonnage and the 90,000 figure for submarines. Briand replied, as only a prime minister in political trouble at home could. Those benchmarks are what is expected of you by parliament and public. Defend them, even if you think them unattainable, but be prepared for some kind of compromise.[21] Such ambiguity could not have lifted Sarraut's spirits, for the next day he telegrammed the following summary: there has been active and deliberate collusion against France and her interests by the other four principals, although the Japanese may be quietly sympathetic as they see us being treated "as if we, too, had yellow skin." The press has been "carefully managed." Our resistance to such treatment has minimized the damage, but there is little chance of any success here.[22]

Still, Briand, with what proved to be only a few weeks left in his government, insisted that if France accepted the lesser figure of

175,000 tons in capital ships, she would essentially be free to build as many ships for coastal defence as she considered appropriate. "Every country must be left to determine its own needs in light vessels. No mathematical formula can cover the requirements imposed by reality."[23] But the imminence of Christmas brought no cheer to delegates trapped between their belief that economics and ethics, both, provided sane counsel against the mass production of weapons and their determination not to put their own national security on the block. Balfour and Sarraut went toe to toe, the former pushing for the abolition of submarines from all navies, the latter detecting in the idea a good deal of Britain's maritime self-interest as well as a good deal of naiveté. Would all those countries, beyond the eight represented in Washington, be expected to honour such an undertaking? All the more miffed, Balfour retorted that France had shut the door on any possibility of a reduction in land armaments, and having done so then revealed its intention to expand its submarine fleet.

Hughes, caught in the middle, tried to stay there, agreeing with the principle of abolition but recognizing the French case for retaining their fleet – though only retaining the tonnage they already had, and in half proportion to what had been tentatively allocated to Britain and America.[24] The holy day passed with no effect. On the 26th, in a top secret dispatch to Briand, Sarraut complained bitterly about the campaign so arduously waged by both British and Americans to misrepresent the French case; and four days later, pricked by a press cartoon that depicted France wearing a Prussian helmet, he abandoned secrecy ... and discretion. In a public session he lashed out at what he called an orchestrated "campaign" based on false accusations about French militarism and imperialism. And on the last day of the year, though privately, Jusserand had his own contretemps with Hughes, a man whom he actually admired. Only too mindful of France's painful post-war economic recovery, and of French debts to the United States, the secretary of state needled the ambassador with a comment that it was silly to spend large sums on "useless pieces of armour." To which the ambassador replied with a heated denial that France was behaving irresponsibly, whatever the fraudulent accusations made against her by Washington-based British journalists and by their compliant American colleagues.[25]

The New Year did bring a reprieve for all parties, though hardly a full resolution of the issues that divided them. By then, it was

certainly clear that the haggling and the intemperance could not go on much longer without erasing altogether the ideal that was supposed to have inspired the conference. No advances could be made on the limitation of either land, air, or underseas weapons, but the American-sponsored formula for battleship tonnage was eventually agreed upon in the form of the Five Power Treaty that was signed in February; and in the same month, a Nine Power Treaty on international interests in China was signed as a kind of corollary to the Four Power agreement of the previous December. Safe to say, no one in France was enamoured with the naval treaty, although it did strengthen the arguments of fiscal conservatives who were concerned about escalating government expenditures. One of the latter was Raymond Poincaré, former president of the Republic, and as of mid-January 1922, the new premier and foreign minister of France. Unlike the outgoing Briand, Poincaré was never suspected of being too inclined to conciliate, too attentive to the arguments of foreign governments, or too casual about the imperative needs of French security. So it was on his government that responsibility ultimately fell for ensuring the stormy passage of the Washington naval treaty through France's parliament between the summers of 1922 and 1923.

With the narrative outline of the Conference now in place, one must step back from the relative simplicity of the story line – what happened – so as to tackle its inherent complexities. Why did it happen? In fact, that question is even more daunting than it might seem at first glance, because not everyone will have agreed on the preceding narrative. Was France unfairly treated, even victimized, by the other international powers? Some contemporaries certainly thought not. Early on in the conference, the *New York Times* advised the French not to be obstreperous on the matter of the capital ship formula. By December many American papers were alerting readers to the unreasonableness of France's position – including its bombshell announcement of the new naval-building program – and warning that "French Obstruction [was] Alienating America." Even francophiles were privately warning the embassy that French reluctance to accede to the proposal for naval disarmament was "stirring this country to hostility."[26]

Other observers, however, argued that France had been placed in an untenable situation. One headline in the *Philadelphia Record*

read in part: "Hughes' Bad Blunder Cause of Naval Crisis. His Failure to Foresee that French Would Resent being Ignored by the Big Three." Ralph Courtney in the *New York Herald* was equally caustic. "For five weeks ... the three great Powers continued to negotiate and discuss the whole naval question in secret. No attention was paid to France and her case was taken up only after the others had reached an agreement satisfying their special interests." Drawing upon despatches he had prepared at the time, journalist Mark Sullivan later reminded his readers that what they had observed from the French in 1921–22 really stemmed from 1919 and Wilson's promise of a "military guarantee ... Because we broke the solemn promise our President made," the French stance in Washington was in some sense "justified."[27]

Unsurprisingly, that was the way Ambassador Jusserand saw it. As he had told Hughes in December, the English government, through the English journalists, had done its best to vilify France as a principal threat to world peace. Like his counterpart in the London embassy, the Count de Saint-Aulaire, Jusserand complained to his minister throughout the course of 1922 about the "*intrigue anglaise*," the campaign directed by the English "*contre nous*," or about "*animosité anglaise*," or the "*campagne anglaise*." As a result of those efforts, he wrote, elements of the American press had come to associate Europe in general with militarism and with what the *Washington Post* once described as an "orgy of egotism," and now saw France as "the great obstacle" to peace and reconciliation.[28] Reflecting on the conference itself – this from an ambassador unlikely to commit heresy – Jusserand assured one private correspondent that, ultimately and against its own judgment, France had reduced its "hopes and desires to the very limit recommended by the United States." To which he added the assurance that France's new naval program was designed to replace her ten old battleships, not at once, but over several decades – the first only beginning construction in 1927, the last only in 1941.

To another sympathetic correspondent he opined: "We have been more misunderstood than we have sinned," blame for which must be assumed in large part by the British, particularly because of their "fanciful (I use an exceedingly inadequate word)" accusations about our interest in submarines. More publicly, in an address at the University of Chicago he took the opportunity to deny, again, any suggestion that France was militaristic, and used the

Washington Conference as proof of the "modest" goal France had
set for herself – which had been simply to regain for the navy the
rank it had held before the war. Such modesty, together with a
reduction in the length of French military service from a pre-war
three-year high to the current eighteen months, to the approaching
target of twelve months, was, he asserted, proof positive of his
country's passion for peace.[29]

There was one table in Washington where there was no dissen-
sion on the subject of the conference, that of the embassy on 16th
Street. Elise Jusserand, the very model of discretion, the senior chat-
elaine of the Capital who seemed never to put a foot wrong in pub-
lic, was as irate as her husband about the conference. In a lengthy,
private letter of mid-January 1922 she poured out her distress and
anger to her friend Helen Garfield. As remarkable as this sustained
outburst was, however, it is the more interesting for her evident
command of maritime and political detail. The fact is that she had
been one of four American women – including Lady Aukland
Geddes, wife of the British ambassador – to be named by President
Harding to a special advisory committee to the conference. Not, it
should be said, as some cosmetic gesture to women voters, but
because they were all women of distinction. Mme Jusserand was a
familiar Washington figure not only for her tall, "long-necked ...
patrician bearing [and] ... aquiline features," or for her elegant-but-
never-flamboyant fashions, but also for her "intellectuality and
broad grasp on public questions." Indeed, she was the acknowl-
edged "mental companion and counselor of the Ambassador."
Given such credentials, she and the others were said to have under-
taken "a very great deal of hard work," in the course of which they
had evidently acquired some degree of expertise.[30]

France, she told Garfield, had become the object of a "violent
and unjustified" press campaign, for in truth the country was nei-
ther "militaristic [n]or imperialistic." Indeed, France had been the
first and only country to begin scrapping battleships, and that, well
before the conference. During the war her naval yards had been
turned into arsenals "for making 'seventy-fives' & shells for our-
selves and our allies." Since the November 1918 armistice the gov-
ernment had scrapped five battleships, not obsolete ones but ships
that had been under construction in 1914, some of them more than
half completed. The Washington powers had taken "not the slight-
est account" of this recent history. Had "we gone on spending

money to finish these ships & and to build others ... the Conference would have granted us a ratio based on what we actually possessed, instead of, rather unfairly as we think, limiting us to a ratio based on the perfectly abnormal situation produced for us & for us alone, by the war."

Then insult was added to injury. We were vilified, she complained, for announcing our intention of building one battleship "in replacement of some of our crumbling fleet," while America "is going to lay down or finish two ships, & England to construct two 'super-Hoods.' If this is not disrupting the [naval] holyday, why should it have been considered to be so in our case?" "As for the submarines," she continued, even the American Advisory Committee reported that our goal of 90,000 tons was consistent with the length of the coastline France must defend which – when the colonial possessions are included – is about equal to that of America's coastline at home and abroad. Was this, she asked rhetorically, "so very monstrous?" Yet while there "has not been ink enough in the press to pour abuse upon France ... we have practically no battleships at all now & ... the submarine has become the poor man's defence."

All this has caused such an outburst of ill-feeling that we are extremely sad. The Conference that we had thought was going to bring us all nearer together has had the contrary effect, a great deal of animosity has been aroused against us in this country & the British campaign against us in the American press cannot fail I think to create a very bitter feeling in France. I imagine that very far from bringing us to terms with England ... it will only stiffen us over there in our determination not to be bullied, & to hold out for what we consider our rights, & the attempt to create ill-feeling between this country & ourselves will not, I fancy, be easily forgiven. These latter remarks I have written to no one but you. It is useless to envenom matters still more.[31]

Useless, but perhaps unavoidable; for the French sense of outrage, of poorly concealed collusion against their interests, was going to stiffen the Poincaré government's resolve to stand firm. In roughly a year's time, in January 1923, it would act unilaterally in the Ruhr Valley, thus bringing down on its head the anger of all

those who had already stamped Poincaré and his country with the ugly post-war epithet of "militarist." But none of that is explicable without its prologue, without the legacy of the Washington Conference, and without the *forces profondes* that lay beneath that conference. With the narrative revisited, and unabashedly from the perspective of the man and the country that are the focus of this book, the moment has come to advance some explanations for the events recorded above. Betrayed by the simple disappearance of their allies' pledge to help in any future defence of France, humiliated by the tertiary status accorded them in Washington, and browbeaten by powers that had nothing left to fear from Germany, why did a succession of French governments tolerate – however resentfully – the behaviour of recent allies that was inventive enough to portray them at one and the same time as victim and villain?

One explanation, the most superficial and the least convincing, has to do with the image of France in America; and that, of course, relates directly to the ambassador's role as image-maker. Although these kinds of messages were absolutely contrary to those he thought France should be sending, and which he did his best to combat, there endured in 1921 the chronic press reports of French post-war despondency, public breast-beating, complaints against former allies, and a mindless refusal to give up on the idea of Germans as perpetual enemies. And yet such reports were complemented by stories of the myriad outlets that the French continued to find for self-indulgence and escapism: alcoholic excess, gambling and prostitution, salacious literature, extravagant and extravagantly priced fashion. Sober, hard-working, straight-laced Americans, most of whom had never seen the wartime carnage in northern France or had any idea of the numbers of French dead, widows, and orphans that the war had left behind in France, could easily detect the frivolousness and aimlessness that had long been associated with the French character. Mark Twain's scathing observation that France had "neither winter, nor summer, nor morals," updated by the acerbic comments from some returning soldiers, some returning tourists, some peripatetic journalists, may have fuelled an impression that the French lacked substance and that their willingness to compromise, whether over the Rhineland or their fleet, their temperate complaints over the vanished security guarantee, were signs of weakness rather than strength.

If there is even a scintilla of credibility in this association between the way France was treated and the way France was perceived, the

opportunities for faulting French image-making become endless. Whatever one might say about the destructive impact of German and British propaganda, both seemingly and equally intent on discrediting France, the central question was whether France was doing enough for herself.[32] That, to be sure, was an all too familiar question for Ambassador Jusserand; and quite predictably, as France was embarrassed and excoriated at Washington, a new crescendo of complaints arose in France and America. Predictable, too, were some of the accusations raised against him. He was, after all, "old school," a man with "memories of the old days before automobiles came into use," not quite attuned, it was said, to the power of public opinion in the conduct of foreign relations. Accordingly, even sympathizers tried to delicately point out to the ambassador that not getting the nation's point of view into the American press was the most "fatal" example of false economy. Even the semi-official *Le Temps* of Paris, while acknowledging the embassy's belief that so much anti-French propaganda was actually counterproductive among propaganda-sensitive Americans, claimed, "we are positively defenceless in the United States."[33]

Related to this under-performance, others in Paris said, was Jusserand's excessive optimism that all would be well. Hence, the familiar voice of Pertinax was heard again and again. Just as Jusserand had earlier been said to have failed to alert Clemenceau to the possibility of a non-ratification of Versailles, so he had badly prepared Briand for Washington. Indeed, he had "foreseen nothing and prepared for nothing ... to the scandal of all our experts and to the joy of the British Ambassador." Indeed, by April 1922 word in Paris was that Jusserand's days in Washington were again numbered, largely because the Quai d'Orsay had concluded that "it had not been kept fully informed respecting current American opinion ... and that not enough had been done to present the French viewpoint to Americans." Louis Thomas, that New York–based French journalist, rekindled his enthusiasm for getting rid of the ambassador. The embassy, he claimed, "is a kaleidoscope; no one stays, no one wants to work under the commands of M. Jusserand. It's a true shambles."[34]

"Absolute rubbish," others retorted. If Briand were unprepared for the reaction against his naval demands, it was not because of any ambassadorial failing. Indeed, Jusserand was the only member of the delegation who had expected such a reaction. As for his rumoured retirement, that reflected nothing more than "an attempt

by French politicians to find a 'scapegoat,'" encouraged by the likes of Stéphane Lauzanne, now editor of *Le Matin* and Pertinax at *L'Echo de Paris*.[35] It was true, Frederic William Wile wrote in the *Christian Science Monitor*, that the ambassador had been fingered by his enemies as "the architect-in-chief of France's troubles," and accused by them of being aloof and "inaccessible," a charge that Wile claimed was simply "ridiculed in Washington where the Ambassador [was] known as a diplomatist of uncommon approachability, affability, and candor." On the same day, 1 May 1922, David Lawrence addressed readers of the *Washington Star*. Remember, he said, that there had been "no consistency in the [French] delegation." First it had been headed by Briand, then by Viviani, who had "made preparations to sail home the day he was made head of the delegation," then by Sarraut, "who knew very little of what had been going on and knew much less how to deal with American officials."

Lawrence might have added the fact that apart from Jusserand, and to Clemenceau's great disgust, none of the delegates spoke English. The journalist did point out, however, that because Jusserand knew Americans were so sensitive to foreign propaganda, and because Jusserand had been determined to avoid anything that might harm Franco-American relations, the ambassador had been at odds with some of his masters. That was why some people in France had been trying to "oust" him "for the last four years." Undeniably that was the case, said Wile in the next day's *Monitor*. There had been dissatisfaction in some French quarters with his service, although Americans who were at all "cognizant of diplomatic affairs in Washington would greatly deplore his retirement." A year later the *New York Times* added its voice. The anti-French press campaign of the previous year had been so provocative and so unfair, it said, that "a diplomatist of smaller calibre might easily have forgotten his representative character and precipitated a difficult situation. The self-control and self-sacrifice of M. Jusserand on these occasions were marvelous."[36]

While it seems true and obvious that the ambassador was responsible neither for what had failed to happen in Congress in 1919–20, nor for what had happened at the Disarmament Conference of 1921–22 – true and obvious too that such responsibility rested squarely on the shoulders of the government in Paris – we might add two observations, parenthetically, between our focus on

the ambassador as image-maker and our upcoming, more substantial explanations for French government policy toward the United States of America. One is to confirm what clearly must have been some ministerial unhappiness with the long-serving ambassador. The renewed rumours that Jusserand would be recalled started before the end of April 1922. It took only four days for the *Washington Post* to carry a notice, datelined Paris, that the ambassador would stay. But on 6 May, Jusserand claimed that he had received "no notice one way or another from [his] Government," a statement he repeated to another on 8 May, and to another on 10 May, and another on 13 May, and on the 15th, the 22nd, and the 27th.[37] Someone in the Paris ministry seemed to be finding some satisfaction in the ambassador's discomfort. The second observation is to report that the conference experience clearly whetted his government's appetite for a larger and more prominent information machine.

Having concluded that the Briand government had been out-maneuvred by the British and Germans – with or without their own ambassador's compliance – the Poincaré regime undertook a new propaganda offensive.[38] In early March, Consul-General Liebert was instructed to revive the French Cinematic Service in New York, one which the premier called "a precious instrument." By April the ministry had in hand a report from a lecturer with lengthy experience in America, a man who counselled prudence with Americans worried about foreign propagandists, emphasis upon a France victorious, a France powerful and rich – for Americans "do not pity the weak" – and a speaking style that was informal, anecdotal, without being patronizing. By then, too, the ministry's propaganda office, the Service des œuvres françaises à l'étranger, was launching a university-level lecture series featuring French scholars heading for America. By the autumn the ministry was soliciting advice from American journalists on how its own press services in Paris could be improved, and at least noting public complaints about how poorly the French press was represented in the United States. "While every American newspaper worthy of the name is in some way or other represented in Paris," one journalist complained, "it would be difficult to name a French newspaper which is represented in America by a correspondent who is in the habit of cabling information."[39]

Parenthesis ended, we may turn to another reason for the relatively docile way in which successive French governments had reacted to a series of provocations from London and Washington.

In a word, that reason was money, money manifested in two distinct but inter-related components: war debts and reparations. The fact was that France in 1921–22 felt, and was, vulnerable. The prominent New York banker, and francophile, Otto Kahn summed it up within a few months of the Washington Conference. "It little behooves America to criticize France for adhering to her rights under treaties when America adheres to her financial rights against France. It comes with little grace for us to urge France, impoverished by four years of war, under a vast burden for rebuilding her devastated regions ... to modify her claims against Germany when we, rich and unscathed, refuse to reduce the amount due to us from France as the result of comradeship in a righteous war."[40]

By 1920 that debt was in the order of nearly $3.5 billion, a figure that did not include the pre-April 1917 funds that had been raised through the private banks of America, but only the loans of public money that had been arranged from the date of American intervention in the war until the spring of 1919.[41] Of this total, nearly two billion had been borrowed prior to the armistice of November 1918, to which another billion had been added during the immediate post-war period for the purpose of reconstruction in northern France, and another half billion for the post-war purchases of surplus American war stocks that had been left in Europe. Technically, those demand loans could have been called in on very short notice, at least until both parties agreed on a renegotiation of time-frame and interest rate.[42] This, for reasons to be discussed, the French refused to do. By the end of 1921, which is to say at the time of the Washington Conference, they had only made three years of interest payments – at $20 million per annum – and those only on the nearly half-billion they owed for the surplus war stocks. Within days of the French signature on the Five Power Naval Treaty, Congress created a World War Foreign Debt Commission, which was given the task of renegotiating all allied war debts, specifically over a twenty-five-year period and at an interest rate of 4.25 percent. Equally specific was the Congressional instruction that there was to be absolutely no cancellation of any part of the debt outstanding. One month later, as an earnest of the government's thinking, the State Department instructed the private banks to inform it of any potential loans to foreign borrowers, clearly with a view to preventing further monies going to countries that had not settled with the Debt Commission.[43] All this is to show that the Disarmament Confer-

ence in Washington took place within the context of a growing estrangement between France and America over the issue of war debts, an estrangement in which France held the weaker hand.

From an American point of view, especially that of popularly elected politicians in Congress, it was a non-issue. As a president already in the wings would say in famous response to a question about the former allies' ability to pay: "They borrowed it, didn't they?" In short, the Europeans had needed the money and, in accordance with any commercial transaction, had agreed to pay it back, with interest. And lest this sound outrageously callous, it should be said that neither the Wilson nor Harding governments had insisted on immediate repayment. Indeed, they had proposed changing the debt from demand loans, subject to more or less immediate repayment, to multi-year obligations, and at interest rates that no one could call exorbitant. From a French point of view, however, American expectations were indeed exorbitant, not within a narrow contractual sense but certainly within a broader international, even humanitarian context. Between April 1917 and November 1918 America had made available public funds to support an ally's fight for survival against a mutual enemy, and thereafter funds to support that ally's recovery from four years of enemy occupation and destruction. But that largesse also had substantial benefits for the United States, especially given the fact that the bulk of America's monies borrowed in wartime had actually been spent in America on goods of American manufacture or natural products from American soil. Financially, the United States had emerged from the war a colossus, the dominant creditor nation among a long list of European debtor nations. Its industries – civil and military – were booming, its agriculture had found new markets, its currency was, if anything, on the verge of becoming too strong. And this new muscular condition had developed as its recent enemy and its recent allies had become financially and economically diminished. Was there not some grand gesture America could make to forgive some substantial part of her allies' debt burden, if not the magnanimous gesture of cancelling the debt all together? The question was more than rhetorical, for successive French governments had raised it with successive American officials from the autumn of 1918 onward. Each time, the Americans had said "no," and each such response had reinforced the French inclination to equivocate, defer, and delay. Money, therefore, not simply ships, was part of the

prologue and the play at Washington. As it would be part of the epilogue.

There were two other dimensions to the French position on war debts. One was the heavy cost of putting France right, the other was her capacity to pay the nation's bills. Of the former no one could doubt; of the latter, perhaps inevitably, Americans thought that the French government was inclined to underestimate both its actual and its potential financial health. As for the costs, although less than 10 percent of the national territory had been ravaged by the war, those northeastern departments had been the nation's richest, accounting for 20 percent of pre-war taxes. Within these roughly 20,000 square miles, over 30,000 miles of road surfaces had been destroyed by November 1918, as had some 4,000 miles of railroad track. Over 4,000 towns and villages had been destroyed, a third of them totally; almost 600,000 homes had been hit, a third of them, once again, beyond repair. Schools and hospitals, mines and factories had disappeared beneath the rubble, and almost three million people had been forced to find refuge elsewhere in France. The cost of clean-up, rebuilding, and resettling was staggering, the more so because market forces ensured escalating prices, especially in a region now short of building materials, construction facilities, and labour. As well, there was a host of new costs associated with the medical care of *mutilés de guerre*, and the upkeep of widows and orphans. In the course of the war, and given the extraordinary expenses, the annual deficit had grown by a factor of between six and seven, the public debt had been multiplied by a factor of six – which helped explain the sharp decline in the value of the franc; and that in turn helped explain the sharp rise in post-war construction costs by up to a factor of five.[44] Apart from the latter condition of sharply increased prices, the United States experienced next to none of the exceptional expenditures that the French government and people had had to assume.

As for the ability to pay, the two governments adopted, and maintained, sharply different stances. Successive American administrations, endorsed by many of the nation's media outlets, wondered aloud why it was that France was so reluctant to honour its war debts when it seemed intent on maintaining a military establishment that was the largest in Europe. Why, too, should American taxpayers be paying the interest on public money loaned to foreign governments? Surely, the French could sharply curtail their military

expenditures, and sharply reduce the debt load by limiting their borrowing and increasing their taxes. Until they did so, it was easy enough for trans-Atlantic perceptions to strengthen about French profligacy, about a national character content to live on hand-outs, and yet one greedy enough to bar American investors from sharing in the post-war profits that promised to accompany the rebuilding of France – all of these, precisely the kind of perceptions against which the embassy was constantly battling. What it had to do was sell the notion that, on the one hand, France was executing an astonishing recovery thanks to the industry and continuing self-sacrifice of its people and, on the other, that the Republic was so strapped financially that it could not entertain immediate, even early, repayment of its debts. As for the issue of an outright cancellation of that debt, Ambassador Jusserand seems to have left such proposals to the politicians and journalists, reserving for himself the oft-repeated assurance that the debt would be paid. As soon as possible. In the interim, his country's progress was remarkable, thanks in part to an increase – by a factor of five – in the individual tax burden between 1913 and 1920. Early the next year he reported that progress to an audience in New York. Almost all of the cultivatable land had been cleared of debris, and half of it was again under production. Almost 40 percent of the displaced labour force had returned to their pre-war jobs. Most of the rail services were back to normal, half the road surfaces were usable, nearly 80 percent of the industrial infrastructure was back in operation although only 60 percent of the country's critical coal-producing capacity had been restored.[45]

Certainly not all was well. Quite apart from the exceptional wartime damages to the productive infrastructures in northeastern France, and the attendant costs of post-war recovery, the country had to contend with a host of other liabilities that stiffened its reluctance to reimburse America. One was the over 400 million pounds sterling that France owed to Britain; a second was the over three billion franc loss in pre-war investments and wartime loans to Russia which were lost when the Bolsheviks came to power in the autumn of 1917.[46] Then there was the issue of the national currency. Using 1914 as 100, by the summer of 1921 the value of the franc was hovering around 40 after a fall that had been accelerated by the Anglo-American decision of March 1919 to abandon the exchange controls used to stabilize the wartime franc, itself a

decision that had contributed to rising domestic prices in France. While a weaker franc was a potential boon to French exports – indeed Jusserand claimed that by late 1920 the value of France's global exports was almost equal to that of her imports – it could not in itself offer rapid or full compensation for the large trade deficits that had accumulated in the course of the war, especially with respect to Great Britain and the United States. For example, the trade deficit with America had risen from 418 million francs in 1914 to over six billion francs by 1918, a reflection of an export market that had remained relatively static and an import dependency that had increased by a factor of ten. Besides, the imposition of the Fordney-McCumber tariff in September 1922 significantly raised the protective wall around America and by so doing inhibited French exports to the United States – which was its intention – as well as the commercial revenues that might have been used toward French war debts – which was not.[47]

Of particular consequence to French export revenues and trade imbalance was the advent of Prohibition in the United States. With American public money fast disappearing from the table, and loans through private banks becoming more and more difficult, it was of special importance that French exporters maximize profits through lucrative foreign markets for wines and spirits – especially to America, which had been one of the top pre-war importers of French wines and champagnes. But here, too, American policy seemed contrived to frustrate French efforts at every turn. Even before the end of the war Congress had halted the import of all alcoholic beverages, the first of several anticipated steps to shut down all such domestic production and sales. In mid-January 1919, in the early innings of the Paris Peace Conference, the 18th amendment to the American Constitution was passed into law. It came into effect one year later, two months before the Senate's final, and negative, vote on ratifying Versailles. That law meant the "total exclusion" of imported wines and alcoholic beverages, a prohibition that explains why the French delegation to the Washington Conference brought with it so many "dossiers" of alcohol.

But though it sounded like a purely commercial move against foreign competitors, Ambassador Jusserand was one of few French observers to understand that this new policy was as much a self-denying ordinance as it was a conventional commercial tactic. The

fact was that concerns about the demon drink had reached a new height in America, and legions of pious reformers were out to rescue "alcohol-besotted souls everywhere." They were not about to listen to spurious distinctions between wines and spirits, or to accept the proposition that wines were really medicinal in nature and Nature's primary combatant against alcoholism. Indeed, for the moment, no lobbying effort by the embassy stood a chance of success. Once more, the ambassador came under fire for an alleged lack of energy and an alleged inclination to do the Americans' bidding. And once more the Americans had found yet another way to impair France's economic recovery and, so it was said, the country's ability to pay her war debts.[48]

Then there was the matter of German reparations, a subject invariably connected by the French to their own war debts, two subjects invariably *dis*connected by the Americans.[49] Well before the Paris Peace Conference got underway early in January 1919, it was understood among the victorious allies that Germany would be held financially responsible for the damages her military forces had inflicted upon her neighbours – notably France and Belgium. That expectation had been duly written into the Treaty of Versailles, and its relevant clauses thus became the legal basis for demanding appropriate payment in money or materiel. Like the collection of loans France had made from the United States, this was a formal contract, although unlike the transatlantic transactions, one which the Weimar Republic had neither requested nor respected. Just as France saw injustice in the demands of its principal creditor, the Germans, too, balked at the notion of shelling out money to former enemies because of a treaty they had been forced to sign. From the very beginning of the post-war period, therefore, a vast plain of misunderstanding had to be navigated if Wilson's dream of international harmony had a chance of being realized. Americans thought it was unfair of former allies to renege on their contractual obligations; "they borrowed the money." The Germans, despite their own historic precedents, thought it was unfair that they should be stuck with a bill that simply had been served upon them, that in 1919 had been left without a final figure, and that in the spring of 1921 had finally been pegged at a hefty 132 billion gold marks.[50] The French thought it was unfair – given their four-year sacrifice – that Americans expected full repayment of their debt, plus interest, while

Washington rejected any link between those debts of some $3 billion and the roughly $18 billion in reparation payments that the Germans owed France.[51]

Thus it was that the prelude to the Washington Conference, as well as its epilogue, were shaped by enduring disputes over the rhetoric of justice and the reality of money. The Weimar Republic continually dragged its feet on reparations, time and time again coming through with only partial payments and usually behind schedule. The French, caught between the enormous costs of their own reconstruction and the increasingly vocal demands of their American creditors, dragged their heels in turn on the matter of war debts. The Americans, now rich as Croesus, with no enemies from the Atlantic, and with only one potential threat from the Pacific, wanted to move at speed. Not only was there a plan to ensure world peace by handcuffing possible rivals to a naval formula that satisfied American interests, and a plan to reduce French land armaments – which would reduce their expenditures, reduce Franco-German antagonism, and increase French potential to repay the war debts – but the Harding administration had other plans as well. One was to tighten the screws on foreign debtors by dissuading private banks from making future loans. Another was to create an international commission to study the whole question of German reparations and, in particular, to assess that republic's capacity to pay the bill that had been finalized only six months before the conference opened in Washington. The latter proposal was advanced by Secretary of State Hughes in late 1922. The French government responded without a trace of enthusiasm, partly, no doubt, because the Americans had evinced no comparable interest in trying to assess France's capacity to pay war debts, partly because the French government had a plan of its own, and partly because they resented Hughes's efforts to dissuade them from acting on that plan.[52]

In October 1922 Premier Poincaré shuffled Louis Barthou from the Justice portfolio to the chairmanship of the International Reparations Commission. The understanding between these two elder statesmen was that the erratic, unpredictable flow of German reparations payments had to be recognized as an ongoing violation of the Treaty of Versailles. Once that judgment was formally recognized by the Belgian, Italian, and British members of the Commission, some form of punitive action could be taken against the

resolutely dilatory Weimar Republic. By late December, the Belgians and Italians had combined with the French to declare Germany in default of her timber payments; and on 9 January 1923 a second tripartite vote found the Germans in default again, this time over their coal payments. By then it was clear to most observers what was going on. A legal base was being laid for a plan of action, one that would send Belgian and French armed forces into Germany's industrial heartland, the Ruhr Valley.[53]

On 11 January those forces moved to occupy the mines and factories in and around cities like Dortmund, Dusseldorf, and Ruhrort, hoping to seize control of the productive infrastructure and thus to ensure a more complete fulfillment of Germany's reparation obligations. Their patience exhausted by four years of German obstruction, and by four years of what they saw as Anglo-American obstruction, the government in Paris had finally chosen a path of firmness. The move was popular in France, and Ambassador Jusserand – while promising an early withdrawal once Germany resolved to honour her pledge – reminded Americans that France had quickly fulfilled its reparation obligations to Germany in the early 1870s, even though as the defeated power it, too, had considered that requirement an "unjust imposition."[54] The move triggered an effective campaign of passive resistance in Germany and, predictably, a new wave of anti-French sentiment in London and Washington. Those reactions, combined with the escalating costs of the occupation and an attendant weakening of the franc, all contributed to the need for a settlement of another order. In August 1925 the Franco-Belgian forces retired from the Ruhr, leaving in their wake both contemporary and historical arguments about the wisdom and the efficacy of such attempts at muscle flexing.[55]

One former American secretary of state, Bainbridge Colby, told a New York audience in April 1923 – celebrating the 20th anniversary of Jusserand's arrival in America – that the question of France's security was at the heart of all international issues, adding that her action in the Ruhr had been "absolutely justified and perfectly understood by most people in all countries." Ten days later the president general of the Daughters of the American Revolution urged members attending their annual congress to "Hail France! We wish her well in her struggle for justice," a plea that met with "instant applause." In June a journalist for the *New York Tribune*, and no consistent francophile, told his readers that Germany

had always exaggerated the punitive nature of Versailles, under-estimated her ability to pay reparations, and essentially provoked the French into the Ruhr occupation.[56] Contrary to Colby's public assurances, however, far from everyone applauded the French action. The Hearst presses jumped on the Ruhr operation to remind its sixteen million readers from New York to San Francisco of past experiences with Europeans: "France's Militarism's Menace No New Thing." The recent action against Germany proved yet again that French "Rulers" – no accidental word – were "Brutal, Greedy, Swashbuckling." France needed to be told plainly and simply that America was "Disgusted with her Militarism."[57]

A dying Woodrow Wilson agreed. His conviction unshaken that Poincaré was a "bully" and Foch "an excited militarist," the former president remarked to a friend: "I would like to see Germany clean up on France, and I would like to meet Jusserand and tell him that to his face."[58] Secretary of State Hughes did not go so far, but was no fan of the French tactic. By the autumn of 1923 he was back on track with the idea of a commission of inquiry to explore the question of Germany's capacity to pay reparations, an idea that the Ruhr action had delayed but hardly extinguished. Despite having enjoyed a long friendship with Ambassador Jusserand, Hughes thought Poincaré's decision to occupy the Ruhr was regressive and his resistance to a commission unhelpfully "obstinate." That was because the Secretary had already made up his mind that Germany had "no present capacity" to pay her reparations obligations, and that what was needed was a study to determine her future capacity. Following a series of talks with Jusserand in early November, he was also convinced that the French intended to stay indefinitely in the Ruhr, and to resist any inquiry unless it was one that looked at reparations *and* allied war debts.[59] Indeed, Premier Poincaré left no room for doubt. It made no sense to try to assess "anything but" Germany's present capacity to pay reparations, for to try to gauge her potential over an "indefinite period" meant "indulging in calculations which rest upon absolutely no basis."[60]

Still, the German mark was in trouble, the franc was in trouble, and the Americans were best placed to help stabilize both. Slowly, through the months of November and December, the Poincaré government gave ground – not in the Ruhr, where French troops remained, but on the monetary front. In the last month of the year, the New York–based French Information Bureau released its Bulle-

tin #29, which included the titular assurance: "France Has Never Thought of Repudiating Her War-Debts."[61] Unable to hold off any longer the creation of a committee of experts to examine the reparations imbroglio – though not the issue of allied war debts – the French acceded to American pressure. Between January and April 1924 the new committee, under the chairmanship of the American banker Charles Dawes, laboured in Paris to produce a new plan for German reparation payments. In essence, it left the total obligation unchanged, but stretched out the payment periods and projected a large loan of American money to help stabilize the mark and help float the first year of payments. Doubtless it was progress, but how much was doubtful, for everything hinged on the willingness of France to evacuate the Ruhr. This, neither Poincaré nor his successor as of May 1924, Edouard Herriot, was prepared to do, at least not without concessions. Once again the idea of a British guarantee of French security was raised, but without success; then, the idea of securing a British pledge to take joint action against any German treaty violations; then, an attempt to secure a promise to act with France in the event of German reparation defaults, all with the same lack of result. Ultimately, having been pushed "into one surrender after another," in the summer of 1924 the best that Herriot could get was an agreement to delay the actual evacuation of French forces to the summer of 1925.[62]

The sustained reluctance of successive French governments to loosen their stranglehold on the Ruhr raises another explanation for France's early post-war policy, one that says something both about its patient, compliant, resigned character up to 1922, and about its more impatient, forceful, risk-implicit character in 1923 and 1924. Confronted by media campaigns designed to undermine their credibility and magnify their avarice, and constrained by the overbearing political counsels of their principal financial creditors, French governments had a third and fundamental reason for trying to steer a course between dependence and independence. They did not trust the Germans, they did not feel secure, they did not believe they could win a strictly bilateral war against an industrially and demographically superior enemy. Take that away, remove the German factor, and neither winning the propaganda war nor assuring access to foreign treasuries would have counted for nearly as much as they obviously did in the early post-war period. Clemenceau

would not have pushed for a semi-autonomous Rhineland and
would not have been seduced by allied pledges to the future defence
of France. Briand would not have shut the door on discussions
about reductions in land armaments in Washington. Poincaré, by
nature no risk-taker, would not have gambled on how the Germans
and the Anglo-Americans might respond to the use of force in the
Ruhr. And for their ambassador in America, the task at hand was
multiple and daunting: convince enough Americans that France
was not militaristic, despite her position on land armaments and
the presence of her troops in the Ruhr, that France's rapid recovery
was proof of a natural material wealth, despite her current inability
to start paying off her debts, that Germany remained a threat to the
security of her neighbours, despite the loss of her fleet, the dis-
banding of her air force, the forbidding of conscription, and the
attendant dependence on a small, professional army.

There is no reason to believe that in the matter of such fundamen-
tals the ambassador personally disagreed with either the instruc-
tions or the expectations of his government. Now approaching his
seventies, he could not shake the memories of German invasion,
memories both youthful and mature. In a telegram to his minister in
January 1921 he insisted that, to date, there was no difference
between the Weimar Republic and the Kaiser's fallen empire. The
current government in Berlin was putting its faith in the "sharpened
sword" just as Wilhelm II had put his in the "iron fist." "These
people have experienced no conversion." But neither had he, in two
senses. A year and a half later he remained convinced that there was
no possibility of a Franco-German rapprochement, because the
Germans had never expressed any remorse for their role in the com-
ing of the last war. [63]

Nor had Jusserand changed his mind about the critical impor-
tance of the United States to France's future or the most effective
strategy to pursue in cultivating relations with America and Ameri-
cans. The way one coped from Washington with the German threat
was by ensuring that the road between France and America's good-
will and resources was kept in good repair; and that meant patience
and prudence, as it always had. At the height of the Washington
Conference, amid foreign-based attacks on France and French-
based attacks on its ambassador, Jusserand counselled restraint:
"Above all, let the storm pass. One does not hoist one's sails in the
midst of a hurricane." What was needed was "moderation, not

excess."[64] What was not needed were popular song-writers, carica-
turists, journalists in France, going out of their way to poke fun at
Americans, precisely because what was needed were Americans of
goodwill and talent, voluntary propagandists for France who could
do the job more effectively than any Frenchman and without the
risk of France being marked as one of those foreign powers whose
surreptitious meddling the State Department had warned against.
What was not wanted were indiscreet and provocative remarks
from well-meaning post-war *missionnaires*, even the non-pareil
Georges Clemenceau, who was feted across America in November–
December 1922.

Caught between his friendship with the intrepid "Tiger" and his
instructions for caution from Premier Poincaré, Jusserand did his
best to control the direction of conversation between President Har-
ding and his eminent guest – so much so that Clemenceau, despite
his appreciation for the ambassador's delicate situation, was later
said to have complained that Jusserand had done all the talking.[65]
Also not wanted were the higher profile and more overt campaigns
of persuasion that were already being conducted by Consul General
Liebert in New York and being tolerated, if not outright encour-
aged, by certain quarters of the Quai d'Orsay. His new French
Information Bureau was exactly the kind of agency that would
arouse American suspicions of foreign propaganda.[66]

For the rest, it was best to stick to the old formula. Avoid public
confrontations with people intent on baiting France;[67] repeat
France's intention to pay her debts in the fullness of time; emphati-
cally deny the tired accusations of French militarism and imperial-
ism; deny the "wicked" charges that sometimes appeared in the
American press about the savage conduct of French colonial troops
in the Rhineland, though deny carefully so as not to enflame Ameri-
can attitudes toward people of colour. Let the Germans incur the
wrath and disgust of Americans by their exaggerated claims and
accusations, and the British too, whose occasional outbursts of
extreme anti-French sentiment left thoughtful Americans uneasy.
Parenthetically and in this connection, one writer applauded
Jusserand for not making the frequent British mistake of confusing
"Babbit" and "Main Street" with "America and Americanism,"
although it should be said that the ambassador believed that an
Anglo-French entente was "absolutely indispensable" to the preser-
vation of peace in Europe.[68] Above all, promote France's place in

the cultural pantheon of the world and never cease to remind Americans of their historic ties to France. Speaking at the White House in May 1922, the atmosphere still charged with dust from the disarmament conference, Jusserand recalled that the first time the new American flag with its thirteen stars had been saluted in European waters was when John-Paul Jones had pulled into the port of Quiberon. Then, presenting to President Harding the modern flag that had flown from the Eiffel Tower since April 1917, "side by side with the tricolor of France [itself] devised for us by Lafayette during our revolution," Dr Jusserand concluded: "All things we know come to an end; such will be the fate of the friendship between France and America – the day when the stars shall fall from the sky or from the flag of the United States."[69]

This invocation of the past, so typical of an ambassador who was an historian, provides an appropriate reminder of the historian who was also an ambassador – and of the human being who was behind both. The war years had taken their toll on the lives of the ambassador and his wife. There had been no vacations, the capital's summer heat and humidity notwithstanding, and no grand parties, either as hosts or guests, while soldiers added their blood to the soil of Champagne. Their sole diversion as a couple had been the daily carriage ride down the slopes from 16th Street into Rock Creek Park, and the ambassador's often solitary walks among the trees, perhaps recalling the endurance marches once led there by Theodore Roosevelt, more certainly pondering the fate of a France sometimes tottering on the edge of collapse. Gone now from the written record are recreational allusions to tennis and fencing, replaced only by the walks and the forest birds reminiscent of a childhood near St Haon-le-Châtel. Apart from the essays that were bound within the Pulitzer Prize–winning volume, Jusserand appears to have written little during the war, a lull which is hardly surprising given the trying conditions that engulfed his embassy after 1914. One exception was a preface to a book of 1917, dedicated to the American ambulance corps, in which he was able to reassert not only the cherished Franco-American connection but also his formula for retaining friendships: "spend nothing and keep quiet."[70]

If not writing, what? Sometimes, depending on the complement of embassy personnel, the work was especially arduous. The end of the war, though celebrated, had brought no free time. By the late

summer of 1919 the ambassador had a single secretary, two typists, and was in dire need of a filing clerk, a decoder, and a press analyst. A few months before the Washington Conference, Elise reported that her husband was "swamped just now with work," partly in this case, because his bilingual, "almost irreplaceable" stenographer had died. Less than two years later, as the heat was building over the Ruhr, a junior diplomat at the embassy alerted the ministry to a crisis in the making. The ambassador was ill with bronchitis, the position of *conseiller* had yet to be filled, the functioning diplomats were down to two – one of whom had the flu – the sole decoder was doing so much overtime that his doctor had advised a holiday, and the budget was so over-run that the ambassador was paying the typists out of his own pocket.[71]

All this at a time when the American and British governments, as well as significant voices in their respective presses, were expressing concern over the French decision to apply force to German reparation payments. All that and more, for the ambassador was more sick than he had been since birth. For at least two weeks in February–March 1923, he was confined to bed, the victim of fever, ear ache, and other flu-like symptoms, the aggregation of which was finally diagnosed as bronchitis. And in the midst of this health crisis, and that of an embassy seriously short-staffed, came word from Paris that Elise's sister Marian had died at the age of sixty-six. Elise, though still recovering from her own extended bout of influenza, had to make plans for an impromptu voyage home, thus raising the prospect of "separate solitudes," which the ambassador described as "very unpleasant to both of us." The fact was that over the space of twenty years they had never before been separated by the Atlantic, a condition until then carefully ensured by a couple devoted to one another.[72] But by the end of April Elise had returned to her second home, having dealt with the sadness surrounding her sister's empty apartment and grateful to find her husband almost entirely cured, "although not quite as strong as I would wish."[73] But time would heal him, that and the annual escape to France – the ambassadress being less than candid when she claimed to enjoy the Capital's summer weather. In late July the couple left for their customary three-months' leave in their homeland, their health recovered, and at long last with the post of embassy counsellor filled by André de Laboulaye, whom the delighted ambassador held "in particular esteem and affection." Reassuring, too, was their govern-

ment's recent decision not to relocate the embassy to a site which it had purchased on S. Street before the war – once it had learned that the German government owned the property directly across the street.[74]

Days after their departure for France the Jusserands received disturbing news from Washington. President Warren Harding, an affable man, had died suddenly in San Francisco and been succeeded by his vice-president, Calvin Coolidge, a man whom the embassy *chargé d'affaires* found to be far more laconic and reserved. Charles Evans Hughes remained at the State Department, a constancy that must have pleased the absent ambassador, whose friendship with Hughes had so far proven strong enough to weather sharp differences over ships, debts, and reparations. Almost inevitably, the latter item became the key subject of discussion when in early November the returned Jusserand met Coolidge in his new role as president. Specifically, what the American wanted to discuss, and promote, was the Hughes proposal for a commission of financial experts to explore Germany's reparations obligations, the very one that would lead to the tabling of the Dawes plan the following spring.[75] In the interim, the embassy carried on its customary struggles with one opponent or another. Hearst was a constant irritation, whether his papers were highlighting the francophobic views of that celebrated English writer H.G. Wells, or warning their readers of a new propaganda assault from the Third French Republic. So also was a new generation of hearing-impaired functionaries in the Quai d'Orsay. While they might ignore embassy appeals for copies of works by French scholars capable of exploding German claims about their innocence in the origins of the last war, they seemed only too attentive to the appeals of Gaston Liebert for a more overt propaganda effort.[76]

Still, not all was lost, or dark. Embassy life in Washington had recovered some of its pre-war glitter, gradually accommodating itself to a degree of post-war gaiety that had for too long seemed inappropriate. Coolidge, Hughes, and Jusserand did meet for purposes other than the solemn – like the occasion of the president's first state reception in the White House, a splendid affair with a guest list of over two thousand. Sharply at nine the scarlet-clad trumpeters of the United States Marine Corps had struck up "Hail to the Chief" as the president and Mrs Coolidge, followed by a uniformed entourage, descended the great staircase to form a receiving

line in the Blue Room. The First Lady wore a dress of white satin, complete with a three-foot train, and carried a bouquet of white roses held motionless by a simple white ribbon. One by one, couple by couple, the guests advanced to their hosts, starting with members of the Cabinet, men all, but accompanied by ladies in pink chiffon, lavender chiffon, pink velvet, black velvet, gold and black brocade, each accented in some way by pearls, diamonds, emeralds and rhinestones, or by ermine, chinchilla, or silver fox.

Then followed the diplomatic corps, led as always by France's diminutive representative and his slightly taller, elegantly dressed consort of twenty-eight years. As that contingent of colourful uniforms, the beribboned and begowned, slowly made its way through the Red Room into the East Room for lively chatter, they were followed by the other two thousand invitees, all of whom were greeted with a presidential word or two and then hastened on, all within the space of an hour and half, the presence of each fleeting passerby permanently recorded in the society columns of the *Washington Post*. The evening highlight over with, hosts and guests could relax where they chose: among the palms in the East Room, set off by displays of pink carnations, the Red Room with its red, the Blue Room, unexpectedly, with white carnations and lilies, the state Dining Room with pink chrysanthemums. Above the sounds of conversation and laughter the efforts of the Marine Band were perfectly audible, shifting as the evening wore on from martial to dance music, until the President and First Lady bade good night and retired upstairs to the private apartments.[77]

What the French ambassador thought about such occasions we cannot know for sure. That they were part of the job, the custom of foreign representatives and domestic political elite, was obvious enough; and by now he and Elise had been attending such Washington functions for over twenty years. But one suspects that a couple, private by nature and not given to banal conversation, accepted these publicly staged, carefully rehearsed, decorous events for what they were: matters of professional obligation, some fulfilled with more enthusiasm than others.[78] What is clear is that their appreciation of the truly beautiful went beyond the flowers impeccably nurtured in the White House conservatory, or the splendour of the silks, the polished medals, the sparkling jewelry that earned the applause of the society columnists. This we know because of a thoughtful address that the ambassador had delivered the year

before to the annual convention of the American Federation of Arts, an address subsequently entitled "The Inestimable Value of Beauty." In all, it was a personal testament to natural beauty, beauty as the "Maker" had made it, that creative force which he several times referred to as the "great Gardener."

Children, he counselled, must be taught to appreciate the beauty surrounding them on any given day. They must be taught to open their eyes, to discern the spectacular not only in the Grand Canyon or the Yellowstone Park but in the "elegant nerve structure" of a simple leaf. This the schools must do, and attending adults, so that the visual beauty, even "of modest thorns and brambles," and the auditory beauty offered by the songs of the wild birds and the hum of insects were not overlooked through ignorance or indifference. Unless an effort were made to recover an older, fast-dwindling appreciation of what the Gardener had given, subsequent generations would never notice the wild roses and the honeysuckle in Rock Creek Park, would never know the solace which its forests and its creatures could provide to those with eyes to see and ears to hear. "I know of a couple," he said, "who, during the saddest days of the World War would ... pace the woods around this city and whose troubles were made less acute, for awhile, by those peaceful surroundings." Indeed, almost daily, that same couple continued to take the embassy's red-wheeled, open *barouche* pulled by two dark bays to the banks of nearby Rock Creek, where she would wait for him, blowing him a kiss as he set off on a long walk. But that couple had been instructed as children not to overvalue the utility of the factory chimney, and undervalue "the beauty of a tree."

These days, he suggested, humankind was at a turning point. On the positive side, there were signs of renewal in cities like New York, Chicago, and Philadelphia, as unhealthy streets and decrepit buildings were being replaced by public parks and gardens. In Washington, however, the future was less clear, and by implication less bright. The capital's first designer, the French officer Major L'Enfant, had provided a blueprint for a city of exceptional beauty, laid out spaciously, symmetrically, according to the architectural ideals of eighteenth-century France. But that officer had not foreseen the developers of the twentieth century, had not anticipated that the natural landscape would be abused, "uniformly leveled, with hills dumped into valleys, crushing rivulets out of existence," so that "more houses can ... be huddled together."[79]

This closing invocation of historical experience came as naturally to this historian as the paean to natural beauty with which he had begun his address. One was an expression of a deep-seated, personal philosophy rooted in the Roannais countryside, the other a glimpse of his professional philosophy as historian. As he thought Nature could inspire and console, so he believed History could teach. These two great muses had long been central to the life of Jules Jusserand, and perhaps it was only coincidence that his clearest testaments to both were published within a few years of each other, and when he was in his mid-to-late sixties. His thoughts on "The Writing of History" were published in 1926, a year after his final departure from Washington; but since the essay itself obviously preceded its publication, and since the commission for preparing the essay had derived from his presidency of the American Historical Association in 1921, it seems appropriate to use this moment to explore his views on the discipline of History.

Those views, it should be said, took the form of but one essay in a volume of four, although Jusserand's title was employed for the book as a whole. The other authors were Wilbur C. Abbott, Charles W. Colby, and John Spencer Bassett. According to the then-editor of the *American Historical Review*, the annual conference of December 1920 had produced few papers of "extraordinary excellence" and too many that were "distinctly ill-written." For that reason a special committee had been struck for the purpose of advancing ideas on how to "stimulate the better writing of history." With that as the committee's mandate, Bassett wrote the report's preface, reminding its readership of the volume's working premise, namely that the writing of History, specifically in the United States, "was not in a satisfactory state." Too many readers were being put off by the "heaviness of style" that had come to characterize the work of too many academic historians. In their attempts to be more "scientific," that is more accurate and more attentive to their sources, they had lost "the charm of literature." Where once the best historians had "lived like proconsuls over provinces of literary expression," their successors were rather more like "hard-working centurion[s]."[80]

By then writing as a past-president – only the second foreign national to be elected to that position since the association's inception in 1884 – Dr Jusserand certainly did not dispute the premise.[81] Although in the manner of one of his literary heroes he warned

against confusing "flowers" with "fruits," he cited at some length
the wisdom of other heroes. "Style" meant writing that was "per-
fectly luminous," bearing "no obsolete words nor words having the
smack of the tavern"; or, "in order to prove that you can write ... it
is not absolutely necessary to be dull"; or, in his own words, "An
historian who uses so dull a style that he will not be read is as use-
less as a painter who should use invisible colors."[82] But colour is no
substitute for substance. Historical writing is an evidence-based dis-
cipline that offers no room for "tales of wonder," no place for imag-
ining "what may have been said." It relies on the written record,
published and archival; and those sources must be cited with care
and precision, although in "notes and appendices" rather than in
the literary text itself. "The cook has to peel his potatoes, but he
does not have to peel them on the dining-room table." For what the
stylistic flourish and the pedestrian citation have in common is their
association with the very essence of the discipline – which is to say
the search for Truth capitalized. To that end Jusserand quotes
Polybius: "Truth is for history what eyes are for animals"; and
Cicero: "Never dare to say anything false, and never dare withhold
anything true"; and Lucian of Samosata: The historian must "as the
comic poet says, call a fig a fig," and always be "an impartial judge
prejudiced against no one."[83]

But there were, it seems, a few caveats to the Jusserand philoso-
phy of history. One of them relates to his belief in the utility of his-
torical studies, that is to say a belief that knowledge of the past can
offer up prescriptions for avoiding mistakes in the present. Most of
his examples are "simple and general" in nature – "unbearable
abuses breed revolution" – but one has a ringing specificity. It is a
mistake, he mused, when a country like Germany before 1914
exaggerates the weakness and decadence of its anticipated enemies.
That illustration was so specific, and so contemporary, that it seems
far from the ideal of the impartial judge. And underneath the ver-
dict of an historian who was at the same time an ambassador is
another that informed so much of his own historical writing.

The admirable Lucian may well expect the historian to be "a
stranger ... without a country," as might the admirable Fénelon
when he claimed the historian "belongs to no time or country."
Even the cherished Gaston Paris, writing in a besieged Paris of
1870, and the cherished Taine, had counselled that ideal. But Dr
Jusserand was not entirely sure. Sometimes impartiality was no

more than the offspring of indifference. And sometimes, as well, there were subjects that were too close to the historian's heart, as the result of which any attempt at impartiality would only be in vain. Better, he thought, not to judge too severely the historian who could not "veil his nationality or his faith." Yet there was one more caveat. In a remark that is so reminiscent of his ambassadorial stance on propaganda, he declared that even a patriotic bias could be carried too far, to a point where the allegiance became counter-productive. "Exaggeration, which is a semi-lie, with a part that is true and a part that is not, is soon detected, and the reader in his vexation deduces not only all that is false but a part of what is true. The boaster thus proves the loser."[84]

The intersection between Jusserand as ambassador and Jusserand as historian was never better illuminated than in December 1921, partly because he absented himself from the Washington Confer-ence in order to preside over the annual meeting of the American Historical Association in St Louis, and partly because the title of his presidential address was "The School for Ambassadors." In it he offered up a blend of history, both personal and professional, and diplomatic reflection. As a work of history, it is both impressive and revealing. Impressive because it is meticulously documented, drawn liberally from sources in five languages (Greek, Latin, Spanish, Italian, French, and English), and ultimately because he demon-strates such a command of the early history of his ambassadorial profession. No light-headed, after-dinner speech this. It is revealing for similarly multiple reasons. Here, once more, we find an expres-sion of Jusserand's belief in History as an instrument for helping the present avoid the mistakes of the past: "The past is like a great reflector; we want to keep it bright and its light turned toward the future."

Here, too, is the familiar theme of associating his interest in his-tory and language – broadly speaking, his education – with the shock of 1870, the conviction that ignorance had been at the root of the defeat, along with the attendant determination of his class and generation to become "useful citizens for hard-tried, bleeding France." That resolve was no abstract notion for Jusserand. It was at the absolute core of being an ambassador. Drawing with ease from some twenty medieval and early-modern "manuals" on the conduct of diplomacy, he isolated a series of characteristics that had been deemed essential for the effective diplomat. Though good

looks were said to help, and oratorical talent, none was more important than that his knowledge "should be boundless." History should be "his chief study" but in truth, he should be a "living encyclopedia," conversant in scripture, dialectics, mathematics, geography, astronomy, philosophy, art, music, and foreign languages – even English, although the idea that *it* should be learned "never occurred to any one" until later in the eighteenth century.[85]

Lest any should miss the point, he underscored that the European diplomatic tradition had always called for the "best men" whether long-term or occasional *missionnaires*, by which was meant writers, poets, learned men: Dante, Petrarch, Boccaccio, Machiavelli, Ronsard, Chaucer, Sir Philip Sidney. And their mission, so often, was to serve as "messengers of peace," as agents skilled enough to serve the interests of their sovereign – whether monarch or electorate – to pre-empt war. But to do this well, this ambassador-president suggested, required qualities that surpassed physical stature, speaking skills, and broad education. Some were intrinsically "moral" in nature. There had been a time when piety had been important, or at least the appearance thereof. In more modern times, he granted, punctuality, alcoholic moderation, and personal modesty served in its place. More important, though trickier by far, was the ambassador's ability to be nimble-footed on the high-wire between truth and lies. There was a difference, the earlier manuals allowed, between lies from "a private man" and casuistry from someone acting in the best interests of his country. Indeed, if they did anything, the collection of pre-eighteenth-century handbooks on diplomatic conduct had left the door open to lying by their very ambiguity. Quoting Sir Francis Bacon, Jusserand reminded his audience of historians that lies were like gold and silver alloys. They "debase the article but may make the metal work better." But since the eighteenth century there had been a growing consensus that honesty was its own reward, both personally and diplomatically. Which is why, the ambassador observed with a subtlety and a candour that were equally clear, Imperial Germany ultimately had paid a price when it adopted as its "guiding principle that of wolves and ravens," the principle that "necessity has no law ... that force and falsehood were sure to triumph." How different this, France's current ambassador purred on a text from Thomas Jefferson, in a room filled with American historians: "I know but one code of morality for men ... whether acting singly or collectively. He who

says, I will be a rogue when I act in company with a hundred others, but [an] honest man when I act alone, will be believed in the former assertion but not in the latter."[86]

There were two other qualities that an ambassador required, according to the manual-informed Dr Jusserand, both closely related. Not only must an effective diplomat be an individual of broad knowledge but as early as the seventeenth century, he was advised to take the time to "study the country where he is, and personally see people of all ranks, talk with them, understand the trend of opinion and so discover the various forces at play there." And unlike his masters who remained at home, because he understood the terrain and they did not, it was as important to speak the truth to them as it was to his hosts. "He may have lights that the sender has not, and he must, under his responsibility, follow them ... More than once," he said, "I had to put those lights into practice during the Great War." In other words, ambassadors were far more than mere ciphers, following instructions to the letter, whether good or bad. Their information and their reading of circumstances were essential to the policies ultimately determined by their governments; and to that end an ambassador occasionally had to chide his superiors for their inefficiencies and thoughtlessness, just as Ronsard had once upbraided Henry II: "Do you think you are God?"[87] As Montaigne had put it: "They do not simply execute, but form also and direct by their own advice the will of their masters." At the same time, perhaps with his German homologues in mind, he added that, however important their services, ambassadors must not mistake themselves for "actual princes" any more than they should forget the ancient advice that an embassy known for its "sumptuous establishment" was probably committing a "folly."[88] Thus summarized, so ended Ambassador Jusserand's erudition-laced nostrums to his peers in the American Historical Association, offering them, in all, considerable insight into his views on History, Diplomacy, and the ground between them. These were the lights by which he had lived two distinguished careers. As they had for so long in the past, so would they illuminate his final months in Washington and the retirement years awaiting him.

7 Creation and Remembrance

With the exception of 1903, their first year in Washington, the Jusserands had spent all of their subsequent summers in France, a custom that had continued until August 1914 and their obligatory, uncomfortable passage back to America. The next four wartime summers had kept them in place, exiles from Paris and their beloved Saint-Haon-le-Châtel. The first six months of 1919 were compensation of a sort for their enforced time away, dominated as the period had been by the post-war peace conference at which the ambassador played no major role; and that summer, unusually, the couple had reversed their prewar custom by leaving their residence on the newly named avenue du Président Wilson for the embassy on 16th Street. Thus it was not until the summer of 1920 that the old pattern was resumed, in the wake of a year's painful display of presidential pique and congressional tenacity.

Thereafter, for the next four years, custom had reasserted itself, including the summer of 1923 when Jusserand had worked in a nostalgic visit to Scotland and paid a nostalgic call on Britain's pre-war foreign secretary, the now visually impaired Sir Edward Grey. More reassuring, no doubt, was one of the next summer's events in Paris – not a particularly high-profile event, only a banquet, but one that was soon to acquire considerable significance. It was an evening staged to celebrate Franco-American friendship, organized for a conference of American advertising executives. Jusserand had been asked to speak, and had predictably sounded the chord of friendship between America and France, and only slightly less predictably – given his views on aesthetics – urging the delegates not to deface their countryside with billboards. More telling, however, was another remark, and the "rising ovation" it received. Referring

to Ambassador Jusserand, Senator Jean Dupuy, the banquet chair-
man, recollected: "President Coolidge told me: 'Don't take this man
away from us; you can't replace him.'"[1]

The remark was not accidental. In May 1924 a loose coalition of
centre-left parties known as the *cartel des gauches* had been suc-
cessful in the general election; and on 14 June a new government
had taken power under the premiership of Edouard Herriot, who,
like so many premiers before him, also took charge of the foreign
ministry. Almost immediately, and simultaneously, two issues rose
to prominence, connected uncertainly, but certainly connected. One
was the sudden re-emergence of rumours about the enforced retire-
ment of Ambassador Jusserand, although now, reportedly, as but a
single change within a much greater shakeup of foreign ministry
personnel. Reportedly, too, according to the *Washington Post* of 21
June, there was an intent to go beyond a simple rejuvenation of the
service with younger and allegedly more energetic men, and to pro-
mote agents who were ideologically sympathetic to the vision of the
new regime, agents unlike too many within a service that the *cartel*
had long considered to be a "hot-bed of reaction."[2]

The other issue was the Herriot administration's early decision to
join the British Labour government in formally recognizing the rev-
olutionary regime that had held power in Russia since the autumn
of 1917, a decision frowned upon by the American State Depart-
ment. On the very day the *Post* article about the anticipated
shakeup at the Quai d'Orsay was date-lined from Paris, Jusserand
reported from Washington Hughes's belief that the Soviet Union
remained unreliable as an international player and, if anything, had
actually revived its predisposition for "terrorism."[3] In short, France
and the United States were no longer on the same page, and
Jusserand was the bearer of such news – Jusserand who was almost
seventy years of age, who preferred carriages to cars, who had been
sent to rescue Warsaw from the Red Army, and who privately
seemed to have shared Hughes's dark reading of a Soviet regime he
once had associated with "the powers of evil."[4] Which of these cre-
dentials, the ambassador's age or his conservatism, weighed most
heavily on Herriot's mind is unclear. But in tandem, in 1924, they
had come to constitute a liability for an ambassador who wished to
remain in service and in Washington.

Still, the ministry said nothing to him in August or September,
"not a word, either from the President, the Premier, or any Cabinet
Minister." By early October the Jusserands were in transit back to

Washington. On their arrival, and in response to the rumours that had been circulating since June, Jusserand assured reporters that he would be staying "for a long time." On 9 October the ambassador saw President Coolidge. They talked about France's impressive recovery effort, also about the need for France to keep her arms at the ready, lest – as Jusserand put it – the Germans should be tempted to strike again against a neighbour they thought had become complacent. As they had, he added, in 1914. But not a word about his recall.[5] Indeed, almost to the very end, until mid-October, the ministry denied any intention of replacing its ambassador in Washington. Then, on 15 October, Premier Herriot notified the long-serving diplomat that he would be retired at the end of the year, in ten weeks' time, and that he would be replaced by sixty-one-year-old Emile Daeschner, currently director of administrative affairs at the Quai d'Orsay. According to the Paris-based journalist Sisley Huddleston, it was to be just one of some 150 personnel changes within the ministry, some involving promotions, some changes of venue, some retirements, some rewards, and some punishments, although readers of the *Washington Post* and the *New York Times* were assured that in Jusserand's case, it was mainly a question of his age.[6]

Whatever the government's motivation, it seems very clear that the announcement came as no welcome news to Dr Jusserand. It took less than a fortnight for him to suggest that Herriot's calendar was a little unreasonable, given all the arrangements that would have to be made for the move home, and for the surfeit of anticipated farewells. It would be unseemly, he suggested, for the long-serving dean of the ambassadorial corps to decamp the Capital in a rush. Besides, he added, since the presentation of his credentials to President Roosevelt had taken place at the beginning of 1903, twenty-two years earlier, it would make more sense for the change-over to take place in January. Five days later, with no response from his minister, the ambassador confided to John Finley: "My days are numbered here, and I do not know the number, which still increases my difficulty."[7] But it was far more than the timing of his departure. It was the very principle.

Of course it was the government's right to change personnel as it saw fit, he wrote to a friendly member of the French Senate; still he could not shake off the conviction that his utility to his country remained undiminished, or his underlying doubt about the wisdom

of the decision. As he said to another correspondent, he could only hope that the decision to retire him did not prove to be "a throwing away of opportunities which it might have been better to avoid." To Finley the ambassador confessed "deep sorrow" at the prospect of leaving America, to Owen Wister "great sadness," although he acknowledged the obvious: retirement could not have been far off in any event. With Robert Lansing he went a step further, confessing not just sadness but "bitterness,"[8] an understandable response, given the prolonged exposure to rumours of his recall, the government's repeated and sustained denials of those rumours, and the precipitate notification that he had less than three months to clear his desk. Another affront was to follow. On 29 November Jusserand telegrammed Paris. He had just learned, not from his ministry but from the Press Association, that he was to leave his post on 6 January. But owing to a series of invitations and obligations he had accepted beyond that date, he wrote, this was impossible. The next day he explained that the number of American-planned public and private events to celebrate his long mission – unprecedented for a foreign diplomat, duration and celebration both – reflected so well on Franco-American friendship that common sense dictated a later departure date.[9]

In fact, he got his way. On 20 January he had his final audience with President Coolidge, by all accounts a friendly occasion – though a suggestive one at that. Recent practice had provided for an incoming ambassador to present the recall letters of his predecessor. This, Jusserand refused to do, saying that he preferred a personal leave-taking, implying perhaps a state of discontent with his own masters.[10] He and Elise left Washington for the last time on 22 January 1925, surrounded by old friends and well-wishers. Assailed by reporters on his return to Paris three weeks later, the retired ambassador would only say: "Finding myself not in accord with my successor and the Premier, I prefer not to give an interview." With that, the reporter for the *Christian Science Monitor* was left to his own devices: "The incidents connected with his recall have never been clear. When he left France after this holiday ... last autumn, there was every reason to believe that he would long continue his services. It was for him and everybody else a surprise to learn that he had been replaced. It is understood that the Quai d'Orsay reproached him for certain public observations on the problem of inter-allied debts."[11]

Certainly the debt question had remained intractable, impervious
to the efforts of even the most seasoned and skilled ambassador. In
Jusserand's last months in Washington, this was one of the two
thorniest, if familiar, issues with which he had to contend. Knowing
since mid-October 1924 how limited his time was, in mid-November the ambassador engaged in several conversations with Secretary
of Treasury Andrew W. Mellon. The gist of the ambassador's
proposal, in keeping with the French Finance Ministry's recent
Inventaire de la Situation Financière de la France, was as follows:
France had spent more money, had lost more men, and suffered
more infrastructure damage during the war than any of her allies.
How different her situation would have been, Jusserand remarked,
had the war taken place on English or American soil. Hence, the
French Republic warranted special consideration: a ten-year moratorium on payment of its debts to America, and an interest-free second decade during which payments would be made directly against
the borrowed capital. Mellon, well versed in the customary
responses of the Wilson, Harding, and now Coolidge administrations, called the proposals "excessive," suggested that the debt was
not beyond the strength of the rapidly recovering French economy,
and said "no."[12] There was nothing new in the American response
to a French proposal that was new only in detail rather than in principle; and nothing new, either, in a French perception that the
English government – alert to rumours of the Mellon-Jusserand
talks – was doing its best to scotch any special pleading on the part
of France. It is as hostile to us now, Jusserand reported, as it was at
the time of the Washington Conference.[13]

What *was* new was the storm that started to break around the
ambassador, a storm that clearly succeeded – rather than preceded –
notification of his recall. Feeling perhaps a sense of imminent liberation, however unwanted, the outgoing ambassador seemed to
welcome opportunities to make public remarks about the debt
question. In early December he told an audience in New York City
that France would indeed "pay to the last cent," quickly adding,
however, that his country had suffered more than any other during
the war, and that five-sixths of the money borrowed from America
had been spent in America. In short, it was a plea of sorts. A few
weeks later, he repeated to a Washington audience France's intention to pay her debts, though reminded them of the inordinate costs
she had been forced to assume during and after the war, and argued

the need for a short-term moratorium and preferential terms for repayment.[14] Once again there was nothing new in substance to the ambassador's remarks. But the British government's objections to the principle of special status for France, the American government's objections to the principle of delaying payment on borrowed money, and the Herriot government's unease with an ambassador too senior and now too liberated to be submissive, all conspired to assure Jules Jusserand of a pyrotechnical finish to his career.

Immediately after the Washington speech, the Hearst press carried a story suggesting that President Coolidge had "rebuked" Jusserand for his public reference to the moratorium idea – a suggestion quickly denied by the White House. Still, the press world acknowledged that there were some upset feelings about the conduct of such "open" diplomacy, which is to say trying to recruit public opinion in a political cause. For its part, however, the internationally attuned *Christian Science Monitor* judged it a healthy thing to go beyond "hidebound official channels," especially when Mr Mellon had been "officially" informed of the French proposal, and it provided several recent precedents to deflate the significance of the Jusserand initiative.[15]

Not everyone was as understanding, at least such was suggested by eddies within other quarters of the press world, notably some operating out of Paris. On 26 December Jusserand reported that elements of the American press had picked up on a story from France to the effect that the Herriot government was displeased with him, and that it had ordered his silence for the remaining days of his mission – an allegation, incidentally, that certainly did apply to the outgoing and outspoken French ambassador in London.[16] There was even a suggestion that the discussions with Mellon had been undertaken on his own initiative, without instructions or mandate from the French government. To which he replied, unbidden by Paris: his minister would appreciate the "inanity" of any accusation that he would be trying to short-circuit official channels by attempting to negotiate in public. Yes, he had publicly acknowledged his conversations with Mellon about a possible moratorium, but not before Mellon himself had gone public. And as for that "public," the select New York audience had been guests of New York University, invited to witness the conferral by that institution of an honorary degree on the ambassador of France. The Washington audience were members of a subscription-based "current history class."[17]

It mattered not, beyond the satisfaction of self-defence. The die was cast, and despite his efforts he was leaving at a time when the debt question was becoming more damaging than ever. The American government remained hostile to any cancellation or alleviation of the French debt burden, even in the form of a short-term moratorium. Instead, American taxpayers were being told that they had already paid nearly $800 million to service the interest on money lent to France. That calculation came from Senator David A. Reed, an acknowledged francophile, who included in his report the following testament: "The French ambassador – Mr. Jusserand – has done the best that his great talent enables him to do, but he is without authority. He has done much to keep the situation placid ... because his efforts have gone far toward preventing this question from becoming acute."[18] It was as succinct and as insightful an instance of praise as any ambassador was likely to hear. If it was not always possible to secure maximum advantage for one's country in dealings with another power, it was essential to ensure that the abrasions between them were kept to a minimum. This, Reed observed, Jusserand had managed to do, no small feat in a world not coloured solely by money. Indeed, the second and overlapping issue that dominated Jusserand's final months in Washington was the all-too familiar question of national image.

Here, too, the ambassador experienced complaint and praise, as he had done for so long. One incident in the last months of his stay in Washington was symptomatic of that lengthy experience. In mid-November 1924 he took on a quite different speaking engagement, this time to the Art and Archaeological League of Washington. In this speech, consistent with his remarks of the previous July in Paris, he pleaded with his audience to return to the clean and spacious lines, the grand squares, envisaged for the District of Columbia by the genius that had been Major L'Enfant. That vision, he suggested, and not for the first time, had become clouded in recent years, a development that explained "the intrusion of new ugliness." It was time to halt the construction of "those huge cubes of apartment buildings, without visible roofs ... cornices ... terraces" and new government buildings "which vary little from those cubes." Some responded with delight, concluding that here was a foreigner who cared more about the aesthetics of Washington "than do nine-tenths of the cheese-paring members of congress in whose hands the destiny of Washington lies." Dr Charles Moore, chair-

man of the National Fine Arts Commission, assented. "If asked to say what DC should do to develop the city as an art center, I would say 'Keep the French ambassador here.'" Still, there was no denying that the aesthete who was a diplomat was approaching the margin of diplomacy. Before long certain newspapers were carrying headlines accusing him of having pronounced Washington "ugly." He protested, of course: "I never alleged that 'Washington is ugly,' which is the reverse of what it is, and what I think, and why should I have said the reverse of what I think?" And the *New York World*, for one, published its retraction, but the incident became part of the unusual notoriety that surrounded the ambassador in late 1924, just as it illustrated how delicate was the task of associating France with a special insight into beauty without offending by the appearance of assumed cultural superiority.[19]

That risk, to be sure, was one of the lower ones on Dr Jusserand's lengthy list. Higher up was the work of inveterate francophobes, people and agencies that could be relied on to tarnish the reputation of France. As the embassy saw it, there were times when the German and British governments were practically hand in hand, sparing no effort in the American press to associate France with extravagance – when it owed money; with alcohol and lax morals – when America was experimenting in prohibition and reviving puritanical ideals. In 1924, with the debt question unresolved, the French army still in the Ruhr Valley, and Parisians hosting the summer Olympics, papers like New York's *Sun and Globe* and the *Herald* were seen as being typically critical of France, to say nothing of Hearst papers like the *New York American*. The *Washington Post* also had its moments. In late May it gave some prominence to reports that the American anthem and the American flag had both been booed by unruly French spectators; and in connection with the attendant tourist trade, the *Chicago Tribune* reported that staff at the Palace of Versailles suspected that American visitors had run off with forty-seven dinner place settings.[20] Only months after Jusserand's departure the paper published a particularly nasty piece that combined a succession of slurs aimed at France and the French – "self-seeking and misdoing," "partly real and partly assumed sufferings," "self-deceit" – with ad hominem slights aimed at prominent American francophiles like the "money-changer" Otto Kahn, "who not only butters the French roll but smothers it in jam."[21] On another public front, Senator Robert Latham Owen of Oklahoma

was identified by the embassy as a German sympathizer of the first
degree, a man who was doing his best to exonerate Germany from
what had happened in the summer of 1914 and, as such, one who
was "in complete communion" with Weimar propaganda.[22]

Not everyone was, or ever had been. If Senator Owen could be
relied upon to take the German side, House of Representatives John
J. Rogers was prepared to assure a distinguished audience that
France had been provoked into the Ruhr, had been stripped of the
guarantee of its security, and yet had remained true to the long tra-
dition of Franco-American friendship.[23] The American Federation
of Labor, led by Samuel Gompers, also defended the Ruhr action,
and the Daughters of the American Revolution were regarded as
prime francophilic assets, though no organization rivalled in
Jusserand's view the Alliance Française – "the most important voice
we have in America when it comes to propaganda." In the press
world, French-language publications like the New York–based
Courrier des Etats-Unis and Le Moniteur franco-américain, the
Chicago Daily News, or the Literary Digest were also regarded as
papers prepared to give France a fair hearing.[24] To say nothing of
the New York Times where the educator and editorial writer John
Finley wrote pieces highly sympathetic to France, some of them
unsigned, many of them designed to instruct. Writing in June 1924
of the "Rheims Restoration," he recalled "the most recent bar-
baric of disasters" which had befallen the cathedral, its "features
marred" by "wickedness ... and iniquity."[25]

But the presence and persistence of France's defenders were but
confirmation of her attackers, both sides proof of an ongoing strug-
gle left novel only by changes in detail. And because France had not
"won" that war, nor lost it, French proponents of change and
French proponents of prudence continued their own internecine
combat. Gaston Liebert, the consul-general in New York, had been
permitted to re-create a wartime information service under the
name of the French Bureau of Information, and to publish under its
auspices a weekly bulletin called Facts, Figures and Weekly News.
His energy and ambition were unmistakable, and his own reports
certainly suggest that in 1923–24 the bureau was building up an
American press clientele who expressed an interest in securing pre-
cise and reliable information on France. In sum, Liebert claimed
that an increasing number of newspapers and press associations
were relying on the bulletin's research data – often without attribu-

tion – and that the influence of the bureau, and therefore of France, was increasing, one measure of which was that it was coming under attack by German propagandists.[26]

But not only by the Germans. Although Liebert had his supporters in America, notably some prominent members of the France-America Society, he and the ambassador had long tangled over the issue of propaganda; and in the spring of 1924 there was an outright clash between Liebert and Frank Pavey, president of the Federation of the Alliance Française. One unsigned note appeared in Paris in April, suggesting that the New York Bureau was costing too much and was coming under suspicion as an example of foreign propaganda. This was precisely the point Pavey had been making for some time and which had attracted the attention of several newspapers, including the *New York Times* and *Le Courrier des Etats-Unis*. In June Pavey confronted Liebert directly: "No foreign government ought to be allowed to maintain any such office within the limits of the United States." The prominent New York lawyer and servant of France Maurice Léon obviously agreed, as apparently had decision-makers in Paris. Only weeks after the departure of the Jusserands from American soil, Léon, though grieving the ambassador's retirement, now was able to celebrate one element of the foreign ministry's great personnel shakeup – namely the simultaneous departure of Gaston Liebert for a post as minister in Havana. "I hope," he said, that the disappearance of M. Liebert ... will end the lamentable state of things for which he was responsible [and] put an end to the troubling episodes which kept occurring throughout the lifetime of the French Bureau of Information."[27]

Though doubtless there were some in the Capital and in Paris who took some satisfaction in the final leave-taking of Jules Jusserand, in deference to his long career they seemed to have held their tongues. By contrast, the ambassador was showered with letters of appreciation from across the country. Frederick Cunliffe-Owen, president of the France-America Society, concluded that the Herriot government, "which seems perfectly crazy," had "done the most foolish thing that it is possible to conceive," by removing the ambassador at "a moment where [France] specially needs the friendship of the Americans." George Wickersham, former attorney-general in the Taft administration and long-term member of the France-America Society, obviously agreed: "knowing that there was no one who could fill your place and hoping that your government

would not attempt the hopeless task." Most moving for the ambassador, among these private exchanges, indeed so much so that he said the words would be preserved as a family heirloom, was the testimonial from Robert Lansing. Not only did the former secretary of state join others in deploring "the fact that your Government has seen fit to take this step," but he explained his reaction to a deeply moved ambassador. This act, Lansing wrote:

> will take away the most useful and acceptable representative that the French Government ever sent to this country. No ambassador or minister from a foreign country has found so warm a spot in the hearts of the American people ... You are not only admired and esteemed but you are actually loved by Americans ... I have never heard in the course of the years any American speak of you unkindly.
>
> As I look over the years of the World War, when you and I were in such intimate association, when men's tempers were on edge, and when passion and prejudice impaired deliberate judgment, I realize how considerate and generous you were in spite of many provocations. On occasions we ought to have quarreled, but we never did. The record of our intercourse bears witness to the important part that friendship may play in the settlement of diplomatic differences.[28]

Other tributes were expressed publicly. The *New York Times* and the *Christian Science Monitor* made a point of the fact that Jusserand's twenty-two-year period as ambassador was unprecedented, "longer than any ambassador ever accredited to the United States;" and the Boston paper's editorial offered special applause to the ambassador's sensitive and shrewd avoidance of anything that smacked of "nationalistic propaganda."[29] In early December a group known as the Civic Forum paid public tribute to Jusserand, with speeches by prominent New Yorker Henry J. Morgenthau and Robert Underwood Johnson, permanent secretary of the American Academy of Arts. Having recently served as American ambassador to Italy, Underwood Johnson undiplomatically lamented the enforced retirement of Barrère from Rome and Jusserand from Washington. That decision, he said, "is the nearest approach to self-isolation that France has ever made [and] a break in the continuity of influence."[30] New York University crowned the outgoing ambas-

sador with yet another honorary degree of laws. The Daughters of the American Revolution voted a motion of thanks for his sustained service to both countries. The France-America Society, the Federation of the Alliance Française, and the American Society of the Legion of Honor sponsored a grand banquet for him at the Waldorf-Astoria in New York.[31]

And Washington put on its own culinary send-off at the Willard, with some 1,000 invited guests from the worlds of politics, arts, and academics – including representatives from fifteen of the eastern universities that had conferred upon him honorary degrees. That affair, with Chief Justice Taft as honorary chairman, offered radio listeners of WPC Radio Corporation an opportunity to tune into a thirty-minute concert by the Empress of France orchestra, an hour of after-dinner speeches – including short presentations to the Jusserands of gold medals with inscribed reference to the "affection and esteem from the people of the city of Washington" – then more music by the United States Marine Band, and a closing program of dance music by the Hotel Astor orchestra. Jusserand was praised as "the representative of the grace, the wit and the culture of France," and he in reply praised Americans for their generosity of spirit and – with an artful historical allusion – for "never forgetting a service rendered [even] were it a century and a half ago."[32] Nor did the applause end as Washington disappeared down the track, for in Paris, too, he and Elise were soon feted at the American Club by American ambassador, Myron Herrick, and the entire audience of 250 members and guests rose to pay tribute to the recent retiree with a rousing rendition of "For He's a Jolly Good Fellow."[33]

But lest one should be deceived by the recent breakers of recognition and appreciation, it must be said that the ambassador and his wife also experienced much sadness, some of it reinforced by public interrogations in America of the Herriot government's decision, and some of it by an understandable nostalgia. On 25 November, just on the eve of all the public commemoration, Jean-Adrien-Antoine-Jules Jusserand made formal application for his retirement pension.[34] It must have been with mixed feelings. Clearly, he did not want to leave his post, but clearly, too, he was not going to miss the chronic little wars with the bureaucrats in Paris. In February he told Owen Wister that his desk was so overloaded with paperwork that he could not tell the colour of the wood below, and in November – on the very day he applied for his pension – he declined yet another

speaking engagement on the grounds of being overworked. The size of his staff was inadequate for the tasks at hand, particularly the facility in New York where a one-legged veteran could not keep up with the demand for tourist visas, a situation that led to Olympian lineups and pretty much "the worst propaganda" France could have.[35]

But matters were about to become more personal. Apart from office furniture, a few paintings, tapestries, vases, and busts that were the property of the state, everything in the embassy belonged to the Jusserands: including all the furniture, linen, silverware, and glassware, even that portion of the coal supply reserved for their "private" use and paid for personally. And almost all these furnishing, with the exception of the coal and sundry articles were being returned to France.[36] Which is where his last dispute with his masters arose: the moving expenses. Following French custom, the Quai d'Orsay required a breakdown between the packing and the actual transport charges, a requirement that the ambassador could not satisfy. American moving companies provide a single price, he said; and finally, well and truly impatient, he ventured: "I would have thought that in the uncommon case of an ambassador who has been at his post for 22 years, used his own furniture, and undertaken his own repairs, etc., it would be possible for him to be reimbursed on the basis of a single bill."[37]

Long accustomed to the insensitivities of distant bureaucrats, the ambassador also had a habit of speaking out against perceived impoliteness and inattentiveness. He had a "virile intellect," one journalist reported, "straightforward and outspoken."[38] Rude behaviour was not the Jusserand style, neither that of husband nor wife. *Doyenne* of the Washington diplomatic corps since 1912, Elise Jusserand had conducted herself not only with dignity but with compassion, welcoming the wives of incoming diplomats, including – so it was said – the wife of Germany's first post-war ambassador. Not only welcomed them but also advised them on matters of protocol which, if mishandled, could damage a husband's career. Though first impressions might confuse a natural reserve with coldness, conversation quickly lit up her face "with the warmest interest and friendliness."

At the same time, no one ever suggested that Mme Jusserand was a social butterfly, decorous but superficial. She rejected out of hand any notion that women were not well suited for diplomatic work,

insisting to a female journalist: "All this talk about sex differences I
have little patience with. Capacity and incapacity depend upon the
individual, not upon sex." In matters of dress she was a "conserva-
tive," making but small gestures to the changing trends of fashion,
contemporary press photographs suggesting a preference for the
graceful but simple lines of dresses and coats that suited her tall,
still slender figure. She was reputed to live "the quietest of lives," a
woman of strong religious faith, content with a small group of close
friends, and with recreation defined mainly by quiet rides and
walks in nearby Rock Creek Park, and reading. Indeed, it was
reported that she "loved books even as he did."[39] Little was said
publicly, however, about her ongoing charity work from wartime to
peacetime. In her final years at the embassy she worked in Washing-
ton with the charitable arm of St Matthew's and with the Little Sis-
ters of the Poor. In France she worked hand in hand with at least
two charitable organizations, one designed to support the needs of
badly wounded veterans, the other those of destitute war widows.
Both involved the marketing and sale of handicrafts produced by
such war victims, with the financial proceeds being returned to
them; and Mme Jusserand was actively engaged in running a net-
work of American women, including Helen Garfield, who
promoted the sales of such hand-manufactured goods in their
respective cities.[40]

For all his intellectual prowess and the formalities associated
with his office, the ambassador, too, had a human touch. If his days
of tennis and fencing were over, his love of the outdoors was not.
Neither was his love of animals, especially wild birds, an apprecia-
tion that took on public expression in late December 1924, just
days before his departure from Washington. He and Elise dedicated
a combination birdbath and fountain "to the Birds of Piney
Branch," a gift from "Elise and Jules Jusserand (1903–1925)."
Installed at 5000 14th Street NW, the fountain, made of French mar-
ble and designed by a Lyon architect, was offered as a "thank-you"
to the birds of Rock Creek Park and in the hope that it would long
remind those feathered creatures "of his life among them."[41] Nor
were the birds alone in appreciating the ambassador's soft spot. He
brought tears to the eyes of some elderly residents of the care home
in front of which the fountain had been erected, by recalling the vir-
gin landscape that had greeted him there when he had first arrived
in Washington two decades earlier. So was he to touch a good

number of State Department and White House personnel on the day he went to say good-bye to Hughes and Coolidge, moving as he did down the corridors, from office to office, recalling names with impressive ease, even those of the hallway messengers.[42] It was true what so many of the public tributes had identified when they said he had endeared himself to so many Americans. And he had done so not with forced bonhomie but by means of a quiet dignity, a quiet ease of manner, and a quiet sense of humour.

That was what people meant when they referred to a "witty" Jusserand, in reference to a humour that was understated, often subtle, never ribald. It was the humour of a man who publicly recalled being treed by Roosevelt's dog, in the self-effacing story recounted earlier. Light-hearted, too, was the private exchange with James Garfield in which the retiring ambassador joked about the way he had pronounced the word "bowl" when making a presentation to Roosevelt in 1909, a word which he still insisted "sh'd rime with owl."[43] His was also the wit of one who reckoned that America needed no "burdensome standing armies," because on her north "she had a weak neighbor; on the south, another weak neighbor; on the east, fish; on the west, fish." Indeed, in that very connection, he once replied to a suggestion that the undefended Canadian-American border should be a model for squabbling European countries, by offering an exchange. "Would you like to change neighbors? Take ours and give us your Canadians. Then we'll take down our defences." But he could also pretend innocence. On one occasion, in response to a crowd perplexed by the design of a statue of George Washington once installed on the grounds of the Capitol – a nude statue of the first president with his finger pointing to the skies – promptly offered his interpretation. "He is saying, 'My soul is in Heaven, and my clothes are in the National Museum.'"[44]

By February 1925 all of this, the retirement celebrations, the anxieties and the laughter, the parting of friends, had entered the halls of remembrance. Jules and Elise Jusserand would never return to America. Their remaining years together, and those of Elise long after, were spent between Paris and Saint-Haon-le-Châtel. In the capital they had acquired a new apartment on the avenue Montaigne, very close to the Champs-Elysées and across the Seine from the Quai d'Orsay, a spacious residence that could accommodate a small domestic staff.[45] In tiny Saint-Haon they occupied the

two-storey family home that overlooked – still overlooks – a large and ancient garden protected by coniferous boxwood and yew trees, and which from its upper balcony afforded a view northward to the hills of the Beaujolais. There, especially in the summer months, they held extended reunions with a family grown large over the years; as Elise put it: "brothers, sisters, nieces, nephews, and grand-dittos." The home, purchased years before by Jusserand Senior and left "undivided between his children," and still without a telephone, was truly a family refuge. Empty for most of the year, in the summers it became a gathering spot for his children who, with their own children – "we alone having none" – "lived there in peace together." Thanks, however, to the supplementary facilities provided by two additional homes that Dr Jusserand had acquired in the village, they were able to accommodate and feed as many as twenty-four at a time, and that with "ten missing!" At times, the comings and goings of family members made the retired couple feel as if they were inside a "kaleidoscope," although Elise admitted that they felt "quite lonely" when the numbers fell as low as thirteen or fourteen."[46]

Since loneliness is a natural condition for research historians, one might assume that most of Dr Jusserand's scholarly work was done during the fall and winter in Paris, where the best libraries and archives were within walking distance of his apartment. If any post-retirement incentive were required for him to resume his work as scholar, it came within a month of the return from Washington. In March 1925 he became *Membre de l'Institut de France* by means of election to the Académie des Sciences Morales et Politiques. The honour was both a recognition of a long and distinguished career as an historian of medieval England and eighteenth-century America, and a reward for an equally long and distinguished career as a diplomat. That diplomacy was a factor in this election became very clear in light of a special fundraising campaign to cover the costs of manufacturing an appropriate ceremonial sword to be worn with the dress uniform of the academician. Initiated by the Comité France-Amérique in Paris and supported by the France-America Society in the United States, the campaign concluded in December 1926 with a luncheon at the Ritz Hotel and a presentation of the sword to Jules Jusserand. Typical of such artifacts, this was a model of extravagance and symbolism; equally distributed along either side from hilt to tip were gold and platinum, encrusted with

diamonds, rubies, sapphires, and jade; the royal lilies of France, the
Republican tricolor; the image of Liberty, her torch held high, and
the thirteen stars of the first American flag. Engraved upon it were
the famous phrase associated with the arrival of American troops in
France in 1917, "Lafayette nous voici," and from the following
year, the French title of Jusserand's Pulitzer Prize winner, *En
Amérique, jadis et maintenant.*[47]

More recently, and perhaps by no coincidence in the year of his
election, he had packaged his presidential address to the American
Historical Association with eight other essays, many if not all of
which he had previously published and which we have therefore
already mentioned in previous pages. Judged by today's scholarly
standards and expectations, the essays would have a mixed recep-
tion. Some of them have a purely narrative function, deriving simply
from the urge to tell a story, whether about the social history of ten-
nis as a sport, or the personal histories of people like the fourteenth-
century genius Petrarch, the sixteenth-century soldier and art-lover
Vespasiano Gonzaga, Duke of Sabbioneta, or his contemporary,
Pierre de Ronsard, poet, gardener, and lover of love. With no obvious
interpretive objective, some of these pieces meander with an aimless-
ness that testifies to their sometimes perplexing organization. Some
are more satisfying for the opposite reasons. One such example sets
out to locate the site of an ancient church where a fifteenth-century
French ambassador was said to have made an offering of thanks for
being saved from a surely unprecedented sixty-six-day sea voyage
between France and Scotland. An assortment of spelling mistakes of
foreign names – an ambassadorial deficiency that Jusserand said was
"unluckily of the best" – had led to considerable historical debate
about the location of the church, indeed even about the identity of a
long-dead saint. Was this a church dedicated to Saint Trignan (Sainct
Treigney) of Wales or to Saint Ninian (or Rinian, or Trenian, or
Trinyan, or Treignan) of Scotland? In short, Jusserand had set out to
solve a mystery, employing his impressive linguistic, paleographic,
and literary skills.[48]

Indeed, what he had preached to American historians in the
1920s, he had been practising for years. Abandon hearsay and
guess work, and get the evidence from texts and archives. But pres-
ent that evidence in ways that stir the imagination, even the emo-
tions, so that the link between writer and reader is strong-soldered.
His own technique grew out of his interests, and his own pen gave

expression to the technique. Whether he wrote about sports or theatre or the ordinary people of streets and market, Jusserand had an eye and a passion for the life experience of individuals. He wrote of the peasants he and Elise once witnessed in Sabbioneta near Mantua, preparing an evening meal in the garden ruins of an ancient palace, "under the mantel of a superb, red-marble chimney," their pumpkins stored in the niches where once busts had been installed, their cabbages and turnips strewn where once there had been marble fountains. He sympathized with Petrarch, bereaved by the death of Laura, comforted by his personal copies of Virgil, Cicero, and Saint Augustine, alarmed by the growing numbers of pigs around Padua or by the encroachment of local marshland. He followed the life of Ronsard, an athlete and musician in his youth, his love of Cassandre unrequited, his hearing impaired, his body increasingly in pain, and he depicted the poet's contemporaries of the Vendôme, making their way in the "autumnal mists," the "roads look[ing] like rivers,": "shiver[ing] in the wet morning air." He brought to life Dr Forman, "a man of queer learning and queer ignorance," who recorded his first attendance at Shakespeare's "A Winter's Tale" in a Southwark theatre in 1611: "strange-looking ... a real doctor at Cambridge and an averred quack of London, a frequent inmate of the royal prisons and the trusted adviser of the fairest ladies at court."[49]

The impulse to continue these acts of creation clearly outlived the act of scholarly apotheosis that was his election to the Academy, but there were increasing signs that the flesh was not always willing, or at least cooperative. In the spring of 1927 the couple suffered a long bout of influenza; in the summer Jules underwent an unsuccessful kidney operation that in turn necessitated a second operation late in the year – which this time led to the removal of one malfunctioning organ. By March 1928 he was home, unable as yet to leave the apartment but relieved to be back "at my writing desk."[50] He was working on several projects, one of which was published later in the year. With more time at his disposal since leaving Washington, and with easy access to the archives of the Quai d'Orsay, Jusserand took aim at a group of French and English historians who, in his view, had besmirched the reputation of an honourable servant of France. The victim was the seventeenth-century Marshal d'Estrades and his modern assailants, these scholars who had concluded that this soldier of Louis XIV had betrayed

king and country by surrendering a besieged Dunkirk to the English
in 1652. Jusserand, loyal as always to his heroes, would have none
of it. In a lengthy article in the prestigious *Revue Historique* he did
everything he could to refute the allegations, employing a stream of
archival citations, a possessive "our" to ensure that no reader
would mistake his own personal allegiance to France, and some
pretty strong language – alleging in turn that one English scholar
had not only misinterpreted the character of d'Estrades but had
managed to undermine his own thesis by using contradictory evi-
dence, while the two French scholars in question had both misread
d'Estrades and offered an argument that was "difficult to follow."[51]

Less troublesome, he hoped, were his own remaining projects,
each of which had its own personal dimension. One was personal
only in the sense that it represented the culmination of a project for
which he had assumed editorial responsibilities in the early 1890s,
before he had turned forty. It was a multi-volume series of diplo-
matic documents addressed to the period from 1648 to 1789 and
comprising French foreign ministry instructions to its ambassadors
and ministers abroad, each volume produced with an introduction
and a formidable set of notes provided by the editor. In 1929 the
ministry produced two more volumes. Numbers 24 and 25 pro-
vided the instructions to France's representatives in England for the
period from 1648 to 1690, and had been assembled, introduced,
and annotated by a then seventy-four-year-old Jusserand. It was,
reported an old American acquaintance to readers of the *American
Historical Review,* "a triumph of editing" and a "masterpiece of
historical presentation."[52]

Another project was also personal, but in the sense that it was
another example, one of the last, of Jusserand's interest in indiv-
idual actors and his predilection for defending the maligned. In
this case, the task was to provide what he considered to be a more
balanced view of Edmond-Charles Genet, French ambassador to
America in 1793–94. By studying the unpublished papers of the
Genet family, to which he had been given private access, Jusserand
tried to find some redeeming features in a diplomat whom Thomas
Jefferson had described as an arrogant "hot head," foolish enough
to have questioned the authority of President Washington, and
whom Jusserand himself recognized as having suffered from
"impetuosity, imprudence, impudence [and] a complete lack of dis-
cretion." Still, this very bright, well educated, multilingual and, by

1793, experienced diplomat, had been ill served by what Jusserand found were some badly flawed instructions from his minister. The combination of personal conceit and poor guidance was what had brought the ambassador down. He had been recalled in disgrace in 1794 but, given the wave of executions in revolutionary France, he had chosen to remain in America where he died in 1834 – though not before commencing a line of descendants, one of the youngest of whom had died fighting for France in April 1917. Not the most substantial of defences for a professional historian to erect, but one that demonstrated once again archival ardour, art, and national allegiance.[53]

Those qualities were all evident in Jules Jusserand's final projects, both of which have engaged our attention earlier, and at considerable length. One, a memoir-like volume was entitled *Le Sentiment Américain pendant la Guerre* and published in 1931. Consistent with the title, the contents applied only to the war years themselves. Consistent with the author, they combined direct quotations from embassy documents with constructions that were anything but impartial. Reviewing the book later that year, Charles Seymour combined praise for Jusserand's "literary skill" with a set of warnings. The title, he suggested, might be improved upon by calling it *Pro-French Sentiment*, for this was no objective study of American opinion across the board. It is "really a memoir ... faithful to the creed of those belligerent days."[54] The other project, of course, was the work he intended to call *What Me Befell*, the lengthy and complete memoir upon which he was working when he died.

Jusserand's health had continued to deteriorate, and old friends were dying. In May 1928, not long home from the hospital, Jusserand learned of the death of Sir Edmund Gosse, an old English friend and great francophile. November 1928 brought the death in Paris of Julia Tuck (née Stell), wife of the wealthy banker and philanthropist Edward Tuck and a woman who had been especially close to Elise. Myron Herrick, American ambassador to Paris, and "my friend for twenty-five years," died in March 1929, just a few days after Jusserand had visited him in the hospital. And late in 1931 their old friend Helen Garfield died in America.[55] Through this line of grief could be traced Jusserand's own decline. June of 1929 found the couple at Evian, taking "a complete rest" on orders from his doctor, for, as Jusserand reported, "I have been very ill.

Rest, rest, rest is the burden of the Doctor's advice." For that reason
they were obliged to cancel plans for a return visit to America. It
was just as well, for in September he was again hospitalized; his
condition was described as grave as physicians feared the failure of
the remaining kidney. By October he was feeling better and follow-
ing a strict regime, too strict in one sense. "Part of the regime
should include ... cease working, cease writing; but then why not
cease breathing?" He was better, but struggling, subject to "fre-
quent relapses" and limited to a "brief time of work" per day. Early
in 1930 he was in trouble again, which meant yet another kidney
operation and a two-month stay in hospital that left him too weak
to hold a pen. In August he was able to write to Owen Wister: "I
was very near ... crossing that great divide; but I still belong, how-
ever, to the minority, with ups and downs." Summoning up more
good humour for John Finley, he quoted the sixteenth-century poet
Clément Marot – "My spring and my summer have jumped out the
window" – but expressed gratitude for years of good health, and
took pleasure from a window at Saint-Haon through which he
could "love and admire all that is good in the world." Elise, too,
found pleasure where she could, reporting to Wister that her hus-
band was "keeping fairly well, much better than a year ago," add-
ing that she was "proportionately happy."[56]

But their life together was obviously winding down. Late in the
day, while working on a memoir that was never to go beyond the
Roosevelt years, he obviously had had flashes of remembrance of
years far more recent. In his last months on earth, in 1931–32 when
his health was failing, he inserted two post-retirement experiences
into a draft text intended to be confined to 1909. One was about
the summer at Evian, when he had sent Elise back by boat from
Meillerie on Lake Leman in order to struggle back on foot himself,
over the rocky, mountainous ground described earlier by Rousseau,
later by Lamartine, "thoroughly exhausted," his leg bleeding but
driven on by the ghost of Roosevelt to finish the course. The other
was a recollection of the Grand Roc of his youth, high in the Monts
de la Madeleine, and an equally recent summer when his health was
badly compromised. He had struggled for a final time to the sum-
mit, doubtless with boyhood memories of his brother and the dog
"Perdreau," and "kissed the rugged stone good-bye."[57] America,
too, was doubtless present in his mind during those final months.
He was "deeply worried," Elise subsequently reported, "by the

feeling in the United States against France." In a trans-Atlantic radio broadcast in the early summer of 1932, only weeks before he died, Jules Jusserand admitted to his American friends: "The sands in the hour glass are running low; I must take leave, probably forever." His text amounted to what the French might call a *profession de foi*, in this case an admission of a love of America and a vow of faith in an eternal Franco-American friendship.[58] He died, as you know, on 18 July 1932, of kidney failure, at home, his hand clasped in that of Elise, death expected but not just then. Only hours before he had been reciting to her, by memory, various poems by an old acquaintance, Robert Browning.[59]

Four days earlier, he had been working on chapter XIV of his memoirs. It was then that fatigue had set in for good. "Too weak to wield the pen," Elise recounted, "it literally dropped from his hand. It is a great consolation to me," she continued, "to think that his keen and active mind never for an instant was clouded, that he was himself to the very end, & still living a life of active service. Even when the last two or three days it tired him too much, too much to read, he thought of the poems he had liked & recited to me, long lines from his favourite poems of Browning ... And so I had him, his very self, until death led him gently away, & now I have the memory of the many years of happiness that it was given to me to live at his side & to be the better for, & that nothing can take from me." In a letter to Owen Wister she added: "When, the last few days, he realized that the end had come, he faced it with the serenity you had wished him & the memory of which helps & sustains me now in my solitude."[60]

Following a preliminary, private service in his home, and to the strains of Chopin's funeral march, Jules Jusserand's remains were taken to the church of Saint-Pierre de Chaillot for a public ceremony, the flower-covered catafalque accompanied by an honour guard of French infantry and followed by two nuns, the Jusserand family, and a host of official delegates from governments around the world. Excepting the representatives from France, none were more prominent than those from America.[61] Following the requiem mass, conducted in the church where they had been married thirty-seven years before, the coffin was taken to the station for the fallen ambassador's final trip to Saint-Haon. There, in the small green valley below the ancient ramparts, the bell tower of the medieval church, and a large stone cross, he was laid to rest, beside his father

and mother, and his sister-in-law, Marian Richards.[62] On a head-
stone designed for two, there was a Latin inscription from the ninth
chapter of Ecclesiastes: "Whatsoever thy hand findest to do, do it
with thy might." No need was felt for the remaining text: "for there
is no work, nor device, nor knowledge, nor wisdom, in the grave,
wither thou goest."

Jules Jusserand was at rest, but the acts of remembrance were to
continue for years thereafter. The very day of that quiet death in
Paris, President Herbert Hoover conveyed his condolences to
Madame Jusserand, mourning the loss of a "true and firm friend"
of America, while Secretary of State Henry L. Stimson declared that
"no man in recent times" had done more for the friendship between
the two countries. The *New York Times* published an unsigned edi-
torial in praise of the ambassador, which a grateful Elise later con-
firmed had been written by their old friend Dr Finley; and on its
editorial page the *Los Angeles Times* described Jusserand as a "dip-
lomat of the finest fiber" as much an American "in thought and
understanding as he was a Frenchman by birth and in loyalty."[63]
For its part, the Académie des Sciences Morales et Politiques paid
tribute to this its most recent casualty, acknowledging Jusserand as
"one of the greatest diplomats of our time" and an academician
whose "intellectual qualities" were matched only by "his simplicity
and modesty."[64]

Three more ambitious acts of remembrance were soon underway.
One was set in motion in Paris but culminated in Saint-Haon-le-
Châtel. In September 1934 a monument was unveiled just outside
the western wall of the village, a tall stone monument bearing a
copper plaque on which appears in bas-relief the bearded profile of
the late ambassador and Saint-Haon's most famous son. The
inscription in raised copper letters reads simply: J.J. Jusserand,
Ambassadeur de France, 1855–1932. Fittingly, his visage overlooks
both the deep green valley between Saint-Haon-le-Châtel and
nearby Saint-Haon-le-Vieux, and to the west, the rising, forested,
beloved slopes of the Monts de la Madeleine.

Two years later, in Washington's Rock Creek Park, another mon-
ument was unveiled, this one by President Franklin Roosevelt, who
said that Jusserand had practised "the highest standards of diplo-
matic ethics," and offered special praise for his "shunning of pro-
paganda."[65] The monument was the inspiration of a private group

of prominent Americans, mainly from New York and Washington, who had befriended the French ambassador over the course of his twenty-two-year stay in Washington. It was they who had raised the money for the design and construction of a semi-circular, high-backed bench in pink granite, bearing the simple inscription "Jusserand. Personal Tribute of Esteem and Affection. 1855–1932." And it was they who, under the heading of the "Jusserand Memorial Committee," had secured the support of the Federal Commission of Fine Arts and subsequently that of Congress in allocating a small piece of federal property south of Pierce Hill for the purpose – the first time such approval had been given to honour a foreign diplomat.[66] The bench was installed on the slopes to the east of Rock Creek, just above the roadway known as Beach Drive, and appropriately close to the former site of the embassy on 16th Street. Approached from the front by five ascending granite stairs, the bench offered a perfect vista for observing the birds of Rock Creek Park. In 1936 some 3,000 spectators and dignitaries watched Elise Jusserand, still dressed in black, quietly place a bouquet of red roses on the rose-coloured granite.[67] Today, like the husband and his widow, the monument is all but forgotten, its surface dulled, its steps askew, its tranquility disturbed by a stream of passing automobiles.

The third major act of remembrance had actually been completed before the stones had taken shape in France and America. This one took the form of a book, *What Me Befell: The Reminiscences of J.J. Jusserand*, and it was very much a joint production of Jules and Elise. They were his memoirs, to be sure, the very project on which he had been working at the time of his death. But her role in this affair was so important, and so revealing of her strength of character, that it seems appropriate to end this "life" of Jusserand with the most important person in his life.

Within a year of her husband's death Elise Jusserand was completing the arrangements he had made for the publication of the memoirs. They were to appear with Houghton Mifflin in Boston and Constable in London, published as they had been written, in English. In May 1933 Mme Jusserand prevailed upon John Finley to write a preface to the work. "If you say 'yes,' I shall be more grateful than I can ever express, & even more if possible." A month later, she asked a second favour – though in the first instance nothing more than a word to say he agreed with her. The publishers had

not been happy with the title, finding it, in her words, "a bit awk-
ward, not quite in keeping with the times." Before his death,
Jusserand had offered as an alternate *From Morn 'til Evening*, but
"Evening alas was not reached & so that title would no longer be
appropriate." As for their suggestion, *Golden Days*, "*entre nous*
this seems to me banal;" and "the dear author was never banal ... I
hope so much that you will be of my thinking." Lest Finley be at all
unsure of what that thinking was – the more so as she suddenly
appointed him arbitrator in the matter – she promptly wrote again.
Golden Days "sounds as if I had heard it before," whereas her hus-
band's title sounded "so much more like him." It was, she granted,
"unusual, but he never was usual."[68]

The more she thought about it, the more she was convinced that
Golden Days would not do at all. Indeed, it now seemed "horribly
banal"; and Houghton-Mifflin's attempt at a compromise, by using
What Me Befell as a sub-title to *Golden Days* struck her as being
"absurd, the two having not the slightest connection." So she had
felt compelled to explain again. Her husband's title had derived
from the fifteenth-century poem "The Kingis Quair" and the lines:
"Me thought the bell said to me. Tell me Man qwhat the befell." "I
like it," she reminded Finley, "firstly because he chose it & because
he was fond of bells. In our walks about St. Haon he always used to
stop to listen to the chimes of the angelus & when he was in the
hospital he used to make me open the windows to let in the chimes
of the neighboring church." Still, she conceded, "sentiment has lit-
tle or no part in book-selling & so perhaps I am wrong." Finley was
confirmed in his involuntary role as "arbitrator," "the only person
in those great United States [in] whose judgment in such matters I
have perfect confidence." As long as he understood what she
thought was best. And, as it turned out, he did. In July 1933, pre-
ceding the autumn publication of *What Me Befell*, Dr Finley sent
word that she had won.[69]

But she was not always right. In November 1936, standing beside
Mrs Roosevelt, Madame Jusserand said hopefully: "I do not think
any nation would dare to make war."[70] Like so many others with
memories of the previous carnage, she was spectacularly wrong.
The new war came, France was defeated, and France revived. She
continued to live on the avenue Montaigne, through the German
occupation, the Vichy government of Marshal Pétain, and finally
the Liberation. Three years later, on 1 July 1948, she died at home,

at the age of 86, having bequeathed what remained of her estate to the Catholic Institute of Paris.[71] Following a final visit to the church of Saint-Pierre de Chaillot, she was returned to St.-Haon-le-Châtel, for a final family reunion, laid to rest beside her husband, her sister, her parents-in-law, her brother-in-law, Etienne, and his wife, Marie, her sister-in-law, Jeanne, and her husband, Léon Clédat. It is there that they are to be found, where a climbing rose now obscures their names, below the crest of an ancient village, across a narrow road from the sheep, in the valley where the cuckoo still sings.

Conclusion

"When a book is just finished ... there is always for the author a doleful hour, when retracing his steps, he thinks of what he attempted, the difficulties of the task, the unlikeliness that he has overcome them. He is awe-stricken and shudders."[1] Dr Jusserand was right, although he might have shuddered the more, had he made a greater effort himself to bring his own works together in the form of thoughtful, substantial conclusions. But because so much of his work presented itself either as purely narrative in concept, or as collections of essays assembled under one cover, he could often manage with epilogues – the ends of tales – or simply with the last page of the last essay. These days, readers want more. Rather than being left to their own devices to decipher where their author has come to stand at the end of his or her labours, they appreciate, if not expect, some final counsel – especially those who have been hounded by professors insisting that even undergraduate essays require some kind of peroration. What, then, do I hope to have accomplished in and by this work?

At its heart, I think, is the resuscitation of a life that was on the verge of oblivion. But I hope this revival surpasses any sequentially presented offering of "facts" and extends to something of an interpretation, an analysis, of both the subject himself and the issues he confronted as a scholar and diplomat. Ultimately, it is the human being that interests me the most; and for that reason I have chosen to start this beginning-of-an-end with some of the other things this book is about, as well as what it is not.

Starting with the latter, while this book is about an individual, it is necessarily also about relations between France and America in

the first two decades of the twentieth century. For that very reason, in order to keep the focus constant, I have either reduced or eliminated many of the outer concentric circles within which more could be said about France and England, France and Russia, France in the Far East, the Levant, the Caribbean. Those more interested in such subjects than they are in Jules Jusserand may be disappointed. Others, I am hopeful, may be relieved. Both should know that my approach was not inadvertent. Wisely or not, effectively or not, I have tried to keep him in my sights – and yours – at all times, reaching out when I thought it necessary to enlarge the context in which he was operating at any given time, but trying not to let ambiance and circumstance obscure the ambassador.

At the same time, it is worth repeating, context is critical. Through the lens of Jusserand's life a discerning reader will have noticed innumerable flashes of societies in transition. Here was a man who spent his early apprenticeship in the foreign ministry copying and recopying minutes and memoranda by hand, having as his choice of instruments either steel or quill pens. Typewriters, telephones, automobiles were in various stages of infancy, and aircraft but a dream. By the time of his death, five decades later, he owned his own Hotchkiss automobile, had seen moving pictures of himself giving a talk at Yale, had seen the American Lindberg cross the Atlantic from west to east, the Frenchmen Coste and Bellonte from east to west, and had spoken to an American radio audience from Paris. Other changes, though less attention-grabbing than the latest technologies, were just as fundamental. One of them, certainly, was the slow democratization of French society – albeit, when it came to women still being denied the right to vote, an incomplete democratization. Born and early-educated under an emperor, Jusserand had received his advanced education under the Republic, as had so many male, middle-class servants of a French state still liberating itself from the grip of aristocratic, landed wealth. Education was becoming the key to the republican kingdom, prized by those already its beneficiaries and promoted by them to the legions of ordinary citizens, boys and girls who would grow up in far larger numbers than ever before to read letters and posters, newspapers and magazines. That ability, when combined with the expansion of male suffrage, produced a potent mixture that required a governing but elected elite to give more and more thought to the mood and expectations of the country's voters.

That need was but one of many impulses that stimulated the growth of both municipal and state bureaucracy. The more governments were expected to respond to the needs of an electorate, an increasingly aware and informed electorate, the greater the pressures to increase their public services and hence the numbers of their personnel. Increased demands on the public purse encouraged the growth of revenues through devices like increased taxes, which in turn required increased levels of staffing in the Ministry of Finance. The details were different but the principle the same when it came to domestic security issues in the Ministry of the Interior, national security issues in the naval and war ministries, educational issues in the Ministry of Public Instruction, and certainly international issues within the Ministry of Foreign Affairs. As for the latter, the single reminder of the ministry's burgeoning propaganda services is sufficient to make the point. Whether for wartime or peacetime application, whether employed among real or potential friends or real or potential enemies, whether educational and cultural in nature or whether more overtly political, those services required more and more money and more and more personnel. All this, regardless of ministry, the twenty-first century has come to expect, but for Jusserand's generation, in those early innings of "big" government, people were just learning to understand what a government in service to them actually required in terms of its own financial and human resources. Dispatched to London in the 1880s by the relatively small *Maison* on the Quai d'Orsay, well before the time of his retirement Jusserand was dealing with an organization too cumbersome to be sensitive – sometimes even sufficiently attentive – to his professional, never mind his personal, needs. What had been a trend even before the war, culminated in the clumsy handling of his enforced retirement in 1924.

Yet another manifestation of changing times and, for him, increasing discomfiture, was the inexorable progress of urbanization, whether in Paris or Washington. To be sure, despite his summer upbringing in the hills of the Roannais, he was no country-boy. State employee with a residence in Paris, frequenter of libraries and archives, concert-goer, lover of museums, Jusserand had nothing against the urban environment. Nothing, that is, as long as it was respected by architects who could distinguish between the climate of northern Europe and that of Washington, and was not overrun by developers intent on maximizing population density at the

expense of aesthetics, transforming natural landscapes into artificial turfs, and plastering what had once been natural environments with advertising billboards. Whether he believed that combat against such blights could be entrusted to men primarily interested in making money, or whether he anticipated the intervention of agents employed by a public authority at public cost, remains quite unclear.

Conversely, what should be clear is that this is a book about Franco-American relations, though one with more of a human face than is often seen in diplomatic histories. For anyone even remotely francophilic in sentiment, that theme is today full of dissonance. International issues in the first decade of the twenty-first century, when Paris and Washington have not always seen eye to eye, have prompted a stream of books, a river of internet sites, and a torrent of jokes, all of which mock contemporary France. Needless to say, none has the faintest idea of what has been lost since the days of Jules Jusserand. None, I suspect, would know his name, or know of the extraordinary lengths to which their own compatriots had gone to celebrate the ambassador and Franco-American relations in the years prior to the Second World War. What they have heard of is the fall of France in 1940, the years of Franco-German collaboration under the Vichy regime, the imperiousness of General de Gaulle, and the willfulness of successive French governments when it came to the pursuit – natural enough – of what they perceived to be France's national interests.

What they know even less about is America's failure to ratify the Versailles treaty of 1919 or to honour Wilson's pledge to defend France. Nor will they know of America's insistence on signing separate treaties with Germany and Austria in 1921, divorcing Germany's obligations to pay reparations to France from France's obligations to pay war debts to America, or exploring Germany's capacity to pay what she owed while simply insisting that France was capable. It was not entirely one-sided, to be sure; and no one better understood that than an ambassador who was frequently upset by the actions and inaction of his own government. But had he lived to see the outbreak of war in Europe in 1939, my guess is that he would have lamented the marginal role America had been prepared to play in the approach to that war, and traced the origins of that tentativeness back to the crucial period between 1919 and 1924, when what the Wilson government had refused to call a wartime alliance had quickly eroded under the weight of peace. And

without a doubt, he would have thought that things might have turned out differently had he been allowed to stay in America and refashion some rapprochement.

This evocation of the role of diplomatic representatives serves as a reminder of other issues that are both part of the Jusserand experience and part of the profession as a whole. Those which are specific to him and broadly to his peers, past or present, include the distinction between politician and diplomat. The former, starting with election and sometimes culminating in the role of decision-maker in the executive branch of government, is far freer to speak her or his mind than any of that government's agents abroad. The latter, as Jusserand reminded his audience of professional historians in 1921, were expected to inform those who had sent them, offer counsel when it seemed appropriate, follow instructions from those same masters, and express their thoughts to the host government with an appropriate mixture of tact, precision and, when necessary, firmness. Common to all foreign representatives is also the risk of appearing to intrude into the political life of that host country, whether of the sort associated with the clumsy maneuvring by Ambassador Genet against George Washington, or with the more recent, strident efforts by people associated with the von Bernstorff embassy to swing American opinion behind Germany's wartime cause. Even as twentieth-century governments learned the importance of educating/informing/persuading their own electorate, so they also grew more sensitive to the risks implicit in foreign governments trying to manipulate that same constituency. That sensitivity, on the part of host governments anywhere, obviously endures to this day, as does Ambassador Jusserand's base-line strategy: stay clear of politics, and promote all forms of cultural and intellectual exchange.

In his case, however, the issue had a special significance and resonance. Historically, it was in his lifetime that one witnessed the advent of modern techniques for mass persuasion, partly because of the strengthening impulse of democratic politics and public opinion, partly because the advertising tools that had so recently been refined for a mass consumer culture were available and proved so transferable to political culture, and partly because the demands imposed by global warfare – its circumference, durability, and costs – also underlined the critical matter of public morale. The concept of propaganda was an old one, but for France, in the years immedi-

ately following the German invasion of 1914, the nation's very sur-
vival seemed to depend on the determination of its citizens to resist
and on the assistance of friends abroad. It was this constellation of
circumstances that brought Jules Jusserand into particular promi-
nence, and with him the continuing debate over his strategy of per-
suasion in America. Some French observers, we have seen, thought
the ambassador had taken discretion to a fault. So afraid was he of
offending Americans, they alleged, that he failed to represent both
wartime and postwar France with requisite vigour. Others, both
French and American, and truthfully in far larger numbers, thought
that he had got it just right. In his memoirs, former Vice-President
Thomas Marshall praised the ambassador for having always
avoided "rough-shod methods" of persuasion, which is to say for
having stuck to what some called his "old-style" diplomacy; and
George Wickersham, former attorney-general, praised Jusserand
for his "admirable circumspection," even in wartime, during the
period of American neutrality, "never overstepping the bounds of
propriety ... and yet ... very subtly spread[ing] widely an under-
standing and a sympathy for France."[2]

But under some circumstances American praise had the potential
to turn beneficiary into victim. Given the customary turnover in
Washington's ambassadorial corps, it had taken the French ambas-
sador only nine years to become the senior foreign representative,
or dean. No one else was to succeed him, however, for the next thir-
teen; and in that twenty-two-year period of the Jusserand mission,
Britain's ambassadors to America numbered six, Germany's six,
Italy's six, and Russia's five. In sharper contrast still, the United
States had nine different ambassadors in Paris.[3] In short, and by
contrast, Dr and Mme Jusserand, she an American by birth,
enjoyed a very special status in Washington society, their return
voyages from France being represented as "home" voyages as much
as those that had been outward bound.[4] But to some French observ-
ers, especially those who thought the ambassador should be selling
France with more energy and imagination, there remained a doubt.
Had he ingratiated himself so successfully with Americans that he
had become more receptive to their view of the world than was
healthy for a representative of France? Certainly no one ever
accused him of treachery, or even of deliberately surrendering
France's interests, but unmistakably his critics sensed a connection
between what they implied, critically, had become over time a

mid-Atlantic psychology and what they regarded as his low-key, old-fashioned approach to diplomacy.

Among the symptoms that these critics detected in this "old-style" affliction was the ambassador's reliance on a sympathetic American elite to promote francophilia at the expense, so they feared, of reaching out to the men and women of Main Street. In turn, that emphasis had contained within it, by their reading, an exaggerated respect for the power of traditional, elite culture: public lectures, opera, art, literature ... and scholarship. Certainly some thought that the ambassador was a little too distracted by his scholarly commitments, most notably in December 1921 when, in the middle of the Washington Conference, he had departed for St Louis to preside over the annual meeting of the American Historical Association. So it was that the scholarly card that had been so central to Jusserand's friendship with Roosevelt and other American intellectuals, could be bent backwards by a few critics to read liability rather than asset. Such sleight of hand, it is perhaps worth including in these closing remarks, was not inspired by malice, any more than I wish to malign those who read the cards differently. While they do seem to have been in a small minority, Jusserand's wartime and post-war critics were not frivolous men, and certainly were no lesser patriots than the ambassador himself. They shared with him a concern about how best to represent France's interests, and a determination not to resort to exaggeration, never mind lies. They differed with him on the desired height of France's propaganda profile in America, therefore on the extent to which Americans should be relied upon to promote France, and therefore on the wisdom of recruiting a high-brow, traditionally minded American elite to shape the views of ordinary citizens. My conclusion, drawn from American testimony, and to the effect that Jusserand's prudent strategy paid off, is in no way intended to dismiss the apprehensions of his fellow patriots or to disparage their motives.

Patriotism, I have tried to suggest, was a constant theme in the life of Jules Jusserand, stretching from the youth-experienced humiliation of 1870, to the diplomatic career, to the parallel career of historian. While reviewers of some of his writing thought they were seeing a little too much understanding for France and a little too little for her rivals, he simply confessed to the charge, and defended it. Today, on those grounds, his critics would be even more numerous, and probably on other grounds as well. Apart

from *English Wayfaring Life in the Middle Ages*, which as a pioneering work of social history is still respected, my sense is that little of his work is read today. Despite the serious research that went into most of his publications, the illustrations incorporated, the source references provided, I would venture to suggest that today's professionals would complain along lines similar to my own: organization, even chronology, a bit too challenging; interpretation sometimes belittled by narrative; heroes writ over-large, as romanticists with an eye to tragedy are inclined to do. Indeed, as I have earlier allowed, some today are uneasy simply about work focused on individuals, written large or small, seeing in them mere distractions from the more important work of understanding societies. Some, I dare say, would even take issue with his manner of writing, though on this he and I are of one mind.

There was in his day, and by his lights, a problem with historical writing. The determination to be scientific, rather than impressionistic, had, he and others alleged, resulted in such a superfluity of data and such turgidity of prose that none but experts in the field had patience enough to read the final product. As for the authors, one editor of the *American Historical Review* concluded some eighty years ago that too many potential contributors seemed not to have "read a single paragraph aloud." Had they done so, he was certain, they would have realized that they were "driving over corduroy and not concrete."[5] Jules Jusserand, though his spoken English remained accented throughout his entire stay in America, must have had a better ear. His book on Ronsard was said to offer "delightful reading." His wartime book entitled *With Americans of Past and Present Days* earned one reviewer's praise as a piece of "delightfully written English," another's as one full of "sparkle and gracefulness"; while Yale's Charles Seymour, reviewing the same book in French translation, judged Jusserand "an artist of so much literary skill."[6] It was a theme that ran through his entire scholarly life, a desire not so much to impress readers as to communicate with them, to reanimate the past for them with sensitive evocations of landscape, of individuals great and small, their dress, their temperaments, their tragedies, indeed all what them befell.

What manner of man was he, this diplomat and scholar? My first response is to admit that I wish I could be sure, sure as a person of faith. But that summons up, once more, the whole question of biography. It was with considerable interest and recognition that I

encountered the following remark by an eminent literary biographer. "For the best of biographers," Frederick Karl confessed, "the reader thinks that the subject is well in hand; that in fact, the biographer has command, when he or she may be floundering." More disturbingly, he added: "Covering up is as much a tool of the biographer as being able to fake sincerity is part of a politician's equipment." Disturbing, too, is the remark of yet another biographer, who warns against "the oppressive weight of modern archives," vast quantities of "evidence" which – if recorded in full – are capable of smothering author and reader alike.[7] With respect to the latter, all I can say is that I have tried to exclude the non-essential which, pound for pound, would exceed the weight of what has been included. With respect to the former, I would say this.

After close to a decade of research on Ambassador Jusserand, I have learned enough to keep the wild-eyed floundering to a minimum, but also enough to know what I have not learned. A complete inventory would both frustrate and exhaust any reader, so an abbreviated list will have to do. I do not know whether Jules Jusserand ever painted a fence, cleaned his shoes, or actually drove a car. I do not know whether he suffered from allergies, have no explanation for the curious tilt to his head and neck, and can only wonder whether he and Elise had chosen not to have children. Apart from that of sloth, of which he was surely innocent, I know not whether he was subject to any of the other deadly sins. In the absence of evidence to the contrary, I *think* not, but am fully mindful of our species' instinct to self-protect. As Marc Pachter puts it, there is a "reluctance to share one's intimate life with some unknown representative of posterity – pinned by him like a butterfly to a board."[8] Rephrased, indeed repeated, in each of us there is that *coin secret* where no one else intrudes. In the case of Jules Jusserand, I am left with the wish I shared years ago with one of Louis Barthou's arch-critics, namely to spend an hour with him in a confessional, "behind the small wooden grill, just to know what he really thinks about himself."[9]

Evidence and inference will have to stand in for confession. As in what I take to be most cases, the cradle years and the school years were critical to the formation of Ambassador Jusserand. Nurtured by a religiously devout mother, schooled by lay brothers, but rescued from the humiliation of national defeat by an anti-clerical, Republican regime that would eventually separate church and state,

Jusserand became and remained throughout his life a man of private and discreet faith. First son in a prosperous middle class family of Lyon, he learned at home the importance of being well educated, a condition which he achieved apparently without major mishap to his faith. The combination of family affluence and higher education opened doors to personal and subsequently professional travel, experiences which – well before his career in America – had taken him across the European continent from Scotland in the north to Italy in the south, from Paris to St Petersburg, and which had also left him with memories of Egypt and North Africa.

Not a wealthy man, he had been born with brains, invested with a Catholic faith, a superior education, and a collection of middle-class values – those that Poincaré's biographer identifies as "order, dignity, politeness, honesty, thrift" and assembles under the current label of "unfashionable." Poincaré, John Keiger writes, "was the hero of ... moderation, by virtue of which conventional greatness is axiomatically denied."[10] Something similar might be said of Jusserand, without resurrecting the issue of degrees of greatness, or the differences between major and minor lives. The point is that the ambassador seems to have taken nothing to excess, lest it was an appetite for work. Like his one-time president and prime minister, Jusserand was a centrist by temperament, a stranger to bravado, a foreigner to extravagance of lifestyle or – with some wartime exceptions – of expression. Self-discipline and composure were central to his personality, as was a sense of *droiture*, or uprightness, which found distasteful the seamy side of Emile Zola and the graphic violence of Henri Barbusse. Humour he had, but a humour that relied on wit and clever repartee rather than rehearsed jokes or lewd innuendo. And gravitas, too, in full measure, variously demonstrated but always calculated to ensure that neither he nor France was taken lightly.

His subordinates understood that better than any. Indefatigable himself, and a perfectionist, the ambassador's office style was formal, some said stern, others "authoritarian," which is to say that his tongue could be sharp and the respect he commanded sometimes the "offspring of fear." At the same time, some acknowledged that beneath the exterior of a no-nonsense boss was someone who was thoughtful, even compassionate.[11] And not always a stickler for the rules. Reflecting back on his own lengthy career, Auguste de Saint-Aulaire recalled an early encounter with Jusserand, long

before either had reached ambassadorial rank. Saint-Aulaire had been a candidate for admission to the foreign ministry, Jusserand a young examiner. Attempting to bluff his way through an oral response to a question about which he knew nothing, Saint-Aulaire was surprised to receive a good mark for his answer, then somewhat chastened by Jusserand's aside to a fellow examiner. "It's much more important for a diplomat to be able to evade an unexpected question and to speak without saying a thing than it is for him to be able to recite word for word some page from a manual."[12] There, in a single incident, was a premonition of the later Jusserand: wit, withering candour, pragmatism, and sensitivity.

That he had a soft spot is clear enough, whether one turns to the volumes of evidence accumulated in the form of his historical treatment of heroes and heroines, or to a man long haunted by the eyes of a dying owl, or whether to what we know of his nearly forty years of wedded life. By all accounts, his own and others, he was absolutely devoted to his wife, as was she to him. One recalls from 1903 his regret about leaving Elise in Washington, even for a few days, the first time they had been separated in eight years of marriage. Twenty years later, on the occasion of Marian Richards's death, they were separated again, only for a few weeks, but with mutually expressed apprehension about the well-being of the other; and just less than a decade later, they shared their last moments together, hand in hand, just as they had wandered side by side near Petrarch's Padua, in Ronsard's Vendôme, and so often in Roosevelt's Rock Creek Park. It was, George Wickersham testified, "a singularly perfect union."

Well-read and intelligent, a woman of surpassing dignity and discretion, Elise Jusserand was the ambassador's closest companion and confidante, the "ideal companion for this man of extraordinary mentality."[13] She seems to have attended most of his speaking engagements – whether on aesthetics or the economy, or on subjects historical or literary. No light-weight in intelligence, or in strength of character, her formality may have given way more easily than his to expressions of personal concern and interest: whether in the children of embassy employees or the nephews and nieces in Saint-Haon, or in the welfare of women and children left widowed and orphaned by the war. Much more than an embassy ornament, an elegant companion to the ambassador, Elise Jusserand was a woman of substance. It would be difficult to conclude otherwise,

given our sense of the ambassador. Had it been left to him to write her epitaph, almost certainly to my mind he would have fallen back on the words of an elderly Rochambeau, words that had obviously moved the ambassador and which he had employed in a wartime essay. "My good star gave me such a wife as I could desire; she has been for me a cause of constant happiness throughout life, and I hope, on my side to have made her happy by the tendrest amity, which has never varied an instant during nearly sixty years."[14]

As for him, it is time to conclude this partnership and to ring out this "doleful hour." In time, perhaps, there will be fewer questions about why I had chosen Jusserand as subject, and fewer moments when someone might be tempted to speculate: "Probably he was all that was left over."[15] He was chosen, certainly, because he was there and neglected, because his papers were voluminous and well-ordered, because there were no competitors for his "life." And I stayed with it, and him, partly because of Plutarch, or rather because of Jusserand's invocation of that Greek philosopher and biographer. In his essay on Abraham Lincoln, Jusserand recalled Plutarch's optimistic prophecy. "It is the fortune of all good men that their virtue rise in glory after their death."[16] I have no ambitions for his glory. It will be enough if he is at last remembered.

Notes

AHA	American Historical Association
AHR	*American Historical Review*
BDFA	*British Documents on Foreign Affairs*
CSM	*Christian Science Monitor*
DAR	Daughters of the American Revolution
DBFP	*Documents on British Foreign Policy*
DDF	*Documents Diplomatiques Français*
FHS	*French Historical Studies*
FO	Foreign Office
FRUS	*Foreign Relations of the United States*
HMSO	Her Majesty's Stationery Office
INS	*International News Service*
LAT	*Los Angeles Times*
LC	Library of Congress
MAE	Ministère des Affaires Etrangères
NARA	National Archives and Records Administration
NYPL	New York Public Library
NYT	*New York Times*
PRO	Public Record Office
SDN	Société des Nations
SOE	Service des Œuvres Françaises
WP	*Washington Post*

INTRODUCTION AND ACKNOWLEDGMENTS

1 Jean-Jules Jusserand. *What Me Befell: The Reminiscences of J.J. Jusserand* (London: Constable 1933): 346.

2 Jusserand, "Chaucer's Pardoner and the Pope's Pardoners," *Essays on Chaucer* (London: N. Trubner for the Chaucer Society 1884): 424; *A French Ambassador at the Court of Charles the Second: Le Comte de Cominges from his Unpublished Correspondence* (London: T. Fisher Unwin 1892): 14; "Introduction" to Jules Simon's *Victor Cousin* in the Great French Writer Series edited by Jusserand (London: Routledge and Sons 1888): np.; *What Me Befell*, 2.

3 Pim Den Boer, *History as a Profession: The Study of History in France, 1818–1914.* (Princeton: Princeton University Press 1998): 335. For the debate in France, see Gaston Paris, *Le haut enseignement historique et philosophique en France* (Paris: H. Welter 1894), including the appendix by Ernest Lavisse.

4 *English Wayfaring Life in the Middle Ages (XIVth Century)*, translated by Lucy Tomlin Smith (London: T. Fisher Unwin, 1891): 405. I agree completely with Jonathan Dewald's suggestion that "the history of society was no uncharted wilderness ... in the 1920s," and therefore not the creation of people like Lucien Febvre and the Annalistes. See his "Lost Worlds: French Historians and the Construction of Modernity," *French History*, ix, no. 4 (December 2000): 428.

5 "Trois Js" [twa gee] or "Three Js", for Jean-Jules Jusserand.

6 Jusserand to Judge T.R. Marshall, 4 December 1924, *Archives du Ministère des Affaires Etrangères*, Série Papiers d'Agents, 095, *Papiers Jusserand* [Hereafter *Pap. Juss.*] 94, f169, p. 240.

7 The preceding quotations, from that of Gosse to that of Sartre, come from: Nigel Hamilton, *Biography: A Brief History* (Cambridge: Harvard University Press, 2007): 1, 130, 145, 158, 164; Laura Marcus, "The Newness of the 'New Biography': Biographical Theory and Practice in the Early Twentieth Century," in *Mapping Lives: The Uses of Biography,* edited by Peter France and William St Clair (Oxford: Oxford University Press, 2002): 202–4.

8 Geoffrey Woolf, "Minor Lives," in *Telling Lives: The Biographer's Art,* edited by Marc Pachter (Washington: Smithsonian Institution 1979): 68.

9 For a succinct, useful study of this academic debate see Elizabeth Colwill, "Subjectivity, Self-Representation, and the Revealing Twitches of Biography," *French Historical Studies*, 24, no. 3 (2001): 421–37.

10 Richard Holmes, "It's a real life opportunity for everyone," *Sunday Times*, 13 May 2001, vi, 5. Addressing the matter of commercial success, Holmes claims that upwards of 3,500 new "life-writing" titles are published annually. See also his "The Proper Study," in *Mapping Lives,* edited by Peter France and William St Clair, 7–18.

11 Holmes, ibid.

12 Theodore Zeldin, *France, 1818–1945*, 2 vols., ii (Oxford: Clarendon Press 1977): 1156; Robert Gildea, *The Past in French History* (New Haven: Yale University Press 1994): 8.

13 "The Critical Biography," in *The College Survey of English Literature*, edited by A.M. Witherspoon et al. (New York: Harcourt Brace 1951): 1196.

14 Louis Barthou, *Promenades autour de ma vie: Lettres de la montagne* (Paris: Les Laboratoires Martinet 1933): 216.

15 Marc Pachter, "The Biographer Himself: An Introduction," in *Telling Lives*, 7.

16 Philip Guedella once likened biography to "big game hunting" and reckoned it "as unfair as only sport can be." Agreeing and disagreeing, simultaneously, Arthur Balfour advised that biography should only be "written by an acute enemy." See Guedella's *Supers and Supermen* (London: T. Fisher Unwin 1920) and S.K. Ratcliffe on Balfour in the *London Observer*, 30 January 1927.

17 Philippe Levillain, "Les Protagonistes: de la biographie," in *Pour une histoire politique*, edited by René Rémond (Paris: Editions du Seuil 1988): 158.

18 Peter France and William St Clair, *Mapping Lives*, 3; John Holmes, "The Proper Study," ibid., 7.

19 André Laboulaye, "J.J. Jusserand, ambassadeur," *Revue des Deux Mondes* (July 1949): 31.

20 Pierre Nora, *Essais d'ego-histoire* (Paris: Gallimard 1987); Jo Burr Margadant, "Introduction: The New Biography in Historical Practice," *French Historical Studies*, 19, no. 4 (fall 1996):1045–58; Jeremy Popkin, "Ego-Histoire and Beyond: Contemporary French Historian-Autobiographers," ibid., 1139–67.

21 *Power and Pleasure: Louis Barthou and the Third French Republic* (Montreal: McGill-Queen's University Press 1991).

22 Alice-Louis Barthou, *Au Moghreb parmi les fleurs* (Paris: Bernard Grasset 1925). Elise and her sister, Marian, translated from the French his *Piers Plowman: A Contribution to the History of English Mysticism* (Fisher-Unwin 1894). Barthou was elected to the Académie Française in 1918, Jusserand to the Académie des Sciences Morales et Politiques in 1925.

23 In particular, my *Marketing Marianne: French Propaganda in America, 1900–1940* (New Brunswick, New Jersey: Rutgers University Press 2004).

CHAPTER ONE

1 Some of the preceding information is to be found in the early pages of *What Me Befell,* but much of it derives from an interview with Jean Mathieu, genealogist by profession and resident, by preference, of Saint-Haon-le-Châtel. 18 May 2006.

2 *What Me Befell,* 16.

3 Ibid., 5–6, 20. See also his Dedication in *With Americans of Past and Present Days* (New York: Charles Scribner's Sons 1916): vi.

4 Ibid., 8–11.

5 Ibid., 12–14.

6 Ibid., 18–22.

7 Ibid., 22–25.

8 Ibid., 27. One of the strategies for correcting such mistakes was to study German methods, from military tactics to scholarship. For early French emulation of German historical method to the emergence of French pioneering efforts in social history, see Matthia Middell, "The Annales," in *Writing History: Theory and Practice,* edited by Stefan Berger, Heiko Feldner, and Kevin Passmore (London: Arnold 2003): 104–17.

9 Père Jusserand to Jules, 3 June 1870, *Pap. Juss.,* 61, p. 8. Curiously, while *What Me Befell* places the death in 1872 (25), the tomb at Saint-Haon carries the inscription of 1871.

10 Jusserand to Cunliffe-Owen, 5 November 1924, MAE, *Ambassade,* 790, "Société France-Amérique," Dossier 1912–1929.

11 Jusserand to Paris, 20 September 1875, MAE, Personnel, 2nd Series, Dossier 831, np.

12 Jusserand, *The Romance of a King's Life* (London: T. Fisher Unwin 1896): 11–12.

13 So grateful was he for the hospitality of Maggie Nicol, her mother, and sister at Achilty that Jusserand maintained an occasional correspondence with her for several years. Unfortunately, the family photo, "the best ... ever I got taken," has disappeared from the Jusserand papers. See her letters of 27 July 1876 and 18 January 1878, *Pap. Juss.,* 61, nos. 23 and 40.

14 The whole of this walking tour from south to north and back can be found in *What Me Befell,* 31–7; and *Romance of a King's Life,* 12.

15 It appears that the Latin thesis on the twelfth-century poet Josephus of Exeter, entitled *De Josepho Exoniensi vel Iscano,* was wrapped up in the course of 1876, for by January 1877 he had in hand one examiner's evaluation – praising the Latin text but finding the analysis too abbreviated. See "critique de ma thèse latine," 28 January 1877, *Pap. Juss.,* 61, p. 34.

The work was published by Hachette that year. See notes of Guillaume Guizot (Ministry of Public Instruction) and Hachette, of 16 October 1877 and 16 November, 61; ibid., nos. 35 and 38.

16 A ministerial report of June 1900 attributed to him the ability to speak English, Italian, and some German, MAE, Jusserand Personnel Dossier 831, np.

17 Ibid., 37–9.

18 Literally a five-footed sheep.

19 The Paris years of 1876–78 are described more fully in *What Me Befell*, 41–3. He reports (42) that he defended his dissertations in November 1877 while working in Paris. Other sources date his doctorate as 1878, presumably the year the degree was granted. See *Dictionnaire de biographie française*, vol. 18 (Paris: Librairie Letouzy et Ané 1994): 1042–3; and Charles Lyon-Caen, "Jules Jusserand, 1855–1932," 16 December 1933, Institut de France: Académie des Sciences Morales et Politiques (Paris: Firmin-Didot 1933), 32.

20 Jusserand to Foreign Minister Charles Freycinet, 29 May 1880, MAE, Personnel Dossier 831. By June, Dr Clark in Cavendish Square had diagnosed "gastro-intestinal catarrh" and "congestion of the lungs," and recommended two full months of complete rest from work. Certificate of 12 June 1880, *Pap. Juss.*, 61, p. 331.

21 Jusserand to mother, 1 November 1880, *Pap. Juss.*, 61, p. 82; and *What Me Befell*, 52–3.

22 Jusserand to mother, 7 February 1881, *Pap. Juss.*, 61, pp. 91–2. For more detail on French ambitions, see J. Dean O'Donnell, *Lavigerie in Tunisia: The Interplay of Imperialist and Missionary* (Athens: University of Georgia Press 1979).

23 Jusserand to mother, 24 May 1881, *Pap. Juss.*, 61, pp. 100–1; and to George Wickersham, 11 July 1923, ibid., 78, np.

24 The characterization of the consular service comes from the outspoken diplomat Count Auguste de Saint-Aulaire. See his *Confession d'un vieux diplomate* (Paris: Flammarion 1953): 27.

25 See his embassy personnel file, communication of 20 September 1901 to Gilliams Press Syndicate, MAE, *Ambassade*, 895, np.

26 Note of 31 January 1886, MAE, Personnel Dossier 831, np.

27 1 November 1886, ibid. Jusserand's own account of the Tunis file is in *What Me Befell*, 53–69.

28 Jusserand to mother, 1 April 1884, *Pap. Juss.*, 61, pp. 123–5.

29 Jusserand to mother, 5 June 1880, *Pap. Juss.*, 61, p. 79; and 12 August 1882, 61, pp. 113–14; 16 September 1885, 61, pp. 175–7; 13 October

1887, 61, pp. 354–5. Ferdinand-Marie de Lesseps was the founder and principal animator of the Suez Canal Company, or the Compagnie Universelle du Canal Maritime de Suez, founded in 1858.

30 Jusserand to mother, 1 October 1885, *Pap. Juss.*, 61, pp. 179–80.

31 Jusserand to Mother, 3 September 1885, *Pap. Juss.*, 61, pp. 168–9.

32 Jusserand to mother, 22 October 1885, *Pap. Juss.*, 61, pp. 186–7; and 7 December, 61, pp. 195–8; Guillaume Guizot to Mme Jusserand, 8 and 11 December 1885, ibid., pp. 197–8, 199–200; *What Me Befell*, 72. For the Collège de France see Terry Nichols Clark, *Prophets and Patrons: The French University and the Emergence of the Social Sciences* (Cambridge: Harvard University Press 1973): 51–5.

33 *Le Roman anglais: Origine et formation des grandes écoles de romanciers du XVIIIe siècle* (Paris: Le Pay 1886); *Le Roman au temps de Shakespeare* (Paris: Asnières 1887).

34 *Le Théâtre en Angleterre depuis la conquête jusqu'aux prédécesseurs immédiates de Shakespeare* (Paris: Hachette 1878); *Observations sur la vision de Piers Plowman à propos des "Notes to texts A. B. and C" du Rev. W.W. Skeat* (Paris: 1879). The poem derives from as many as fifty-two manuscripts, but principally from three fourteenth-century texts; hence the preceding reference to versions A, B, and C.

35 "Chaucer's Pardoner ... " *Essays on Chaucer*, xiii, 423–36. (London: N. Trubner, for the Chaucer Society 1884); *Les Anglais au moyen âge: La vie nomade et les routes d'Angleterre au XIVe siècle* (1884); *Le Roman anglais et la réforme littéraire de Daniel Defoe. Conférence* (Bruxelles: Imprimerie Ferdinand Larcier 1887); *What Me Befell*, 79. The 1887 volumes included Gaston Boissier's *Madame de Sévigné*, Jules Simon's *Victor Cousin*, and Albert Sorel's *Montesquieu*.

36 Barely a month had elapsed between 13 October 1887, when he acknowledged the risks he was taking on behalf of his brother, Etienne, and 16 November, when he told his mother that he was likely being posted to London. Jusserand to mother, 16 November 1887, *Pap. Juss.*, 61, pp. 265–6.

37 Waddington to Foreign Minister Ribot, 12 June 1890, MAE, Personnel Dossier 831, np.

38 Jusserand diary entry (circa June) 1889, *Pap. Juss.*, 64, p. 257.

39 See *What Me Befell*, 113; and D.W. Prowse, "Their Modus Vivendi," *Evening Telegram*, 4 October 1902. A press clipping, *Pap. Juss.*, 76, p. 2.

40 Jusserand diary, May 1889, *Pap. Juss.*, 64, pp. 239–40; *What Me Befell*, 121–3. Later in life he advised any ambassador to be: "learned and supremely eloquent" – though wary of "being carried away by his own

gift of speech." He also stressed the importance of careful preparation, without resorting to a memorization of text. See his "The School for Ambassadors," AHR, p. 7 of On-Line version. Original article appears in AHR, 27, no. 3 (April 1922): 1–38.

41 Jusserand to MAE, 31 March 1890, Pap. Juss., 62, pp. 176–1. There were two other sous-directions, one for Africa, another for Asia and the Americas. See Paléologue to Jusserand, 28 April 1890, ibid., pp. 32–3.

42 Jusserand to mother, 24 May 1890, Pap. Juss., 61, p. 321; MAE, Personnel Dossier 831, np.

43 Jusserand to mother, 1 October 1885, Pap. Juss., 63, pp. 179–180; Jusserand to Dilke, July 1890, British Library, Papers of Sir Charles Wentworth Dilke [hereafter Dilke Papers], Add 43884, vol. xi, f. 113–17, and f. 118–21.

44 See "Seconde chemise: Réservé" with reference to an article of 14 April 1894, in MAE, Personnel Dossier 831, np.; What Me Befell, 153.

45 What Me Befell, 125–9,154.

46 Ibid., 195–6.

47 Ibid., 177–8, 202–3. Jusserand was accompanied to St Petersburg by his wife of four years, whom I have chosen to introduce subsequently (see p. XXX).

48 Cotton Morrison, 20 May 1879, Pap. Juss., 61, p. 50; 19 August 1879, ibid., p. 69; Jusserand to mother, 7 May 1881, ibid., 61, pp. 98–9.

49 Jusserand makes mention of one of his watercolours, done in London, in a letter to his mother of 6 May 1885, Pap. Juss., 61, pp. 138–9; report of press interview with Jusserand in Paris, 21 November 1902, LAT, 4.

50 What Me Befell, 90–111; Waddington to Jusserand, 20 December 1890, Pap. Juss., 62, pp. 201–2; "Horace Howard Furness," in With Americans, 328.

51 Jusserand recalled his appointment as editor in a letter written many years later to John Finley. See Jusserand to Finley, 29 March 1927, NYPL, Finley Papers, Box 81. The series is entitled Recueil des instructions données aux ambassadeurs et ministres de France depuis les traités de Westphalie jusqu'à la Révolution française.

52 John Viscount Morley, Recollections, 2 vols. i (New York: Macmillan 1917): 301.

53 For further information on Gaston Paris, Hippolyte Taine, and many other scholars of that generation, see William R. Keylor, Academy and Community: The Foundation of the French Historical Profession (Cambridge: Harvard University Press 1975), and Jonathan Dewald, Lost

Worlds: The Emergence of French Social History, 1815–1970 (University Park, Penn.: Pennsylvania State University Press 2006).

54 *What Me Befell*, 47, 141–52. Jusserand sent Gladstone a photograph of the "Victory" following his 1892 visit to Paris. See Jusserand to Gladstone, 29 February 1892, British Library, *Gladstone Papers*, Add.44514, vol. ccccxxix, ff. 85. He also sent a copy of one of his own books, with this confession: "But to speak truth, I send it much less with a hope it may prove useful, than out of *vanity* and because I feel the honour it will be for that son of mine to pass your threshold."

55 Jusserand diary, 4 August 1889, *Pap. Juss.*, 64, p. 259; *What Me Befell*, 155; André Laboulaye, "J.J. Jusserand ambassadeur," 30. Although Jusserand was not explicit on the subject, it is likely that he was also offended by Zola's "characteristic detachment" from the ongoing cold war between France and Germany. See Michael E. Nolan, *The Inverted Mirror: Mythologizing the Enemy in France and Germany, 1898–1914*. (New York: Berghahn Books 2005): 28.

56 Baring to Jusserand, 31 December 1900, *Pap. Juss.*, 67, p. 12; J. Lawrence to Jusserand, 4 January 1901, ibid., pp. 59–60; Mary Augusta Scott to Jusserand, 24 February 1901, ibid., pp. 100–1.

57 14 November 1902, *Washington Post* [hereafter WP], 1.

58 *Les sports et jeux d'exercise dans l'ancienne France* (Paris: Plon-Nourrit 1901). The volumes of the original edition of *Histoire littéraire du peuple anglais* had appeared in 1894, and the first volume in English in 1895.

59 Diary entries for 1889, *Pap. Juss.*, 64, pp. 228–48; *What Me Befell*, 85–6.

60 *What Me Befell*, 16, 90, 137. In June 1890 Ambassador Waddington wrote to the director of the courts in the Tuilleries gardens, recommending Jusserand as a "very good lawn tennis player." Waddington to M. Biboche, 12 June 1890, *Pap. Juss.*, 62, p. 193.

61 Copy of rental agreement, 30 January 1884, *Pap. Juss.*, 61, p. 391. In a letter to Dilke of 3 September 1892, Jusserand refers to his at-home, morning work on diplomatic correspondence, British Library, *Dilke Papers*, Add 43884, vol. ix, f. 122–3.

62 Jusserand to mother, 9 and 19 February 1887, *Pap. Juss.*, 61, pp. 244–5, 248–9. "Turc," however, continued to lead a chequered life, one resumed in a Saint-Haon chicken coop, and ended, so far as the family knew, when he was acquired as a guard dog by some traveller. *What Me Befell*, 75–7.

63 Jusserand diary, June 1888, *Pap. Juss.*, 64, pp. 219–23; *What Me Befell*, 89.

64 *What Me Befell*, 113–14; Jusserand to mother, 3 November 1888, *Pap. Juss.*, 61, p. 288.

65 Jusserand to Gladstone, 2 December 1892, British Library, *Gladstone Papers*, Add 44516, vol. 431, ff. 291; Francis Charmes, 10 November 1895, *Pap. Juss.*, 67, p. 40.

66 Jusserand to Dilke, 29 July 1895, British Library, *Dilke Papers*, Add 43884, vol. xi, f. 132–3.

67 Jusserand to Cunliffe-Owen, 5 November 1924, MAE, *Archives d'Ambassade* [henceforth *Ambassade*] , 790, "Société France-Amérique. Dossier 1912–1929."

68 George Thomas Richards was a Paris-based partner in the John Monroe & Co. Bank of New York and Paris. He died sometime between 1895 and 1902. His wife was Lucy Ellen, née Killearn, of Boston or, alternatively, a Kernochan of New York. She died suddenly, in Paris, in 1906 at the age of seventy-eight. Together, the couple had had three children: Marian (1857–1923), Elise (1862–1948), and a brother, G.L. Richards, who became a civil engineer. See Jusserand to Dilke, 5 November 1906, British Library, *Dilke Papers*, 43884, vol. xi, f. 147–48; WP, 28 September 1902, p. 21; "A Tribute," by Maurice Léon, 12 July 1948, *New York Times (NYT)*, 18.

69 Jusserand's request is dated 5 August; Gabriel Hanotaux's authorization is dated 10 August, MAE, Personnel Dossier, 831, np. See also June 1900 entry, ibid., for the reference to the Richards's degree of wealth. The wedding was reported in *Le Temps* on 17 October, in which account Tuck was described as an "uncle," a term inspired by affection rather than law. For Ribot's role in promoting Jusserand's career, see Waddington to Jusserand, 15 April 1890, *Pap. Juss.*, 62, pp. 191–2. See also Isabelle Dasque, "Etre femme de diplomate au début du XXe siècle: pouvoir social et pouvoir d'influence," in *Femmes et diplomatie: France, XXe siècle*, edited by Yves Denéchère. (Bruxelles: Presses Interuniversitaires Européennes 2004): 26.

70 Jusserand to Dilke, September 1896, British Library, *Dilke Papers*, Add 43884, vol. xi, f. 143; *What Me Befell*, 158.

71 *What Me Befell*, 159–62.

72 Léon Clédat to Jusserand, 3 and 13 November 1899, *Pap. Juss.*, 65, pp. 257–8, 260–1; Cica to Jusserand, 24 December 1899, ibid., pp. 262–5; Cica to Jusserand, 19 April, 18 June, 25 July 1900, ibid., 66, pp. 76–8, 79–81, 92–3.

73 Cica to Jusserand, 24 December 1899, *Pap. Juss.*, 65, pp. 262–5. Not surprisingly, perhaps, there appear to be fewer traces of correspondence

from brother Etienne and his wife, Marie. Exceptions include a letter of 7
April 1900, from Port Said, and 4 August 1900, *Pap. Juss.*, 66, pp. 73–4,
96.

74 *What Me Befell*, 169–213.

75 An edited version of his address can be found in WP, 15 March 1903, 3.
See also Jusserand to Paris, 24 March, and 16 June 1903 *Pap. Juss.*, 1,
pp. 28–36, 125–9; and *What Me Befell*, 281.

76 The *Figaro* article was translated and reproduced by the *Washington Post*
on 3 November 1902, p. 11. There is a document dated 10 July 1902 in
Jusserand's personnel file at the Quai d'Orsay that suggests he was first
offered the headship of the key *Direction Politique*, a position he appar-
ently declined on the grounds that he "would not have the requisite energies
[*forces nécessaires*] for such an honorable but often onerous position."

77 Review by W.J. Ashley, *Political Science Quarterly*, vol. 4, no. 4 (Decem-
ber 1889): 685–6.

78 Jusserand's review of *Ephemera Critica, Or Plain Truths About Current
Literature*, extracted from *La Revue Critique*, 3 June 1901, pp. 13–19,
for a volume entitled *Literary and Critical Extracts, 1866–1908*, in the
British Library.

79 Peter Lambert, "The Professionalization and Institutionalization of His-
tory," in *Writing History. Theory and Practice*, edited by Stefan Berger,
Heiko Feldner, and Kevin Passmore (London: Arnold 2003): 46.

80 Jusserand, "Introduction," Great French Writers series. In this instance,
the introduction to Jules Simon's *Victor Cousin* (London: George
Routledge and Sons 1888). One senses his indebtedness to Hippolyte
Taine, a personal friend, whose multi-volume *Histoire de la littérature
anglaise* had appeared in 1863, and quite possibly to his own contempo-
rary Gustave Lanson, whose *Histoire de la littérature française* was in
progress by the late 1880s. Lanson, like Jusserand, was interested in indi-
vidual artistic genius. For Lanson, see M. Van Montfrans and M. Ruud,
"Travailler pour la patrie: Gustave Lanson, the Founder of French Aca-
demic Literary History," *Yearbook of European Studies*, 12 (1999):
145–72.

81 See "The Forbidden Pastimes of a Recluse," "A Journey to Scotland in
the Year 1435," and "Paul Scarron," all in *English Essays from a French
Pen* (London: T. Fisher Unwin 1895): 11–23, 24–61, 62–157.

82 *A French Ambassador at the Court of Charles the Second. Le Comte de
Cominges From His Unpublished Correspondence* (London: T. Fisher
Unwin 1892): 13; "One More Document Concerning Voltaire's Visit to
England," *English Essays from a French Pen*, 193–202.

83 "Chaucer's Pardoner and the Pope's Pardoners," in *Essays on Chaucer*, 436.
84 *Shakespeare in France under the Ancien Régime* (London: T.F. Unwin 1899) originally published as *Shakespeare en France sous l'ancien régime* (Paris: Colin 1898). See also John Pemble, *Shakespeare Goes to France: How the Bard Conquered France* (London: Hambledon and London 2005): 59–60.
85 *Le Roman anglais et la réforme littéraire de Daniel Defoe*; "Jacques 1er d'Ecosse fut-il Poète?" *Revue Historique*, vol. 64 (May–August 1897): 1–49.
86 *English Wayfaring Life* (1891), 9.
87 Review by David Evett of *The English Novel in the Time of Shakespeare*, *Modern Languages Journal*, vol. 51, no. 4 (April 1967): 236.
88 "Introduction" to the Great French Writers series (1888), np.; Jusserand, *Histoire abrégée de la littérature anglaise* (Paris: Librairie Delagrave 1896): 226.
89 "The Forbidden Pastimes of a Recluse," in *English Essays from a French Pen*, 12; "Introduction," to *The Comical Romance and Other Tales by Paul Scarron*, 2 vols. (London: Lawrence and Bullen 1892), xli.
90 Jusserand, *A Literary History of the English People*, vol. 2 (New York: G.P. Putnam's Sons 1926): 3–4; *The Romance of a King's Life* (London: T. Fisher Unwin, 1896): 76.
91 Delcassé to Margerie (Washington) 27 January 1903, MAE, *Ambassade*, 895, np.; 30 November 1924, *LAT*, D11.
92 1 February 1903, *NYT*, 12; *What Me Befell*, 220.
93 3 February 1903, *WP*, p. 3; Jusserand to Paris, 11 February 1903, *Pap. Juss.*, 1, pp. 5–9.
94 Allan Nevins, *Henry White: Thirty Years of American Diplomacy* (New York: Harper & Brothers 1930): 223; *What Me Befell*, 152.
95 For Jusserand's accreditation speech see 3 February 1903, *National Archives Record Administration* [henceforth NARA], M53, Reel 30. For his report on the occasion, see 7 February 1903, MAE, *Ambassade*, Personnel, 895, np.
96 Roosevelt to Kermit, 8 February 1903, in *The Letters of Theodore Roosevelt*, edited by Elting E. Morrison, 8 vols. (Cambridge: Harvard University Press 1951–54) [Hereafter *Roosevelt Letters*]: iii, 422.

CHAPTER TWO

1 Roosevelt to Lounsbury, 11 February 1903, *Roosevelt Letters*, iii, 424.

2 "Jusserand Writes a Book ... ," 18 May 1916, *WP*, 6.

3 Jusserand, *Les Sports et jeux d'exercise* [1901]; "Some Maxims of Life," *The University Record*, x, no. 3 (January 1906): 105–10. See also review of *Les Sports* by the Marquise de Fontenoy, 11 December 1906, *WP*, 6.

4 "Spenser's 'Twelve Private Morall Vertues as Aristotle Hath Devised,'" *Modern Philology*, iii, no. 3 (Jan. 1906): 373–83; "'Piers Plowman,' the Work of One or Five," ibid., vi, no. 3 (Jan. 1909): 329. See also Samuel Moore, "Studies in 'Piers the Plowman,'" *Modern Philology*, 11, no. 2 (Oct. 1913): 177–93.

5 "Ben Jonson's Views on Shakespeare's Art," vol. x, 297–320, of *The Works of William Shakespeare* (Stratford-on-Avon: Shakespeare Head Press 1907).

6 "What to Expect of Shakespeare," *Proceedings of the British Academy, 1911–1912* (London: Oxford University Press 1912): 231, 238; 3 May 1925, *WP*, S16.

7 *Ronsard* (Paris: Hachette 1913); reviewed by Murray P. Brush in *Modern Language Notes*, 28, no. 8 (Dec. 1913): 257–9; "Ronsard and his Vendômois," in Jusserand's *The School for Ambassadors and Other Essays* (New York: G.P. Putnam's Sons 1925): 155–214. Marie de Médici was Queen Consort, then Queen of France (1600–1610).

8 Jusserand to Paris, 11 February 1903, *Pap. Juss.*, 1, pp. 5–9; *What Me Befell*, 221–22; Delcassé to Jusserand, 13 March 1903, *Ambassade*, 895. For recent biographies of the president, see Kathleen Dalton, *Theodore Roosevelt: A Strenuous Life* (New York: Alfred A. Knopf 2002) and Sarah Watts, *Rough Rider in the White House: Theodore Roosevelt and the Politics of Desire* (Chicago: University of Chicago Press 2003).

9 Jusserand to Paris, 4 May 1903, *Pap. Juss.*, 1, pp. 71–81; *What Me Befell*, 230–3. Ironically, as fascinated as he was by European culture, Roosevelt also expressed concerns lest Americans become, like the Europeans, "over-civilized [and] over-refined." See Lawrence W. Levine, *Highbrow-Lowbrow: The Emergence of Cultural Hierarchy in America* (Cambridge: Harvard University Press 1988): 236–37.

10 Jusserand to Paris, 25 February 1903, *Pap. Juss.*, 1, pp. 15–18.

11 Jusserand to Paris, 24 March 1903, *Pap. Juss.*, 1, pp. 28–36; *What Me Befell*, 222.

12 Roosevelt to Jusserand, 11 July 1905, *Roosevelt Letters*, iv, 1268; and also in *Pap. Juss.*, 69, pp. 3–5; Roosevelt to Jusserand, 3 August 1908, *Pap. Juss.*, 70, pp. 13–14; Roosevelt to Jusserand, 5 December 1911, *Roosevelt Papers*, Library of Congress [hereafter LC], Series 3A, Reel 370.

13 *What Me Befell*, 254; Roosevelt to Jusserand, 8 February 1904, *Roosevelt Letters*, iv, 718.

14 Roosevelt to Jusserand, 7 July 1909, *Pap. Juss.*, 71, p. 5; Jusserand to Roosevelt, 22 March 1910, ibid., pp. 25–8.

15 *What Me Befell*, 329–35; "President as Pacemaker," 26 May 1906, WP, 4; Evelyn Virginia Wiley, "Jules Jusserand and the First Moroccan Crisis, 1903–1906" (Unpublished dissertation: University of Pennsylvania, 1959): 30.

16 29 October, 1906, WP, 7; 15 December 1907, WP, M9; 20 November 1910, WP, 1; 1 May 1911, WP, 6.

17 Jusserand to Paris, 23 April 1903, *Pap. Juss.*, 1, pp. 64–8; Excerpt from a Doubleday book entitled *The Real Theodore Roosevelt as Told in the Private Letters of Major Archie Butt*, 3 February 1924, *Los Angeles Times* [hereafter LAT], 27; *What Me Befell*, 254. Among the books he selected to take from the White House was the Jusserand presentation copy of *La Chanson de Roland*. Jusserand to Paris, 3 March 1909, *Pap. Juss.*, 70, p. 92.

18 Roosevelt to Jusserand, 12 April 1906, *Pap. Juss.*, 69, p. 11; 27 June 1906, ibid., p. 19; Handwritten note, 23 May 1907, ibid., 70, p. 4; 28 June 1907, WP, 5; Elise to Roosevelt, 27 October 1906, *Roosevelt Papers*, LC, Series 1, Reel 69.

19 Roosevelt to Jusserand, 7 March 1909, *Pap. Juss.*, 70, p. 18.

20 Excerpt from *The Private Letters of Maj. Archie Butt*, 13 March 1924, *LA Times*, 5; Owen Wister, *Roosevelt: The Story of a Friendship, 1880–1919* (New York: Macmillan 1930): 167. One may wonder if the "joke" had been intentional, for three years earlier Roosevelt had asked Elise whether she was "reconciled" to her husband's pronunciation of "bowl, as a dissyllable." See Wiley, "Jules Jusserand," 37.

21 Jusserand to Paris, November 1908, *Pap. Juss.*, 3, pp. 214–16; 23 May 1909, ibid., 4, p. 63. "Friends Greet T.R.," WP, 20 November 1910, 1. The "Pauline" story dates from November 1910, but the White House courts were back in active use by May 1911; and Jusserand continued to play there with fellow diplomats and members of the Taft administration. See 1 May 1911, WP, 6.

22 5 April 1893, MAE. *Ambassade*, Dossier "ambassade, 1873–1942," 873, np.

23 Article on embassy life, 19 November 1905, WP, SM, 2; *What Me Befell*, 219.

24 "Cockades and Livery of Foreign Embassies," 8 August 1909, WP, T, 4.

25 25 February 1903, WP, 7.

26 2 January 1910, *WP*, 2.

27 Jusserand to Paris, 25 February 1904, *Pap. Juss.*, 1, pp. 252–7.

28 "Gorgeous Gowns," 18 February 1906, *WP*, 1; articles of 2 November
 1913, 25 November 1913, 26 November 1913, *WP*, ES9, 2, 5.

29 Jusserand to Paris, 23 April 1903, *Pap. Juss.*, 1, pp. 64–8. Noteworthy is
 the claim that Paul Cambon, French ambassador to London from 1898
 to 1920, "could not speak except to ask for his carriage and footman."
 See Keith Eubank, *Paul Cambon: Master Diplomatist* (Norman,
 Oklahoma: University of Oklahoma Press 1960): 209.

30 5 July 1903, *LAT*, 2; "David Bust ... ," 8 January 1904, *WP*, 6.

31 "Ambassador Greeted," 30 November 1904, *WP*, 5; "Honor to
 L'Enfant," 23 May 1911, *WP*, 1–2.

32 Delcassé to Embassy, 6 November 1902, *Ambassade*, 895.

33 Jusserand to Paris, 11 February 1903, *Pap. Juss.*, 1, pp. 5–9; "Homes of
 Embassies," 12 June 1904, *WP*, E2; "New German Embassy," 26 June
 1905, *WP*, 2.

34 Article and photo, 20 October 1907, *WP*, R6; "French embassy artistic,"
 1 March 1908, *WP*, ARF6; Jusserand's description of 22 November 1924,
 Pap. Juss., 60, p. 357. Suggestive of the era was the embassy's simple
 3-digit telephone number: 828. See Elise to Helen Garfield, 22 April
 1911, *Garfield Papers*, LC, Box 115.

35 "House for Jusserand," 24 January 1911, *WP*, 3.

36 Jusserand to Paris, 4 May 1904, *Pap. Juss.*, 1, pp. 324–8.

37 Jusserand to Paris, 11 February 1903, *Pap. Juss.*, 1, pp. 10–12.

38 Jusserand to Paris, 20 June 1904, *Pap. Juss.*, 1, pp. 355–8.

39 Jusserand to Paris, 25 January 1905, *Documents diplomatiques français
 (hereafter DDF.)*, II, vol. 6, no. 49, p. 63; 10 June, ibid., vol. vii, no. 27,
 p. 28; 11 June, ibid., no. 41, pp. 45–7. His complaints of being left in the
 dark appear to have been as frequent as they were ineffective. For
 example, see his plea of 21 November 1911, *DDF*, III, vol. i, no. 175,
 p. 166

40 "How France Pays Her Diplomats," 13 November 1908, *WP*, 6; "Dossier
 général," 30 January 1908 to December 1909, Personnel, *Ambassade*,
 889, np.; also circular from Minister Pichon, 30 December 1909, ibid.

41 Pichon to Jusserand, 8 April 1908, MAE, *Ambassade*, Personnel, "Dossier
 général," 889.

42 Jusserand to Paris, 4 March 1910, Personnel, *Ambassade*, 889. The
 ambassador's protests seem to have prompted some rethinking in the
 ministry, which announced some months later that the overall budget
 was going to be slightly increased, as was the ambassador's housing

allowance; a special allocation for heating and lighting was added. See Pichon to Jusserand, 26 May 1910, Personnel, *Ambassade*, 889.

43 Jusserand to Paris, 8 October 1910, Personnel, "Dossier général," *Ambassade*, 889, np.; 23 November, ibid.

44 Pichon to Jusserand, 12 November 1910, Personnel, *Ambassade*, 889, np.; Paris to Jusserand, 20 June 1911, ibid.

45 Jusserand to Pichon, 30 November 1913, MAE, *Ambassade*, Personnel, "Dossier général," 889, np.

46 Hay to Jusserand, 3 May 1904, NARA, M99, Reel 26. Jusserand to Hay, 4 May 1904, NARA, M53, vol. 31; Jusserand to Hay, 17 January 1905, NARA, M53, vol. 31; Hay to Jusserand, 19 January 1905, NARA, M99, Reel 26. In fact, French speeding infractions in Washington were treated more delicately than those committed by one British embassy secretary in Massachusetts, whose offence and $25.00 fine were reported on the front page of the *Washington Post*, 27 September 1904, 1.

47 Hay to Des Portes de la Fosse, 22 August 1905, NARA, M99, reel 26.

48 For example, see Jusserand to State, 8 April 1903, NARA, M53, Reel 30; 20 June 1903, ibid; 20 July 1903, ibid; Jusserand to Paris, 6 January 1907, *Pap. Juss.*, 3, pp. 1–5; Jusserand to State, 27 November 1909, *Foreign Relations of the United States* [hereafter FRUS] 1908, 260–2.

49 Jusserand to Hay, 29 March 1904, and 11 April 1904, NARA, M53, vol. 31.

50 State Department to Jusserand, 11 January 1908, FRUS, 1908, 327–8; "Champagne Duty Lowered," 29 January 1908, WP, 9.

51 State Department to Jusserand, 30 April 1909, FRUS, 1909, 248.

52 15 August 1909, WP, 11; 24 October 1909, WP, E4; "The Jusserand Interview," WP, 26 October 1909, 6; Nevins, *Henry White*, 286.

53 Jusserand to Paris, 1 February 1910, Dossier Philander Knox, *Ambassade*, 341, np.; 12 and 16 March 1910, WP, 4,1.

54 27 May and 16 October 1913, WP, 3 and 3. In his annual report for 1910 and 1912, Ambassador Bryce concluded that Jusserand was proving more tenacious than his government on the matter of American protectionism. See Bryce to London, 5 April 1911, *British Documents on Foreign Affairs* (BDFA) 1, C, vol. 14, no. 97A, p. 267, and vol. 15, p. 266. The most detailed account of Franco-American commercial and financial relations before the war is to be found in Yves-Henri Nouailhat, *France et Etats-Unis: Août 1914–Avril 1917* (Paris: Publications de la Sorbonne 1979): 25–42.

55 Jusserand to Paris, 18 January 1904, *Pap. Juss.*, 1, pp. 214–19; Jusserand to State Department, 26 February 1904, NARA, M53, vol. 31.

56 Jusserand to Paris, 2 November 1904, *Pap. Juss.*, 1, pp. 381–2; 2 November 1904, WP, 11; 12 February 1908, WP, 5; *What Me Befell*, 262.

57 See Ambassador Bacon (Paris) to State, 2 August 1911, and ensuing documents to 1913, in NARA, M568, Reel 1.

58 Roosevelt to Hay, 2 April 1905, *Roosevelt Letters*, iv, 1156–7.

59 "Memorandum of interview" [between Jusserand, Root, and Roosevelt] 15 December 1905, NARA, M53, Reel 32; No attempt was made to conceal the threat of French punitive action. See 20 January 1906, WP, 5; Jusserand to State Department, 13 February 1906, NARA, M53, Reel 32.

60 27 July 1908, WP, 1.

61 J. Fred Rippy and Clyde E. Hewitt, "Cipriano Castro, 'Man Without a Country,'" AHR, 55, no. 1 (Oct. 1949): 36–53.

62 For much fuller accounts of the Venezuelan affair, see Embert J. Hendrickson, "Root's Watchful Waiting and the Venezuelan Controversy," *The Americas*, vol. 23, no. 2 (Oct. 1966):115–29; and "Roosevelt's Second Venezuelan Controversy," *Hispanic American Historical Review*, vol. 50, no. 3 (Aug. 1970): 482–98; William M. Sullivan, "The Harassed Exile: General Cipriano Castro, 1908–1924," *The Americas*, vol. 33, no. 2 (Oct. 1976): 282–97. For Root's role, see Philip C. Jessup, *Elihu Root*, 2 vols., i, (Hamden Conn.: Archon Books 1964): 495–6.

63 Roosevelt to Hay, 2 April 1905, *Roosevelt Letters*, iv, 1158; Jusserand to Paris, 18 October 1903, *Pap. Juss.*, 1, pp. 373–7. See also Ernest R. May, "The Far Eastern Policy of the United States in the Period of the Russo-Japanese War: A Russian View," AHR, 62, no. 2 (Jan. 1957): 345–51.

64 Jusserand to Paris, 5 January 1904, DDF, II, vol. 4, no. 1, p. 218, and 16 February 1904, *Pap. Juss.*, 1, pp. 236–243.

65 Jusserand to Paris, 16 February 1904, DDF, II, vol. 4, no. 12, p. 367; 25 January 1905, ibid., vol. 6, no. 9, p. 62.

66 Jusserand to Paris, 9 March 1904, *Pap. Juss.*, 1, pp. 274–86. For Roosevelt's reference to Wilhelm's vanity, see Jusserand to Paris, June 1905, DDF, II, vol. vii, no. 91, p. 90. Jusserand thought that, while Americans liked German flattery, they discerned the reasons behind "so much politesse." 6 March 1905, DDF, II, vi, no. 29, p. 173.

67 Jusserand to Paris, 18 October 1904, DDF, II, vol. 5, no. 96, p. 456.

68 Jusserand to Paris, 18 October 1904, DDF, II, vol. 5, no. 96, p. 457; 25 January 1905, ibid., vol. 6, no. 9, p. 63.

69 *What Me Befell*, 302; 10 June 1905, WP clipping in *Pap. Juss.*, 69. For domestic praise of Jusserand's efforts, see *Le Temps*, 17 June 1905. As a testament to his feelings for the ambassador and for France, Roosevelt

said that he could envisage some future day when the United States might find itself at war with any of the other powers: Britain, Germany, Russia, or Japan. Jusserand to Paris, 25 January 1905, DDF, II, vol. 6, no. 9, p. 64.

70 See a series of press clippings from *New York Tribune*, 6 June 1905; *Courrier des Etats-Unis*, 6 June 1905; *Evening Star*, 6 June 1905; in *Pap. Juss.*, 69. p. 51; 10 June 1905, WP, *Pap. Juss.*, 69.

71 Jusserand to Baron Kaneko, 22 August 1905, *Pap. Juss.*, 141, np.; Jusserand to Ministry, 23 August 1905, *Pap. Juss.*, 141, np.

72 Jusserand to Paris, 9 March 1904, *Pap. Juss.*, 1, pp. 280–1; Roosevelt to Hay, 2 April 1905, *Roosevelt Letters*, iv, 1156–7.

73 Jusserand to Roosevelt, 25 June 1905, NARA, M53, vol. 31; Roosevelt to Henry Cabot Lodge, 11 July 1905, *Roosevelt Letters*, iv, 1272; William C. Askew and J. Fred Rippy, "The United States and Europe's Strife, 1908–1919," *Journal of Politics*, iv, no. 1 (Feb. 1942), 68–79.

74 Roosevelt to Jusserand, 25 July 1905, *Pap. Juss.*, 141, folio "Affaire du Maroc"; Jusserand to Roosevelt, 26 July 1905, ibid.; Roosevelt to Jusserand, 21 August 1905, ibid., 69, p. 6.

75 See despatches nos. 69, 71, 75, 82, 85, 87, 99, 101, 129, 137 dated between 4 and 27 June 1905, in DDF, II.

76 Roosevelt to Jusserand, 25 April 1906, *Pap. Juss.*, 69, pp. 12–13; and to Whitelaw Reid, 28 April 1906, *Roosevelt Letters*, v, 236; Wiley, "Jules Jusserand", 259–60. For his part, Jusserand told a New York audience that their president was "the greatest man of the western hemisphere – head and shoulders above everyone else ... a great man." 28 June 1907, WP, 5.

77 The president himself confided to Jusserand: "I wish to Heaven, not on your interest but in the interest of all civilized mankind, that France could take all Morocco under its direction." 2 August 1908, *Pap. Juss.*, 70, pp. 13–14.

78 *What Me Befell*, 233. Bryce to London, Report on Heads of Foreign Missions, 1912, 1913, BDFA, I, C, vol. 15, pp. 91, 368.

79 Jusserand to William Loeb, 28 December 1908, *Pap. Juss.*, 71, p. 3; Jusserand to Paris, 1 November 1910, ibid., 4, pp. 152–6. Bryce to London, Report on Heads of Foreign Missions, 1912, BDFA, I, C, vol. 15, p. 91.

80 Excerpt from the *Evening Star*, 8 June 1905, *Pap. Juss.*, 69.

81 Editorial, 2 June 1909, LA *Times*, np.; excerpt from Butt's *The Real Theodore Roosevelt*, 20 February 1924, LAT, 10.

82 "Envoy Chases Dog," 7 April 1912, WP, 10.

83 The original, front-page story appeared on 10 May 1907, WP. The jocular, and seemingly fraudulent, denial appeared on 2 and 5 December 1910, WP, 1, 9. See Ambassador Bryce's mini-portrait of Jusserand in Bryce to London, 6 March 1908, BDFA, 1, c, vol. 13, no. 83, p. 102.

84 André Laboulaye, who worked in the Jusserand embassy, maintained that while his boss accepted the moral tenets of his Catholic faith, his faith never displaced his reason. "One does not believe what one wants to believe," he would say with a sigh. Laboulaye, "J.J. Jusserand," 32.

85 "Washington Photographer," 3 November 1907, WP, E16.

86 She does seem to have been a regular Church attendee. See, for example, her note of 15 April 1911 to Mrs Helen Garfield, Garfield Papers, LC, Box.115.

87 Bryce to London, Report on Heads of Foreign Missions, 1912, BDFA, 1, c, vol. 15, p. 91; Michel Marbeau, "Une timide irruption: Les femmes dans la politique étrangère de la France dans l'entre-deux guerres," in Femmes et diplomatie: France, XXe siècle, edited by Yves Denéchère (Bruxelles: Presses Interuniversitaires Européennes 2004): 32–5.

88 "Society Saw Opening," 17 June 1908, WP, 3; "Mme Jusserand," 2 June 1909, LAT, 7.

89 21 March 1910, WP, 2; 28 December 1911, WP, 9; 1 September 1912, WP, np.; 10 October 1915, NYT, 80; for Lady Durand, see 3 January 1904, WP, ES2; Baroness Hengelmuller, 4 November 1906, WP, SM10; Lady Bryce, WP, E7; Baroness von Sternburg, 24 November 1907, WP, M3.

90 Jusserand to Paris, 14 April 1907, Pap. Juss., 3, p. 89; Roosevelt to Sir George Trevelyan, 1 October 1911, Roosevelt Letters, vii, 348.

91 Speech to honour the memory of French scientist André-Marie Ampère, 4 December 1908, NYT, 8.

92 Jusserand to Paris, 23 May 1911, Pap. Juss., 5, pp. 36–40; and 29 January 1912, ibid., pp. 116–19.

93 Jusserand to Paris, 22 April 1913, Pap. Juss., 71, p. 277; "French Writer," 8 December 1913, WP, 4.

94 In April 1906 Congress prohibited Secretary of State John Hay from accepting the French government's award of the Grand Cross of the Legion of Honor. See 6 April 1905, WP, 6.

95 Jusserand to Paris, 26 April 1911, Pap. Juss., 5, pp. 33–5; Jusserand to Paris, 12 December 1912, ibid., 6, pp. 92–5. See Gabriel Hanotaux, Le Comité 'France-Amérique': Son activité de 1909 à 1920 (Paris: Comité 'France-Amérique' 1920); and the French embassy records on the early years of the Comité, MAE, Ambassade, 790. "Dossier 1912–1914."

96 See for example, Jusserand to Paris, 7 April 1912, *Pap. Juss.*, 5, pp. 176–8.

CHAPTER THREE

1 Marie McNair, "Those Were the Days," WP, 20 December 1942, S2.
2 See "Auto Atoms," 22 March 1914, WP, 16; 19 June, WP, 6; 27 June, WP, 7, 5 August, WP, 3.
3 Jusserand to Paris, 29 December 1903, *Pap. Juss.*, 1, pp. 209–11; "British Envoy Received," 3 December 1903, NYT, 5.
4 See Sir Percy Sykes, *The Right Honourable Sir Mortimer Durand: A Biography* (London: Cassell 1926): 266–71; Nelson Manfred Blake, "Ambassadors at the Court of Theodore Roosevelt," *Mississippi Valley Historical Review*, vol. 42, no. 2 (Sept. 1955):191–2, 200. See the sympathetic portrait of Durand, 22 November 1903, WP, E5; and for the prolonged press inquiry into the circumstances of his recall – including the allegation that Mrs Roosevelt and Lady Durand did not get along – see articles in WP, 17 December 1906, 6; 20 December, 2; 23 December, 1; 24 December, 2, 6; and 8 March 1907, 6. Bryce's career is neatly summarized in "Bryce to Quit Post," 11 November 1912, WP, 1, 8.
5 Seward W. Livermore, "Theodore Roosevelt, the American Navy, and the Venezuelan Crisis of 1902–1903," AHR, 51, no. 3 (Apr. 1946), 452–71.
6 See "Given Special Rank," 11 January 1903, WP, 3; "Von Sternburg Delighted," 1 February, NYT, 2; "The Decoration of Holleben," 9 April, WP, 6.
7 "Received in New Rank," 8 August 1903, WP, 7.
8 Jusserand to Paris, 23 April 1903, *Pap. Juss.*, 1, pp. 64–8. For von Sternburg's relationship with the Roosevelt family, see WP, 26 March 1907, 1. For an extended portrait of his wife, the former Lilian Langham, see 24 November 1907, WP, M3.
9 "Baron von Sternburg Urges Friendship," 23 April 1903, NYT, 5.
10 German immigration in 1903 was in the order of 40,000, compared to 12,000 in 1902; and the embassy reckoned that the community as a whole retained strong ties to their homeland. Jusserand to Paris, 9 March 1914, DDF, II, vol. 4, no. 24, p. 443.
11 8 August, ibid., pp. 152–4; 9 March 1904, ibid., pp. 274–9; 20 June, ibid., pp. 355–8.
12 For von Sternburg, see 20 June 1907, WP, 6 and the report on his death, 25 August 1908, 1. For von Bernstorff, see 26 December 1908, "Is Great for Golf," WP, 7.

13 G. Lechartier, *Intrigues et diplomatie à Washington (1914–1917)* (Paris: Plon 1919): 1–10. See Reinhard Doerries's fine study *Imperial Challenge: Ambassador Count Bernstorff and German-American Relations, 1908–1917*, translated by Christa D. Shannon (Chapell Hill, University of North Carolina Press 1989).

14 5 February 1909, "Germany Our Friend," *WP*, 2; 6 May, "Envoys Tell of Peace," *WP*, 5; 15 May, "Bernstorff Lauds Fleet," *WP*, 12; 26 November, "Bernstorff to Stay," *WP*, 4; 21 December, "Urged to Study Germans," *WP*, 4; 7 May 1910, *WP*, 12. Although it took five years for the matter to come to light, Bernstorff's Philadelphia speech was said to have been heavily plagiarized, a claim made by the British author William Harbutt Dawson, and confirmed by the Academy. See article of 24 December 1914, *WP*, 3.

15 Robert J. Young (ed.), *French Foreign Policy 1918–1945: A Guide to Research and Research Materials* (Wilmington, Delaware: Scholarly Resources 1991): 8–9; Mark Hayne, "Change and Continuity in the Structure and Practice of the Quai d'Orsay, 1871–1898," *Australian Journal of Politics and History*, xxxvii, no. 1 (1991): 61–76; and "The Quai d'Orsay and Influences on the Formulation of French Foreign Policy, 1898–1914," *French History*, ii, no. 4 (1991): 427–52.

16 Robert J. Young. *Marketing Marianne*, 14–15; Jusserand to Paris, 30 November 1913, *Ambassade*, 889, np.

17 Forecast as reported by his old friend Maurice Paléologue, *Journal, 1913–1914* (Paris: Plon 1947): 203–4.

18 Jusserand, *Le Sentiment américain pendant la guerre* (Paris: Payot 1931): 21. Jusserand to Delcassé, 30 August 1914, no. 142, *DDF*, 1914, (3 August–31 December) (Paris: Imprimerie nationale 1999): 129–32; 24 August, *WP*, 5; Jusserand to Finley, 2 December 1914, New York Public Library [hereafter NYPL] *Finley Papers*, Box 14, dossier J.

19 "Fight to Finish," 25 August 1914, *WP*, 1, 10; Jusserand to Paris, 30 August 1914, *Pap. Juss.*, 9, pp. 3–7; 31 August, ibid., p. 9, 1; 31 August, *WP*, 8;

20 Jusserand to Paris, 19 September 1914, *Pap. Juss.*, 9, pp. 28–31; 22 September 1914, *WP*, 3.

21 Enclosure entitled "A Memorandum by Thomas Beaumont Holder," in Spring-Rice to Grey, 14 February 1914, *The Papers of Woodrow Wilson*, edited by Arthur S. Link et al. (Princeton: Princeton University Press 1979) vol. 29, 254 [hereafter *Wilson Papers*]. See Jusserand's memoir-like account in *Sentiment*, 28; also Jusserand to Paris, 7 September 1914, *DDF*, 1914, nos. 178 and 180, pp. 167–8; 8 September, *Pap. Juss.*, 45,

p. 7; 9 September, *Sentiment*, 29–30. See also "Von Bernstorff Peace Talk Insincere," WP, 22 September 1914, 2; and Paolo E. Coletta, *William Jennings Bryan, ii, Progressive Politician and Moral Statesman, 1909–1915* (Lincoln: University of Nebraska Press 1964–69): 253.

22 Jusserand to Paris, 22 September 1914, *Pap. Juss.*, 45, pp. 14–15; reproduced in DDF, 1914, no. 300, pp. 255–6.

23 Jusserand to Paris, 14 January 1915, *Pap. Juss.*, 45, p. 20. For his part, House reported that Jusserand "evinced a total lack of belief in [German] sincerity." See House diary entry, 13 January 1915, *Wilson Papers*, vol. 32, p. 64.

24 Jusserand to Garfield, 9 March 1913, LC, *Garfield Papers*, Box 115.

25 The observation came from a very friendly and forgiving Robert Lansing. See Daniel M. Smith, *Robert Lansing and American Neutrality, 1914–1917* (New York: Da Capo Press 1972): 73.

26 Jusserand to Wilson, 4 June 1915, LC, *Woodrow Wilson Papers*, Reel 69.

27 Well before the war, Bryan had acquired the reputation for public moralizing and for being, as one speaker put it, "the greatest apostle of the Prince of Peace on earth today." Bryce to London, 28 November 1907, BDFA, *Confidential Print*, Part 1, C, vol. 12, p. 246; 3 March 1913, WP, 10; for his moral code, see article of 14 April, 1913, WP, 3; Jusserand, *Sentiment*, 25, 34–9; Jusserand to Paris, 3 June 1915, *Pap. Juss.*, 11, pp. 165–7; 10 June, ibid., 11, pp. 175–8; 11 November, *Pap. Juss.*, 13, pp. 17–19; 1 January 1916, ibid., 13, p. 146.

28 Jusserand to Paris, 12 May 1915, *Pap. Juss.*, 11, pp. 95–7; 12 August, ibid., 12, pp. 95–9. See also Robert C. Hilderbrand, *Power and the People: Executive Management of Public Opinion in Foreign Affairs, 1897–1921* (Chapel Hill: University of North Carolina Press 1981): 123–5.

29 Jusserand to Paris, 10 June 1915, *Pap. Juss.*, 11, pp. 175–8; 24 June, ibid., 45, p. 34; 14 June, ibid., pp. 189–91; "Lansing Man of Genius," 11 June 1915, WP, 6.

30 Jusserand to Paris, 29 October 1914, *Pap. Juss.*, 9, pp. 91–3; Nouailhat, *France et Etats-Unis*, 99–107.

31 The State Department did not announce this relaxation until March 1915; however, Martin Horn suggests that Jusserand had persuaded Lansing through the services of Samuel McRoberts of National City Bank. See Horn, *Britain, France, and the Financing of the First World War* (Montreal: McGill-Queen's University Press 2002): 60–1.

32 Jusserand to Paris, 7, 14 March 1915, DDF, no. 311, pp. 402–03; Horn, *Britain, France and Financing*, 77; and his "A Private Bank at War: J.P.

Morgan & Co. and France, 1914–1918," *Business History Review*, 74 (spring 2000): 85–112.

33 Jusserand to State, 3 September 1914, FRUS, 1914 Supplement, Reel 25, pp. 490–2; Jusserand to Bryan, 3 September 1914, LC, *Woodrow Wilson Papers*, Reel 63; Jusserand to Paris, 9 December 1914, DDF, 1914, no. 641, pp. 630–1; Jusserand to State, 16 January 1915, FRUS, 1915, Reel 25, pp. 681–2; State to Jusserand, 1 February, ibid., p. 689; Jusserand to State, 16 February, ibid., pp. 690–2; Bryan to Wilson, 22 January 1915, *Wilson Papers*, 32, p. 106. See also Marjorie Milbank Farrar, *Conflict and Compromise: The Strategy, Politics and Diplomacy of the French Blockade, 1914–1918* (The Hague: Martinus Nijhoff 1974).

34 Lansing to Jusserand, 1 December 1914, FRUS, 1914, Reel 25, pp. 292–3. By May 1915 the British had been stopping cotton shipments, thus enraging American suppliers. See Jusserand to Paris, 26 May 1915, DDF, 1915, ii, no. 7, pp. 7–8. For the *Metapan* incident see Bryan to Jusserand, 21 January 1915, FRUS, 1915, Reel 25, pp. 744–5, and Jusserand to Bryan, 23 January, ibid., pp. 746–7.

35 Nouailhat, *France et Etats-Unis*, 134.

36 House to Grey, 8 July 1915, in Colonel Edward M. House, *The Intimate Papers of Colonel House*, edited by Charles Seymour, 4 vols. (London: Ernest Benn 1926–28): ii, 56. See also Mary R. Kihl, "A Failure of Ambassadorial Diplomacy," *Journal of American History*, 57, no. 3 (Dec. 1970): 648.

37 Jusserand to Paris, 24 August 1915, DDF, 1915, ii, no. 430, pp. 635–6; 30 August, *Pap. Juss.*, 12, pp. 137–40. Conversely, Spring-Rice maintained that the economic effect of the blockade on American producers and shippers was minimal, an argument that editors at the *Washington Post* found unconvincing. See "Denies Trade Is Hurt," 20 December 1915, WP, 1, 4, and editorial, 21 December, WP, 6.

38 Jusserand to Paris, 31 July 1915, *Pap. Juss.*, 12, pp. 51–3; Jusserand to War, 25 February 1916, *Pap. Juss.*, 13, pp. 253–8.

39 With reference to what was often ministerial "ignorance," Mark Hayne concludes that experienced diplomats like Jusserand believed it was up to them to seize the initiative in the face of the "ineptness and internal divisions" that they detected in Paris. See Hayne, "The Quai d'Orsay," 450.

40 Jusserand to Paris, 26 November 1914, *Pap. Juss.*, 9, pp. 167–9; 26 April 1915, 11, pp. 62–5.

41 Jusserand to Paris, 23 September 1914, *Pap. Juss.*, 9, pp. 32–4; 12 December 1914, ibid., pp. 211–13; 5 January 1915, ibid., 10, p. 7. For an explanation of the circumstances behind the preparation of the *Livre*

Jaune, and the involvement of the *London Times*, see Andrew Barros and Frédéric Guelton, "Les imprévus de l'histoire instrumentalisée: Le Livre jaune de 1914 et les documents diplomatiques français sur les origines de la Grande Guerre, 1914–1928," *Revue d'histoire diplomatique*, no. 1 (2006): 3–22.

42 Jusserand to Paris, 28 January 1915, DDF, i, no. 109, pp. 155–6; 14 February, ibid., no. 208, pp. 274–5; 10 March, *Pap. Juss.*, 10, pp. 213–16; 24 April, DDF, i, no. 508, pp. 711–12. For an authoritative exploration of the atrocities issue, see John Horne and Alan Kramer, *German Atrocities, 1914* (New York: Yale University Press 2000).

43 Jusserand to Paris, 6 November 1914, *Pap. Juss.*, 9, pp. 119–21; 18 November 1915, ibid., 13, pp. 39–43.

44 Jusserand to Paris, 3 November 1914, *Pap. Juss.*, 9, p. 104.

45 Jusserand to Paris, 8 April 1915, *Pap. Juss.*, 11, pp. 19–24; 10 December, ibid., 13, p. 88; 30 December, ibid., p. 137.

46 Jusserand to Paris, 29 May 1915, DDF, ii, no. 31, 52; and *Ambassade*, 740, np.; 30 September 1915, ibid., iii, no. 99, p. 103; 1 January 1916, MAE, *Papiers Berthelot*, 18, p. 29.

47 Jusserand to Paris, 3 June 1915, *Pap. Juss.*, 11, p. 167; 25 June 1915, DDF, ii, no. 160, p. 244; 10 November 1916, *Pap. Juss.*, 15, pp. 86–9; 27 December, ibid., 45, p. 107.

48 Jusserand to Paris, 5 February 1917, *Pap. Juss.*, 45, p. 121; 4 March, ibid., p. 136; 20 March, ibid., p. 144.

49 Jusserand to Paris, 18 January 1915, *Pap. Juss.*, 10, pp. 45–8; 9 February, ibid., pp. 108–11, 112–15. For Stillman and other prominent American francophiles see James H. Hyde to Philippe Berthelot, 14 November 1915, MAE, *Papiers Berthelot*, 20, pp. 7–24.

50 Jusserand to Paris, 26 February 1915, *Pap. Juss.*, 10, pp. 163–4.

51 Jusserand to Paris, 27 April 1917, *Pap. Juss.*, 141, dossier 3, "Correspondances échangées."

52 Jusserand to Paris, 16 January 1915, *Pap. Juss.*, 10, pp. 40–1; 25 September 1914, DDF, no. 320, pp. 269–70; 10 November 1914, *Pap. Juss.*, 9, p. 129; 27 August 1915, ibid., 12, pp. 131–2. See also Charles Thomas Johnson, *Culture at Twilight: The National German Alliance, 1901–1918* (New York: Peter Lang 1999).

53 "Germans Here Will Strike U.S.," 19 February 1916, WP, 2.

54 Dernburg, "Germany and the Powers," *North American Review*, vol. 200, as reported by the French embassy: December 1914, *Ambassade*, 130, np.; Jusserand to Paris, 15 September 1914, DDF, no. 254, pp. 218–20; Jusserand to Paris, 22 December 1914, *Pap. Juss.*, 9, pp. 241–3;

19 April 1915, ibid., 11, p. 51. See also Reinhard R. Doerries, "Promoting Kaiser and Reich: Imperial German Propaganda in the United States during World War 1," in *Confrontation and Cooperation: Germany and the United States in the Era of World War 1, 1900–1924*, edited by Hans-Jurgen Schroder (Providence: Berg 1993): 135–65.

55 Jusserand to Paris, 4 September 1914, *Pap. Juss.*, 9, pp. 10–11; 15 September, ibid., p. 24; 30 January 1915, DDF, 1, no. 121, p. 166; 12 March, *Pap. Juss.*, 10, pp. 217–19; 6 May 1915, DDF, no. 575, p. 812; Bosseront d'Anglade to Jusserand, 17 June 1915, *Ambassade*, 751, "Dossier guerre."

56 Jusserand to Paris, 1 January 1916, *Pap. Juss.*, 13, p. 150.

57 Jusserand to Paris, 16 August 1915, DDF, ii, no. 396, p. 601.

58 Jusserand to Paris, 12 March 1915, *Pap. Juss.*, 10, pp. 217–19.

59 Jusserand to Paris, 27 October 1914, DDF, no. 433, p. 423; 18 December, *Pap. Juss.*, 9. p. 228.

60 Jusserand to Paris, 9 November 1916, *Pap. Juss.*, 15, p. 74.

61 For the history and the condition of French anti-Americanism, from the eighteenth to the twentieth centuries, see Philippe Roger's *The American Enemy: A Story of French Anti-Americanism*, translated by Sharon Bowman (Chicago: University of Chicago Press 2005).

62 Jusserand to Paris, 12 September 1915, *Pap. Juss.*, 12, pp. 184–5; 30 September 1915, ibid., pp. 237–9.

63 Jusserand to Paris, 17 November 1914, 9, *Pap. Juss.*, 9, pp. 142–4; 3 August 1915, ibid., 12, pp. 65–6; 12 August, ibid., pp. 95–9.

64 Jusserand to Paris, 12 May 1915, *Pap. Juss.*, 11, p. 97; 29 July 1915, ibid., 12, pp. 38–9; 18 November, ibid., 13, pp. 39–43; 1 January 1916, ibid., p. 151.

65 Jusserand to Paris, 26 January 1916, *Pap. Juss.*, 13, p. 193.

66 Jusserand to Paris, 25 September 1914, *Pap. Juss.*, 9, p. 42; Jusserand to Paris, 1 January 1916, *Pap. Juss.*, 13, p. 152.

67 Jusserand to Paris, 26 June 1916, *Pap. Juss.*, 45, p. 63; De Polignac to Philippe Berthelot, MAE, *Papiers Berthelot*, 20, p. 128.

68 Jusserand to Paris, 30 January 1915, *Pap. Juss.*, 10, p. 90; 30 April, ibid., 11, p. 81; 30 April, DDF, i, no. 537, p. 743; 5 August, *Pap. Juss.*, 12, pp. 79–80.

69 Jusserand to Paris, 2 November 1916, *Pap. Juss.*, 45, p. 80.

70 Jusserand to Paris, 14 February 1915, DDF, i, no. 208, p. 274; 5 March, *Pap. Juss.*, 10, pp. 190–1; 3 August, ibid., 12, pp. 60–1.

71 Jusserand to Paris, 16 June 1915, *Pap. Juss.*, 45, pp. 31–3; 12 October 1916, ibid., 15, pp. 13–17.

72 6 December 1915, *Sentiment*, 57; 7 September 1916, WP, 2; Berthelot to
Polignac, 19 September 1916, MAE, *Papiers Berthelot*, 20, pp. 138–9; 2
December 1916, *Sentiment*, 85; 13 December, MAE, *Papiers Berthelot*, 19,
p. 91; 6 March 1917, Jusserand to Paris, MAE, *Maison de la Presse* [here-
after *Maison*] 21, np.

73 Finley to Jusserand, 24 February 1915, and 4 May 1916; Extract from
Jusserand's letter of recommendation to Paris, of 6 January 1916, all in
NYPL, *Finley Papers*, Box 19, File "Jusserand."

74 Jusserand to Ribot, 27 April 1917, *Pap. Juss.*, 141, np.

75 Casenave to Paris, 15 December 1916, MAE, *Papiers Berthelot*, 19, pp.
93–104.

76 De Polignac to Ernest Guy (Paris), 30 December 1916, MAE, *Papiers
Berthelot*, 20, "Polignac," p. 163.

77 Polignac report on his mission to the United States. 10 March 1917, MAE,
Papiers Tardieu, 84, pp. 11–27.

CHAPTER FOUR

1 Briand to Jusserand, 2 October 1916, *Pap. Juss.*, 88, p. 6. Like many
other foreign diplomats in Washington, Stéphane Lauzanne was married
to an American woman of California origins. For the terms of his 1908
mission to the U.S.A., see Paris to Jusserand, 27 January 1908, *Pap. Juss.*,
88, p. 3.

2 Jusserand to M. Gueyraud (New York), 29 February 1916, MAE,
Ambassade, 748, np.; Jusserand to Heilmann, 6 March, ibid.

3 Jusserand to Cunliffe-Owen, 12 January 1917, MAE, *Ambassade*, *Société
France-Amérique*, 790, np.

4 Lauzanne to Paris, 16 December 1916, MAE, *Papiers Berthelot*, 19, pp.
1–6,111.

5 Lauzanne to Paris, 16 December 1916, ibid., p. 110. For a brief history
of the *Maison*, see *"Note sur les services de propagande"* 9 April 1918,
MAE, Series Y, 1, pp. 43–48.

6 Lauzanne to Jusserand, 12 March 1917, *Pap. Juss.*, 88, pp. 55–6;
Jusserand to Lauzanne, 13 March, ibid., pp. 57–8.

7 Ribot to Jusserand, 14 April 1917, in Ribot's *Journal d'Alexandre Ribot
et correspondances inédites, 1914–1922* (Paris: Plon 1936): 53.

8 Ribot to Jusserand, 15 April 1917, *Pap. Juss.*, 144, p. 59; Tardieu to
Jusserand, 19 April, ibid., p. 104; André Tardieu, *France and America*
(Boston: Houghton Mifflin 1927): 236–7. Robert Lansing, while of two
minds about the desirability of setting up a French mission, confessed to

Wilson his doubts about being able to "ever make M. Jusserand compre-
hend" an American rejection of the idea – knowing the "sentimental
character of the French and how readily they take offense." Lansing to
Wilson, 6 April 1917, *Personal and Confidential Letters from Secretary
of State Lansing to President Wilson, 1915–1918* (Washington: National
Archives and Record Service 1968): 363–4.

9 Note of 15 April 1917, *Pap. Juss.*, 144, pp. 60–2; Tardieu to Ribot, 21
 May 1917, MAE, *Série Guerre*, 512, p. 186. Again, on the 27th, Jusserand
 made no mention of press or propaganda in his note to Lansing on the
 structure and personnel of the Commission. See Jusserand to Lansing, 27
 May 1917, MAE, *Ambassade*, Haut Commissariat, 751, np.

10 Tardieu to Paris, 19 October 1917, MAE, *Maison*, 21, np.; Lauzanne to
 Jusserand, 9 November, *Pap. Juss.*, 88, pp. 96–102.

11 For information on that ministerial shakeup, see Young, *Marianne*, 58.

12 Stevenson Hume Evans to Jusserand, 3 January 1917, MAE, *Ambassade*,
 740, np.; Max Lazard to Jusserand, January 1917, *Pap. Juss.*, 100, pp.
 36–8.

13 Liebert to Berthelot (Paris), 16 January 1917, MAE, *Maison*, 20, np.; de
 Polignac to Tardieu, 10 March 1917, MAE, *Papiers Tardieu*, 84, pp. 25–6;
 de Polignac to Berthelot, 23, December 1916, MAE, *Papiers Berthelot*, 20,
 p. 160; Polignac to Ernest Guy, 30 December 1916, ibid., pp. 163–4.

14 Jusserand to Paris, 27 January 1917, *Pap. Juss.*, 15, p. 239; 27 April
 1917, *Pap. Juss.*, 141, np.

15 Jusserand to Paris, 24 May 1917, *Pap. Juss.*, 141, np. Bergson had
 indeed judged the ambassador "too stiff to become an intimate of Wil-
 son" and blind to the fact that Wilson placed too much trust in German
 assurances of good faith. The latter charge was manifestly incorrect, and
 reason enough for Jusserand to be angry. See the extended editorial note
 regarding Bergson's account on Jusserand, to Paris, 3 March 1917, *Wil-
 son Papers*, 41, pp. 315–16. A year later, on a trip to America, Bergson
 contemplated trying to see Wilson without using the intermediary ser-
 vices of the ambassador. See House diary, 14 June 1918, ibid., 48, p.
 317.

16 3 January 1916, Dossier Louis Aubert, *Pap. Juss.*, 100, np. It appears
 that the ministry forwarded to Jusserand this, and a number of other
 reports by Aubert. In another report, of 4 January, Aubert said that
 Jusserand believed that 85 percent of Americans were behind the allies. "I
 would like to believe it," Aubert wrote, "but don't." Ibid.

17 Jusserand to Ribot, 24 May 1917, *Pap. Juss.*, 141, np.

18 Ibid.

19 Jusserand to Ribot, 21 July 1917, *Pap. Juss.*,16, pp. 80–6.

20 Jusserand to Paris, 16 January 1917, *Pap. Juss.*, 15, p. 215.

21 Jusserand to Ribot, 12 June 1917, *Pap. Juss.*, 141, np.

22 Jusserand to Paris, 3 July 1917, *Pap. Juss.*, 16, pp. 59–64; Jusserand to Paris, 6 November 1918, ibid., 52, p. 26.

23 Jusserand to Paris, 15 February 1918, *Pap. Juss.*, 17, pp. 76–8; 8 June 1918, MAE, Série B, 22, p. 22; 31 October 1918, ibid., 18, p. 48; 26 September 1919, ibid., p. 288.

24 Jusserand to Ribot, 12 June 1917, *Pap. Juss.*, 141, np. A year later he complained of the superior attitude too often manifested by French army officers on mission. They must present themselves, he counselled, as friends come to "inform" their American counterparts, not to "teach" them. Jusserand to Paris, 18 May 1918, *Pap. Juss.*, 17, p. 154.

25 24 November 1917, WP, 2; Lyon-Caen, "Jules Jusserand," pp. 46–7.

26 Jusserand to Paris, 5 April 1917, *Pap. Juss.*, 45, p. 148.

27 Jusserand to Paris, 5 April 1917, *Sentiment*, 107; 14 September 1917, *Sentiment*, 107. Jusserand to Paris, 6 August 1918, *Pap. Juss.*, 17, pp. 246–7; See also David Stevenson, "French War Aims and the American Challenge, 1914–1918," *Historical Journal*, 22, no. 4 (Dec. 1979): 881.

28 Jusserand to Pichon, 19 June 1917, *Pap. Juss.*, 141, np.; Jusserand to Albert Thomas (War), 12 October 1917, *Sentiment*, 128–9.

29 Jusserand to Paris, 9 December 1915, *Pap. Juss.*, 13, pp. 81–3; to Consul-General Gueyraud, 19 February 1916, MAE, *Ambassade*, 748 "Dossier télégrammes de presse," np.

30 Jusserand to Pichon, 24 May 1917, *Pap. Juss.*, 141, np.; to Paul Deschanel, president of the Chamber of Deputies, 24 May, ibid.; to Xavier Charmes, 27 October, ibid.

31 Premier and Foreign Minister Alexandre Ribot to Jusserand, 18 August 1917, *Pap. Juss.*, 141, np.

32 "Diplomats," 22 March 1915, WP, 4; Jusserand to Garfield, 1 November 1915, LC, *Garfield* Papers, File Jusserand; Jusserand to Paris, 12 August 1918, *Pap. Juss.*, 17, pp. 264–6; 26 October 1924, WP, SO3. Apart from the daily carriage ride, which preceded walks in Rock Creek Park, and the unbroken pursuit of his scholarly interests, the ambassador's remaining wartime diversion seems to have been the Washington Fencers Club. There he was regarded as "one of the most active members" and the sponsor of an annual trophy. See 16 November 1915, WP, 4.

33 2 November 1914, WP, p. 8; Jusserand to the artist Gustav Brock (New York), 9 June 1917, MAE, *Ambassade*, 351, "Mission Viviani-Joffre"; and to W.B. Strang, 3 October 1917, ibid. See also the portrait of Jusserand

in wartime by James B. Morrow, 16 March 1919, LA *Times*, III 26; an article of remembrance of 25 October 1936, WP, B2; and his own account of the daily outing in *Sentiment*, 114.

34 "Fair Artists in Corps," 19 January 1914, WP, 4; Lauzanne to Jusserand, 29 July 1917, *Pap. Juss.*, 88, p. 73 et seq.; "Mme J.J. Jusserand is the Doyenne," by Mayme Ober Peak, 17 June 1923, WP, 72.

35 Jusserand to Finley, 29 December 1916, MAE, *Ambassade*, 747, "Dossier Finley," np.; Jusserand to Xavier Charmes, 27 October 1917, *Pap. Juss.*, 141, np.; to John Finley, 29 October, MAE, *Ambassade*, 747, "Dossier Finley"; to Myron Herrick, 3 June 1918, *Pap. Juss.*, 87, pp. 39–40.

36 Jusserand to Paris, 1 October 1918, *Pap. Juss.*, 18, pp. 1–6.

37 Jusserand to Paris, 12 June 1917, *Pap. Juss.*, 141, np.

38 21 May 1916, NYT, vi, 209; 2 September, *Chicago Tribune*, 7.

39 Gaillard Hunt, AHR, xxii, no. 3 (April 1917): 670.

40 *With Americans*, 335.

41 Ibid., 122–4, 250–4, 244.

42 Ibid., 266.

43 Ibid., 11–19, 247.

44 Ibid., 133, 274.

45 Ibid., 312–13.

46 Ibid., 342.

47 Jusserand to Pichon, 24 May 1917, *Pap. Juss.*, 141, np.; to Deschanel, 24 May, ibid.; to Ribot, 14 November, ibid.

48 Report on the annual dinner of the Pennsylvania Society, 9 December 1917, WP, 14; Hall to Jusserand, 8 January 1918, *Pap. Juss.*, 17, p. 17.

49 Spring-Rice to Balfour, 13 July 1917, *Letters and Friendships*, ii, p. 403. For Lord Northcliffe's "rough and unfeeling assault" on Spring-Rice, see article of 17 February 1916, WP, 3, and editorial of 18 February, 6; and David H. Burton, *Cecil Spring-Rice: A Diplomat's Life* (Rutherford: Farleigh Dickinson University Press 1990): 197–8.

50 'Ex-Attaché,' "France and England Wisely Avoided Propaganda in U.S.," 4 August 1918, WP, ED1. How misleading it was is most simply confirmed by the presence, as of May 1918, within the French foreign ministry of a Commissariat Général à l'Information et à la Propagande, within which in turn was a Section des Etats-Unis. See Young, *Marianne*, 58 et seq.

51 "President Lights 'Miss Liberty,'" 3 December 1916, WP, 1–2; and report of 5 December 1916, *Christian Science Monitor* [hereafter CSM], 1.

52 7 September 1917, WP, 4.

53 9 December 1917, WP, 14.

54 Jusserand to Gabriel Louis Jaray (Comité France-Amérique), 9 July 1918, MAE, *Ambassade*, 790, np.

55 15 July 1918, *Sentiment*, 143–4.

56 Maison de la Presse to MAE, pre-July 1917, MAE, *Maison*, 20, np.; Ministry of Beaux-Arts to MAE, 2 July 1918, MAE, Série B, 22, pp. 34, 43.

57 Comité du Livre to Minister, 26 June 1917, MAE, *Maison*, 1, np.; Jusserand to Paris, 12 April 1918, *Pap. Juss.*, 17, pp. 112–14.

58 "Note sur la propagande," 1916, MAE, *Maison*, 20, np. Tardieu to Paris, 26 January 1918, MAE, *Papiers Tardieu*, 85, pp. 54–5.

59 For newspaper readership, even in 1949, see Bernard C. Cohen, *The Press and Foreign Policy* (Princeton: Princeton University Press 1963): 257. In the 1970s no more than 20 percent of Americans were deemed to be "relatively well informed about foreign policy issues." See Ralph B. Levering, *The Public and American Foreign Policy, 1918–1978* (New York: William Morrow 1978): 20–1.

60 Jusserand to Paris, 31 March 1916, *Wilson Papers*, 36, pp. 389–90.

61 Meyer Berger, *The Story of the "New York Times" 1851–1951* (New York: Simon and Schuster 1951); Elmer H. Davis, *History of the "New York Times," 1851–1921* (Reprint, New York: Scholarly Press 1971); Harrison E. Salisbury, *Without Fear or Favor: The "New York Times" and Its Times* (New York: Times Books 1980).

62 Jusserand to Paris, 7 January 1915, *Pap. Juss.*, 10, pp. 13–14. For confirmation of this difficulty, see Melvin Small, "Historians Look at Public Opinion," in his own edited volume, *Public Opinion and Historians* (Detroit: Wayne State University Press 1970): 13–32.

63 Bosseront d'Anglade to Jusserand, 17 June 1915, MAE, *Ambassade*, 751, Dossier Guerre, np.; Jusserand to Paris, 9 July, *Pap. Juss.*, 11, p. 270; 23 July, ibid., 12, pp. 25–9. See Howard Bray, *The Pillars of The Post: The Making of a News Empire in Washington* (New York: Norton 1980); Tom Kelly, *The Imperial Post: The Meyers, the Grahams, and the Paper that Rules Washington* (New York: William Morrow 1983); Chalmers M. Roberts, *The Washington Post: The First 100 Years* (Boston: Houghton Mifflin 1977); Lloyd Wendt, *"Chicago Tribune": The Rise of a Great American Newspaper* (Chicago: Rand McNally 1979)

64 Jusserand to Heilmann, 10 May 1915, MAE, *Ambassade*, 744, Dossier Duval, np.; Heilmann to Jusserand, 12 May, ibid. For Hearst see Ferdinand Lundberg, *America's 60 Families* (New York: Halcyon House 1937): 267–9.

65 See the press resumés by P. Ortiz of August, September, October 1915, and February 1916, MAE, *Ambassade*, 744, Dossier Hearst, np.; Jusserand to Paris, 23 September 1915, *Pap. Juss.*, 12, pp. 216–17.

66 Jusserand to Paris, 27 October 1916, MAE, *Ambassade*, 743, Dossier Hearst, np.; Jusserand to Lauzanne (New York), 30 October, *Pap. Juss.*, 88, pp. 14–15; Jusserand to Paris, 12 November, ibid., 45, p. 81. Tardieu recalled this "insidious campaign" to portray France as too far gone for American help to do any good, in his post-war *France and America*, 232.

67 Jusserand to Paris, 10 March 1917, *Pap. Juss.*, 15, pp. 281–4; J.H. Duval (Hearst Press) to Jusserand, 5 July 1917, MAE, *Ambassade.*, 744, Dossier Duval, np.; Lauzanne to Jusserand, 10 July, ibid., 743, Dossier International News Service; Lauzanne to Jusserand, 17 July, ibid., 743, Dossier Hearst. Jusserand to Paris, 4 June 1918, *Pap. Juss,* 17, p. 176. Roosevelt to Jusserand, 22 March 1918, *Roosevelt Papers*, LC, Series 3A, Reel 401.

68 Jusserand to Paris, 2 September 1915, *Pap. Juss.*, 12, p. 150; 24 October 1915, ibid., p. 302. Less known are the happier cases of Mlle de Brettignies and Mlle Thuliez, whom the Germans had intended to execute for their part in assisting allied soldiers. Jusserand prevailed upon a dithering Wilson to exert American influence in Berlin. Such intervention, the ambassador argued, would be no infraction of neutrality but rather an action for humanity. See his account in *Sentiment*, 46–8.

69 Jusserand to Paris, 26 January 1916, *Pap. Juss.*, 13, p. 193; 30 March, MAE, *Maison*, 20, np.

70 De Polignac to Tardieu, 10 March 1917, MAE, *Papiers Tardieu*, 84, pp. 18–20; Jusserand to Paris, 12 June, *Pap. Juss.*, 141, np.; Tardieu to Paris, 26 July 1917, MAE, *Série Guerre*, 513, pp. 178–79.

71 Pierre de Lanux to Polignac, June 1917, MAE, *Série Guerre*, 513, pp. 247–8.

72 In 1917–18 the committee is said to have issued, worldwide, 75 million copies of printed materials. See Willis Rudy, *Total War and Twentieth-Century Higher Learning: Universities of the Weestern World in the First and Second World Wars* (Rutherford: Farleigh Dickinson University Press 1991): 49; also Hildebrand, *Power and the People*, pp. 144–65; James R. Mock, *Words that Won the War: The Story of the Committee on Public Information, 1917–1919* (New York: Russell and Russell 1939); Stephen Vaughn, *Holding Fast the Inner Line: Democracy, Nationalism, and the Committee on Public Information* (Chapel Hill: University of North Carolina Press 1980). See also Peter Buitenhuis, *The Great War of Words: British, American, and Canadian Propaganda and Fiction, 1914–1933* (Vancouver: University of British Columbia Press 1987);

James Duane Squires, *British Propaganda at Home and in the United States* (Cambridge: Harvard University Press 1935).

73 Casenave to Tardieu, 9 August 1918, MAE, Série B, 22, pp. 181–7.

74 See, for example, Lloyd E. Ambrosius, *Woodrow Wilson and the American Diplomatic Tradition: The Treaty Fight in Perspective* (New York: Cambridge University Press 1987), 12–13.

75 Frank Polk to Wilson, 22 May 1916, *Wilson Papers*, 37, p. 93; House to Wilson, 1 June 1916, ibid., p. 134; Briand to Jusserand, 28 May 1916, MAE, *Ambassade*, 341, "Dossier Colonel House," np.

76 Jusserand to Paris, 16 October 1915, *Pap. Juss.*, 12, pp. 279–82; 15 February 1916, ibid., 45, pp. 44–5; 14 November 1916, ibid., 15, p. 104.

77 Jusserand to Paris, 27 October 1916, *Pap. Juss.*, 15, pp. 53–7; 2 December, *Sentiment*, 90.

78 Jusserand to Paris, 18 December 1916, *Sentiment*, 90.

79 Jusserand to Paris, 16 December 1916, *Pap. Juss.*, 45, pp. 93–4; 18 December, *Sentiment*, 90.

80 House to Wilson, 4 December 1916, *Wilson Papers*, 40, p. 138.

81 Jusserand to Paris, 20 December 1916, *Pap. Juss.*, 45, pp. 96–9; *Sentiment*, 91.

82 Nouailhat, *France et Etats-Unis*, 396–7; Jusserand to Paris, 22 January 1917, *Sentiment*, 92–3.

83 Jusserand to Paris, 26 January 1917, *Pap. Juss.*, 15, p. 224.

84 Jusserand to Paris, 20 December 1916, *Pap. Juss.*, 45, p. 99; 21 December, ibid., p. 100.

85 See 4 February 1917, WP, p. 6; 15 February, WP, pp. 1, 5; Doerries, *Imperial Challenge*, 220–8. Jusserand knew that von Bernstorff had argued against the reversion to unrestricted submarine warfare. See entries for 31 January, *Sentiment*, 94, and Jusserand to Paris, 10 February, *Pap. Juss.*, 45, p. 126.

86 26 October 1924, WP, p. 503; Jusserand to Paris, 15 February 1917, *Pap. Juss.*, 15, pp. 257–9; 25 February, *Sentiment*, 93–4.

87 Jusserand to Paris, 6 March 1917, *Pap. Juss.*, 45, pp. 139–40; *Sentiment*, 93–4. See also Henry Blumenthal, *Illusion and Reality in Franco-American Diplomacy, 1914–1945* (Baton Rouge: Louisiana State University Press 1986): 32–3.

88 16 March 1917, *Sentiment*, 97–8.

89 Jusserand to Paris, 25 May 1917, *Pap. Juss.*, 16, pp. 15–16.

90 Jusserand to House, 23 August 1917, *Intimate Papers*, iii, 164. In August, the Pope had offered to mediate between the warring parties. Long after his retirement, Jusserand clung to his belief that Wilson had

resented the papal initiative. See his "Communication," *AHR*, xxxvii, no. 4 (July 1932): 818; also David Stevenson, "French War Aims," 885.

91 Wilson to House, 2 September 1917, *Wilson Papers*, 44, p. 120; House diary, 10 September 1917, ibid., 185.

92 House diary, 28 February 1918, *Wilson Papers*, 46, p. 488; Jusserand to Wilson, 29 July 1918, ibid., 49, p. 124

93 Jusserand to Paris, 12 February 1918, *Pap. Juss.*, 17, p. 67; 8 April, ibid., pp. 107–09; 24 July, *Sentiment*, 148–9; "Spirit of Victory," 7 September 1918, *NYT*, 3. Jusserand to Herrick, 31 October 1918, *Pap. Juss.*, 87, p. 46. See also David Stevenson, "The Failure of Peace by Negotiation in 1917," *Historical Journal*, 34, no. 1 (March 1991): 65–86.

94 In a private letter to Franklin K. Lane, Jusserand contended that there should be no exclusively German language schools in America, and no German taught in the primary schools. The language, he said, was being used to create a "breeding place of disloyal enemies." But he acknowledged that it should not be banned at higher levels, a tolerance not inspired by a higher ideal, but by the need to better understand these enemies and to better anticipate what they "are thinking and hatching." Jusserand to Lane, 26 March 1918, *Pap. Juss.*, 17, pp. 102–3.

95 Jusserand to Paris, 6 January 1918, *Pap. Juss.*, 17, p. 12; 30 August, ibid., pp. 285–8; 12 October, ibid., 18, pp. 18–19.

96 Indeed, Lansing complained to House that he rarely saw the president and that, accordingly, the State Department was "sailing without a chart." House diary, 4 January 1917, *Wilson Papers*, 40, p. 408. Jusserand to Paris, 14 October 1918, *Pap. Juss.*, 18, p. 26; 28 October, ibid., p. 43; 4 November, ibid., 52, p. 17.

97 Jusserand to Paris, 28 October 1918, *Pap. Juss.*, 18, p. 43.

98 On the occasion of Jusserand's presentation of two Sèvres vases to the American Senate. 25 September 1918, *CSM*, 1.

99 Jusserand to Paris, 10 October 1918, *Sentiment*, 152–3.

100 United States Serial 7443. Document No. 765, 8 January 1918.

101 Lauzanne to Jusserand, 31 October 1918, *Pap. Juss.*, 88, pp. 168–70; Jusserand to Paris, January 1918, *Pap. Juss.*, 17, pp. 31–2; 11 October 1918, *Wilson Papers*, 51, p. 308.

102 Jusserand to Paris, 2 November 1918, *Pap. Juss.*, 52, pp. 7, 8.

103 Jusserand to Paris, 3 November 1918, *Pap. Juss.*, 52, p. 9; *Sentiment*, 154–5.

104 Jusserand to Paris, 11 November 1918, *Pap. Juss.*, 52, p. 49; 11 November, *Sentiment*, 156–7; 12 November, *WP*, 1.

105 Jusserand to Paris, 13 November 1918, *Pap. Juss.*, 52, p. 59; 17 November, ibid., 52, p. 81.

1 Spring-Rice to Balfour, 5 January 1917, *The Letters and Friendships of Sir Cecil Spring-Rice. A Record,* edited by Stephen Owen, 2 vols. ii (Westport: Greenwood Press 1971): 386.
2 5 May 1917, Diary of William Phillips, *Wilson Papers,* vol. 42, p. 233.
3 See Jusserand to Paris, 6 June 1918, ibid., vol. 48, p. 254; 25 July 1918, ibid., vol. 49, pp. 91–3, and 26 July, ibid., pp. 111–12; Jusserand to Colville Adrian de Rune Barclay, 11 October 1918, ibid., vol. 51, p. 307.
4 Jusserand to Wilson, 29 July 1918, ibid., vol. 49, p. 123.
5 Volumes 48 to 51 of the *Wilson Papers,* covering May to early November 1918, are rich in inter-allied materials relating to this Siberian issue. See also Michael Jabara Carley, "The Origins of French Intervention in the Russian Civil War, January–May 1918," *Journal of Modern History,* vol. 48, no. 2 (Sept. 1976): 413–39.
6 Jusserand to Paris, 13 November 1918, *Pap. Juss.*, 52, p. 59.
7 Jusserand to Paris, 3 November 1918, *Pap. Juss.*, 52, p. 10; 14 November, ibid., p. 66; 14 November, ibid., pp. 68–9.
8 Jusserand to Paris, 19 November 1918, *Pap. Juss.*, 52, p. 88; 22 November, ibid., p. 98; 27 November, ibid., p. 119.
9 Raymond Poincaré, *Au Service de la France*, x, *Victoire et Armistice,* 1918 (Paris: Plon 1933): 439. Frank Polk (State Department) to Lansing, 9 December 1918, [telegrams for Jusserand from Paris] *Wilson Papers,* vol. 53, pp. 345–6; Diary of Edith Benham, 20 January 1919, ibid., vol. 54, p. 175. See also Nevins, *Henry White,* 461.
10 French proposal under cover notes from Jusserand to State Department, 29 November, and from Frank Polk to Wilson, 2 December 1918, *Wilson Papers,* vol. 53, pp. 292–8.
11 Readers may note that this chapter's account of Jusserand's sojourn in Paris, between December 1918 and July 1919, relies heavily on American sources. The ambassador's formal memoirs, *What Me Befell,* end with the Roosevelt years, his informal wartime memoirs, *Le Sentiment Américain,* end with the Armistice of November 1918, and what I have called the *Papiers Jusserand* in the archives of the French Foreign Ministry, though massive in volume, yield little trace of his activities during that roughly six-month period.

12 Jusserand to Finley, 26 November 1918, *Finley Papers*, NYPL, Box 30,
 File "J General."

13 Jusserand to Helen Garfield, 24 April 1919, *Garfield Papers*, LC, Box
 115; to John Finley, 31 July 1919, *Finley Papers*, NYPL, Box 39, File
 "Jusserand, Ambassador"; to Senator Lodge, 25 April 1919, *Papers of
 Henry Cabot Lodge*, Massachusetts Historical Society, Reel 53. I owe the
 latter reference to Dr Rob Hanks.

14 See Jusserand's communications to Lansing, 1 January 1919, *Lansing
 Papers*, LC, vol. 40; and 7, 8, 9, 10 January, vol. 41. Alexandre Ribot,
 Journal, 271. See also the admiring portrait of Mrs Lansing, whose
 French was said to be "fluent," in WP, 18 July 1915, SM4.

15 See Jusserand to Wilson, 8 May 1919, *Woodrow Wilson Papers*, LC, Reel
 405. In a note to Lansing of 1 January 1919, Jusserand had hand-cor-
 rected his personal stationery to read 28 avenue du Président Wilson,
 Lansing Papers, LC, vol. 40. Sometime between 1904 and 1914 the
 Jusserands had moved around the corner, from their first married quar-
 ters on the avenue Marceau to 28 avenue du Trocadéro, possibly acquir-
 ing the Richards' family apartment following the death of Elise's mother
 in 1906.

16 Edouard de Billy to Tardieu, 24 January 1919, MAE, *Papiers Tardieu*, 82,
 pp. 225–7; 5 February, ibid., p. 241; House diary, 14 March 1919, *Wil-
 son Papers*, vol. 55, p. 499; Chambrun (DC) to Paris, 5 March 1919, MAE,
 B, 1, p. 33; De Billy to Tardieu, 29 March 1919, MAE, *Papiers Tardieu*,
 82, p. 266; Casenave to Tardieu, 12 May 1919. Ibid., pp. 293–4.

17 See David Stevenson, "French War Aims and the American Challenge,"
 891–2.

18 Diary of Dr Grayson, 13 March 1919, *Wilson Papers*, vol. 55, pp. 486–9.

19 Georges Clemenceau, *Grandeur and Misery of Victory* (London: George
 G. Harrap 1930): 191.

20 Ibid., 281.

21 Casenave to Tardieu, 22 July 1919, MAE, *Papiers Tardieu*, 82, pp. 400–1.
 See also William R. Keylor, "The Rise and Demise of the Franco-Ameri-
 can Guarantee Pact, 1919–1921," *Proceedings of the Annual Meeting of
 the Western Society for French History*, vol. xv (1988): 367–77; Antony
 Lentin, "The Treaty that Never Was: Lloyd George and the Abortive
 Anglo-French Alliance of 1919," in *The Legacy of the Great War*, edited
 by William R. Keylor, 105–17. Boston: Houghton Mifflin 1998.

22 Diary of Colonel House, 14 March 1919, *Wilson Papers*, vol. 55, p. 499;
 Grayson Diary, 13 March, ibid., 489.

23 House Diary, 6 May 1919, *Wilson Papers*, vol. 58, pp. 482–3; Grayson
 Diary, 14 June, ibid., vol. 60, p. 545.
24 Grayson Diary, 14 June 1919, *Wilson Papers*, vol. 60, p. 547; House
 Diary, 23 June 1919, ibid., vol. 61, pp. 112–15. As a corrective to
 Wilson's jaundiced views, see the portrait of Poincaré as the quintessen-
 tial moderate by J.F.V. Keiger, *Raymond Poincaré* (Cambridge:
 Cambridge University Press 1997).
25 Jusserand to Wilson, 24 June 1919, *Wilson Papers*, LC, Reel 413.
26 Wilson to Jusserand, 25 June 1919, *Wilson Papers*, vol. 61, p. 173; Edith
 Benham diary, 25 June 1919, ibid., p. 180; Tasker Howard Bliss to
 Eleanora Bliss, 24 June 1919, ibid., p. 136.
27 Jusserand to Pichon, 17 July 1919, *Pap. Juss.*, 18, pp. 104–8; 29 July,
 ibid., p. 149; 8 September 1919, CSM, 4.
28 Jusserand to Paris, 15 July 1919, *Pap. Juss.*, 18, pp. 98–101; Diary of
 Henry Fountain Ashurst, 15 July 1919, *Wilson Papers*, vol. 61, p. 492;
 19 July, *Le Temps*, 1.
29 Jusserand to Pichon, 30 July 1919, MAE, Series B, vol. 1, 115; Nicholas
 Murray Butler, *Across the Busy Years. Recollections and Reflections*, 2
 vols., vol. ii (New York: Charles Scribner's Sons 1939–1940): 200–1.
30 Jusserand to Tardieu, 27 August 1919, *Pap. Juss.*, 144, pp. 196–203. See
 also William R. Keylor, "France's Futile Quest for American Military
 Protection, 1919–1922," in *Une Occasion Manquée? 1922: La Recon-
 struction de l'Europe*, edited by Marta Petricioli (Bern: Peter Lang 1995):
 70–1.
31 Jusserand to Lodge, 25 April 1919, *Papers of Henry Cabot Lodge*,
 Massachusetts Historical Society, Reel 53. The influential, semi-official
 Paris newspaper *Le Temps* undertook a careful examination of the
 Senate's reservations, judged all of them to be sensible, and suggested
 that all the allied signatories of the 1919 treaties would be wise to accept
 them. See 7 December 1919, *Le Temps*, 1.
32 Jusserand to Paris, 13 August 1919, *Pap. Juss.*, 52, pp. 202–3; 14
 August, ibid., 18, pp. 201–4; 17 August, ibid., p. 220; 27 August, ibid.,
 p. 255; memo by Dr Grayson, 17 November 1919, *Wilson Papers*, vol.
 64, p. 43.
33 Jusserand to Tardieu, 20 September 1919, *Pap. Juss.*, 144, pp. 207–10.
34 Keylor, "The Rise and Demise," *Proceedings*, 372. On Wilson's death
 early in 1924, Jusserand addressed to Paris a long and generally sympa-
 thetic appraisal of the president, praising him for finally committing to
 the war effort "de tout coeur" but voicing his conviction that Wilson had

wanted all – in this case the Treaty, the League, the Guarantee – or nothing. See report of 4 February 1924, MAE, B, 5, pp. 150–5.

35 Jusserand to Paris, 11 September 1919, *Pap. Juss.*, 52, pp. 298–9; 18 October, MAE, *Ambassade*, 341, "Dossier President Wilson," np.; 22 November, MAE, B, 38, p. 96; memo by Dr Grayson, 17 November, *Wilson Papers*, vol. 64, p. 44. Wilson's "massive stroke" had occurred on 2 October. See Margaret Macmillan, *Paris, 1919* (New York: Random House 2001): 490–1.

36 Jusserand to Paris, 22 November 1919, MAE, B, 38, p. 94.

37 Jusserand to Paris, 30 July 1919, *Pap. Juss.*, 19, p. 157; 20 August, ibid., p. 217.

38 Maurice Casenave to Tardieu, 10 May 1919, MAE, *Papiers Tardieu*, 82, p. 291.

39 Jusserand to Tardieu, 20 September 1919, *Pap. Juss.*, 144, pp. 207–10.

40 Jusserand to Paris, 14 August 1919, *Pap. Juss.*, 18, p. 202; 25 August, MAE, B, 23, p. 32; 26 August, *Pap. Juss.*, 18, pp. 232–3; to Tardieu, 27 August 1919, ibid., 144, pp. 196–203.

41 Jusserand to Paris, 3 August 1919, *Pap. Juss.*, 52, p. 157; 16 August, ibid., p. 215; 17 September, MAE, B, 2, p. 15; 30 September, *Pap. Juss.*, 52, p. 367; to James S. Metcalfe, 14 November, *Ambassade*, 747, "Dossier Life," np.

42 Jusserand to Paris, 18 September 1919, *Pap. Juss.*, 52, p. 334; Jusserand to Mme Taufflieb, 28 November 1919, ibid., 78, np.

43 Jusserand to Paris, 14 September 1919, *Pap. Juss.*, 52, p. 315; 17 September, ibid., p. 333; 23 September, ibid., p. 345.

44 Jusserand to Paris, 19 July 1919, *Pap. Juss.*, 18, pp. 91–3.

45 Jusserand to Paris, 10 July 1919, MAE, B, 23, pp. 3–4; 28 July, ibid., 1, p. 112; 16 October, ibid., 23, p. 69; 6 October, *Pap. Juss.*, 18, pp. 293–4.

46 Jusserand to Paris, 18 August 1919, *Pap. Juss.*, 18, p. 208.

47 André Tardieu's statement, 18 September 1917 to the *New York Times*, MAE, *Papiers Tardieu*, 83, pp. 487–99; Jusserand's remarks, 28 April 1918, WP, 8. Anthony Klobukowski, Commissioner General for Information, 1 November 1918, MAE, Series Y, 1, p. 257; Jusserand to Paris, 4 September 1919, *Pap. Juss.*, 18, pp. 238–40.

48 De Billy to Tardieu, 11 March 1919, MAE, Papiers Tardieu, 82, p. 255.

49 Edouard de Billy (Washington) to Tardieu, 21 January 1919, MAE, *Papiers Tardieu*, 82, p. 222; 24 January, ibid., pp. 228–30; Klobukowski to Pichon, 16 February, MAE, Y, pp. 18–22; Report to Tardieu, 27 March, MAE, *Papiers Tardieu*, 85, pp. 547–8; Jusserand to Paris, 26 July, MAE, B, 23, pp. 13–15; Casenave to Tardieu, 25 September 1919, MAE, *Papiers*

Tardieu, 86, p. 162; Jean Clary, "Aux Etats-Unis avec la Mission Tardieu," *Ecrits de Paris*, 267 (1970): 3–64.

50 See Young, *Marianne*, 58–71, 80.

51 Session of 12 October 1917, *Assemblée Nationale, Chambre des Députés, Journal Officiel*, 2683–7.

52 Ibid., 2693–5. The term was coined by Stéphane Lauzanne in his praise-filled remarks about Jusserand, in *Great Men and Great Days* (New York: Appleton and Co. 1921): 140.

53 Ibid., 2695–6.

54 Jusserand to Ira Bennett, 15 September 1919, MAE, *Ambassade*, 743, "Dossier International News Service"; Casenave to Tardieu, 31 October 1919, MAE, *Papiers Tardieu*, 82, p. 455; André Monod to Quai d'Orsay, 30 March 1920, MAE, *Service des œuvres françaises à l'étranger* [hereafter SOE] 59, np.

55 Jusserand to Paris, 2 March 1920, MAE, *Ambassade*, 740, *"Presse et Opinion, Dossier 1920–1923,"* np. The book was *The Economic Consequences of the Peace* (1920).

56 "Notice sur les correspondants," 10 August 1919, MAE, *Papiers Tardieu*, 83, p. 642.

57 Jusserand to Paris, 11 January 1920, MAE, B, 38, p. 173; 13 February, *Pap. Juss.*, 54, p. 37; House diary, 28 March, *Wilson Papers*, 65, p. 140; Jusserand to Paris, 19 March, MAE, B, 39, p. 41; Lansing to Henry Morgenthau, 23 February 1920, *Morgenthau Papers*, LC, Reel 9. "Envoys Lose Powers," 14 March 1920, WP, 1, 14.

58 Jusserand to Paris, 16 February 1920, *Pap. Juss.*, 54, p. 57.

59 The letter was sent to Senator Gilbert Hitchcock. Jusserand to Paris, 8 March 1920, Pap. Juss., 54, pp. 129–30. It was met with a temperate but forceful denial on the front page of *Le Temps*, 11 March 1920. See also Thomas W. Ryley, *Gilbert Hitchcock of Nebraska: Wilson's Floor Leader in the Fight for the Versailles Treaty* (Lampeter: Edwin Mellen Press 1998): 184.

60 See Polk to Wilson, 13 March 1920, with enclosure, Jusserand to Polk, 11 March; Wilson to Polk, 15 March, *Wilson Papers*, vol. 65, pp. 84–7. Polk reported that Jusserand had been "rather belligerent" at the outset of their conversation, an impression reinforced by Jusserand, who admitted he had used language he thought best not to record. But, Colby continued, the ambassador had "cooled down" when he realized there would be neither retraction nor explanation of the president's remarks about French militarists. See entry for 15 March, ibid., p. 98; Jusserand to Paris, 9 March, *Pap. Juss.*, 54, p. 132.

61 Jusserand to Paris, 5 April 1920, DDF, I, no. 340, p. 485.

62 Jusserand to Paris, 25 February 1920, *Pap. Juss.*, 54, p. 86; Colby to Wilson, 5 April 1920, and Wilson to Colby, 7 April, *Wilson Papers*, 65, pp. 155–8. At least one New York press article condemned French militarism and raised the spectre of an extended occupation of the Ruhr. See Jusserand to Paris, 6 April, MAE, B, 2, p. 158.

63 Keylor, "Rise and Demise," *Proceedings*, 373.

64 David S. Newhall, *Clemenceau: A Life at War* (Lampeter: Edwin Mellen Press 1991): 465; Kenneth O. Morgan, "Lloyd George and Clemenceau: Prima Donnas in Partnership," in *Britain, France and the Entente Cordiale since 1904*, edited by Antoine Capet (London: Palgrave, Macmillan 2006): 37.

65 "French Envoy's Recall Hinted," 17 February 1920, *San Francisco Examiner*, 1; Paléologue to Jusserand, 16 February, MAE, Jusserand Personnel Dossier, np.

66 Jusserand to Professor Charles Downer, 14 May 1920, *Pap. Juss.*, 101, np.; Pavey to Jusserand, 17 May 1920, ibid., np.

67 Jusserand to Léon, 4 June 1920, *Pap. Juss.*, 101, "Dossier presses attaques," np.; editorial of 9 June in NYT, ibid., np.; article of 10 June in *L'Eclair de l'Est,* ibid., np.; article of 17 June in CSM, ibid., np.

68 Millerand to Jusserand, 12 June 1920, *Pap. Juss.*, 101, "Dossier presses attaques," np.

69 It is worth noting that Clemenceau left no such accusation in his memoirs, not even in the chapter "Mutilations of the Treaty of Versailles ... Mutilations by America." Indeed, Jusserand is not mentioned. See *Grandeur and Misery*. Nor is this accusation mentioned by J.B. Duroselle in his *Clemenceau* (Paris: Fayard 1988), although Jusserand is included in a short list of Clemenceau's "friends." See 909.

70 Article of 14 June 1920 in the *Philadelphia Public Ledger*, in *Pap. Juss.*, 101, "Dossier presses attaques," np.

71 Jusserand to Liebert, 2 January 1920, *Pap. Juss.*, 93, pp. 132–3. The allegation, it should be noted, was denied by George Peabody, in whose home the remarks were said to have been made. Peabody to Jusserand, 6 January, ibid., pp. 43–4; as well as by Myron Herrick, 10 January, ibid., pp. 179–80.

72 Jusserand to Paris, 4 February 1920, *Pap. Juss.*, 54, p. 10.

73 Jusserand to Paris, 17 February 1920, MAE, B, 2, p. 117; 26 February, ibid., 39, pp. 14–15; 19 May, ibid., 23, p. 174; 22 March, *Pap. Juss.*, 54, p. 169; 23 March, MAE, *Ambassade*, 740, "Dossier Presse et Opinion ... March 1920–January 1924," np.

74 Jusserand to Paléologue, 20 February 1920, *Pap. Juss.*, 54, pp. 68–9.
75 Casenave (New York) to Jusserand, 6 May 1920, MAE, *Ambassade*, 776, "Dossier Haut Commissariat," np.; Millerand to Casenave, ibid. See the report by Gilbert Chinard of 26 May on the operation of the *Service d'Information*, ibid.
76 Jules Henry (Washington) to Paris, 8 October 1920, MAE, B, 24, pp. 4–5.
77 For the complexities behind French thinking about this war, see Michael Jabara Carley, "The Politics of Anti-Bolshevism: The French Government and the Russo-Polish War, December 1919 to May 1920," *Historical Journal*, 19, no. 1 (March 1976): 163–89. See also Marjorie Milbank Farrar, *Principled Pragmatist: The Political Career of Alexandre Millerand* (New York: Berg 1991): 272–75.
78 D'Abernon was instrumental in promoting the idea of Weygand's critical contribution. See his *An Ambassador of Peace*, 2 vols. (London: Hodder and Stoughton 1929):70; and *The Eighteenth Decisive Battle of the World: Warsaw, 1920* (London: Hodder and Stoughton 1931): 94. For corrective views, see M.B. Biskupski, "Paderewski, Polish Politics, and the Battle of Warsaw," *Slavic Review*, 46, nos. 3–4 (autumn\winter 1987): 506–7; Norman Davies, "Sir Maurice Hankey and the Inter-Allied Mission to Poland," *Historical Journal*, 15, no. 3 (September 1972): 556. Philip C.F. Bankwitz, *Maxime Weygand and Civil-Military Relations in Modern France* (Cambridge, MA: Harvard University Press, 1967): 22–3. In his recent biography of Weygand, Barnett Singer gives Weygand a good deal of credit for Polish military success. See *Maxime Weygand: A Biography of the French General in Two World Wars* (Jefferson, North Carolina: McFarland and Co. 2008): 51–6.
79 General Maxime Weygand, *Mémoires*, 3 vols., ii, *Mirages et Réalité* (Paris: Flammarion 1957): 94–171. The table spat was triggered by what Weygand considered to have been Jusserand's overly enthusiastic remarks about the wartime effectiveness of the American army. The general thought the diplomat was making unfavourable comparisons with the French army, and said so. The diplomat, in turn, interpreted the general's response as being anti-American, and therefore offensive, in the presence of his American wife, Elise. See ibid., 94–5.
80 Jusserand's reports to Paris claim no exceptional role for himself. See 4 August 1920, DDF, ii, no. 295, pp. 373–5; 11 August, ibid., no. 333, pp. 426–7; 14 August, ibid., no. 350, p. 449; 17 August, ibid., no. 359, p. 463; 23 August, ibid., no. 385, pp. 497–8. See also, Clerk (Prague) to Curzon, 24–5 July 1920, *Documents on British Foreign Policy* [hereafter DBFP], 1st series, vol. xi. nos. 349, 340, pp. 400–1.

81 Elise Jusserand to Helen Garfield, 6 October 1920, LC, *Garfield Papers*, Box 115, np. Jusserand's hand-written personnel resumé, 19 August 1920, MAE, *Dossier Personnel*. See also 17 September 1920, WP, 6.

82 See Editorial of 29 September 1920, WP, 6.

83 Embassy to Paris, 27 October 1920, *Pap. Juss.*, 101, np.

84 For a fuller discussion of these two issues, French war debts and German reparations, see chapter 6.

85 Aukland Geddes to London, 3 January 1921, DBFP, 1st Series, vol. xvi, no. 559, p. 598.

86 Jusserand to Paris, 17 December 1920, DDF, 1920, iii, no. 325, pp. 464–5; 25 December, ibid., no. 350, pp. 498–500; 19 December, MAE, B, 61, pp. 3–5;

87 Jusserand to Paris, January 1921, *Pap. Juss.*, 101, np.; 17 January, ibid.

88 Jusserand to Paris, 4 February 1921, MAE, Y, vol. 410, pp. 80–1; 12 May, DDF, 1921, vol. 1, no. 371, pp. 587–8.

89 Barthélemy (Chicago) to Jusserand, 11 February 1921, MAE, Y, vol. 410, pp. 103; Jusserand to Paris, 19 February, MAE, *Ambassade*, vol. 743, "Dossier International News Service"; 20 February;" ibid., vol. 748, "Dossier *New York World*"; 15 March, MAE, Y, vol. 410, p. 161.

90 Jusserand to Paris, 25 February 1921, MAE, Y, vol. 410, pp. 117–22.

91 Liebert to Jusserand, 25 March 1921, *Pap. Juss.*, 93, pp. 80–1; Jusserand to Paris, 7 April, MAE, B, 24, pp. 153–6. Note, in a subsequent reply, the ministry denied that Taufflieb was on an official mission, and agreed with the ambassador that the times were not right for any more missions. Paris to Jusserand, 9 April, ibid., p. 160.

92 Jusserand to Paris, 25 April 1921, DDF, 1921, vol. 1, no. 320, pp. 508–9.

CHAPTER SIX

1 The Knox resolution would have extended American interest to the peace of Europe as a whole, and projected consultation and cooperation with other powers whose freedom was threatened by the new menace. But it avoided reference to the ultra-sensitive subject of the League of Nations. See Jusserand to Paris, December 1920, DDF, iii, no. 372, pp. 529–60.

2 De Fleuriau (London) to Paris, 9 January 1921, DDF, iii, no. 408, pp. 577–80.

3 Briand to Jusserand, 29 January 1921, MAE, Series Y, 410, p. 70; 17 March 1921, *Chicago Tribune*, 1; LAT, 11; WP, 1; Briand to Viviani, 1 April 1921, MAE, Y, 410, pp. 179–81.

4 Wallace (Paris) to DC, 9 April 1921, NARA, M568, Reel 1; 21 April 1921, WP clipping in MAE, *Ambassade*, 740, Presse et Opinion, Untitled Dossier (1920–1924)

5 Jusserand to Paris, 14 June 1921, DDF, 1, no. 471, pp. 755–56; 12 July, NYT, 2; Jean Clary, "Aux Etats-Unis avec la Mission Tardieu," 65; Clemenceau, *Grandeur and Misery*, 278–9.

6 12 July 1921, NYT, 2.

7 In particular, see *The Washington Conference, 1921–22: Naval Rivalry, East Asian Stability and the Road to Pearl Harbour*, edited by Erik Goldstein and John Maurer (London: Frank Cass 1994). For an even broader exploration of global politics in the early 1920s, see chapter 2, "The Emasculation of International Security, 1920–1925," of Robert Boyce's forthcoming *The Great Interwar Crisis and the Collapse of Globalization* (London: Palgrave-Macmillan, 2009).

8 16 November 1921, *New York Tribune*, MAE, *Ambassade*, 652, "Conférence de Washington." For further detail on the French experience, see Joel Blatt, "The Parity that Meant Superiority: French Naval Policy Towards Italy at the Washington Conference, 1921–22, and Interwar French Foreign Policy," *French Historical Studies*, xii, no. 2 (autumn 1981): 223–48; and "France and the Washington Conference," *Diplomacy and Statecraft*, iv, no. 3 (1993): 192–219.

9 De Margerie (Brussels) to Paris, 17 November 1921, MAE, *Ambassade*, 652, "Conférence de Washington"; Jusserand to Paris, 14 November, DDF, 1921, ii, no. 359, pp. 558–9; Mark Sullivan, *The Great Adventure at Washington: The Story of the Conference* (New York: Doubleday, Page & Co. 1922): 190–3.

10 Bernard Oudin, *Aristide Briand: Biographie* (Paris: Laffont 1987): 419.

11 Article by Janet Stewart, 16 November 1921, unidentified press clipping, MAE, *Ambassade*, 652, "Conférence de Washington"; 21 November," text of Briand's speech, ibid.

12 The judgment is that of Robert Boyce, who adds: "it was hardly likely" that France would "attack the one ally capable of ensuring its survival." See "Behind the Façade of the Entente Cordiale after the Great War," in *Britain, France and the Entente Cordiale since 1904*, edited by Antoine Capet (London: Palgrave Macmillan 2006): 53.

13 23 November 1921, Minutes of meeting, MAE, *Ambassade*, 652, "Conférence de Washington." For an exploration of Anglo-French differences over the matter of disarmament, see Andrew Barros, "Disarmament as a Weapon: Anglo-French Relations and the Problems of Enforcing

German Disarmament, 1919–28," *Journal of Strategic Studies*, xxix, no. 2 (April 2006): 301–21.

14 17 November 1921, WP, 2.

15 23 November 1921, NYT, MAE, *Ambassade*, 652, "Conférence de Washington"; 26 November, *Boston Globe*, ibid.

16 26 November 1921, piece by Lt. Col. Repington, NYT, MAE, *Ambassade*, 652; 26 November, piece by Wickham Steed, WP, ibid.; 27 November, Pertinax, "Curzon's Speech," NYT, ibid.; Viviani to Briand, 29 November, ibid.

17 9 December 1921, NYT, MAE, *Ambassade*, 652, "Conférence de Washington;" 10 December, ibid.; 10 December, WP, ibid.; Viviani to Briand, 11 December, ibid.

18 Sarraut to Briand, 15 December 1921, MAE, *Ambassade*, 652, "Conférence de Washington."

19 Sarraut to Briand, 16 December, ibid.; Hughes to Briand, ibid. The full text of the latter can be found in FRUS, 1922, vol. 1, pp. 130–3.

20 Briand to Hughes, 19 December 1921, MAE, *Ambassade*, 652; Briand to Sarraut, ibid.; Admiral du Bon to Marine, 19 December, ibid.; Sarraut and Jusserand to Briand, 20 December, ibid.

21 Sarraut to Briand, 20(?) December, ibid.; Briand to Sarraut, 20 December, ibid.

22 Sarraut to Briand, 21 December 1921, ibid.

23 Briand to Sarraut, 23 December, ibid.

24 Sarraut to Briand, 2 telegrams of 24 December, ibid.

25 Sarraut to Briand, 26 December, ibid.; "Déclaration de M. Sarraut," 30 December, ibid.; Jusserand to Briand, 31 December, ibid. See also Merlo J. Pusey, *Charles Evans Hughes*, 2 vols., ii, (New York: Columbia University Press 1963): 482.

26 23 November 1921, Repington article, NYT, MAE, *Ambassade*, 652, "Conférence de Washington," 17 December, Frederic William Wile article, *Philadelphia Public Ledger*, ibid.; 29 December, David Lawrence article, *Washington Star*, ibid.; T.G. Winter to Jusserand, 19 December, ibid.

27 20 December 1921, *Philadelphia Record*, MAE, *Ambassade*, 652, "Conférence de Washington," 26 December, *New York Herald*, ibid.; Sullivan, *The Great Adventure at Washington*, 199. For a recent appraisal of French approaches to the associated issues of security and international disarmament, see Andrew Webster, "From Versailles to Geneva: the Many Forms of Interwar Disarmament," *Journal of Strategic Studies*, xxix, no. 2 (April 2006): 225–46.

28 Jusserand to Paris, 27 January 1922, MAE, Série B, 62, p. 8; 30 January,
 ibid., p. 16; 30 April, ibid., p. 34; 29 March, ibid., 4, pp. 96–7; 9 Decem-
 ber, ibid., 65, p. 69. See also Comte de Saint-Aulaire, *Confession d'un
 vieux diplomate* (Paris: Flammarion 1953): 732–3. See also David
 Stevenson, "Britain, France and the Origins of German Disarmament,
 1916–19," *Journal of Strategic Studies*, xxix, no. 2 (April 2006):
 194–224.

29 Jusserand to T.G. Winter, 23 December 1921, MAE, *Ambassade*, 652; to
 Thomas Lamont, 16 February 1922, *Pap. Juss.*, 87, p. 152; 14 June, NYT,
 22.

30 "Influence of American Women Felt in Present Day Diplomacy," 22 Jan-
 uary 1922, WP, 53. The two other women were Mrs Eleanor Franklin
 Egan, a writer and expert on the Far East, and Mrs Thomas G. Winter,
 president of the General Federation of Women's Clubs. See "Diplomatic
 Women," by Mayme Ober Peak, WP, 72.

31 Elise Jusserand to Helen Garfield, 10, 18 January 1922, LC, *Garfield
 Papers*, Box 115. Her use of "seventy-fives" is a reference to the 75mm
 artillery gun, that of the "super-Hoods" a reference to newer models of
 the British battlecruiser HMS *Hood*, itself commissioned only in 1920.

32 In the spring of 1921, for example, Jusserand reported on the
 francophobic tenor of the Hearst presses, an organization which, like the
 leopard, "never changed its spots," as it continued to portray Germany
 as victim of theft, lies, and murders, and Britain and France as callous
 exploiters. See 15 March 1921, MAE, Y, 410, p. 161. The German
 embassy on Massachusetts Avenue was in the process of opening its
 post-war doors in November 1921, on the eve of the naval conference.
 See 20 November 1921, WP, 13.

33 19 December 1921, *New York Tribune*, MAE, *Ambassade*, 652,
 "Conférence de Washington"; Maurice Léon to Jusserand, 26 January
 1922, *Pap. Juss.*, 101, np.; 27 January, *Le Temps*, MAE, B, 24, p. 231.

34 30 January 1922, CSM, *Pap. Juss.*, 101, np.; 5 March, *Philadelphia
 Ledger*, ibid.; 29 April, *Washington Star*, ibid.; 30 April, *Washington
 Post*, ibid.; Louis Thomas to Marcel Ribière, 28 May, MAE, B, 295,
 pp. 1–3.

35 Lauzanne as critic is a little surprising, given his support of the ambassa-
 dor's propaganda strategy during the war – see my chapter 4, notes 5 and
 6, and chapter 5, note 52 — and his favourable chapter on Jusserand in
 his *Great Men and Great Days*, 140–58.

36 21 December 1921, *New York World*, MAE, *Ambassade*, 652,
 "Conférence de Washington;" 1 May 1922, piece by Frederic William

Wile, *Christian Science Monitor*, 3; 1 May, piece by David Lawrence, *Washington Star*, *Pap. Juss.*, 101; 2 May, *Christian Science Monitor*, 20; "France's Diplomatic Publicist," 13 May 1923, NYT, 1, section 3. Michel Drouin, "Le voyage de 1922," in *Clemenceau et le monde anglo-saxon*, edited by Sylvie Brodziak and Michel Drouin (Paris: Geste Editions 2005): 141.

37 29 April 1922, Washington Star, *Pap. Juss.*, 101, np.; 2 May, WP, ibid.; Jusserand to Archibald Hopkins, 6 May, ibid.; 8 May, to Félix Levy, ibid.; 10 May, to Bishop O'Brien, ibid.; 13 May, to John Rathom, ibid.; 15 May, to Duc de Richelieu, ibid.; 22 May, to Dr W.W. Keen, ibid.; 27 May, to Dudley Butler, ibid.

38 There is an irony of sorts here. If some French officials and journalists thought they had been bested by the British and therefore needed to be more aggressive themselves, the fact was that American opinion had been unsettled by the British blitz and may have become even less receptive to the propaganda efforts of any foreign power. On American reactions, see Donald S. Birn, "Open Diplomacy at the Washington Conference of 1921–2: The British and French Experience," *Comparative Studies in Society and History*, xii, no. 3 (July 1970): 318–19.

39 Poincaré to Liebert, 4 March 1922, MAE, SOE, 91, np.; "Note pour Monsieur Dejean," 11 April, Series B, 25, pp. 67–70; Paul Fuzier to Jean Giraudoux, 11 April, MAE, SOE, 59, np.; "Note pour Monsieur Dejean," 16 October, ibid., pp. 136–7; "Note pour la sous-direction d'Amérique," 30 October, ibid., p. 139; "France Lacks Information," 7 November, *Christian Science Monitor*, MAE, *Ambassade*, 740, "Presse et Opinion."

40 Article by Edwin L. James, 16 July 1922, NYT, in MAE, *Ambassade*, 740, "Presse et Opinion."

41 André Tardieu reports that in May 1919 the House of Representatives withdrew the bill for post-war credits which had been passed in November 1917. See his *France and America*, 242–3.

42 Benjamin D. Rhodes provides a war debt total for France of $3,404,818,945.01, most of which fell under the Liberty Loan interest rate of 5%. See "Reassessing 'Uncle Shylock': The United States and the French War Debt, 1917–1929," *Journal of American History*, 55, no. 4 (March 1969): 788. David Strauss reports that another half billion dollars had been borrowed from private banks between 1918 and 1924. See *Menace in the West: The Rise of French Anti-Americanism in Modern Times* (Hartford Conn.: Greenwood Press 1978): 127.

43 See Rhodes, "Reassessing," 792–3.

44 Tardieu, *France and America*, 180–94; Georges Bonnefous, *Histoire politique de la Troisième République*, ii (Paris: Presses Universitaires de France 1957): 456–7; Robert J. Young, *Under Siege: Portraits of Civilian Life in France during World War 1* (New York: Berghahn Books 2000); "Out of the Ashes: The American Press and France's Postwar Recovery in the 1920s," *Historical Reflections/Réflexions Historiques*, 28, no. 1 (spring 2002): 51–72.

45 Jules Jusserand, "The Economic Situation in France," *Proceedings of the Academy of Political Science in the City of New York*, 9, no. 2 (February 1921): 79. The ambassador attached particular importance to confronting the notion that France had been unwilling to assume an increased tax burden. See his dispatch to Briand, 31 January 1921, MAE, Y, 410, p. 74, and Tardieu, *France and America*, 242–3.

46 Martin Horn, *Britain, France and the Financing*, 183.

47 Representative Joseph Fordney and Senator Porter McCumber, ibid., 85–6; Strauss, *Menace in the West*, 128; P.M.H. Bell, *France and Britain, 1900–1940. Entente and Estrangement* (London: Longman 1996): 133; Kenneth Mouré, *The Gold Standard Illusion: France, the Bank of France, and the International Gold Standard, 1914–1939* (Oxford: Oxford University Press 2002): 35; *Managing the Franc Poincaré: Economic Understanding and Political Constraint in French Monetary Policy, 1928–1936* (New York: Cambridge University Press 1991): 11–12; Jusserand, "The Economic Situation," 80.

48 See two important articles by William R. Keylor: "'How They Advertised France': The French Propaganda Campaign in the United States During the Breakup of the Franco-American Entente," *Diplomatic History*, 17, no. 3 (summer 1993): 351–73; and "Prohibition Diplomacy: An Incident of Franco-American Understanding," *Contemporary French Civilization*, 5, no. 3 (1981): 299–316.

49 Much has been written on the subject. Of particular interest are: Stephen A. Schuker, *American "Reparations" to Germany, 1919–33: Implications for the Third World Debt Crisis* (Princeton: Department of Economics, Princeton 1988); *The End of French Predominance in Europe: The Financial Crisis of 1924 and the Adoption of the Dawes Plan* (Chapel Hill: University of North Carolina Press 1976); Marc Trachtenberg, *Reparation in World Politics: France and European Economic Diplomacy, 1916–1933* (New York: Columbia University Press 1980); Sally Marks, "Reparation in 1922," in *Genoa, Rapallo, and European Reconstruction in 1922*, edited by Carole Fink, Axel Frohn, and Jurgen Heideking (Cambridge: Cambridge University Press 1991): 65–76.

50 The German government itself had imposed heavy reparation programs on its own recent enemies: the French in 1870–71, and the Russians in March 1918.

51 At roughly four gold marks to one dollar, the total reparations bill in American currency was approximately $33 billion, 55 percent of which had been assigned to France.

52 In November and December Hughes warned Jusserand against any French military action to enforce German reparations payments. See Betty Glad, *Charles Evans Hughes and the Illusions of Innocence* (Urbana: University of Illinois Press 1966): 222; Kenneth Paul Jones, "Alanson B. Houghton and the Ruhr Crisis: The Diplomacy of Power and Morality," in *U.S. Diplomats in Europe, 1919–1941*, edited by Kenneth Paul Jones (Santa Barbara: ABC Clio 1983): 30.

53 See my *Power and Pleasure*, 173–6.

54 6 February 1923, CSM, 3.

55 Jacques Kayser, *Ruhr ou Plan Dawes? Histoire des Réparations* (Paris: André Delpeuch nd); Jacques Seydoux, *De Versailles au Plan Young: Réparations, dettes interalliés, reconstruction européenne* (Paris: Plon 1932); Sally Marks, "Poincaré-la-peur: France and the Ruhr Crisis of 1923," in *Crisis and Renewal in France, 1918–1962*, 28–45, edited by Kenneth Mouré and Martin S. Alexander (New York: Berghahn Books 2002).

56 Consulate General to Paris, 8 April 1923, MAE, B, 26, pp. 3–4; 17 April, WP, 2; Jusserand to Paris, 25 June, MAE, *Ambassade*, 741, "Dossier Mark Sullivan."

57 George Wickersham to Jusserand, 10 February 1923, MAE, *Ambassade*, 744, "Dossier Universal Service"; press clippings, March–April, ibid.; Jusserand to Paris, 5 November, MAE, B, 62, pp. 141–2. For the figure of sixteen million, see Consul Liebert to Paris, 20 April 1922, MAE, *Ambassade*, 743, "Dossier International News Service."

58 James Kerney's *The Political Education of Woodrow Wilson* (New York: Century Co. 1976): 476.

59 Chilton (DC) to London, 13 October 1923, DBFP, 1st Series, xxi, no. 393, pp. 564–5; 4 November, ibid., no. 444, pp. 627–8; 6 November, WP, 1

60 See Chilton (DC) to London, 6 November 1923, DBFP, 1st, xxi, no. 451, pp. 642–3; 8 November, no. 456, p. 648; 9 November, ibid., no. 460, pp. 651–2; 14 November, ibid., no. 469, pp. 667–8; Hughes Memo re conversation with Jusserand, 7 November, FRUS, 1923, vol. 2, pp. 91–4; Hughes to Herrick (Paris), 9 November, ibid., pp. 94–5; Poincaré to Hughes, 10 November, ibid., pp. 95–97.

61 17 December 1923, Bulletin #29, "Facts, Figures," MAE, *Maison*, 23, np.

62 See Alan Cassels, "Repairing the Entente Cordiale and the New Diplomacy," *Historical Journal*, 23, no. 1 (March 1980): 147; P.M.H. Bell, *France and Britain*, 144–9; Peter Jackson, "France and the Problem of Security and International Disarmament after the First World War," *Journal of Strategic Studies*, 29, no. 2 (April 2006): 247–80.

63 Jusserand to Paris, received 5 January 1921, DDF, 1920–21, vol. 3, no. 391, p. 555; to Paris, 5 December 1922, MAE, *Ambassade*, 350, np.

64 Jusserand to Paris, 27 January 1922, MAE, B, 62, p. 8.

65 Jusserand to Paris, 5 December 1922, MAE, *Ambassade*, 350, np.; see also Michel Drouin, "Le voyage de 1922," and Robert Hanks, "Le voyage de 1922 vu par les Américains," in *Clemenceau et le monde anglo-saxon*, edited by Sylvie Brodziak and Michel Drouin, 123–45 and 147–76 respectively (Paris: Geste Editions 2005). Clemenceau had the same complaint when it came to having a good conversation with General Pershing. See Duroselle, *Clemenceau*, 891.

66 Jusserand to Paris, 19 December 1920, MAE, B, 61, p. 5; to Coudert, 21 March 1922, *Pap. Juss.*, 98, p. 325; to Paris, 21 June 1922, MAE, B, 4, p. 121; to Paris, 8 January 1923, MAE, B, 62, pp. 84–6; In a dispatch to Paris of 19 April, Liebert refers to accusations of propaganda in some American papers, accusations encouraged by a certain French spokesman in Washington. See MAE, *Maison*, 23, "Etats-Unis."

67 In April 1924 he declined an invitation to speak to the American Academy of Political and Social Sciences. Having seen a list of prospective speakers, and inferred a pro-German character, he preferred to disappoint anyone looking for a public fight. Jusserand to Wister, 10. April 1924, LC, *Wister Papers*, Box 25.

68 Jusserand to Paris, 1 September 1922, MAE, B, 65, pp. 6–7; 8 May 1923, MAE, SOE, 40, "Section des œuvres diverses," np.; 16 March 1923, MAE, B, 4, pp. 187–8; 13 May 1923, "France's Diplomatic Publicist," NYT, section 3, 1; 14 January 1924, WP, 3; 8 April 1924, LAT, A4, reporting on a Jusserand speech in New York.

69 31 May 1922, WP, 2

70 Preface to Amis de la France, *Le Service de Campagne de l'Ambulance Américaine* (Paris: Plon 1917): ii.

71 Jusserand to Paris, 3 August 1919, *Pap. Juss.*, 52, p. 157; 16 August, ibid., p. 215; 17 September, MAE, B, 2, p. 15; 30 September, *Pap. Juss.*, 52, p. 367; Jusserand to James S. Metcalfe, 14 November, MAE, *Ambassade*, 747, "Dossier Life"; Elise to Helen Garfield, 17 June 1921, LC, *Garfield Papers*, 115; Jules Henry to Paris, 1 March 1923, MAE, B, 295, pp. 4–6.

72 Mayme Ober Peak, "Diplomatic Women," 17 June 1923, WP, 72.

73 21 February 1923, NYT, 13; Jusserand to George Wickersham, 3 March,
Pap. Juss., 78, np.; Jusserand to John Finley, 7 March, NYPL, Finley
Papers, Box 81; Elise to Helen Garfield, 7 March, LC, Garfield Papers,
Jusserand to James Garfield, 30 March, ibid.; Elise to Helen Garfield, 27
April, ibid.

74 8 June 1923, WP, 8; 24 June, 21; 23 July, 27; Jusserand to George
Wickersham, 3 July, Pap. Juss, 78, np.; 1 February 1925, LAT, 6.

75 Chargé to Paris, 13 August 1923, MAE, B, 5, pp. 66–7; 7 November, WP, 1.

76 Jusserand to Paris, 25 November 1923, MAE, B, 62, pp. 148–9; 19
December, ibid., 5, pp. 126–7; Liebert to Paris, 28 December, MAE, Mai-
son, 23, np.

77 "Color Marks First Coolidge Reception," 14 December 1923, WP, 1.

78 André Laboulaye, an embassy officer, later recalled the patron's marked
preference for instructive conversation over the simply banal. See his "J.J.
Jusserand ambassadeur," 30.

79 Jusserand, "The Inestimable Value of Beauty," American Magazine of
Art, xiii, no. 11 (November 1922): 451–4; 19 July 1932, WP, 3. Two
years later, in a speech to the American Association of Museums, he
invited even pacifists to join the "war against bad taste and ugliness." See
14 May 1924, WP, 9.

80 Jusserand et al, The Writing of History (New York: Lenox Hill 1926.
Reprint. New York: Burt Franklin 1974); J.F.J. (James Franklin
Jameson), "The Meeting of the American Historical Association at Wash-
ington," AHR, 26, no. 3 (April 1921): 432–3, and "The Meeting of the
American Historical Association at St Louis," ibid., 27, no. 3 (April
1922): 419. See also editorial, 28 September 1926, WP, 6.

81 The first foreign-born president, elected in 1904, was Goldwyn Smith of
the University of Toronto. See Emil Pocock, "Presidents of the American
Historical Association: A Statistical Analysis," AHR, 89, no. 4 (October
1984): 1016–36.

82 Ibid., 5, 13, 16.

83 Ibid., 6–8.

84 Ibid., 22–5; see review of 2 September 1926, WP, 6.

85 Jusserand, "The School for Ambassadors," AHR, 27, no. 3 (April 1922):
426–4. My references are to the AHA on-line edition, 1–38.

86 Ibid., 28.

87 While consistent with his remarks to the AHA, this line is taken from
Jusserand's "Message to Smith College on the Occasion of the Ronsard
Celebration," Modern Language Journal, ix, no. 6 (March 1925): 335–8.

88 "The School for Ambassadors," 24.

CHAPTER SEVEN

1 3 January 1924, Jusserand to Count D'Apchier, *Pap. Juss.*, 109, p. 19; 29 July 1924, WP, 4.
2 "Shake-Up Due for French Diplomats," 22 June 1924, WP, Editorial section, 19.
3 Jusserand to Paris, 21 June 1924, *Pap. Juss.*, 60, p. 299.
4 Jusserand to Stanley Washburn, 28 February 1921, LC, *Washburn Papers*, Carton 1.
5 Jusserand, to Paris, 9 October, 1924, *Pap. Juss.*, 60, p. 318; 5 October 1924, WP, SO4; 18 October 1924, CSM, 1; Jusserand to Saint-René Taillandier, 26 November, *Pap. Juss.*, 94, p. 204.
6 Herriot to Jusserand, 15 October 1924, MAE, *Jusserand Dossier Personnel; 18 October,* CSM, 1; 19 October, WP, 3; 21 October, WP, 3; 21 October, NYT, 1. Peter Jackson refers to a "changing of the guard within the Quai d'Orsay" in connection with Herriot's efforts in the autumn of 1924 to ensure support for the Geneva Protocol for the Pacific Settlement of International Disputes. See Jackson "France and the Problems of Security and International Disarmament after the First World War," *Journal of Strategic Studies*, vol. 29, no. 2 (April 2006): 275. See also his "Pierre Bourdieu, the 'Cultural Turn' and the Practice of International History," *Review of International Studies*, no. 34, (2008):178–80.
7 Jusserand to Paris, 24 October 1924, MAE, *Jusserand Dossier Personnel*; Jusserand to Finley, 29 October, NYPL, *Finley Papers*, Box 81, File "Jusserand."
8 Jusserand to Maurice Bompard, 18 November 1924, *Pap. Juss.*, 94, folio 169, pp. 147–8; 26 November, ibid., p. 205; Jusserand to Finley, 23 October, NYPL, *Finley Papers*, Box 81; Jusserand to Wister, 5 November, LC, *Wister Papers*, Box 25; Jusserand to Lansing, 12 November, LC, *Lansing Papers*, vol. 62.
9 Jusserand to Paris, 29 November 1924, *Pap. Juss.*, 60, p. 364; 30 November, MAE, *Jusserand Dossier Personnel*
10 Jusserand to Paris, 20 January 1925, *Pap. Juss.*, 60, p. 430; 21 January, WP, 1.
11 Chargé d'affaires to Paris, 22 January 1925, MAE, *Ambassade, Personnel*, 895; 5 February, CSM, 1.
12 Jusserand to Paris, 14 November 1924, *Pap. Juss.*, 60, pp. 345–6; 21 November, ibid., pp. 354–5.
13 Jusserand to Paris, 10 December 1924, *Pap. Juss.*, 60, pp. 378–9.
14 6 December 1924, CSM, 3;

15 Jusserand to Paris, 25 December 1924, *Pap. Juss.*, 60, p. 401; 26 December, CSM, 1.

16 See Saint-Aulaire, *Confession d'un vieux diplomate*, 752.

17 Jusserand to Paris, 26 December, 1924, *Pap. Juss.*, 60, pp. 402–3; 23 December, WP, 3; 28 December, WP, EFI; 6 December, CSM, 3.

18 See Hughes to Herrick (Paris) 30 December 1924, *FRUS*, 1925, 1, p. 135; also 30 December, WP, 1.

19 16 November 1924, *Chicago Tribune*, section 1, p. 7; 16 November, WP, 1; Jusserand to Chief Editor of the *New York World*, MAE, *Ambassade*, 748; 13 December, WP, 6.

20 Jusserand to Paris, 19 May 1924, MAE, B, 63, p. 56; Laboulaye to Paris, 8 August, ibid., p. 90.

21 Liebert to Paris, 15 January 1924, MAE, *Maison*, 23; Jusserand to Paris, June 1924, MAE, B, 63, pp. 67–70; See also "Après la Conférence de Washington: L'Influence allemande aux Etats-Unis," 13 October 1925, MAE, B, 27, pp. 26–9; 24 May 1925, WP, A1.

22 Jusserand to Paris, 10 March 1924, MAE, B, 6, pp. 5–6.

23 Jusserand to Paris, June[?] 1924, MAE, B, 63, pp. 67–70

24 Jusserand to Paris, 9 January 1924, MAE, B, 63, p. 10; 16 January, ibid., pp. 14–21; 24 February, MAE, Y, 04, pp. 61–3; 18 April, MAE, B, 26, p. 85; Liebert to Paris, 9 May, MAE, *Maison*, 24. For *Le Moniteur*, see MAE, B, 29C, p. 2.

25 Frederick Coudert to Finley, 17 June 1924, *Pap. Juss.*, 96, p. 261; Jusserand to Paris, 19 June, MAE, B, 63, pp. 83–4; Finley to Jusserand, 24 June, *Pap. Juss.*, 96, p. 262.

26 See, for example, his reports to Paris of 25 January 1924, MAE, *Maison*, 23; 1 April, ibid., 64; 11 April, MAE, B, 26, pp. 79–82; 21 August, MAE, *Maison*, 25; Young, *Marketing Marianne*, 84–6.

27 Unsigned note for Monsieur de Peretti, 17 April 1924, MAE, *Maison*, 24; Pavey to Liebert, 4 June, ibid., 25; Maurice Léon to Paris, 3 February 1925, MAE, B, 26. In February the French cabinet decided to place the Bureau under the aegis of the embassy in Washington, a belated success for Jusserand; but there was no immediate change owing to the fall of the Herriot administration in April. See note of 12 April, MAE, *Maison*, 25.

28 Cunliffe-Owen to Jusserand, 4 November 1924, MAE, *Ambassade*, 790, *Société France-Amérique*. Dossier 1912–1913; Wickersham to Jusserand, 19 October, *Pap. Juss.*, 111, p. 124; Lansing to Jusserand, 12 November, LC, *Lansing Papers*. Vol. 62.

29 "Capital Will Miss Witty Jusserand," 9 November 1924, NYT, Section iv, p. 6; "Capital Plans Farewell," 24 November, CSM, 3; editorial, 24 January 1924, CSM, 16.

30 5 December 1924, Civic Forum Testimonial, *Pap. Juss.*, 111, p. 144.

31 3 January 1925, DAR motion, MAE, *Ambassade, Personnel*, 895; 30 November, 1924, LAT, D11.

32 10 January 1915, WP, 10; 11 January, LAT, F12; 11 January, WP, 1.

33 25 February 1915, WP, 1.

34 25 November 1924, MAE, *Ambassade. Personnel*, 895.

35 Jusserand to Wister, 2 February 1924, LC, *Wister Papers*, Box 25; Jusserand to Edwin H. Danby, 25 November, *Pap. Juss.*, 94, folio 169; Jusserand to Paris, 14 June, *Pap. Juss.*, 60, p. 291.

36 Jusserand to Paris, 21 October 1924, *Pap. Juss.*, 60, p. 328. Upon his arrival in January 1925, Emile Daeschner had to rent a nearby apartment while renovation work was done to the interior of the embassy and while he awaited the arrival of state-owned furniture.

37 Jusserand to Paris, 13 December 1924, *Pap. Juss.*, 60, p. 383.

38 9 November 1924, NYT, Magazine, 6.

39 "Mme J.J. Jusserand is the Doyenne," 17 June 1923, WP, 72; 26 October 1924, WP, S03; 2 November, WP, S011; 23 August 1925, WP, SM3.

40 See Elise to Helen Garfield, 24 June 1920, LC, *Garfield Papers*, Box 115; 6 October 1920, 12 December, 17 June 1921, 23 March 1923, ibid.; 17 June 1923, WP, 72.

41 24 November 1924, CSM, 1; 26 December, WP, 1.

42 21 January, LAT, 10.

43 Jusserand to Garfield, 27 December 1924, LC, *Garfield Papers*, Box 115.

44 Thomas A. Bailey, *A Diplomatic History of the American People* (New York: Appleton-Century-Crofts 1940. Revised edition 1969): 4; 9 November 1924, NYT, Magazine, 6; 9 September 1934, text of an address by General Gouraud, *Pap. Juss.*, 109, pp. 194–203.

45 In a note to Owen Wister of 20 January 1936, Elise refers to the "servants," including a butler, and said she had missed his call because she could not hear "the doorbell from my part of the house." LC, *Wister Papers*, Box 25.

46 Elise to Helen Garfield, 6 October 1920, LC, *Garfield Papers*, Box 115; Jusserand to Maurice Bompard, 18 November 1924, *Pap. Juss.*, 94, folio 169, pp. 147–8; Jusserand to Wister, 8 July 1929, 10 August, 1 September 1930, LC, *Wister Papers*, Box 25.

47 *Dictionnaire de biographie française*, vol. 18 (Paris: Librairie Letouzey et Ané 1994), 1042–43; Dossier "Epée d'Académicien, 1925–1927," *Pap. Juss.*, 111. The English title being *With Americans of Past and Present Days* (1916).

48 See the collection of essays in the volume entitled *The School for Ambassadors and Other Essays* (New York: G.P. Putnam's Sons 1926).

49 Ibid., 65–101, 117–51, 155–214, 227–52,

50 Jusserand to Finley, 29 March 1927, 22 August, 19 March 1928, NYPL, *Finley Papers*, Box 81.

51 "Le Maréchal d'Estrades et ses Critiques," *Revue Historique*, 158 (May–August 1928): 225–54.

52 See *Recueil des Instructions données aux Ambassadeurs et Ministres de France depuis les Traités de Westphalie jusqu'à la Révolution Française*, vols. xxiv and xxv (Paris: Ministère des Affaires Etrangères et E. de Boccard 1929). Wilbur C. Abbott, *AHR*, vol. 35, no. 2 (Jan. 1930): 340–2; Jusserand to Finley, 29 March 1927, 19 March 1928, NYPL, *Finley Papers*, Box 81.

53 "La Jeunesse du Citoyen Genet d'après des documents inédits," *Revue d'Histoire Diplomatique*, 44, no. 1 (1930): 237–68.

54 Charles Seymour's review of *Le Sentiment Américain* in *AHR*, vol. 37, no. 2 (Jan. 1932): 339–40.

55 Press clippings regarding death of Julia Tuck, 12 November 1928, *Pap. Juss.*, 90, folio 46, p. 145; and death of Gosse, 30 January 1929, ibid., 94, folio 169, p. 278; and of Herrick, ibid., 87, p. 79; Jusserand to Garfield, 5 January 1932, LC, *Garfield Papers*, Box 115.

56 Jusserand to Wister, 15 June 1929, LC, 3 July, 17 August 1930, Jusserand and Elise, 6 December 1930, *Wister Papers*, Box 25; Jusserand to Finley, 29 July 1929, 4 October, 16 September 1930, NYPL, *Finley Papers*, Box 81; 25 September 1929, *LAT*, p. 1; Jusserand to Baxter, 20 March 1930, *Pap. Juss.*, 86, pp. 195–6.

57 *What Me Befell*, 11, 339–41.

58 John Finley, "The Admirable Ambassador: An Estimate of the Late J.J. Jusserand," *Légion d'Honneur* (published by the American Society of the Legion of Honor), vol. 3, no. 2 (October 1932): 94; 19 July 1932, *NYT*, 17.

59 19 July 1932, *WP*, 3.

60 Elise to Finley, 20 August 1932, 9 June 1933, NYPL, *Finley Papers*, Box 81; to Wister, 14 December 1932, LC, *Wister Papers*, Box 25.

61 22 July 1932, *WP*, 7.

62 Interred beside them are brother Etienne (1939) his wife, Marie (1932); sister Jeanne (1939) and her husband, Léon (1930).

63 19 July 1932, *NYT*, 17; 20 July, *LAT*, A4.

64 An English text of Charles Lyon-Caen's memorial address to the Academy was published in the Légion d'Honneur, vol. 5, no. 1 (July 1934): 29–53.

65 8 November 1936, *LAT*, 2.

66 The work of the Memorial Committee, from inception to completion, can be found in a separate dossier of the John Finley Papers, Box 81, in the New York Public Library.

67 10 October 1936, *WP*, x7; 31 October, *WP*, x4; 7 November, *WP*, x3; 8 November, *WP*, M1.

68 Elise to Finley, 13 May 1933, 9 June, 17 June, 31 July, NYPL, *Finley Papers*, Box 81.

69 Elise to Finley, 20 June 1933, Finley to Elise, 11 July, ibid.

70 8 November 1936, *NYT*, 30.

71 See "Le Carnet," 4–5 July 1948, *Le Monde*; Déclaration de Succession, 23 June 1950. Archives de Paris, Série DQ7, 32402, folio 154.

CONCLUSION

1 Jusserand, quoted in the *LAT*, 16 March 1919, III26.

2 Thomas R. Marshall, *The Recollections of Thomas R. Marshall, Vice-President and Hoosier Philosopher* (Indianapolis: Bobbs-Merrill 1925): 258–9; George W. Wickersham, "He Was a Man," *Légion d'Honneur*, iii, no. 3 (Jan. 1933): 153.

3 Bailey, *A Diplomatic History*, 13.

4 "The French Ambassador is lucky, whichever way he crosses the Atlantic, he goes home," a remark attributed by Jusserand to an unidentified American general. See 30 November 1924, *LAT*, D11.

5 The editor was John Franklin Jameson. His complaint appears in a letter quoted in John Spencer Bassett's "The Present State of History-Writing," in Jusserand et al., *The Writing of History*, 128–9.

6 Reviews: *Modern Language Notes*, vol. 28, no. 8 (December 1913): 257; *NYT*, 21 May 1916, vi, 209; *AHR*, vol. 22, no. 3 (April 1917): 670; ibid., vol. 37, no. 2 (January 1932): 339.

7 Frederick R. Karl, *Art Into Life: The Craft of Literary Biography* (Youngstown, Ohio: Etruscan Press 2005): xiii; Leon Edel, "The Figure Under the Carpet," 23.

8 Marc Pachter, "The Biographer Himself," 5.

9 Young, *Power and Pleasure*, 227.

10 J.F.V. Keiger, *Raymond Poincaré*, 1, 344.

11 Bernard Auffray, *Pierre de Margerie (1862–1942) et la vie diplomatique de son temps* (Paris: Librairie C. Klincksieck 1976): 120; Charles de Chambrun, *L'Esprit de la diplomatie*, 423; André Laboulaye, "J.J. Jusserand, ambassadeur," 29.

12 Comte de Saint-Aulaire, *Confession d'un vieux diplomate*, 18–19.

13 Wickersham, "He Was a Man," 151.

14 Jusserand, "Rochambeau and the French in America, from Unpublished Documents," in his own *With Americans of Past and Present Days*, 24.

15 Geoffrey Wolff, "Minor Lives," 57.

16 Jusserand, "Abraham Lincoln," in *With Americans of Past and Present Days*, 306.

Source Materials

ARCHIVAL SOURCES. FRANCE

Ministère des Affaires Etrangères. (Paris)

DOSSIER JUSSERAND (PERSONNEL) 2E SERIE, #831
095 FONDS JUSSERAND, 166 CONTAINERS

1–30	Chrono de la correspondance politique (1903–1925)
46	Télégrammes expédiés (1914–1917)
52	– (1918–1919)
54	– (1920)
60	– (1923–1925)

Correspondance particulière et privée:

61	Lettres diverses (1808–1890)
62	Lettres reçues (1887–1894)
63	Lettres reçues (1895–1899)
64	Correspondance anglaise (1885–1899)
65	Correspondance reçue à Copenhague (1898–1899)
66	Choix de lettres reçues (1900–1901)
67	Correspondance littéraire (1900–1902)

Washington:

69	Documents concernant le Prés. Roosevelt (1903–1906)
70	Douze lettres de Roosevelt, plus ... (1907–1910)
71	Préparatifs ... (1908–1914)
72	Correspondance Roosevelt-Jusserand (1916–1918)
73	Personnel-Lettres (1903–1914)
74	Affaires concernant le personnel de l'ambassade (1902–1913)

SERIE MAISON DE LA PRESSE

SERIE B. AMÉRIQUE

61–70 Etats-Unis, correspondance politique (1919–1929)
295 Ambassade de France (1922–1939)

SERIE GUERRE (1914–1918)
512–14 Etats-Unis. Mission Tardieu (1917–1918)

SERIE SOCIÉTÉ DES NATIONS (SDN):
1904 Presse: Dossier Général (1921–1939)

SERIE Y. INTERNATIONALE
01–4 Propagande de la France, dossier général (1918–1937)
132 Comité interallié de propagande (1918–1922)
410 Etats-Unis (1920–1921)

SERIE PAPIERS D'AGENTS
 095 Klobukowski
61 Dossier Commissariat Général (1918–1921)
 010 Berthelot
01–2 Dossier Général (1915–1916)
03 Propagande. Comités (1916–1917)
18 Propagande (1915–1916)
19 – (1916–1917)
20 Personal dossiers. Polignac, et al.
 166 Tardieu
82–86 Missions aux Etats-Unis (1918–1919)

Ministère des Affaires Etrangères (Nantes)

SERIE AMBASSADE DE FRANCE (WASHINGTON)
130 Propagande allemande
340 Dossiers des personnalités (1919–1923)
341 – (1910–1923)
350 Relations americano-françaises (1916–1923)
351 Etats-Unis. Relations extérieures (1917)
652 Conférence de Washington (1921)
740 Presse et Opinion (1915–1939)
741 Journaux et Journalistes (1920–1927)
743 Presse Opinion. Hearst (1915–1922)
744 – (1915–1922)
747 – (1914–1926)

748 – (1914–1926)
749 – (1916–1925)
751 Première Guerre. Haut Commissariat (1916–1919)
776 Haut Commissariat (1919–1921)
782 Subventions œuvres françaises (1899–1930)
790 Comité France-Amérique (1912–1941)
791 Sociétés (1911)
873 Ambassade (1893–1942)
880 Voyages (1909–1924)
889 Personnel de l'Ambassade (1895–1914)
895 – (1902–1925)
900 Personnel des Consulats
907 Corps Diplomatiques Etranger (1911–1912)
908 –

SERIE SERVICE DES ŒUVRES FRANÇAISES À L'ETRANGER (SOE)
01 Constitution du service: personnel
02 Dossiers Généraux (1925–1931)
40 Etats-Unis (1923–1931. Section œuvres diverses
43 Dossier Général, Section œuvres littéraires et artistiques
59 Comité catholique des amitiés françaises ... (1920–1927)
 Comité protestant de propagande (1921–1930)
69 Œuvres. Section diverse (1923–1931)
84 Œuvres. Section Tourisme, Sports et Cinéma (1915–1930)
91 Etats-Unis. Section Tourisme, Sports et Cinéma (1921–1935)
92 Œuvres. Section Tourisme, Sports et Cinéma (1922–1926)
477 Associations. Section œuvres diverses

Archives de Paris.

Administration de l'Enregistrement des Domaines et du Timbre.
Déclarations de Succession. Série DQ7. Nos. 32152, 32154, 32171,
32402, 32406, 32448, 32463.

ARCHIVAL SOURCES, UNITED STATES

Library of Congress

J.J. Jusserand and Elise Richards Jusserand Collection
Papers of James Rudolph Garfield (1865–1950)
Papers of Charles Evan Hughes (1836–1950)

Papers of Robert Lansing (1864–1928)
Papers of George B. McClellan (1865–1940)
Papers of Henry Morgenthau (1856–1946)
Papers of Theodore Roosevelt (1858–1919)
Papers of Elihu Root (1845–1937)
Papers of Stanley Washburn (1912–1945)
Papers of Woodrow Wilson (1856–1924)
Papers of Owen Wister (1860–1938)

National Archives and Record Administration (NARA)

Correspondence of Secretary of State Bryan with President Wilson,
 1913–1915. 4 vols. [Microform]. Washington: National Archives and
 Record Service 1963.
Personal and Confidential Letters from Secretary of State Lansing to
 President Wilson, 1915–1918. [Microform]. Washington: National
 Archives and Record Service 1968.

RG59:
 M99, Communications from State Department to French Diplomatic
 Representatives, 1900–1906.
 M53, Notes from the French Legation to the State Department,
 1902–1906.
 M568, Records of the Department of State. Political Relations between
 the United States and France, 1910–1929.

New York Public Library

– Papers of John H. Finley (1863–1940)

ARCHIVAL SOURCES, GREAT BRITAIN

Papers of Sir Charles Dilke. British Library. ADD 43884
Papers of Sir William Gladstone. British Library. ADD 44514–516

PUBLISHED DOCUMENTS

British Documents on the Origins of the War, 1898–1914. Edited by
 G.P. Gooch and Harold Temperley. London: HMSO 1927–1938. 11
 vols.

British Documents on Foreign Affairs: Reports and Papers from the
Foreign Office Confidential Print. Edited by Kenneth Bourne and D.
Cameron Watt. Part 1. Series C. North America, 1837–1914. Vols. 12,
13, 14, 15 North American Affairs, 1906–1914.
Documents Diplomatiques Français (1871–1914). Paris: Imprimerie
Nationale 1929–1959. 40 vols. 2nd Series (1903–1911), 3rd Series
(1911–1914).
Documents Diplomatiques Français (1914–1919). Paris: Imprimerie
Nationale 1999.
Documents Diplomatiques Français (1920–). Paris: Imprimerie Nationale
1997.
Documents on British Foreign Policy, 1919–1939. 1st Series. London:
HMSO 1974.
Foreign Relations of the United States. Diplomatic Papers. Washington:
Government Printing Office 1909.

NEWSPAPER PRESS

*Chicago Tribune, Christian Science Monitor, Le Temps, Los Angeles
Times, New York Times, San Francisco Examiner, Washington Post.*

JUSSERAND PUBLICATIONS

Jusserand, Jules. *De Josepho Exoniensi vel Iscano, theism proponebat
lugdunesi litteratum facultati* (Paris: Hachette 1877).
– *Le théâtre en Angleterre depuis la conquête jusqu'aux pré-décesseurs
immédiates de Shakespeare.* Paris: E. Leroux 1881.
– (Pseudonym Jacques Tissot) *La Tunisie.* Paris: A. Colin 1888.
– "Chaucer's Pardoner and the Pope's Pardoners," *Essays on Chaucer*,
13, 422–36. London: N. Trubner & Co. 1884.
– *Le Roman anglais. Origine et formation des grandes écoles de
romanciers du XVIIIe siècle.* Paris: Le Pay 1886.
– *Le Roman anglais et la réforme littéraire de Daniel Defoe. Conférence*
Bruxelles 1887.
– *The English Novel in the Time of Shakespeare.* London: T.F. Unwin
1903 [1890]. *Le Roman au temps de Shakespeare.* Paris: Asnières
1887.
– *English Wayfaring Life in the Middle Ages (XIVth Century).* London:
T.F. Unwin 1891. *Les Anglais au Moyen Age. La vie nomade et les
routes d'Angleterre au XIVe siècle* (1884)

- *A French Ambassador at the Court of Charles the Second: Le Comte de Cominges.* London: T.F. Unwin 1892.
- *Piers Plowman: A Contribution to the History of English Mysticism.* New York: Putnam's Sons 1894.
- *English Essays from a French Pen.* New York: Putnam 1895.
- *A Literary History of the English People.* 2 vols. London: G.P. Putnam's Sons 1895 [1909]. *Histoire littéraire du peuple anglais* (Paris: Firmin-Didot 1894).
- *Le roman d'un roi d'Ecosse.* Paris: Hachette 1895. Translated as *The Romance of a King's Life* [James I]. London: T.F. Unwin 1896.
- *Histoire abrégée de la littérature anglaise.* Paris: C. Delagrave 1896.
- "Jacques Ier d'Ecosse fut-il poète? Etude sur l'authenticité du 'Cahier du Roi,'" *Revue historique* 64 (May–Aug. 1897): 1–49.
- *Shakespeare in France under the Ancien Regime.* London: T.F. Unwin 1899. *Shakespeare en France sous l'ancien régime.* Paris: Colin 1898.
- *Les sports et jeux d'exercise dans l'ancienne France.* Paris: Plon-Nourrit 1901.
- "Plain Truths," *Revue Critique*, 3 June 1901, 3–19.
- "'Piers Plowman,' The Work of One or of Five," *Modern Philology* 6, no. 3 (Jan. 1909): 271–329.
- "Spenser's 'Twelve Private Morall Vertues as Aristotle hath devised,'" *Modern Philology* 3. no. 3, (1906): 373–83.
- Ben Jonson's Views on Shakespeare's Art," vol. 10, pp. 297–320, in *The Works of William Shakespeare* (Stratford-on-Avon: The Shakespeare Head Press, 1904–07) 10 vols.
- *What to Expect of Shakespeare.* London: Published for the British Academy by H. Frowde 1911.
- *Ronsard.* Paris: Hachette 1913.
- *With Americans of Past and Present Days.* New York: C. Scribner's Sons 1916. *En Amérique Jadis et Maintenant.* Paris: Hachette 1918.
- *Brothers in Arms:* a new edition of *With Americans of Past and Present Days.* Chautauqua, New York: The Chautauqua Press 1919.
- "The Economic Situation in France," Address of 9 December 1920. *Proceedings of the Academy of Political Science in the City of New York* 9, no. 2 (Feb. 1921): 76–81.
- "The Inestimable Value of Beauty," *American Magazine of Art* 13, no. 11 (November 1922): 451–4.
- "The School for Ambassadors." Presidential address ... before the AHA, St Louis, December 28, 1921. *AHR*, 27, no. 3 (April 1922): 426–64. On-Line Edition, 1–38.

- *The School for Ambassadors, and Other Essays.* New York: Putnam 1925 ("The School" coming from Jusserand's AHA lecture).
- "A Message to Smith College on the Occasion of the Ronsard Celebration," *Modern Language Journal* 9, no. 6 (March 1925): 335–8.
- *The Writing of History,* by Jusserand, Wilbur Cortez Abbott, Charles W. Colby, and John Spencer Bassett. New York: Lenox Hill 1926. Reprint: New York: Burt Franklin 1974.
- "Le Maréchal d'Estrades et ses critiques," *Revue historique* 158 (May–Aug. 1928): 225–54.
- *Grotius étudié par les secrétaires d'ambassade français en 1711.* Lvgdvni Batavorvm: E.J. Brill 1929.
- "La Jeunesse du citoyen Genet d'après des documents inédits," *Revue d'Histoire Diplomatique* 44, no. 1 (1930): 237–68.
- *Le sentiment américain pendant la guerre.* Paris: Payot 1931.
- "Communication," Letter to Editor, AHR 37, no. 4 (July 1932): 817–19.
- *What Me Befell: The Reminiscences of J.J. Jusserand.* London: Constable 1933.

Edited Works

- "Introduction" *Great French Writers,* 5 vols. London: Routledge and Sons 1887. [Subjects: de Sévigné, Montesquieu, Victor Cousin, George Sand, Turgot.] [Authors: Gaston Boissier, Albert Sorel, Jules Simon, E.M. Caro, Léon Say....]

Speeches and Introductions

- Introduction to the English translation of Paul Scarron's *The Comical Romance and Other Tales,* 2 vols., vol. i, pp. vii–liv. London: Lawrence and Bullen 1892.
- "Some Maxims of Life," Convocation address, University of Chicago, *The University Record,* January 1906, 105–10.
- Introduction, Shakespeare's *The Winter's Tale.* Cambridge, Mass: University Press 1907.
- "France and the United States at San Francisco," *American Journal of International Law* 3, no. 4 (Oct. 1909): 975–7.
- Introduction to James Breck Perkins, *France in the American Revolution.* Boston: Houghton Mifflin 1911.
- Preface. *Amis de la France: le service de campagne de l'ambulance américaine décrit par ses membres.* Paris: Plon-Nourrit 1917. English original, Boston: Houghton Mifflin 1916.

- Introduction and notes to Paul Vaucher, *Angleterre* 24, 25, of *Recueil des instructions données aux ambassadeurs et ministres de France, depuis les traités de Westphalie jusqu'à la Révolution française. Publiés sous les auspices de la Commission des archives diplomatiques au ministère des Affaires étrangères.* Paris, 1929.

REVIEWS OF JUSSERAND'S WORKS

- Ashley, W.J. "English Wayfaring Life in the Middle Ages." *Political Science Quarterly* 4, no. 4 (Dec. 1889): 685–6.
- Browne, W.H. "Jacques Ier d'Ecosse fut-il poète?" *Modern Language Notes* 12, no. 7 (Nov. 1897): 209–11.
- Smith, G. Gregory. "The Romance of a King's Life ... Jacques Ier d'Ecosse fut-il poète? Etude sur l'authenticité du Cahier du Roi." *English Historical Review* 13, no. 51 (July 1898): 575–6.
- Garnett, James M. "A Literary History of the English People." *American Journal of Philology* 31, no. 3 (1910): 335–9.
- Brush, Murray P. "Ronsard." *Modern Language Notes* 28, no. 8 (Dec. 1913): 257–9.
- Hunt, Gaillard. "With Americans of Past and Present Days." *American Historical Review* 22, no. 3 (Apr. 1917): 669–71.
- Moore, Samuel. "Studies in 'Piers the Plowman.'" *Modern Philology* 11, no. 2 (Oct. 1913): 177–93.
- Seymour, Charles. "Le Sentiment Américain pendant la Guerre." *American Historical Review* 37, no. 2 (Jan. 1932): 339–40.
- Johnson, Allen. "The Writing of History." *American Historical Review* 32, no. 2 (Jan. 1927): 293–5.
- Abbott, Wilbur C. "Recueil des instructions données aux ambassadeurs et ministres de France depuis les traités de Westphalie jusqu'à la Révolution française." *American Historical Review* 35, no. 2 (Jan. 1930): 340–2.
- Evett, David. "The English Novel in the Time of Shakespeare." *Modern Language Journal* 51, no. 4 (Apr. 1967): 235–6.

ABOUT JUSSERAND

Finley, John. "The Admirable Ambassador: An Estimate of the Late J.J. Jusserand," *Légion d'Honneur*, 5, no. 1 (July 1934): 91–4. Published by the American Society of the French Legion of Honour.

Laboulaye, André de. "J.-J. Jusserand, Ambassadeur de France," *Revue des Deux Mondes*, July 1949, 27–43.

Lyon-Caen, Monsieur [*secrétaire-général perpétuel*]. "Eloge à Jusserand. Académie des sciences morales," 16 December 1933 (Paris: Firmin-Didot 1933). Published in English as "Jules Jusserand, 1855–1932," *Légion d'Honneur* 5, no. 1 (July 1934): 29–53.

Jusserand Memorial Committee, New York. *Jean Jules Jusserand: Ambassador of the French Republic to the United States of America, 1903–1925* (New York: Jusserand Memorial Committee 1937): 1–3. 9 plates.

Wickersham, George W. "He Was a Man," *Légion d'Honneur* 5, no. 1 (July 1934): 149–55.

Wiley, Evelyn Virginia "Jean Jules Jusserand and the First Moroccan Crisis, 1903–1906." Dissertation: University of Pennsylvania: 1959.

CONTEMPORARY AND HISTORICAL WORKS

Agulhon, Maurice, A. Nouschi, and R. Schor. *La France de 1914 à 1940.* Paris: Nathan 1993.

Albert, Pierre. *La France, les Etats-Unis et leurs presses.* Paris: Centre Pompidou 1977.

Alexander, Martin S. (ed.). *Knowing Your Friends: Intelligence Inside Alliances and Coalitions from 1914 to the Cold War.* London: Frank Cass 1998.

– and John V. Keiger. "Enforcing Arms Limits: Germany post 1919; Iraq post 1991 – Introduction," *Journal of Strategic Studies* 29, no. 2 (April 2006): 181–93.

Allard, Paul. *Le Quai d'Orsay.* Paris: Editions de France 1938.

Ambrosius, Lloyd E. *Woodrow Wilson and the American Diplomatic Tradition: The Treaty Fight in Perspective.* New York: Cambridge University Press 1987.

Aron, René and Arnaud Dandieu. *Le Cancer américain.* Paris: Rieder 1931.

Askew, William C. "The United States and Europe's Strife, 1908–1913," *Journal of Politics* 4, no. 1 (Feb. 1942): 68–79.

Aubert, Louis et al. *André Tardieu.* Paris: Plon 1957.

Auffray, Bernard. *Pierre de Margerie (1862–1942) et la vie diplomatique de son temps.* Paris: Librairie C. Klincksieck 1976.

August, Thomas G. *The Selling of the Empire: British and French Imperialist Propaganda, 1890–1940.* Westport: Greenwood Press 1985.

Bailey, Thomas A. *A Diplomatic History of the American People*. New York: Appleton-Century-Crofts 1969.

Baillou, Jean. *Les Affaires étrangères et le corps diplomatique français*. Vol. 1: *De l'Ancien Régime au Second Empire*. Vol. 2: *1870–1980*. Paris: CNRS Editions 1984.

Bankwitz, Philip C.F. *Maxime Weygand and Civil-Military Relations in Modern France*. Cambridge, Mass.: Harvard University Press 1967.

Barros, Andrew. "Disarmament as a Weapon: Anglo-French Relations and the Problem of Enforcing German Disarmament, 1919–1928," *Journal of Strategic Studies* 29, no. 2 (April 2006): 301–21.

– and Frédéric Guelton. "Les imprévus de l'histoire instrumentalisée: le Livre Jaune de 1914 et les Documents Diplomatiques Français sur les origines de la Grande Guerre," *Revue d'histoire diplomatique* 1 (2006): 3–22.

Barrot, Olivier and Pascal Ory (eds.). *Entre Deux Guerres: La création française, 1919–1939*. Paris: François Bourin 1990.

Barthou, Alice Louis. *Au Moghreb parmi les fleurs*. Paris: Bernard Grasset 1925.

Barthou, Louis. *Promenades autour de ma vie: Lettres de la Montagne*. Paris: Les Laboratoires Martinet 1933.

Beale, Marjorie A. *The Modernist Enterprise: French Elites and the Threat of Modernity, 1900–1940*. Stanford: Stanford University Press 1999.

Becker, Jean Jacques. *1914: Comment les Français sont entrés dans la guerre*. Paris: FNSP Editions 1977.

Bell, P.M.H. *France and Britain, 1900–1940: Entente and Estrangement*. London: Longman 1996.

Berger, Meyer. *The Story of the New York Times 1851–1951*. New York: Simon and Schuster 1951.

Berger, Stefan, H. Feldner, K. Passmore (eds.). *Writing History: Theory and Practice*. London: Arnold 2003.

Birn, Donald S. "Open Diplomacy at the Washington Conference of 1921–22: The British and French Experience," *Comparative Studies in Society and History* 12, no. 3 (July 1970): 297–319.

Biskupski, M.B. "Paderewski, Polish Politics, and the Battle of Warsaw," *Slavic Review* 46, no. 3/4 (autumn–winter 1987): 503–12.

Blake, Nelson Manfred. "Ambassadors at the Court of Theodore Roosevelt," *Mississippi Valley Historical Review* 42, no. 2 (Sept. 1955): 179–206.

Blatt, Joel. "France and the Washington Conference," *Diplomacy and Statecraft* 4, no. 3 (1993): 192–219.

– "The Parity that Meant Superiority: French Naval Policy towards Italy at the Washington Conference, 1921–22, and Interwar French Foreign Policy," *French Historical Studies* 12, no. 2 (autumn 1981): 223–48.

Blumenthal, Henry. *France and the United States: Their Diplomatic Relations, 1789–1914*. Chapel Hill: University of North Carolina Press 1970.

– *Illusion and Reality in Franco-American Diplomacy, 1914–1945*. Baton Rouge: Louisiana State University Press 1986.

Boemeke, Manfred F., Gerald D. Feldman, and Elizabeth Glaser (eds.). *The Treaty of Versailles: A Reassessment after 75 Years*. New York: Cambridge University Press 1998.

Bonnefous, Georges and Edouard Bonnefous. *Histoire politique de la Troisième République*, 2 vols. Paris: Presses Universitaires de France 1957–1959.

Boyce, Robert. *The Great Interwar Crisis and the Collapse of Globalization*. London: Palgrave-Macmillan, forthcoming 2009.

– (ed.). *French Foreign and Defence Policy, 1918–1940: The Decline and Fall of a Great Power*. London: LSE Routledge 1998.

– "Behind the façade of the Entente Cordiale after the Great War." In *Britain, France and the Entente Cordiale since 1904*, edited by Antoine Capet. London: Palgrave Macmillan 2006): 41–63.

Bray, Howard. *The Pillars of the Post: The Making of a News Empire in Washington*. New York: Norton 1980.

Bréal, Auguste. *Philippe Berthelot*. Paris: Gallimard 1937.

Brinnin, John.M. and Kenneth Gaulin. *Grand Luxe: The Transatlantic Style*. New York: Holt 1988.

Brodziak, Sylvie and Michel Drouin, *Clemenceau et le monde anglo-saxon: Actes du colloque international*. Paris: Geste Editions 2005.

Brooks, Charles W. *America in France's Hopes and Fears, 1890–1920*. 2 vols. New York: Garland 1987.

Buitenhuis, Peter. *The Great War of Words. British, American, and Canadian Propaganda and Fiction, 1914–1933*. Vancouver: University of British Columbia Press 1987.

Burch, Philip. *Elites in American History*. 3 vols. New York: Holmes and Meier 1980–1981.

Burton, David H. *Cecil Spring-Rice: A Diplomat's Life*. Rutherford: Farleigh Dickinson University Press 1990.

Butler, Nicholas Murray. *Across the Busy Years: Recollections and Reflections,* 2 vols. New York: Charles Scribner's Sons 1939–1940.

Cable, Mary. *Top Drawer: American High Society from the Gilded Age to the Roaring Twenties.* New York: Atheneum 1984.

Capet, Antoine (ed.). *Britain, France and the Entente Cordiale since 1904.* London: Palgrave Macmillan 2006.

Carley, Michael Jabara. "The Origins of the French Intervention in the Russian Civil War, January–May 1918: A Reappraisal," *Journal of Modern History* 48, no. 3 (Sept. 1976): 413–39.

– "The Politics of Anti-Bolshevism: The French Government and the Russo-Polish War, December 1919 to May 1920," *Historical Journal* 19, no. 1 (March 1976): 163–89.

– "A Soviet Eye on France from the Rue de Grenelle in Paris, 1924–1940," *Diplomacy and Statecraft* 17 (2006): 295–346.

Carlisle, Rodney. "The Foreign Policy Views of an Isolationist Press Lord: W.R. Hearst and the International Crisis, 1936–1941." *Journal of Contemporary History* 9 (July 1974): 217–27.

Carroll, John M. "Owen D. Young and German Reparations: The Diplomacy of an Enlightened Businessman." In *U.S. Diplomats in Europe, 1919–1941,* edited by K.P. Jones, 43–60. Santa Barbara: ABC-Clio 1983.

Carse, Alice Felicitas. "The Reception of German Literature in America as Exemplified by the *New York Times,* 1919–1944." Dissertation: New York University 1973.

Cassels, Alan. "Repairing the Entente Cordiale and the New Diplomacy," *Historical Journal* 23, no. 1 (March 1980): 133–53.

Chambrun, Charles de. *L'esprit de la diplomatie.* Paris: Editions Corréa 1944.

Charle, Christophe. *Les Elites de la République, 1880–1890.* Paris: Fayard 1987.

Clark, Priscilla P. *Literary France: The Making of a Culture.* Berkeley: University of California Press 1987.

Clark, Terry Nichols. *Prophets and Patrons: The French Universities and the Emergence of the Social Sciences.* Cambridge, Mass.: Harvard University Press 1973.

Clary, Jean. "Aux Etats-Unis avec la Mission Tardieu," *Ecrits de Paris* 297 (1970): 60–6.

Clemenceau, Georges. *The Grandeur and Misery of Victory.* London: George G. Harrap and Co. 1930.

Coletta, Paolo E. *William Jennings Bryan.* Vol. 2, *Progressive Politician and Moral Statesman, 1909–1915.* Vol. 3, *Political Puritan.* Lincoln: University of Nebraska Press 1964–1969.

Colwill, Elizabeth. "Subjectivity, Self-Representation, and the Revealing Twitches of Biography," *French Historical Studies* 24, no. 3 (summer 2001): 421–37.

Contosta, David R. and Jessica R. Hawthorne. *Rise to World Power: Selected Letters of Whitelaw Reid, 1895–1912.* Philadelphia: American Philosophical Society 1986.

Crubellier, Maurice. *Histoire culturelle de la France, 19è–20è siècles.* Paris: Colin 1974.

– *L'Ecole Républicaine, 1870–1940.* Paris: Editions Christian 1993.

Curti, Merle Eugene. *Bryan and World Peace.* New York: Octagon Books 1969.

D'Abernon, Viscount Edgar. *An Ambassador of Peace: Lord D'Abernon's Diary,* 2 vols., vol. 1, *From Spa (1920) to Rapallo (1922).* London: Hodder and Stoughton 1929.

– *The Eighteenth Decisive Battle of the World: Paris, 1920.* London: Hodder and Stoughton 1931.

Feuillerat, Albert. *French Life and Ideals.* New Haven: Yale University Press 1925.

Dalton, Kathleen. *Theodore Roosevelt: A Strenuous Life.* New York: Alfred A. Knopf 2002.

Dasque, Isabelle. "Etre femme de diplomate au début du XXe siècle: pouvoir social et pouvoir d'influence." In *Femmes et diplomatie,* edited by Yves Denéchère, 23–42, Bruxelles: Presses Interuniversitaires Européennes 2004.

Davies, Norman. "Sir Maurice Hankey and the Inter-Allied Mission to Poland, July-August 1920," *The Historical Journal* 15, no. 3 (Sept. 1972): 553–61.

Davis, Elmer H. *History of the New York Times, 1851–1921.* New York: Greenwood Press 1969.

Den Boer, Pim. *History as a Profession: The Study of History in France, 1818–1914.* Princeton: Princeton University Press 1998.

Denéchère, Yves. (ed.) *Femmes et diplomatie: France, XXe siècle.* Bruxelles: Presses Interuniversitaires Européennes 2004.

Dethan, Georges. "The Ministry of Foreign Affairs since the Nineteenth Century." In *The Times Survey of Foreign Ministries of the World,* 203–33, edited by Zara Steiner. London: Times Books 1982.

Dewald, Jonathan. *Lost Worlds: The Emergence of French Social History, 1815–1970.* University Park, Penn.: Penn State University Press 2006.

- "Lost Worlds: French Historians and the Construction of Modernity," *French History* 9, no. 4 (Dec. 2000): 424–42.

Digeon, Claude. *La Crise allemande de la pensée française (1870–1914)*. Paris: Presses universitaires de France 1992.

"Documents diplomatiques français, 1871–1914, Aug.–Dec. 1913," *AHR* 41, no. 3 (April 1936): 544–6.

"Documents diplomatiques français, 1871–1914, March–Jul. 1913, and July–Aug. 1914," *AHR* 43, no. 1 (Oct. 1937): 132–4.

Doerries, Reinhard. *Imperial Challenge: Ambassador Count Bernstorff and German-American Relations, 1908–1917*. Translated by Christa D. Shannon. Chapel Hill: University of North Carolina Press 1989.

- "Promoting *Kaiser* and *Reich*: Imperial German Propaganda in the United States during World War 1." In *Confrontation and Cooperation*, edited by Hans-Jurgen Schröder, 135–65. Providence: Berg 1993.

Drouin, Michel. "Le Voyage de 1922." In *Clemenceau et le monde anglo-saxon: Actes du colloque international (2004)*, edited by Sylvie Brodziak and Michel Drouin, 123–45. Paris: Geste Editions 2005.

Duroselle, Jean-Baptiste. *Clemenceau*. Paris: Fayard 1988.

- *La France et les Etats-Unis des origines à nos jours*. Paris: Seuil 1976.

Edel, Leon. "The Figure Under the Carpet." In *Telling Lives: The Biographer's Art*, edited by Marc Pachter, 16–34. Washington: Smithsonian Institution 1979.

Estèbe, Jean. *Les ministres de la République, 1871–1914*. Paris: FNSP Editions 1982.

Eubank, Keith. *Paul Cambon: Master Diplomatist*. Norman: University of Oklahoma Press 1960.

Farrar, Marjorie Milbank. *Principled Pragmatist: The Political Career of Alexandre Millerand*. New York: Berg 1991.

- *Conflict and Compromise: The Strategy, Politics and Diplomacy of the French Blockade, 1914–1918*. The Hague: Martinus Nijhoff 1974.

Fay, Sidney B. "Documents Diplomatiques Francais, 1871–1914. September 1905–January 1906," *AHR* 45, no. 2 (Jan. 1940): 397–9.

Flood, P.J. *France, 1914–1918: Public Opinion and the War Effort*. London: Macmillan 1990.

Fordham, Elizabeth. "From Whitman to Wilson: French Attitudes toward America around the Time of the Great War." In *Across the Atlantic*, edited by Luisa Passerini, 117–39. Brussels: Peter Lang 2000.

France, Peter and William St. Clair. *Mapping Lives: The Uses of Biography*. Oxford: Oxford University Press 2002.

Gary, Brett. *The Nervous Liberals. Propaganda Anxiety from World War I to the Cold War*. New York: Columbia University Press 1999.

Glad, Betty. *Charles Evans Hughes and the Illusions of Innocence: A Study in American Diplomacy.* Urbana: University of Illinois Press 1966.

Gildea, Robert. *The Past in French History.* New Haven: Yale University Press, 1994.

Goetschel, Pascale and E. Loyer. *Histoire culturelle et intellectuelle de la France au XXe siècle.* Paris: Colin 1994.

Goldstein, Erik and Maurer, John (eds.). *The Washington Conference, 1921–22: Naval Rivalry, East Asian Stability and the Road to Pearl Harbour.* London: Cass 1994.

Gordon, Bertram M. "The Decline of a Cultural Icon: France in American Perspective." *French Historical Studies* 22, no. 4 (fall 1999): 625–51.

Guedella, Philip. *Supers and Supermen.* London: T. Fisher Unwin 1920.

Hamilton, Nigel. *Biography: A Brief History.* Cambridge: Harvard University Press 2007.

Hanks, Robert K. "Le Voyage de 22 vu par les Américains," in *Clemenceau et le monde anglo-saxon: Actes du colloque international,* edited by Sylvie Brodziak and Michel Drouin, 147–76. Paris: Geste Editions 2005.

– "Culture Versus Diplomacy: Clemenceau and Anglo-American Relations during the First World War." Dissertation. University of Toronto 2001.

Hanna, Martha. *The Mobilization of Intellect: Scholars, Writers, and the French War Effort, 1914–1918.* Cambridge: Harvard University Press 1993.

Hanotaux, Gabriel. *Le Comité "France-Amérique": Son Activité de 1909 à 1920.* Paris: Comité "France-Amérique" 1920.

– *Carnets, 1907–1925.* Paris: Editions Pedone 1982.

Hay, John. *Letters of John Hay and Extracts from His Diary,* 3 vols. New York: Gordian Press 1969.

Hayne, Mark. "The Quai d'Orsay and Influences on the Formation of French Foreign Policy, 1898–1914," *French History* 2, no. 4 (1991): 427–52.

– "Change and Continuity in the Structure and Practices of the Quai d'Orsay, 1871–1898," *Australian Journal of Politics and History* 37, no. 1 (1991): 61–76.

Hendrickson, Embert J. "Roosevelt's Second Venezuelan Controversy," *Hispanic American Historical Review* 50, no. 3 (Aug. 1970): 482–98.

– "Root's Watchful Waiting and the Venezuelan Controversy," *The Americas* 23, no. 2 (Oct. 1966): 115–29.

Hilderbrand, Robert C. *Power and the People: Executive Management of Public Opinion in Foreign Affairs, 1897–1921.* Chapel Hill: University of North Carolina Press 1981.

Holman, Valerie and Debra Kelly (eds.). *France at War in the Twentieth Century: Propaganda, Myth and Metaphor.* Oxford: Berghahn 2000.

Holmes, Richard, "The Proper Study." In *Mapping Lives: The Uses of Biography*, edited by Peter France and William St Clair, 7–18. Oxford: Oxford University Press 2002.

Horn, Martin A. *Britain, France, and the Financing of the First World War.* Montreal: McGill-Queen's University Press 2002.

– "A Private Bank at War: J.P. Morgan & Co. and France, 1914–1918." *Business History Review* 74 (spring 2000): 85–112.

Horne, John and Kramer, Alan. *German Atrocities, 1914.* New York: Yale University Press 2000.

– "German 'Atrocities' and Franco-German opinion, 1914. The Evidence of German Soldiers' Diaries," *Journal of Modern History* 66 (March 1994): 1–33.

House, Colonel Edward M. *The Intimate Papers of Colonel House,* edited by Charles Seymour. 4 vols. London: Ernest Benn 1926–1928.

J.F.J. (J. Franklin Jameson). "The Meeting of the American Historical Association at Washington," *AHR* 26, no. 3 (April 1921): 413–39.

– "The Meeting of the American Historical Association at St. Louis," *AHR* 27, no. 3 (April 1922): 405–22.

Jackson, Peter. "Pierre Bourdieu, the 'cultural turn' and the practice of international history," *Review of International Studies* 34 (2008): 155–81.

– "France and the Problems of Security and International Disarmament after the First World War," *Journal of Strategic Studies* 29, no. 2 (April 2006): 247–80.

Jessup, Philip C. *Elihu Root,* 2 vols. 1 (1845–1909), 2 (1905–1937). Hamden Conn.: Archon Books 1964.

Jones, Kenneth Paul (ed.). *U.S. Diplomats in Europe, 1919–1941.* Santa Barbara: ABC-Clio 1983.

– "Alanson B. Houghton and the Ruhr Crisis: The Diplomacy of Power and Morality." In *U.S. Diplomats in Europe, 1919–1941,* edited by Kenneth Paul Jones, 25–39. Santa Barbara: ABC-Clio 1983.

Johnson, Charles Thomas. *Culture at Twilight. The National German-American Alliance, 1901–1918.* New York: Peter Lang 1999.

Karl, Frederick R. *Art Into Life: The Craft of Literary Biography.* Youngstown, Ohio: Etruscan Press 2005.

Kayser, Jacques. *Ruhr ou Plan Dawes?* Paris: André Delpeuch nd.

Keiger, J.F.V. *Raymond Poincaré.* Cambridge: Cambridge University Press 1997.

Kelley, Tom. *The Imperial Post: The Meyers, the Grahams, and the Paper that Rules Washington.* New York: William Morrow 1983.

Kerney, James. *The Political Education of Woodrow Wilson.* New York: Century Co. 1926.

Keylor, William R. *The Legacy of the Great War: Peacemaking, 1919.* Boston: Houghton Mifflin 1998.

– "France and the Illusion of American Support, 1919–1940." In *The French Defeat of 1940*, edited by Joel Blatt, 204–44. Providence: Berghahn Books 1998.

– "France's Futile Quest for American Military Protection, 1919–1922." In *Une Occasion Manquée? 1922: La Reconstruction de l'Europe*, edited by Marta Petricioli, 61–80. Bern: Peter Lang 1995.

– "'How They Advertised France': The French Propaganda Campaign in the United States during the Breakup of the Franco-American Entente, 1918–1923," *Diplomatic History* 17, no. 3 (Summer 1993): 351–73.

– "The Rise and Demise of the Franco-American Guarantee Pact, 1919–1921," *Proceedings of the Annual Meeting of the Western Society for French History* 15 (1988): 367–77.

– "Prohibition Diplomacy: An Incident of Franco-American Misunderstanding," *Contemporary French Civilization* 5, no. 3 (1981): 299–316.

– *Academy and Community. The Foundation of the French Historical Profession.* Cambridge, Mass.: Harvard University Press 1975.

Kihl, Mary R. "A Failure of Ambassadorial Diplomacy," *Journal of American History* 57, no. 3 (Dec. 1970): 636–53.

King, Erika G. "Exposing the 'Age of Lies': The Propaganda Menace as Portrayed in American Magazines in the Aftermath of World War I." *Journal of American Culture* 12, no. 1 (1989): 35–40.

Knock, Thomas J. *To End All Wars: Woodrow Wilson and the Quest for a New World Order.* Princeton, New Jersey: Princeton University Press 1992.

Kuisel, Richard K. "American Historians in Search of France: Perceptions and Misperceptions," *FHS* 19, no. 2 (fall 1995): 307–19.

Lambert, Peter. "The Professionalization and Institutionalization of History." In *Writing History: Theory and Practice*, edited by Stefan Berger, Heiko Feldner, and Kevin Passmore, 42–60. London: Arnold 2003.

Lamont, Edward M. *The Ambassador from Wall Street. The Story of Thomas W. Lamont, J.P. Morgan's Chief Executive*. Lanham: Madison Books 1994.

Langlois-Berthelot, Daniel. "Philippe Berthelot (1886–1934)," *Nouvelle Revue des Deux Mondes* 6 (1976): 574–82.

Lansing, Robert. *War Memoirs:. New York: Bobbs-Merrill* 1935.

– *The Big Four, and Others of the Peace Conference*. New York: Books for Libraries Press 1921.

– *The Peace Negotiations. A Personal Narrative*. Boston: Houghton Mifflin 1921.

Lanux, Pierre de. *Young France and New America*. New York: Macmillan 1917.

Lauren, Paul Gordon. *Diplomats and Bureaucrats: The First Institutional Responses to Twentieth-Century Diplomacy in France and Germany*. Stanford: Hoover Institution Press 1976.

Lauzanne, Stéphane. *Great Men and Great Days*. New York: D. Appleton and Co. 1921.

Lechartier, Georges. *Intrigues et diplomaties à Washington (1914–1917)*. Paris: Plon-Nourrit 1919.

Leffler, Melvyn P. *The Elusive Quest: The American Pursuit of European Stability and French Security, 1919–1933*. Chapel Hill: University of North Carolina Press 1979.

Lentin, Antony. "The Treaty that Never Was: Lloyd George and the Abortive Anglo-French Alliance of 1919." In *The Legacy of the Great War: Peacemaking, 1919*, edited by William R. Keylor, 105–17. Boston: Houghton Mifflin 1998.

Levenstein, Harvey. *Seductive Journey: American Tourists in France from Jefferson to the Jazz Age*. Berkeley: University of California Press 1998.

Levering, Ralph B. *The Public and American Foreign Policy, 1918–1978*. New York: William Morrow 1978.

Levillain, Philippe. "Les Protagonistes de la biographie." In *Pour une Histoire Politique*, edited by René Rémond, 121–59. Paris: Editions du Seuil 1988.

Levine, Lawrence W. *Highbrow/Lowbrow. The Emergence of Cultural Hierarchy in America*. Cambridge, Mass.: Harvard University Press 1988.

Livermore, Seward W. "Theodore Roosevelt, the American Navy, and the Venezuelan Crisis of 1902–1903," *AHR* 51, no. 3 (April 1946): 452–71.

Lundberg, Ferdinand. *America's Sixty Families*. New York: Halcyon House 1937.

Macmillan, Margaret. *Paris 1919*. New York: Random House 2001.

Marbeau, Michel. "Une timide irruption: les femmes dans la politique étrangère de la France dans l'entre-deux-guerres." In *Femmes et diplomatie: France, XXe siècle*, edited by Yves Denéchère, 43–74. Bruxelles: Presses Interuniversitaires Européennes 2004.

Marcus, Laura. "The Newness of the 'New Biography.' Biographical Theory and Practice in the Early Twentieth Century." In *Mapping Lives: The Uses of Biography*, edited by Peter France and William St Clair, 193–218. Oxford: Oxford University Press 2002.

Margadant, Jo Burr. "Introduction: The New Biography in Historical Practice," FHS 19, no. 4 (fall 1996): 1045–58.

Marks, Sally. "Poincaré-la-peur: France and the Ruhr." In *Crisis and Renewal in France, 1918–1962*, edited by Kenneth Mouré and Martin S. Alexander, 28–45. New York: Berghahn Books 2002.

Marshall, Thomas R. *The Recollections of Thomas R. Marshall, Vice-President and Hoosier Philosopher*. Indianapolis: Bobbs-Merrill Co. 1925.

Martin, Benjamin F. *France and the Après Guerre, 1918–1924*. Baton Rouge: Louisiana State University Press 1999.

May, Arthur J. "The Far Eastern Policy of the United States in the Period of the Russo-Japanese War: A Russian View," AHR 62, no. 2 (Jan. 1957): 345–51.

– "Documents diplomatiques français, 1871–1914, Apr. 1906–May 1907," *Journal of Modern History* 25, no. 1 (Mar. 1953): 82–3.

Mégret, Maurice. "Les Origines de la propagande de guerre française: Du service général de l'information au commissariat général à l'information," *Revue d'Histoire de la Deuxième Guerre Mondiale* 41 (Jan. 1961): 3–27.

Meras, Edmond, A. "The Men Who Founded the AATF," *French Review* 41, no. 6 (May 1968): 787–93.

Middell, Matthias. "The Annales." In *Writing History: Theory and Practice*, edited by Stefan Berger, Heiko Feldner, and Kevin Passmore, 104–17. London: Arnold 2003.

Miquel, Pierre. *La Paix de Versailles et l'opinion publique française*. Paris: Flammarion 1972.

Mitchell, Allan. *The German Influence in France after 1870*. Chapel Hill: University of North Carolina Press 1979.

Monnet, F. *Refaire la République: André Tardieu, une dérive réactionnaire*. Paris: Fayard 1993.

Montant, Jean-Claude. "L'organisation centrale des services d'informations et de propagande du Quai d'Orsay pendant la grande guerre." In *Les Sociétés européennes et la guerre de 1914–1918*, edited by J.J. Becker, and S. Audoin-Rouzeau, 135–43. Paris: Université de Paris x, Nanterre 1990.

– "Propagande et guerre psychologique: la Maison de la Presse." *Les Affaires étrangères et le corps diplomatique français*, edited by Jean Baillou, vol. 2, 334–45. Paris: Presses Universitaires de France, 1984.

Morgan, Kenneth O. "Lloyd George and Clemenceau: Prima Donnas in Partnership." In *Britain, France and the Entente Cordiale Since 1904,* edited by Antoine Capet, 28–40. London: Palgrave Macmillan 2006.

Morley, Viscount John. *Recollections*, 2 vols., vol. 1, New York: Macmillan 1917.

Morrison, Elting E. *The Letters of Theodore Roosevelt*, 8 vols. Cambridge, Mass.: Harvard University Press 1951–1954.

Mott, Colonel Thomas B. *Myron T. Herrick: Friend of France*. New York: Doubleday, Doran and Co. 1929.

Mouré, Kenneth, *The Gold Standard Illusion: France, the Bank of France, and the International Gold Standard, 1914–1939*. Oxford: Oxford University Press 2002.

– "The Gold Standard Illusion: France and the Gold Standard in the Era of Currency Instability, 1914–1939." In *Crisis and Renewal in France, 1918–1962*, edited by. K. Mouré, and Martin S. Alexander, 66–85. New York: Berghahn Books 2002.

– (ed.) with Martin Alexander. *Crisis and Renewal in France, 1918–1962*. New York: Berghahn Books 2002

– *Managing the Franc Poincaré: Economic Understanding and Political Constraint in French Monetary Policy, 1928–1936*. New York: Cambridge University Press 1991.

Mugridge, Ian. *The View from Xanadu: William Randolph Hearst and United States Foreign Policy*. Montreal: McGill-Queens University Press 1995.

Nevins, Allan. *Henry White: Thirty Years of American Diplomacy*. New York: Harper & Brothers 1930

Newhall, David S. *Clemenceau: A Life At War*. Lampeter: Edwin Mellen Press 1991.

Nolan, Michael E. *The Inverted Mirror: Mythologizing the Enemy in France and Germany, 1898–1914*. New York: Berghahn Books 2005.

Nora, Pierre (ed.). *Essais d'ego-histoire*. Paris: Gallimard 1987.

Nouailhat, Yves-Henri. *France et Etats-Unis. Août 1917–avril 1917*. Paris: Publications de la Sorbonne 1979.

O'Donnell, J. Dean. *Lavigerie in Tunisia: The Interplay of Imperialist and Missionary*. Athens: University of Georgia Press 1979.

Ormesson, Wladimir d'. "Deux grandes figures de la diplomatie française: Paul et Jules Cambon," *Revue d'Histoire Diplomatique* 57–59 (1943–45): 33–71.

Oudin, Bernard. *Aristide Briand: Biographie*. Paris: Laffont 1987.

Pachter, Marc (ed.). *Telling Lives: The Biographer's Art*. Washington: Smithsonian Institution 1979.

– "The Biographer Himself: An Introduction." In *Telling Lives: The Biographer's Art*, edited by Marc Pachter, 2–15. Washington: Smithsonian Institution 1979.

Paléologue, Maurice. *Journal, 1913–1914. Au Quai d'Orsay à la veille de la tourmente*. Paris: Plon 1947.

Paris, Gaston. *Le Haut enseignement historique et philologique en France*. Paris: H. Welter 1894.

Passerini, Luisa (ed.). *Across the Atlantic: Cultural Exchanges between Europe and the United States*. Brussels: Peter Lang 2000.

Payne, Darwin. *Owen Wister: Chronicler of the West, Gentleman of the East*. Dallas: Southern Methodist University Press 1985.

Pemble, John. *Shakespeare Goes to Paris: How the Bard Conquered France*. London: Hambledon and London 2005.

Perkins, Dexter. "The Department of State and American Public Opinion." In *The Diplomats, 1919–1939*, 1, edited by Gordon Craig and Felix Gilbert, 1:282–308. New York: Atheneum 1963.

– *Charles Evans Hughes and American Democratic Statesmanship*. Boston: Little, Brown and Co. 1956.

Petricioli, Marta (ed.). *Une Occasion Manquée? 1922: La Reconstruction de l'Europe*. Bern: Peter Lang 1995.

Pocock, Emile. "Presidents of the American Historical Association: A Statistical Analysis," *AHR* 89, no. 4 (Oct. 1984): 1017–36.

– "'Made in USA': Les historiens français d'outre-atlantique et leur histoire," *Revue d'Histoire Moderne et Contemporaine* 40, no. 2 (1993): 303–20.

Poincaré, Raymond. *Au Service de la France*, 10 vols., Vol. 10, *Victoire et Armistice, 1918*. Paris: Plon 1933.

Popkin, Jeremy. "*Ego-histoire* and Beyond: Comtemporary French Historian-Autobiographers," *French Historical Studies* 19, no. 4 (fall 1996): 1139–67.

Portes, Jacques. *Une fascination réticente: Les Etats-Unis dans l'opinion française 1870–1914*. Nancy: Presses Universitaires de Nancy 1990.

Pusey, Merlo J. *Charles Evans Hughes,* 2 vols., vol. 2. New York: Columbia University Press 1963.

Ramsden, John. "'French People Have a Peculiar Facility for Being Misrepresented': British Perceptions of France at War, 1914–18." In *Britain, France and the Entente Cordiale since 1904,* edited by Antoine Capet, 8–27. London: Palgrave Macmillan 2006.

Rearick, Charles. *The French in Love and War: Popular Culture in the Era of the World Wars.* New Haven: Yale University Press 1997.

Rémond, René. *Pour une histoire politique.* Paris: Editions du Seuil 1988.

Rhodes, Benjamin D. "Reassessing 'Uncle Shylock': The United States and the French War Debt, 1917–1929," *Journal of American History* 55, no. 4 (March 1969): 787–803.

Ribot, Alexandre. *Journal d'Alexandre Ribot et corrrespondances inédites, 1914–1922.* Paris: Plon 1936.

Rioux, Jean-Pierre, and Jean-François Sirinelli. *Histoire culturelle de la France,* vol. 4, *Le temps des masses.* Paris: Seuil 1998.

Rippy, J. Fred and Clyde E. Hewitt, "Cipriano Castro, 'Man Without a Country,'" *AHR* 55, no. 1 (Oct. 1949): 36–53.

Roberts, Chalmers M. *The Washington Post: The First 100 Years.* Boston: Houghton Mifflin 1977.

Roger, Philippe. *The American Enemy: A Story of French Anti-Americanism,* translated by Sharon Bowman (Chicago: University of Chicago Press 2005.)

Root, Elihu. *Miscellaneous Addresses,* edited by Robert Bacon and James Brown Scott. Port Washington, New York: Kennikat Press 1966.

Rudy, Willis. *Total War and Twentieth Century Higher Learning: Universities of the Western World in the First and Second World Wars.* Rutherford, New Jersey: Associated University Presses 1991.

Ryley, Thomas W. *Gilbert Hitchcock of Nebraska: Wilson's Floor Leader in the Fight for the Versailles Treaty.* Lampeter: Edwin Mellen Press 1998.

Saint-Aulaire, Comte de. *Je suis diplomate.* Paris: Editions de Conquistador 1954.

– *Confession d'un vieux diplomate.* Paris: Flammarion 1953.

Salisbury, Harrison E. *Without Fear or Favor: The New York Times and Its Times.* New York: Times Books 1980.

Schmitt, Bernadotte. "French Documents on the War," *Journal of Modern History* 1, no. 4 (Dec. 1929): 636–41.

Schroder, Hans-Jurgen (ed.). *Confrontation and Cooperation: Germany and the United States in the Era of World War 1, 1900–1924.* Providence: Berg 1993.

Schuker, Stephen A. *American "Reparations" to Germany, 1919–33: Implications for the Third World Debt Crisis.* Princeton: Department of Economics, Princeton 1988.

– *The End of French Predominance in Europe: The Financial Crisis of 1924 and the Adoption of the Dawes Plan.* Chapel Hill: University of North Carolina Press 1976.

Seydoux, Jacques. *De Versailles au Plan Young: Réparations, dettes interalliés, reconstruction européenne.* Paris: Plon 1932.

Singer, Barnett. *Maxime Weygand: A Biography of the French General in Two World Wars.* Jefferson, North Carolina: McFarland and Co. 2008.

– *Modern France: Mind, Politics, Society.* Montreal: Harvest House 1980.

– "From Patriots to Pacifists: The French Primary School Teachers, 1880–1940," *Journal of Contemporary History* 12, no. 3 (July 1977): 413–34.

– and John Langdon. *Cultured Force: Makers and Defenders of the French Colonial Empire.* Madison: University of Wisconsin Press 2004.

Small, Melvin (ed.). *Public Opinion and Historians.* Detroit: Wayne State University Press 1970.

Spring-Rice, Sir Cecil. *The Letters and Friendships of Sir Cecil Spring-Rice,* (1929), ed. Stephen Gwynn, 2 vols. Westport: Greenwood Press 1971.

Squires, James Duane. *British Propaganda at Home and in the United States from 1914 to 1917.* Cambridge: Harvard University Press 1935.

Stevenson, David. "Britain, France and the Origins of German Disarmament, 1916–19," *Journal of Strategic Studies* 29, no. 2 (April 2006): 195–224.

– "France at the Paris Peace Conference: Addressing the Dilemmas of Security." In *French Foreign and Defence Policy 1918–1940,* edited by Robert Boyce, 10–29. London: Routledge 1998.

– "The Failure of Peace by Negotiation in 1917," *Historical Journal* 34, no. 1 (March 1991): 65–86.

– *French War Aims against Germany, 1914–1919.* Oxford: Clarendon Press 1982.

– "French War Aims and the American Challenge, 1914–1918." *Historical Journal* 22, no. 4 (1979): 877–94.

Strauss, David. *Menace in the West: The Rise of French Anti-Americanism in Modern Times.* Westport Conn.: Greenwood Press 1978.

Sullivan, Mark. *The Great Adventure at Washington: The Story of the Conference.* New York: Doubleday, Page & Co. 1922.

Sullivan, William M. "The Harassed Exile: General Cipriano Castro, 1908–1924," *The Americas* 33, no. 2 (Oct. 1976): 282–97.

Sykes, Sir Percy. *The Right Honourable Sir Mortimer Durand: A Biography.* London: Cassell 1926.

Tardieu, André. *France and America: Some Experiences in Cooperation.* Boston: Houghton Mifflin 1927.

Talese, Gay. *The Kingdom and the Power.* New York: World Co. 1969.

Taylor, Philip M. "Propaganda in International Politics, 1919–1939." In *The Origins of the Second World War*, edited by Patrick Finney, 351–71. London: Arnold 1997.

Trachtenberg, Marc. *Reparation in World Politics: France and European Economic Diplomacy, 1916–1933.* New York: Columbia University Press 1980.

Ulrich-Pier, Raphaele. *René Massigli (1888–1988): Une vie de diplomate,* 2 vols. Paris: Ministère des Affaires Etrangerès 2006.

Van Montfrans, Manet and Ruud Meijer, "Travailler pour la Patrie: Gustave Lanson, the Founder of French Academic Literary History," *Yearbook of European Studies* 12 (1999): 145–72.

Vaughn, Stephen. *Holding Fast the Inner Lines: Democracy, Nationalism and the Committee on Public Information.* Chapel Hill: University of North Carolina Press 1980.

Wall, Irwin M. "From Anti-Americanism to Francophobia: The Saga of French and American Intellectuals." *French Historical Studies* 18, no. 4 (fall 1994): 1083–100.

Watson, David Robin. *Georges Clemenceau: A Political Biography.* London: Eyre-Methuen 1974.

Watts, Sarah. *Rough Rider in the White House: Theodore Roosevelt and the Politics of Desire.* Chicago: University of Chicago Press 2003.

Weber, Eugen. *France: Fin de Siècle.* Cambridge: Harvard University Press 1986.

Webster, Andrew. "From Versailles to Geneva: The Many Forms of Interwar Disarmament," *Journal of Strategic Studies* 19, no. 2 (April 2006): 225–46.

Wendt, Lloyd. *Chicago Tribune: The Rise of a Great American Newspaper.* Chicago: Rand McNally 1979.

Werner, M.R. *Bryan.* New York: Harcourt Brace 1929.

Weygand, General Maxime. *Mémoires,* 3 vols., vol. 2. *Mirages et réalité.* Paris: Flammarion 1957.

Wilson, Woodrow. *The Papers of Woodrow Wilson,* 69 vols, edited by Arthur S. Link. Princeton: Princeton University Press 1966–.

Wister, Owen. *Roosevelt: The Story of a Friendship, 1880–1919.* New York: Macmillan 1930.

Wolff, Geoffrey. "Minor Lives." In *Telling Lives: The Biographer's Art,* edited by Marc Pachter, 56–72. Washington: Smithsonian Institution 1979.

Young, Bert Edward. "The Origins of the AATF," *French Review* 21, no. 3 (Jan. 1948): 212–15.

Young, Robert J. *An Uncertain Idea of France: Essays and Reminiscence on the Third Republic.* New York: Peter Lang 2005.

– *Marketing Marianne. French Propaganda in America, 1900–1940.* New Brunswick, New Jersey: Rutgers University Press 2004.

– *France and the Origins of the Second World War.* London: Macmillan 1996.

– (ed.) *Under Siege: Portraits of Civilian Life in France during World War 1.* New York: Berghahn Books 2000.

– "Out of the Ashes: The American Press and France's Postwar Recovery in the 1920s," *Historical Journal/Réflexions Historiques* 28, no. 1 (Spring 2000): 51–72.

– "A douce and dextrous persuasion: French propaganda and Franco-American relations in the 1930s." In *French Foreign and Defence Policy, 1918–1940,* edited by Robert Boyce, 195–214. London: LSE Routledge 1998.

– (ed.). *French Foreign Policy, 1918–1945: A Guide to Research and Research Materials.* Wilmington: Scholarly Resources 1991.

– *Power and Pleasure: Louis Barthou and the Third French Republic.* Montreal: McGill-Queen's University Press 1991.

Zeldin, Theodore. *France 1848–1945.* 2 vols. Oxford: Clarendon Press 1973, 1977.

Index